TRIBAL SCULPTURE

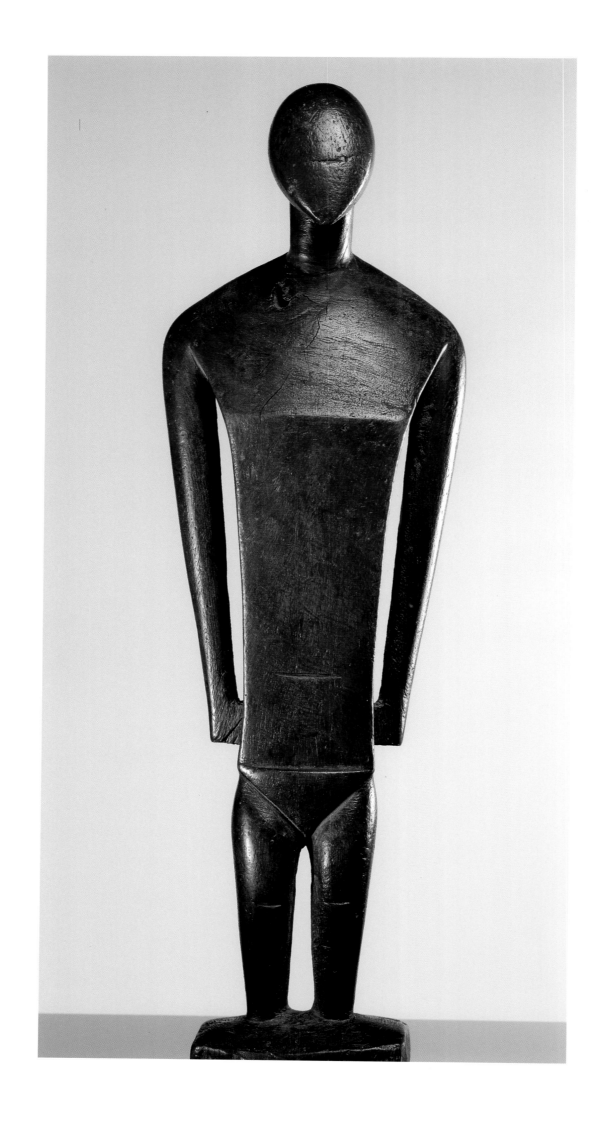

TRIBAL SCULPTURE

Masterpieces from Africa, South East Asia and the Pacific in the Barbier-Mueller Museum

Douglas Newton • Hermione Waterfield

Photographs by

Pierre-Alain Ferrazzini

with 295 illustrations in full color

The Vendome Press

Photography by Pierre-Alain Ferrazzini
Pages 45, 46, 60, 62, 72, 103, 136, 137,
178, 183 Roger Asselberghs
Page 299 Patrick Goetlen
Page 126 R. Steffen

Published in the United States and
Canada by
The Vendome Press
1370 Avenue of the Americas
Suite 2003
New York, NY 10019

Distributed in the USA and Canada by
Rizzoli International Publications through
St. Martin's Press
175 Fifth Avenue
New York, NY 10010

Copyright © 1995 Imprimerie Nationale
Éditions, Paris; Barbier-Mueller Museum,
Geneva

Library of Congress Cataloging-in-
Publication Data
Collection Barbier-Mueller.
Tribal Sculpture. Masterpieces from
Africa, South-East Asia and the Pacific in
the Barbier-Mueller Museum / by Douglas
Newton; photographs by Pierre-Alain
Ferrazzini.
 p. cm.
ISBN 0-86565-962-1 (hardcover)
1. Sculpture. Primitive--Catalogs. 2.
Sculpture—Switzerland—Geneva—
Catalogs. 3. Collection Barbier-Mueller—
Catalogs.
I. Newton, Douglas, 1920- . II. Title.
NB27.S9G463 1995
730' .089—dc20

Printed and bound in France

Frontispiece: small wood figure from
Nukuoro in the Caroline Islands

CONTENTS

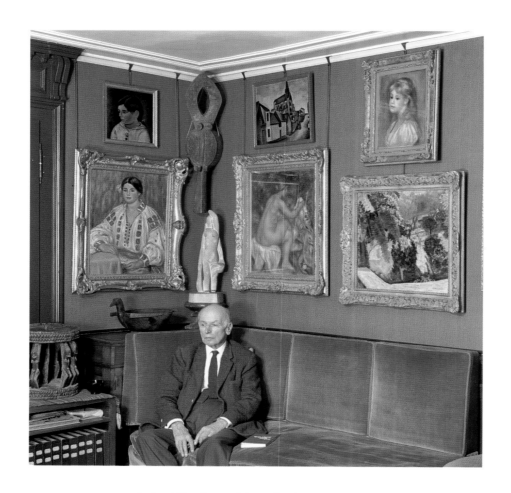

1. *Josef Mueller aged 80, in his house at Soleure*
(photo Kurt Blum).

The Story of a Collection
1907–1994

by Jean Paul Barbier

A twenty-year-old visionary poet, who was not thought to be interested in the painters of his time or to be an assiduous visitor of the Louvre, wrote:"Taste is the fundamental quality that sums up all other qualities."

When I first met Josef Mueller in 1952, I passionately admired this poet, Lautréamont. But I was also convinced that my mother's Louis XVI salon, with its profusion of curios from that period, its puce silk curtains and furniture stamped with the maker's mark, represented the last word in "good taste". It did not take me long to learn, thanks to meeting Josef Mueller, that "good taste" is to "taste" what Redouté's roses are to Goya's engravings and that an ocean separated decorative objects from collector's pieces…

Josef Mueller (Fig. 1) came from a bourgeois family from Soleure, in German Switzerland. From the fifteenth century on the family had owned land in Kriegstetten, where one day in 1886 Josef's father became one of the first men to build a power-station to run the machinery in his factory, situated some seven kilometres away. This enterprising man, who was passionately interested in his work as an industrialist and in politics, did not live long enough to bring up his daughters and his one son. The mother did not survive her last pregnancy, so the boy was only six years old when he found himself an orphan.

I think it is important to trace the astonishing career of a man whose first steps were carelessly supervised by an aged uncle and who grew up with everyone around him talking constantly of the day he would take over as head of the family firm, provisionally entrusted to directors. At school, he became interested in Goethe and Schiller and Virgil, Horace and Homer. But quite unexpectedly a window opened and the adolescent boy's life lit up when he was invited to the house of a school friend whose father owned a quite respectable collection of paintings. Josef gazed fascinated at these pictures, which included works by the great Ferdinand Hodler.

In 1907, Josef Mueller was twenty years old. He had reached his majority and although his actual inheritance was fairly small, he also inherited an accumulated income amounting to quite a tidy sum. As a student at the Zurich Polytechnicum, he schemed to meet Hodler and soon bought two enormous canvases of nude, enlaced couples, which created a scandal when they were exhibited, for the subject of the work was *Die Liebe*, "Love".

To his amazement Hodler discovered that the purchaser of these controversial paintings was not a museum but a twenty-year-old student. He met him, became friendly with him and agreed to let him have the wonderful nocturnal landscape representing the Eiger, Jungfrau and Mönch mountains, which now belongs to my son Thierry, also an informed collector of paintings.

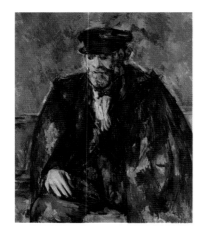

2. *"Portrait of Vallier"*
by Paul Cézanne (1905), purchased
by Josef Mueller in Paris in 1911.

These first purchases give a very precise idea of what was to motivate Mueller throughout his life: the search for exceptional works of painting, chosen not because they were fashionable but according to a single criterion, quality. He gave up the career of industrialist that awaited him and wrote to a friend in 1911: "At last I have discovered the purpose of my life, the pole towards which all my thoughts, efforts and senses will be directed. And the star that shines before my eyes, in the night of a world of change and upheaval, that solitary, distant and peaceful star is Art".

In that same year of 1911 he went to Paris to see Vollard. He had already bought a Van Gogh (not the one he dreamed of) and desperately wanted to acquire a "large Cézanne". Alas, Vollard's prices were out of his reach. However the dealer, touched by his sincerity, informed him that a major canvas by the master of Aix would soon be sold as part of the estate of Henry Bernstein. Vollard promised not to bid against the young collector (then twenty-four years old). That is how Mueller acquired the portrait of the gardener Vallier (Fig. 2) which cost him a whole year's income.

The years 1912 and 1913 found the young engineer *manqué* in the United States. He followed a training course, with little sign of enthusiasm, at the Singer factory, but took advantage of his time there to visit the major museums and collections. In Chicago he made friends with the collector Jérôme Eddy, who owned several works by Kandinsky. As soon as he returned to Europe Mueller started hunting; in 1914 he managed to have two masterpieces by the Russian painter sent to him from Germany: the great *Composition V* of 1911 and *Improvisation 31* (now in the National Gallery, Washington). Still in 1914, he bought a magnificent Picasso dating from the late pink period (1906) from an agent: *Two nude Women*, also known as *The Two Sisters* (Fig. 3). He frequented museums and galleries, quite oblivious of the war. It is certain that he had already become interested in the art of classical antiquity, no doubt stimulated by his incessant reading of the *Odyssey* and the tragedies of Sophocles and Euripides. A photo taken in 1915 at the entrance to the house where he was born and where ninety years later he died shows a Greco-Roman stele beside one of the two Kandinsky paintings he had just received.

During the summer of 1922, Mueller lived in an artist's studio in the Boulevard du Montparnasse. This was the beginning of an astonishing period during which he showed unerring judgment. In 1926–1927 he bought ten works by Miró, then still an unknown artist. He came away from the first Max Ernst exhibition with five remarkable paintings, including the *Grande Forêt* of 1925. At the same time he was a constant visitor to the studio of Léger, collecting an amazing body of his work, some twenty canvases and gouaches. He bought an even more astonishing series of works by Rouault: on his death, Mueller left

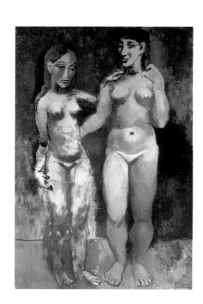

3. *"Two nude Women"*
by Pablo Picasso. Josef Mueller
acquired this great painting of the
Pink Period (1906) in 1914.
© SPADEM 1995

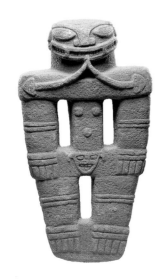

4. *"Jaguar-God" in volcanic stone from Costa Rica (c. 1000 AD), acquired by Josef Mueller in the 1920s.*

more than thirty major early works by this painter, of whom he wrote to his sister in 1907: "I think I have discovered a new Daumier".

In 1929 he married and soon had a daughter, my wife Monique. This man, who until then had only known the discomfort of the artist's studio, now found himself in a spacious apartment in the Avenue de la Bourdonnais. He was the proud owner of a fully-furnished dining room, a drawing room and a bedroom *à la Leleu*, for even if he was indifferent to the decor and could live with yellowing, cracked, smoky walls, in his choice of furniture he followed the dictates of the taste with which nature had endowed him. A few photographs of the apartment show that he owned some lovely wooden bowls from Oceania and some African chairs. Presumably he was not particularly keen on the masks and fetishes he already possessed; they remained in the Boulevard du Montparnasse studio, which Josef Mueller kept on until his return to Switzerland in 1942. They shared the space with important pre-Columbian American sculptures which Josef Brummer had sold to him at the beginning of his stay in Paris (Fig. 4), Japanese tea bowls from Vignier (who was also to sell him a few major African works), Roman and Cycladic marbles (Fig. 5), and drawings and gouaches (mainly by Léger) which he obtained at sales.

Four years later, his marriage ended in divorce and Mueller returned to his studio, sending the main body of his collection of paintings to Switzerland. Thereupon his sister Gertrud Dubi-Mueller, herself a collector of some repute, looked after the large crumbling house in which so many treasures were amassing. At the time Europe was plunged into the most severe economic recession of the century. Mueller told me that he had been reduced to buying "negro art" as he no longer had the resources to acquire first-class paintings because they had become too expensive for him, even though their market value had fallen. In fact, this statement (often repeated in biographical articles) has to be reviewed in the light of the little black school note-books in which he briefly noted down his purchases between 1938 and 1941. A kind of acquisitive passion seems to have gripped him during these years in which his family life finally disintegrated. Objects from every conceivable source, and very often of poor quality, piled up by their dozens in a second studio which he had rented and used as a store-room. Sometimes, the sums were considerable, and the total amount he spent in the space of a year would certainly have enabled him to buy one or two more good paintings had he not been possessed by this frenzy, this passion for collecting.

It almost looked as though the collector of the 1930s was not the same man as the one who had chosen paintings by the most significant, the most remarkable of his contemporaries before the first world war.

It is of more interest to enquire whether Mueller's motives were not in essence the same, relatively speaking, as those of an artist such as Picasso (in his

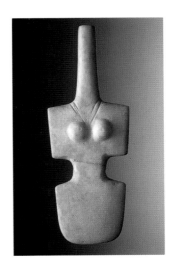

5. *Cycladic statuette from the earliest period (end of the 4th millennium BC). Acquired by Josef Mueller between the wars.*

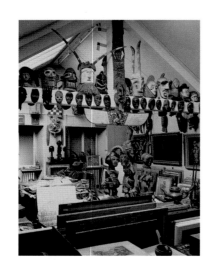

6. *Attic of Josef Mueller's house in Soleure,*
in German Switzerland. c. 1970.

capacity as a collector of negro art). William Rubin[1] has quoted a remark of Picasso's about a mediocre African piece: "You don't need the masterpiece to get the idea." Rubin added: "In any case most of Picasso's African sculptures, far from representing a personal museum of tribal art, were distributed around his studio in more or less the same way as other objects he considered of visual interest, ranging from paintings, sculptures and fabrics to musical instruments (tribal or modern), curios, souvenirs and toys".

One cannot help being struck by the similarity in the approaches of the two men when we find that an antique marionette of Pulcinella greeted visitors on the threshold of the attic room which also contained rows of African masks (Fig. 6) of very unequal quality, surrounded by serried ranks of paintings and, on the floor, folk pottery (Josef Mueller owned more than a thousand Swiss or Alpine glazed plates, some of them dating from the eighteenth and nineteenth centuries and of great value, mixed in with others whose chipped condition rendered them no longer respected or desirable).

Perhaps it would need the eye of an ordinary man-in-the-street and not that of an expert in tribal art to judge the body of work that made up this enormous assemblage of fetishes, masks, drums and African and Oceanic chairs which Mueller had arranged spectacularly in his empty factory. William Rubin was certainly right to emphasize that "Until the 1950s the selection of tribal art kept in the West was fairly random in terms of artistic quality." The catalogues of such fundamental exhibitions as that devoted to African masks for Charles Ratton in 1931 or that devoted to "negro art" at the Museum of Modern Art in New York in 1935 are signal proof of that. However, considering its profusion of genres, variety of styles and differences in scale (Josef Mueller possessed more than 2 500 "ethnic" objects), the collection which I was amazed to discover in Soleure in 1952 was certainly not one to be judged only in terms of the aesthetic quality of this or that object, nor in terms of the value of particular paintings; works by Cézanne, Renoir, Degas, Picasso and Léger hung side by side with paintings by Laprade and Bouche. Quite frankly, I think Franz Meyer[2] was absolutely right when he said: "There is no doubt that Mueller was fully aware of the difference in quality between, for example, the paintings by Carigiet hanging in the stairway and the truly prodigious body of works by Léger in the first room one entered. But absolute quality seemed to count less than creativity..."

As for the tribal art, the number of major pieces that stand out in a sea of disparate objects is sufficient to dispel once and for all any notion of an element of "chance" being involved. In the field of African and Oceanic art, it was also true of Josef Mueller that "it does not need a masterpiece for one to be inspired with ideas." The most sober of the sculptures, the simplest wooden cup, spoke to him in a language which I must humbly admit was to me totally foreign.[3]

It is true that when I joined the Mueller family, I was very poorly equipped to grasp the subtle and silent relations that existed between my father-in-law, his sister Gertrud Dubi and his nephew Rudolf Schmidt on the one hand and the works of art with which they had surrounded themselves on the other. A jurist and historian, passionately interested in poetry, I believed in the omnipotence of intelligence and of the word; I firmly believed, like Aristotle, that a work of art consists of an idea, an idea that exists without matter. For a brief moment I was vain enough to suppose that in giving the hand of his only daughter to a fluent and attentive young man, the old collector would be keen to give him the key to this strange universe of his. I even had hopes that he would treat me, even if condescendingly, as a "colleague", for I regarded myself (legitimately, but not in the eyes of Josef Mueller) as a genuine collector. My library, which already contained a good number of rare editions of French poets of the Renaissance,[4] and my small show-case of antique objects (Fig. 8), seemed to me to show clearly that I was a serious collector.

It would be wrong to say that my evidence was dismissed. Simply: it ceased to exist once I had left Geneva to go to Soleure. Apparently Degas used to say: "The arts must be discouraged!" Well, I was utterly discouraged, in the most radical way imaginable. And yet, during the twenty-five years that were to pass before Josef Mueller's death, I persisted in laying siege to this fortress that never surrendered!

In 1967 (when I was nearly thirty-seven), something extraordinary happened to me. I was in New York, where I used to visit a very shrewd dealer, J. J. Klejman, late every afternoon. As was my custom I had reserved one by one a dozen or so pleasing American-Indian and African pieces. On the eve of my departure, J. J. Klejman showed me a large wooden dish from the New Hebrides, whose majesty amazed me. I asked the price, but when I heard it I had to say that I could not afford that kind of money… Klejman shook his head. He asked me if I had ever wanted to form a collection as good as my father-in-law's. Certainly, I replied, but I did not have the means, it was not possible at that time. The antique dealer looked at me and asked: had I ever worked out how much I was prepared to spend on the dozen or so pieces that I had been reserving, day after day? It was easy to guess the answer: the amount was exactly the price of the large plate from the New Hebrides!

That lesson bore fruit: I immediately began to search for "important" pieces. And since I acquired them at almost the same rate as the more decorative objects I had bought before, I also discovered the budgetary problems that are the common lot of all collectors worthy of that name!

In 1977, Josef Mueller passed away, at the age of ninety. A few years earlier I had asked him what he thought of the idea of setting up a small private

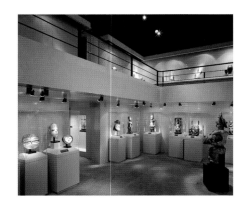

9. View of the ground floor of the Musée Barbier-Mueller, in the rooms of the Vieille-Ville of Geneva reserved for temporary exhibitions.

museum of tribal art, so that all these objects shut up in store-rooms (his and mine) could have been shown to the public. My father-in-law did not vouchsafe an opinion. He had for a long time acted (without pay) as director of the Soleure museum, where he brought many young Swiss painters to the public eye, so he could not be against such a museum in principle. But I am sure he regarded it as distressingly ostentatious to have his name displayed on the pediment of a public building (my wife felt the same). His discretion had not prevented him from showing a selection of African and Oceanic sculpture in 1957 or quietly creating a "Josef Mueller Foundation" for his native village, bequeathing it some fifty major paintings, including Braque, Matisse, Rouault and, of course, Hodler. Josef Mueller concluded the discussion with a phrase that he often repeated: "When I am gone, you can do what you like." My wife and I therefore went ahead. The Barbier-Mueller Museum opened its doors in May 1977 (Fig. 9), three months after my father-in-law's death. It brought together a great many friends, lovers of art, from all over the world. They soon set up an association of friends of the museum, which now has nearly one thousand members.

With the full agreement of my wife, the sole inheritor of the Mueller collections, we proceeded with a heavy heart to break up the *oeuvre* put together in the large house in Soleure—that house of which Pierre Schneider so charmingly wrote: "One could say that painting and sculpture had taken the place of the house, for they were totally solid, while the house was gradually being eroded by time, giving the impression that art itself had become the house of Josef Mueller and that if the works were taken away, all that would remain would be a void".[5]

We examined each piece objectively, judging it by its own qualities and not as part of an *oeuvre*. We decided to dispose of two thirds of the African and Oceanic collection, slightly less of the pre-Columbian collection and a little more of the Mediterranean archaeology. Whether we took the right approach may be judged from the catalogues of the three sales organized by Christie's in London. And of course the proceeds of these sales was reinvested in new purchases. When I became keeper of the museum, I tried, in full agreement with my wife, not to be influenced by the need to close any gaps but to continue choosing as a collector. I had the enormous luck to be able to attend the incredible sales held over a period of nearly thirty years by the ethnography museums of Communist Germany (that is a story that needs to be written) and the museum of Budapest (for the many pieces from these two sources, see below). Financially, it took enormous resources to work on so many fronts. What I in fact wanted was to form coherent bodies of work from certain regions or stylistic centres, such as Nigeria, the Ivory Coast, Tanzania (where I failed to some extent), the various Indonesian islands, New Guinea, New Ireland and the Solomon Islands, not forgetting the art of the Steppes, Cycladic, Villanovan, pre-Etruscan and also

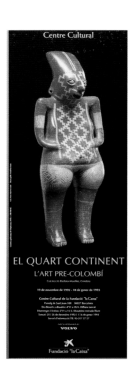

10. Poster for the pre-Columbian exhibition which included 148 pieces from the Barbier-Mueller collections, at its inauguration in Barcelona, prior to a major tour of Spain.

pre-Columbian art—the fact is that we had no works at all from some ancient American civilizations shortly before we began to prepare for the great exhibition (Fig. 10) in 1992 commemorating the voyage of Columbus.

In all these areas, except Indonesia, I was building on solid foundations: the "masterpieces" collected by Josef Mueller, which can be seen in the following pages. Each of our major exhibitions was accompanied by a catalogue. And in order to find out how to group the works in the catalogues, I went to Sumatra, to the Ivory Coast, to Mexico. But let there be no misunderstanding: I visited these countries after our collections had already been formed, which should dispel the ever-present suspicion that some pieces might have been bought from poor villagers who were thus deprived of their ancestral treasures.[6] In fact, I have often said jokingly that our basic purveyors of art were, the Sotheby's tribe and the Island of Christie's, not to mention those skilful dealers who managed to unearth treasures that had long lain dormant in the attics of former colonial officials or military families.[7]

Our publications, which number over forty, have given me a pleasure akin to what I feel as a bibliophile when I discover a little volume that I never dreamed of finding. From catalogues we soon moved on to books, then to the "big book", thanks to our friends in the Imprimèrie Nationale in Paris…

This might seem a far cry from Josef Mueller and his star! And yet I feel more and more close to him, for what inspires my wife and myself is none other than a profound and sincere interest in the quest of man, every man, for aesthetic satisfaction.

In that respect, to present a selection of works always seems something of a betrayal, for it means that a humble piece often makes way for one that is better understood by a public that is more eager to recognize the familiar than to discover the new. Let not the reader take that to mean that I disapprove of the selection made here. It is simply that I have a vague sense of nostalgia for a book that would contain neither a bronze head from Benin, nor a divinity from Nukuoro, nor any other "gem of primitive art", but more modest pieces (Fig. 11), works of craft rather than art, like boomerangs, or those pre-dynastic Egyptian vases to which we once devoted an entire catalogue; for these I feel a special affinity, born of my contact with Josef Mueller, that great collector of African cups, chairs and weapons and Oceanic clubs, boomerangs and shields.

There is nothing factitious about this nostalgia. It is not the coquetry of the "connoisseur". It is an inevitable reflection of the agony of choice. Here, the sense of anxiety is all the keener because of the great fear that true, pure beauty may have been sacrificed to the trappings of artifice… Fortunately, this pitfall would not be fatal. It could even lead to a useful re-evaluation. The life of the collector is always ruled by the dual signs of certainty and doubt.

11. Australian boomerang of the type known as "swan's neck". The beauty of this sculpture gives it a more than purely ethnographic appeal.

1. *Primitivism in 20th Century Art*, New York, The Museum of Modern Art, 1984, p. 14

2. *A Life of Collecting, Josef Mueller, 1887–1977*, Geneva, 1989, p. 48

3. In the field of "primitive" art, Josef Mueller's total lack of interest in the "status of the object", its position in a hierarchy ranging from the pale copy to the sculpture by a master, manifested itself in a way which led me to agree with the verdict of Rubin, who praised my father-in-law's collection of paintings very highly but had more reservations about his tribal art. As an example I can quote my long battle with him (which I won) to persuade him to banish a Senufo drum obviously made for commercial purposes from the entrance hall of the Soleure house. Josef Mueller replied that he could not care less about the origins or traditional character of this object on which he used to deposit his bunch of keys. "Look at it carefully," he said to me, "it has got 'something'. I have kept this drum at my wife's request, though I have never exhibited it in a museum." But in my turn I too began to think it had "got something". Have I given in, or have I begun to sense what Mueller saw in this sculpture and that I can still not see?

4. This collection, focusing on Renaissance poetry in France and Italy, is an undertaking I have been working on endlessly. It is a passion I have had for fifty years and that is reflected in the publication of the catalogue of the works I have been lucky enough to assemble. The three volumes that have already appeared of *"Ma Bibliothèque poétique"*, concentrating mainly on the poets of La Pléiade, have received more praise than our best books on "tribal art" will ever obtain. Why should I conceal the fact that this is a source of great joy to me?

5. *A Life of Collecting, Josef Mueller, 1887–1977*, Geneva, 1989, p. 50

6. This is a question that is constantly being put by visitors to our exhibitions: "How did you manage to discover all these beautiful things in Africa, in Indonesia, etc.?" The most direct reply (that none of this would have been preserved in a tribal society) does not satisfy lovers of tales of adventure. Alas, it is true that colonialism and Christianity (sometimes Islam too) have saved very few of the instruments of ancestral cults. And that the best the modern traveller can expect is to be invited to watch a dance of painted masks, briefly to contemplate fetishes sculpted in haste to replace those that disappeared long ago. All that remains is monuments that are (fortunately!) too heavy to transport; but many of them were destroyed once they were no longer revered.

7. Although it is generally undisputed that private collectors are responsible for nearly all the collections that became public, on the other hand there is always someone who asks whether the *objets d'art* accumulated over a lifetime have been collected 'correctly'. The wealth of Western collections may appear insolent, but in fact they reflect a profound respect for our fellow-men, so near and yet so far.
Suffice to say, in brief, that a collector worthy of that name is anything but a vandal, anything but a thief. There is no difference between an Italian chapel and an African fetish hut: all sacred objects are untouchable. But disaffection is a universal phenomenon. And it is certainly better for a mask that is no longer worn, a statue that is no longer worshipped, to find its way into one of those temples of beauty called museums, than to be destroyed. Had there been no market for antiques, the truth is that everything would have disappeared.

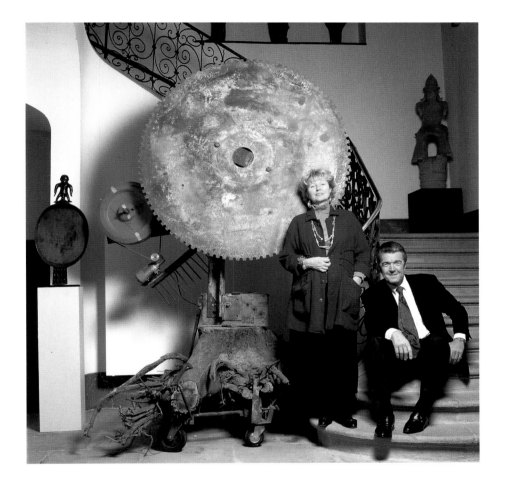

Monique and Jean Paul Barbier-Mueller in Geneva in December 1994.
To the left of the sculpture by Jean Tinguely we see the wooden plate from
the New Hebrides referred to in page 13
A Japanese Haniwa terracotta statue from the first centuries AD can be
seen by the stairs on the right.

The Flat, The Round, and Space

by Douglas Newton

Look, to begin, at a small wood figure from Nukuoro in the Caroline Islands of Micronesia [frontispiece]. It is one of the ultimate reductions of the human form to its simplest components; not as rigorous, certainly, as some of the Bronze Age marble Kusura figures from Anatolia, but much more so than the goddesses from the Cyclades. It would be near the truth to see it as a universal portrait of mankind's earliest ancestors. Adam and Eve, fresh from the hand of God, might have looked like this; completely formed, but with none of the elaborations which became necessary for life after the Fall. No facial features, because the apprehension of the senses was direct; no sexes, because sexual oppositions became apposite only when innocence failed. But this is not God's work: it is man's: it is not a human being, it is a sculpture.

Sculpture: if we think of the word alone, with nothing qualifying it, "sculpture" projects over our mental screens a dazzling torrent of images, each different from the last and the next, which might continue, we feel, endlessly. And behind the consciousness of those images is a subdued awareness that thousands of men and women have toiled over the last forty thousand years to create them. And in a sense, in vain: records and ruins assure us that the greater part of what they made has been swept away by war, revolution, vandalism, looting and sheer neglect. Countless numbers of works have been melted down, broken up to make building materials, casually or vengefully burned. What we know today is a minute fraction of what has existed in the past. That past comes to us largely in fragments: to the extent that in fact we have developed a branch of connoisseurship of the fragment for its own sake.

But these miserable remnants still remind us that sculptors have taken untold amounts of time, an enormous amount of human history, over their work: and why? Why chip at stone and wood, ivory, bone and shell, mold clay and cast metals? What possesses people to do so? and why do we admire so much what they have done? We take for granted that effort and result alike are admirable. But if we step back from the works and ourselves, we can only see that effort, result and admiration have about them something bizarre.

The deepest roots of sculpture and painting, two of the major visual arts—the third is architecture—remain a subterranean mystery of the mind. Song and poetry find their roots directly in the essential functions of the human body itself: they are an outcome of speech, which is due to breathing, and their tempos are derived from the unceasing rhythms of our most vital organs. The heart, the lungs, give us life with their presence or kill us with their absence: without them there can be no life, there can be no song and poetry.

Sculpture and painting have no such intimate physical origins. They are made of materials worked, transformed, with the hands, those anciently, but in

biological terms recently, acquired tools. Thanks to the opposable thumb, our putterings with materials external to us eventually emerge as individual creations new to the universe. The art of sculpture, in fact, is analogous to those legends in which God creates living beings from earth or pieces of wood. The ultimate psychological longing that stimulates the need to do such a thing remains obscure, even to the sculptor himself; we can speculate what experience of deprivation lies beyond it. It seems to be due to an aching feeling that the world is not yet complete. And perhaps it is due to our sharing that feeling that we respond.

Sculpture has been done in several traditional ways, from the European Palaeolithic until now. There is the fully three-dimensional mode, in which the image stands by itself. Or there is relief on a plane, sometimes below it as in the *en creux* reliefs of Egypt, or above it in relief so shallow that it seems be film washed over the surface; or, as with the Pergamon altar, so high that it almost explodes off the plane into the third dimension.

What must strike us forcibly is the conservatism with which these arts have been sustained. Until recent times their techniques and materials have remained the same almost worldwide with the greatest constancy. Painters have applied colors to wood panels, plaster and fabrics; sculptors have used the materials we have mentioned throughout history: and this even when they were introducing styles and subjects which had never been seen before, and shocked their contemporaries. (One is reminded sometimes of those faintly comic photos in which the Surrealists of the early twentieth century, their minds seething with subversive intentions, all the same present themselves to the world dressed in conventional suits and bow-ties.) Only in about the last fifty years has something called "sculpture," for lack of a better word, been made of new materials and taken on new aspects. We may well ask of some of these works whether they can be called by the traditional name. Here they will not be, because they bear no relation to anything done by the artists whose work is shown in this book. They would have said nothing to the sculptors of Africa, Indonesia and the Pacific. As far as the Western world goes, we may be sure that a great traditional sculptor—Benvenuto Cellini, for instance—would certainly have admired, among his successors, Canova's sculpture; he would have seen, if perhaps reluctantly, the point of Henry Moore's; but he would have had no reaction whatever to one of Carl Andre's arrangements of metal plates on the floor, beyond taking care not to step on it.

Only recently has sculpture moved from its traditional modes, and become, as with other arts, a vehicle of personal expression. Before that, it existed within a framework of traditional reasons. Those reasons are plain enough: they were involved with great institutions: society and religion.

Most of the greatest and most complex, most voluminous achievements in sculpture have had a social purpose. The most familiar to us were made at the behest of the builders of Assyria, Babylon, Egypt and Rome, and at last Byzantium: that core of ancient peoples around the eastern Mediterranean driven to expand outwards from their native centers to form wide empires. In all these, sculpture was one of the pillars of social order.

The grand-scale works were intended without doubt to overwhelm resistance, psychological or physical. As in Assyria: those endless palace corridors of reliefs show the figures of rulers overcoming beasts and men, all under the eyes of gravely applauding gods. To foreign ambassadors, to the courtiers, to the ruler himself, they were the totally convincing evidences of total power. The most astonishing of monuments is Egyptian, Ramesses II's temple at Abu Simbel. A whole stone cliff above a bend of the Nile is worked into four vast seated figures of the King, his miniature wives holding his knees, all staring over the river to the deserts beyond. Behind is the darkness of a hall cut into the living rock, its walls a pictorial confusion of images of war and conquest. At its heart, this is no place of worship. On the southern edge of Egypt's influence, it proclaimed to the feeble tribesmen beyond the border the overwhelming power of the north, which could afford to expend so much labor and art on this distant place.

Probably as much of the art of ancient Egypt was below ground as above, on the walls of those long galleries of chambers, carved in relief, which were the tombs. Conquest again, but here of the empire of death, the province of religion. For although the guardian of the underworld stood ready to greet the new soul with his terrible scales—to weigh the heart's measure of righteousness—the tomb's owner could not really doubt that his heart would rise, not sink into the jaws of the annihilating eater of the dead. Why otherwise the reliefs of all the elements of good living, the gods, the prayers? Certainly the quest for immortality was an Egyptian preoccupation: it was a mainspring of their religious life. And, as throughout the world, religion used sculpture to convey its message.

So, if we think of sculpture, we think equally of the kingdom of this world and the kingdom of the next: the secular and the sacred. Both of these are entirely human concerns, and do not bother any other of the world's fauna. It is not surprising, then, that the great majority of sculpture through the ages has been dominated by the human form.

But here problems have arisen. When the eye of God turns towards works of art it is not with enjoyment or criticism: it is with censure: only so can we interpret the strictures of Allah and Jehovah on images as they have been reported by certain of their followers. But if God does not approve of sculpture, the gods are a different case. The gods in fact need sculpture or other images of themselves. When there are many of them, it is by means of images that their

devotees can tell which is which, for they can recognize the gods by their attrib-
utes. Given only the image of a man or woman, an illiterate worshipper could
not tell one god from another. But if the image proves—how implausibly!—how
gracefully the head of a hawk or jackal sits on human shoulders, the worshipper
knows at once it is Horus or Anubis.

The great monotheists wanted no distinctions of this kind, for God was
to be one and indivisible, with no attributes apart from the usual omnipotence
of gods, and God's doctrinal definition. Speaking through Moses, whose mind
must have still been haunted by innumerable phantasms of Egyptian deities,
God proclaimed an end to graven images. In no time at all, the Israelites back-
slid to the old traditions, fell from grace and earned salutary punishment. They
paid greater attention thereafter.

Muhammad abolished the primitive idols of Mecca and spoke to the
same purpose as Moses—he went even further. As a Muslim jurist explained,
making any image of a living thing "is forbidden under every circumstance, be-
cause it implies a likeness to the creative activity of God." So on Judgement Day
artists will face the terrible challenge of giving life to their creations, and unable
to meet it will go straight to Hell. He was hardly taken seriously. Within a hun-
dred years the Umayyad prince Hisham was nonchalantly adorning his hunting
palaces in Palestine and Syria with a swarm of horsemen, women and angels in
painted stucco. And throughout the realm of Islam, other Muslims for hundreds
of years sculptured and painted the human figure with equal lack of restraint.

Christ himself never raised the question; and his followers have seesawed
merrily between use and abstention ever since. Images abounded in His church-
es from the earliest times and still do, in a tradition only interrupted by occa-
sional outbreaks of iconoclasm and its sister, puritanism. Iconoclasm makes its
first appearance in Byzantium, also a century after Muhammad, as the brain-
child of Leo III. It was perhaps partly fueled by Jewish and Muslim ideas—Leo
was fluent in Arabic—certainly by one of those theological disputes that now
seem as absurd as some twentieth century political disputes have become, part-
ly by the apprehension that the love and reverence they bestowed on their icons
had brought people to worship them like idols. It was time to call a halt; it was
time to purify the church and men's minds, whether they liked it or not. Indeed
they did not, but the Emperor's will prevailed, and vast numbers of holy images
were swept away before the tide turned.

The doctrine always spasmodic led a spasmodic existence. In England it
came to the fore briefly at the Reformation and, again briefly, in the Puritan in-
terregnum of the seventeenth century, bringing terrible devastation each time.
It makes one of its last appearances with the great eighteenth century English
poet Christopher Smart who, in the course of praising the creations of God, says:

For Painting is a species of idolatry, tho' not as gross as statuary.
For it is not good to look with yearning upon any dead work.
For by so doing something is lost in the spirit & given from life to death.

But then, everyone knew that Smart was mad; what he said made no difference to painters and sculptors: in his time they had begun to abandon the modes of past art in favor of the worldly and secular. By the end of the eighteenth century, and the outset of the nineteenth, the palaces and churches of the Baroque, those last great manifestos of the powers of monarchy and religion, began to weigh upon the landscape like gigantic stranded monsters. Art began to enter the realm of private life, where it has largely remained ever since.

So, in spite of censure and censorship, the human body has remained for thousands of years the chief, unsurpassed subject of sculpture. Not without cause, when one thinks of the potentialities of the body for the creation of forms. It is possible to imagine a different version of the human body, but quite impossible in the nature of things to imagine an improved version. A vision of radical changes immediately also evokes the vision of those glass cylinders in which, crammed and pale, there barely fit the sad wonders of teratology.

The human body is a harmony, and falls effortlessly into systems of corresponding or opposing curves and angles,. because of the bilateral symmetry it shares with most other biological arrangements, and the range of movements which its extremities can perform. This situation is enhanced when more than one body is involved, as both choreographers and sculptors have known. Discernment, and above all appreciation, of these systems seem to be absolutely fundamental in our aesthetic values. Such systems are highly versatile, and the history of art shows that they can extended beyond the possibilities of the natural human form. They can be expressed in contortions and linkages which only by analogy are based on bodily actualities.

The systems ideally lead to visual formations in which all the elements are in balance, some kinds of which are conceptual. For instance, the Egyptian reliefs in which the enormous figure of a god, or a ruler, is juxtaposed with a myriad of small figures of lower status persons. This is both conceptual—greatness expressed in a visual metaphor—and visual in that the spaces allotted to the actors in the scene are in a spatial balance that sends an implied message: the absolute value of order. The nobleman sitting with his wife and children under an arbor, his servants working diligently before him, shows the merit of a well-run civilian society. The calm king, standing at ease in his chariot with horses rearing in unison, draws his bow with a gracious gesture: in total contrast to the chaotic rabble of enemy bodies that lies before him, befitting the disorder of uncivilized society.

Jean Cocteau once remarked that sculpture is the noblest art, because it forces one to move around it. The idea was not quite new: as he was no doubt aware, in 1546 Benvenuto Cellini wrote,

"Sculpture is seven times the greatest [of the visual arts], because a statue must have eight show-sides and all must be equally good. [And if not] for every one who admires [the sculptor's work] ten will criticize it, if after the first view they walk around it."

But the idea has its limitations: if the movement of the spectator is any criterion, architecture is far greater than sculpture: it is grander in scale, and it obliges us to move not only around it but through it. Even so, there is much sculpture which we cannot move through but which we must see through because the artist has intended us to do so. Complimentarily, some sculpture does the moving for us. It is designed to move of its own accord, metamorphosing from one aspect to another as it goes and we stand still—Alexander Calder's mobiles come at once to mind. And if we stretch our definition a little further, we can take the choreographer to be an artist who uses the body as a kind of moving sculpture.

We are only convinced that a work is a sculpture when it shows the conjunction of two or more forms. The ovate stone Svayambhu lingams of Tantric art, for example, reach perfection of form, besides being replete with profound religious meaning. But looked at solely as sculpture, they arouse a certain unease. They seem too close to nature: too near to the real form of an egg or a water-worn stone. Even when they are carefully chosen and worked to reveal natural colorations which add or exemplify symbolism, this disturbing aura of the entirely natural persists. Only when, as sometimes, its formal purity is altered by indentation or hollowing do they finally convince us that they are sculpture, the work of human hands. By comparison, in even Brancusi's most abstract work, say the *Beginning of the World*, the unitary form is played off against the form of a support the artist himself designed; and in others (*Torso of a Young Girl* or *The Seal*) the single form is cut across sharply by a plane that redefines it and adds to its complexity.

And where shall we look for the human body in the storm of images? Where shall we look for exemplary sculpture? There are two sculptors whose works, in their disparate ways, illustrate its fundamental qualities.

If you stroll long enough through the "museum without walls," sooner or later you find that some of its galleries exist in real museums, just as sooner or later certain dreams come true. For instance, in the old sculpture galleries of the Louvre. A door opens into the gallery of French neoclassic sculpture. What is neoclassicism? Whatever it is, it is white, the marbly white of Greek sculpture after it lost its paint, frosty, sober.

In this corner, though, some action is going on. Two people with limbs flying in several directions: Ruxthiel, says the label, and this is his *Zephyr and Psyche* (1810–1814). Zephyr, with a mindless smile, has one long arm pointing ahead to the future, and one long leg stretching into past space, a diagonal meaning he is at speed. Psyche, a limp counter diagonal, droops backward over his other arm, showing that she is dubious about the outcome of these proceedings. They form a diagram of emotion but, alas for Ruxthiel, they do not convey emotion; neither for themselves nor for us.

Turning away, we see Psyche again at the other end of the gallery. She is with Eros now, and the shock of their conjunction is intense. They are in the hands of Canova, who ordains their pose. We move from pedantry to genius. Psyche reclines, raising and bending backward her upper body, reaching her arms upward in an oval. Eros kneels behind her at right angles, one of his legs also stretched away; as he bends over her, almost at the moment of a kiss, his arms reach down in an answering oval. Above them both rise his huge, unfurled wings. They are all angles and curves playing off against each other in a linkage of geometric, but totally human precision.

Must we admit the powerful erotic charm of this eulogy of the excellence of beauty and its passions? We must. Does that charm seduce us into misjudging the group's purely aesthetic power? It is not only the beauty of the human bodies that produces such a strong effect. Perform the simple mental exercise of smoothing the contours, stripping away the human features, and regarding what remains. Perhaps. For it is still a rich compositional interplay of slender masses and the lines that define them, set off by those soaring, erect panels of wings, that conveys emotion and drama: it is Canova's arrangement of the lines and masses that gives the sculpture its power, not just its seductive subject.

Anyone who visited the exhibition *Henry Moore Intime* held during 1992 in Paris—a reconstruction of his house—could have noticed on one of the library shelves, with their wealth of evidence for the wide net flung by Moore's interests, a large volume on Canova. One does not know what value Moore placed on Canova's work; but they have much in common. Moore and Canova shared their aim for perfection in creating, if in very different ways, relationships between three-dimensional forms, and in this both excel.

Conjunction consists of distance and closeness, wherever one sets the limits of either, as the sculpture itself demands, and it is these limits that create certain internal tensions in a work. Conjunctions of forms make them mutually expressive as they play off against each other.

Here we can mention the question of so-called "negative space"—a misnomer. In sculpture there is space that is solid volume, open space within the work: or no space, which means the sculptor has failed. With *Eros and Psyche*

the arms of each figure do not merely embrace each other in a naturalistic way: they define spaces and thereby mold them into shape. They do this as surely as the hands of Giacometti's *Hands Holding the Void* mold the void as though it were a solid object, make it in fact an invisible object which might resemble the figure's own head.

The forms in Moore's work, particularly his later work, have little to do with angularity, and almost nothing to do with naturalism. The closer he gets to depicting actual subjects, the further he seems to depart from his natural vitality; a group like the *King and Queen*, two hieratic figures enthroned side by side, seems curiously desiccated compared with the great reclining figures. The very earliest of these, in stone, like so much of his sculpture, lie heavily along the ground; their gestures are angular, their gaze direct. The late works are still earth-bound, but the angles have disappeared into sequences of continuous rounded masses that cascade from one to the next, or flow into each other as imperceptibly as streams. Perhaps no other sculptor except Arp has achieved this degree of fluency—Arp takes greater risks than Moore of slipping into incoherence. Both combine it with that satisfaction of the multiple viewpoint that Cellini demanded.

One can pass from considering conjunctions of forms within a sculpture to the conjunction of parts of sculptures, or sculptures constituted of different parts. One recalls here the study of proxemics—the culturally permitted, or preferred, distances between people in communication. But sculpture creates its own world of customs. The placement of two parts, as it occurs in Moore's work, creates spaces between them which are as much architectural as sculptural. They also create tensions between the elements that grip them firmly in balance. One of the masters of such tension is Giacometti: in his groups of figures standing or walking, on a base, it is not the humanity of the figures themselves that matters. It is totally invisible dynamism that vibrates through the spaces between them.

Mass governs space; and mass, it must be understood, is not the same thing as size. Every sculpture, from a President on Mount Rushmore to a netsuke, by a Gutzon Borglum to a Shuzon Yoshimura, commands its own measure of space. It is part of the sculptor's work to define that previously undefined space that he has chosen out of all the undefined space that exists in our world, almost infinite, or at least from the human scale inexhaustible, and it is the viewer's to perceive it. As anyone knows who has ever tried to arrange a group of sculptures, they dictate imperiously their positions and are as territorial as some species of animals.

That space, however, it not always constant. In different circumstances the perceived necessary space, as when a sculpture is moved from one place to

another, as most portable sculpture often is, can change its dimensions. Sometimes this fact is not merely neglected, but hopelessly misunderstood. Thus open air sculpture, however big it really is, may look merely toylike when set down in a huge plaza or extensive gardens. Then we can only perceive the sculpture's natural space when we come within its orbit. Size is not the criterion: a very small sculpture can often command, that is extend its presence through, a relatively much larger space than a colossus.

Here then are some of the determinants of sculpture as we know it or, perhaps we should say, as we have required it be. Like all the other arts, it has been in a constant state of superficial change. The reasons for some of the most recent should now be taken into account.

Reading Meanings

This book deals with the sculpture of the small societies ("tribal societies" is a useful if not strictly accurate term) of Africa, Southeast Asia, and the Pacific Islands. It is hard to realize today how little the Western world knew of those arts a hundred years ago, not to speak of how little they were understood, even by specialists. At first they found their homes in the ethnographic museums. Many collections and museums had held such material before, but the first specialized museum of ethnography is claimed to be the Leiden museum founded in 1837. A number of others opened in quick succession in Europe during the 1880s, including works of art along with the weapons and utensils that made up the bulk of the collections. A lively international commerce in such works was already in progress.

This was the situation when about 20 years later some Paris-based artists were led by curiosity to the Museé d'Éthnographie du Trocadéro and the shops of dealers who sold curios collected by sailors and other travelers. These were mainly African sculptures from the French colonies. This signalled the introduction of tribal art to the general scene. Its exact result is something of a question. The contentions that the artists were transformed by these "new" works, or on the other hand only responded to them because they were already thinking in terms which now crystallized, find almost equally powerful advocates. There can be little doubt that they were psychologically ready.

Interest in Oceanic art began shortly after among the German Expressionists, fostered by the colonial collections in German museums. In France, after making quiet headway for a number of years, the same interest seems to have blossomed in about 1927–1930, with the organization of several important exhibitions and the enthusiasm of the Surrealists. We admire according to our

expectations. The sculptors of Lake Sentani, the part of New Guinea now called Irian Jaya, carved in a style of heroic austerity (p. 267), comparable in some ways to the most austere sculptures of Africa. They painted on bark-cloth, however, startling, flowing images of fish and animals in furious action—at least partly, it seems, in response to the encouragement of collectors. When in 1930 both sculptures and paintings were exhibited for the first time in Paris the audience, we are told, virtually ignored the great wood figures. They felt that their experience of African art had shown them enough of that sort of thing. But they responded enthusiastically to the seething images of the paintings. "Beauty will be convulsive," André Breton had said, and here was something that, no matter what the intentions of the original artists had really been, could be "read" as convulsive.

Whatever effects African and Oceanic works had on the artists themselves, the effects that the artists' interest had on the general public's was decisive (and we shall return to it later). But beyond those two realms, to all intents and purposes the artists' and the public's interest ceased. It is curious to note that the rich traditions of Southeast Asian art have never received anything like the same degree of attention until quite recently, and have made no impression on artists and their work.

Not that African or Oceanic art were accepted generally, or at once. We should not forget the narrowness, the constriction of mind that has infected Western culture. For a few thousand years naturalism, at least modified naturalism, was central to Western, Eastern and ancient American traditions of art. It rose into particular importance in Europe at the beginning of the Renaissance, when it assumed a philosophical, even ethical, value, following the revival of classical models in sculpture and classical texts. In a total reversal of the principles on which iconoclasm was founded, contemporary Renaissance statements show that representation, as naturalistic as possible, was believed spiritually uplifting. The contemplation of excellence in the model—physical excellence, or the moral excellence of personality—was supposed to inspire the viewer to personal excellence. The excellence of the artist's skill was an almost equally exemplary inspiration. Naturalism thus had a value which, if not directly religious, certainly had moral and social weight. This conception dominated the public view of art, if at times not much more than unconsciously, until perhaps 150 years ago.

It is truly memorable that for most of the following period the work of contemporary artists who had any claim to inventiveness or innovation, in all fields, was the butt of incessant derision—a derision that often took a moralistic tone, or indeed sprang immediately from nothing but offended morality. It also had in it more than a tinge of fear: if the classic ideals were flouted, what chaos

might follow? The problem was twofold: the problem of iconography and the problem of style. Both, in the new forms of art, were obviously incompatible with the standards established since the Renaissance. So that laughter rang out unquenchably down to well into living memory; and we do well to remember that only recently has it been quenched.

Then what emerged towards the end of this period of frightened contempt for the contemporary arts was a still, small, modest voice asking, perhaps a little plaintively, "But what does it mean?"

This is a legitimate question, and it is not stupid. It reaches beyond the complacent self-satisfaction of mockery into a genuine inquiry about the problem of meaning in the arts, and this is a modern problem. The question is in fact a crucial one, and remains so for our understanding of modern western art and the art of the rest of the world.

The reason for the existence of the problem has its roots planted rather deeply in the fundamental problems that exist in the processes of human communication, particularly the very imperfect ways that human beings gather information in the first place, then transfer it to others. This is especially true in the case of communication between different cultures: not only ethnic, but generational and ideological cultures.

There is a story that once a lecturer on painting—it may have been the great English critic Roger Fry—asked his audience to contemplate the "imposing central mass" in a picture, sublimely indifferent to the fact that he was referring to a representation of God the Father, which therefore might have for many of his listeners connotations not the less powerful for having nothing to do with their aesthetic responses. Quite often, in fact, subject matter and therefore information about it does count very deeply.

Let those who doubt the value of information review our galleries of Western art from the point of view of a visitor who is totally ignorant of the life, history and thought from which the works sprang between, say, 1200 and 1800. What does he find?

At first he finds, and perhaps thinks he understands, portraits; landscapes; flower pieces. Beyond them he comes to crazed scenes of horror. Massacre: vast scenes of men in lunatic combat, death, rape, blood. Savagery: turmoils of frenzied animals tearing each other to pieces, aided by men. Then worse atrocities still: wailing women in utter misery; hideous scenes of men tormenting other men and women by fire, flagellation, flaying, mutilation and evisceration; and over and over again, endless images of a bleeding, dying man fastened to a great crosspiece. An aesthetics of abattoir and torture-chamber. Can our innocent fail to be shocked by our obsession with unexplained, and to him inexplicable, monstrosities?

But suppose we then describe to him the circumstances surrounding the creation of these works. We can account for the scenes of conflict by describing how, in their day, they were memorials of male heroism, glorious for a thousand reasons. The animal scenes are other manifestations of heroism to a society that valued the hunt. And above all, the most grisly of the images: they are central to the dominant religion of the West. The suffering women mourn the crucified man, who is the Son of God, a Savior who by suffering redeemed mankind. The stoic Flemish martyr having his intestines drawn out on a windlass, the beautiful young Spanish girl carrying her own breasts on a plate, are not merely the fantasies of sadists; they honor those who were willing to die for their faith in the Son of God. These scenes, then, commemorate the leading myths of a religious culture—understanding "myth" as a generally recognized truth.

Our hypothetical stranger will now have rather more of a grasp—at least an intellectual grasp—of what he is looking at.

The stranger, need one say, is ourselves. Only a small percentage even of the crowds of Westerners who visit our art galleries have any clear idea of what they are looking at, could name a saint, a battle, or a classical myth; and only a very few specialists can bring to bear detailed knowledge of the complexity of allusion that the works are often meant to embody. We all have a vague idea that they are part of a tradition to which we belong, and can appreciate their sensuous appeal. If we want to know more precisely about them, we can read the labels that accompany the works: labels here being taken to mean not only something printed on a museum card, but the sum of available information that has been gathered about them by scholars.

Contemporary artists have created their own exigencies about the need for information about their work. "A picture," goes the old saying, "is worth a thousand words"—at the very least, from the modern critic. The work of many living artists seems, even though it actually appears trivial—indeed, the more its appearance seems nugatory—to demand a degree of exegesis that goes far beyond what was so in the past.

The matter is complicated by the present lack of a socially shared myth, which has led many artists to create their own. Joseph Beuys, one of the most charismatic artists of the later twentieth century, created a mythology around his favorite materials: felt, fat, copper, stone. It was based on crucial personal experiences compounded with political thought. But the actual objects or assemblages he created, have little or no sensuous charm; the conjunctions exist in a philosophic but not visual sense. What mattered most to Beuys was his mythology, which can hardly be comprehended without verbal intervention.

Information cannot be a substitute for experience, and moreover, being only a report on experience, distorts experience even while it distorts itself. This

distortion increases over time and cultural distance, and here we begin to speak of the tribal arts. Lacking the schemata of another society, and above all the experience they lead to, who can possibly comprehend fully the thinking of a member of another period or cultural tradition? The other side of the coin is that even the slightest information, so long as it is accurate—at best this can mean little more that it comes from an honest and objective source—is better than none at all. The door to a different world opens, if only a chink. Through it we can spy out a hint of meaning, even of poetry, as from those tattered fragments of papyri that once held complete works by classical authors.

This surely helps us in some ways, but what are they? In the first place, we make some advance in understanding the motives of the makers of certain things that, in the absence of some knowledge about them, will be entirely outside our realm of experience. Better still, we may (at least we hope so) gain some understanding of the first viewers of such things: the emotional responses, otherwise blocked to us, that we can begin to comprehend and eventually perhaps even partly share. With a little effort, this may bring us closer to the experience of the "affective presence." But this is by no means necessarily the case, since what we see through the door crack is so partial.

The thing above all that we cannot possibly do is see what the tribal artists and their audiences saw. We may know something of the viewers' concepts, but their own visual experience—since we cannot share directly their other experiences—of their works is quite simply inaccessible to us: and it was surely not what we see. Information will help us to sympathy, even empathy, but cannot lend us the eyes of others.

If we do not wish to know more precisely, we are left to contemplate "imposing masses" and the other things that go with them. In fact, even with information stored away in our minds, in the long run we are bound to fall back upon the modes of visual experience in which we have been trained and that are familiar to us. These have changed radically in the last century, and we are already far from the modes which then entered the stage. Those of the years from 1906 to 1930 are immediately relevant here.

It was a time during which great advances in knowledge were taking place; but they were not widely known. In the earlier part of this era, contemporary views of tribal societies—and in all justice it must not be forgotten how scanty, how undifferentiated, and how biased most reports about them still were—combined with Darwinian theory and colonial interests to generate a hierarchical scale on which they took a very low place. In popular thought, at best they were childlike, at worst unspeakably savage, morally abominable. To the traditional Western mind, their works shared these aspects, and were therefore beneath serious consideration.

From the point of view of Western artists, these opinions were not fundamentally in question; for them it was what, besides their unfamiliarity, gave the works their freshness and charm. They were searching for alternatives to the moribund tradition the academy had clung to since the Renaissance: the dominance of the classical. The impulse was not altogether new. We can see that the artists were continuing the reaction against established bourgeois society that began perhaps with the Romantic movement, and developed with Flaubert, Rimbaud, Van Gogh and the great figure of Gauguin. In social terms they were not unlike the youthful but less productive rebels of the 1960s, whose rebellion largely went up in smoke. They were involved with what is called, largely for lack of a better word, Primitivism.

When it came to assessment of what they were seeing, the artists proved unable to escape from the ideas and sensibilities of their predecessors. Their reactions were formalist, as with Matisse who compared African sculpture (a Yoruba mask) to Egyptian, or in jocular conversation with Picasso, Vlaminck, and Derain to the *Venus de Milo* ("as good"—"no, much better"). They were still matching their discoveries against the accepted canonical styles.

However, what really attracted some of them was their reading of the emotional force of the object. This was made explicit by Picasso and the German Expressionists, who verbalized what they saw in these works as untrammeled primitive freedom and mystery, the "dark side" of humanity (although Picasso did at one point speak of African sculpture's "rigorous logic," probably Apollinaire said it for him). The most doctrinaire, therefore deluded, of all, the Surrealists, thought Oceanic art was the free expression of dream imagery. Not knowing what they were talking about, they generally talked nonsense. The important point is that none of them were far from the old opinions, favorable or not, of the establishment: they simply turned them on their heads.

Putting their reactions to one side, what really matters is what happened in the studios. With the Parisians, it was a matter of research into new ways of seeing and making. Oddly, they were much more literal in Germany than in Paris: many Expressionist pictures include direct transcriptions of objects rather than references to their principles.

Since the subject of this book is sculpture, it is appropriate at this point to note what a number of the sculptors—rather than the painters—made of their interest. They were often affected by influences which some of them, particularly Brancusi, were in later life ungratefully to disavow. Lipchitz loved African sculpture and collected it (and almost every other kind of sculpture) to the end of his days. He also claimed it had not influenced him, and indeed one has to reach far for any signs that it did. Collecting was in fact a favorite occupation of the artists, and some of them made large assemblies of works.

Among the most notable were those of Picasso and Epstein. Picasso's was only a part of his vast jackdaw's horde of possessions, and he probably looked at it rarely in later life; it is said to be mediocre overall. Epstein, however, put together one of the greatest of all private collections, including capital masterpieces of African and Oceanic sculpture, and he is known to have pored over it constantly.

Other sculptors, both in statement and practice, made it very clear that the influence had been direct and profound, if not permanently at least for a substantial period, and often made by specific objects. Others remain a question of scholarly speculation, apart from those superficial similarities that are all too easy to dredge up, and are quite meaningless. A brief chronology of their work and relationships with each other provides some insight to this, and demonstrates its international effect.

Whether or not Vlaminck, Derain or Matisse was, according to differing claims, the first to "discover" African sculpture, the most famous of the discoverers was Picasso. In 1907, on what may have been a fortuitous visit to the Trocadéro museum, he experienced a revelation in the presence of its African pieces of a different order from that made on him by Iberian sculpture (of the fifth–third centuries BC) the previous year. Whether the African art affected his work on his great *Demoiselles d'Avignon* is uncertain. It launched him into a series of projects for sculpture, mostly never completed. Drawings for some of them are clearly based on the profile of a Baga *Nimba* (p. 45). A completed work, the *Guitar* of 1912 now in the Museum of Modern Art, New York, draws on the forms and construction of Grebo masks in his possession.

On arriving in Paris in 1905 or 1906, the young Modigliani became acquainted with Picasso and Lipchitz, and no doubt sooner or later saw the African sculptures they owned. Constantin Brancusi, whom he met a couple of years later, was then engaged in direct carving in stone; following his example Modigliani carved a series of stone heads during 1909–1911. Their elongated faces are comparable to those of Ivory Coast masks (pp. 86–87), to which they probably owe their inspiration.

Brancusi must also have been aware of African sculpture, in the climate of the time. It apparently did not engage him as an influence until 1913, when he began a number of wood carvings that can be traced to African sources. These include the reliquaries of the Hongwe and features of Senufo masks such as their long ridged necks (p. 79).

The American Jacob Epstein went to Paris in 1902, and later became friendly with Modigliani. He visited the British Museum in 1905, and first became aware of tribal art. It had little practical effect upon him until 1912, when he made his first African purchase, a Fang figure (pp. 143–44). After this

for several years a great deal of his work was powerfully influenced by tribal sculpture. In later life his sculpture followed two courses simultaneously: modeled figures and portrait busts to be cast in bronze, and monumental stone carvings. The bronzes were highly naturalistic; the work in stone retained to the end some of the principles he had absorbed long before from his African exemplars.

Epstein's early work was seen in London by the much younger French artist Henri Gaudier-Brzeska, who remarked on its African affiliations in 1913. Gaudier himself carved some stone pieces influenced by Maori art (p. 342) and the Easter Island colossi, but had no chance to develope this tendency: he was killed in battle two years later.

When World War I ended, there was another phase of collecting, mainly by the poets of the Surrealist movement: Breton, Paul Eluard, Tristan Tzara, Louis Aragon, and (later) Vincent Bounoure, among others. Numerically speaking, the collections stressed Oceanic, Eskimo and Northwest Coast art. In the work of the visual artists, such as Joan Miró and Max Ernst, there exist some references to tribal art, but only in a diffused sense of affinity. The explicit transformations of the previous generation of artists are hard to trace, except for the Easter Island birds transmuted into Loplop by Ernst, and his use of Easter Island heads in his collages. It was after he moved to the United States that Ernst began to collect American Indian art, and its images began to appear in his paintings and sculpture. By and large the same could be said of Giacometti; perhaps only two large sculptures, *The Couple* and *Spoon Woman* (1926–1927), unequivocally show their origin in such African pieces as the Dan ceremonial spoons (p. 57). Even so, his sketchbooks contain drawings of Senufo heads (pp. 75, 79), a *Nimba*, Marquesas (p. 341) and Nukuoro (p. 347) figures, evidently derived from published illustrations.

The most learned of all modern sculptors was Henry Moore. After surviving the First World War, he first became aware of African sculpture in 1920 through reading an essay by Roger Fry. The same year he began to visit the British Museum, and in the old ethnographic galleries he found a road away from the academic "Greek" tradition which was oppressing him in his turn. Moore was impressed by the ability of the tribal artists to remodel the human image, without losing sight of it, into forms of great intensity; he spoke and wrote about this frequently. His sketchbooks are filled with drawings of astonishing range, mainly of African works by the Bamana, Mumuye, Jukun, but also figures from Oceania: Hawaii, the Sepik River, Solomon Islands prows (p. 324), and New Ireland *malanggans* (pp. 314, 315, 318); not to mention the Precolumbian cultures of the Americas. He was also highly conscious of the work of Gaudier-Brzeska and Epstein. All this visual material was very thor-

oughly assimilated, and specific derivations are hardly traceable. The clearest analogies appear in sculptures from the 1930s which echo the enclosed torsos of the *malanggans*. Finally, in 1964, a segment of Moore's *Moon Head* was copied directly from a Mama bovine mask (p. 128).

Much the same story could be related of many lesser artists who followed the lead of the major figures; as so did many of the public. The identification of tribal art with avant-garde art was underlined by the many exhibitions held by museums, dealers, and the Surrealists in which tribal and modern work were shown in tandem. The outcome was paradoxical. In the course of time, the young revolutionaries of modern art became its respected— not to say revered leaders. As a corollary to this, the fact that they once had borrowed from the artists of Africa and Oceania now validated the latter. Their works began to be generally appreciated precisely because they had been imitated. A Moore sculpture, let us say, resembled a New Ireland sculpture: so the New Ireland sculpture was now admired because it resembled a Moore.

In retrospect, it appears that the rather abrupt "discovery" of tribal art by the artists of the early twentieth century and even later had a certain effect on their work for a time, but that in the long run it was sporadic and temporary. The discovery was not so much an influence as a trigger. Once it had been pulled and the shot fired, the artists as a rule went about their other business, with now and then a recall to their past. This did nothing to promote a genuine understanding of tribal art or to establish its proper status. It is time to cease looking at tribal art through the lens of modern art; rather to look at modern art through the lens of tribal art. That is, to examine it in the context of the art of the world.

Tribe and World

To repeat, "tribal art" is a simple, useful term and no more. There is no way in which the tribal arts of Africa, Oceania and Southeast Asia can be conceived of as in any sense a unit. A few tenuous links emerge through the existence of the Austronesian languages, a huge family of related tongues with its homeland in southeast Asia. Thus a connection can be traced between the island of Madagascar, off the east coast of Africa, and Indonesia because both areas are inhabited by speakers of Austronesian languages. At some unknown period Austronesian language-speaking seafarers must have reached Madagascar from far across the Indian Ocean and settled there. This does not imply the least connection between southeast Asia and the west and south of Africa, where a multitude of completely indigenous languages and cultures prevail. A stronger link,

confirmed by both history and archaeology, joins southeast Asia with the Austronesian language speakers of the archipelagos of Melanesia and Polynesia. When they entered the Pacific basin they largely bypassed New Guinea, and made no contact with Australia at all. But none of these particular connections are known to be more than 2,000 to 3,000 years old; they have not been operative in terms of real contact since the earliest part of that period within the large areas, and little if any within the smaller ones.

We see, then, that in the end we are dealing with a vast number of small local cultures, of almost infinite variety, covering an enormous expanse of the Old World. A few simple figures demonstrate this. The Pacific Ocean alone, sparsely populated as it is, covers a third of the globe. The areas of Africa where sculpture is produced extend over roughly two-thirds of the continent. Tribal Indonesia is again a huge geographic region, even if also one inhabited by tiny groups of people.

The time span involved is also immense: Africa, and some believe Indonesia as well, were cradles of the human species, and the islands of the Pacific received their first inhabitants about 50,000 years ago. Perhaps the most ancient works of art in the world are 30,000 year old rock engravings found in Australia. But what were people carving or painting in all the millennia after? It is inconceivable that they did nothing; but virtually nothing remains. Apart from a few ceramics, stone carvings, and some bronzes or brasses, the traditions of art have disappeared. Africa is still richest in remains of the fairly distant past, with its early stone, ceramic, and metal work (pp. 50, 51, 58, 59, 62, 64, 65)—but this is surely a mere token of what once must have existed. The tribal areas are mostly in the tropics, and wood, the main medium here, does not endure long in their climates; it succumbs rapidly to heat and humidity. The rare exceptions are from arid countries such as that inhabited by the Dogon of Mali (p. 35), and perhaps some carvings recovered from caves in Papua New Guinea. Undoubtedly hundreds of ancient art traditions are lost to us forever; we cannot even imagine what they were. The remnants that still exist are the product of a mere few hundred years at most. Nevertheless, upon them we must assess the status of tribal art in its own places, and in the world in general.

The motives behind the creation of many works of tribal are not in the least exceptional to the run of cultures. They conform to the universal requirements of statehood and religion. The aggrandizement of the ruler, where rulers existed, is a perpetual theme: not only in the specialized paraphernalia made for rulers, but even in more general displays of power. Take for example the divine kings of Benin in Nigeria (and need one insist that their institutions, in the sixteenth-seventeenth centuries, had no lineal relationships with those of the

Egyptian Pharaohs of 3,500 years before?). They were the patrons of a highly developed court art, with monopolies over the production of the ivory and metal workers. The *Oba*s who ruled Benin set brass heads of ancestors on their altars (p. 104) from an early period. In the sixteenth century, they covered the columns of their palace with brass reliefs (p. 105) of their courtiers, their soldiers—including foreign mercenaries—their tokens of riches, the embodiments of their supernatural powers—the leopards, the mud-fish—and themselves. In these, they stand frontally to the world in total assurance of their omnipotence. The reliefs are a blatant expression of royal power: so to speak, they are the Abu Simbel of the Bini rulers.

One may turn from the specific and limited functions of royal art to one that is popular and extremely widespread, characterized by the mask. Masks have not been important in most Western societies, or Westernized societies with urban cultures, although they have survived in rural regions for folk dances and festivals. The notion of a mask which is not playful is unfamiliar Western society. To think otherwise is to invite imputations of neurosis: psychological theories speak of the need to hide, to protect, the ego's integrity. In tribal societies, on the other hand, masks have been (and to the extent the societies are still viable, still are) vital to many aspects of life. With their versatility of use, they provide a paradigm of tribal sculpture's range and significance.

One is not mistaken in thinking of their primary use as being tools, at that among the most powerful tools the people could employ to ensure the health of their communities. Certain themes run through the masking traditions of these societies; they are both social and religious, with all the ramifications of both establishments—and rarely can hard and fast distinctions be made between them: they overlap and intertwine. Masks are living presences that represent, and mediate between, the empirical and supernatural worlds at those moments where power, protection, and the crises of life and death are in dubious balance.

Social control, the maintenance and direction of the social compact, is the function of many types of mask. The mask may be actually the vessel of the power of rulers, and make it too dangerous to be worn, as among the Bangwa of Cameroon (p. 134), or, as with the *bansonyi* snake headpieces of the Baga (p. 45), represent the permanence of lineages, or again, in the Gulf of Papua, display the totemic emblems of the lineages themselves (p. 289). It may also be the actual regalia of the chief in New Caledonia (p. 328). Other masks have the more mundane, though supernaturally mandated, tasks of enforcing taboos against the misuse of natural resources, or infringements of the customary regulations of society, or celebrate the raising of taboos (p. 295) in

the Torres Strait and elsewhere. Other aspects of power may be the strength, indirectly emblematic of power in general, of animals: buffalos (p. 128), elephants and pythons (p. 124).

Religion provides the balance that must be maintained between the social world and the forces of the supernatural world. They may be maleficent, and need to be warded off. Masks may represent them explicitly, in the case of a Yoruba mask of a water spirit taking the outward appearance of an antelope (p. 112); or be a reassuring and protective presence like the *Banda* mask of the Baga (p. 49). Certain great Senufo masks (pp. 76–77) are active supernatural combatants against the malevolence of witches, and through their wearers may practice the craft themselves. But, on balance, as many spirits are positively benevolent. They are the bringers of fecundity and prosperity, like the *Nimba* mask of the Baga (p. 44), or the *hudoq* forest spirits of the Kenyah-Kayan Dayak (pp. 228–29). Others represent nature spirits, and are associated in the Sepik River area of Papua New Guinea with their voices (p. 271, 275).

The crossroads of life are marked by the rites that introduce the young to maturity. Masks appear at initiation, sometimes as spirits of the dead: among the Lulua, for instance (p. 176); or in New Britain among the Sio (p. 282) and the Witu islanders (p. 301). They also appear at death among the Igbo (p. 123), on Witu (p. 300), and the funerary rites of New Ireland (pp. 317, 320).

The dance is the prime medium of masking in Africa. Unlike the masqueraders of Melanesia, who as a rule do little more than emerge from a sacred enclosure and parade, African dancers are famous for their activity, often violent, and including such virtuoso performances as stilt-dancing and tightrope walking. African maskers are also not exclusively engaged in ritual, as they are in Melanesia. Sometimes they appear in ritual, at other times—the very same masks, that is—as enjoyable entertainers. Some Baule masks in fact are merely congratulatory on a happy event, say, the birth of twins (p. 91). African and Oceanic masks, then, encompass the full spectrum of human life as their societies and makers experience it.

Apart from the socio-religious aspect, from a formal point of view the dancer makes the sculptured mask into a part of a total three-dimensional creation: a sculpture composed of his moving self, costume and mask which moves, and moves around us. We may recall here the analogous principles of modern mobiles, which perform for us by being in motion.

Scenes are uncommon in the art of tribal societies—the Benin plaques are a rare exception—though there exist groupings of human and other beings that unmistakably hold implications of narrative, "readable" to those already aware of their meaning. Actual narrative art is even rarer, apart from the reliefs on the beams of ceremonial houses in Belau (Caroline Islands). These extended

picture-stories, rather in the manner of our strip cartoons (bandes dessinés), were popular with the German Expressionists, particularly E. L. Kirchner.

In spite of the frequency of animal images in tribal art, including mythical beasts, the human body remains the prevalent subject. The modulations of its forms that are so fascinating in tribal sculpture, so appealing to the artists of nearly a century ago, were then horrifying to the conventionally minded (and as a matter of fact sometimes are today to owners of such works). In many tribal styles, after all, the subject was frankly no more than the starting point for the sculptor. Whether some works were intended to frighten, and if so, which, depended largely on preconceptions: and some of these are surprising. Who would imagine that the delicate antelope mask (p. 112) of the Yoruba might be alarming? or that a simple double spiral, the Asmat of Irian Jaya say, strikes viewers with panic. Neither seems menacing to the uninformed. Others, however strange, were definitely protective. The combination of beauty and horror is rare; and it does not depend on the obviously grotesque.

The body is most often rendered without the illusionism of much Western and Asian art, but still with considerable fidelity to nature. The aim is the portrayal of an ideal of beauty, akin to the idealism of classic sculpture, rather than the image of an individual. In some parts of Africa this was explicitly expressed: the Bamana rate a sculptured figure high because "it looks like a person." Sometimes this followed from the pursuit of a conscious ideal of beauty based on almost Renaissance values. The expression of sanity and physical health is a criterion of sculptural and aesthetic success for the Baule—which of course is not to say that an aesthetically successful sculpture is not *ipso facto* credited with that expression (p. 92). Lwena masks, again, reflect an ideal of female personal beauty, including the scarifications and filed teeth that are recognized marks of it. It seems more than likely that many such examples could be quoted. One might well be the splendid figure of a woman from the Sepik River Iatmul (p. 278). Photographic portrayal of an individual was replaced by conceptual naturalism. The Sepik River modelled skulls (p. 279) were those of named persons, and the features of the man or woman in life would have been discerned through the veil of standard features created in clay. But if personal portraiture is in question, surely the elderly woman in stone from Sumba (p. 243) convinces us that she once lived and wielded authority.

Frequently, in these styles, the sculpture follows the continuous flow of the body's surface, in others a balance is struck between the naturalistic and the formulaic; this has sometimes led to the notion that tribal art is by nature merely repetitive—a fallacy as baseless as the old assumption that ancient Egyptian art, once its conventions were settled, never changed over its several millennia except during the reign of Akhenaten. The formulas of tribal art were no more

inflexible than similar formulas in Western art, which has had its full share of standard images. Examples of a single formula—say the reliquary figures of the Fang (p. 142–43)—show endless variations, and are no more identical to each other than the countless icons of the eastern Europe church.

The manipulation of natural forms is not free, spontaneous, or playful; it is a studied strategy for instiling the maximum energy into them. The head may be stressed (partly because the head is the seat of consciousness), the proportions of the body and limbs and its pose altered in this cause. Strong, answering rhythms predominate. The stone figure from Nias (p. 204) is a perfect example. The large head has annular eyes protruding under arched brows that are echoed by the opposing curves of the pectorals. Arms and leg are set in angular opposition to each other; the columnar penis stands vertically against the horizontals. The energy of a *bulul* from the Philippines (p. 257) is as powerful, but achieved by different means. The thrust of the figure is downwards, achieved through the hard-edged sweeping planes of face and chest, and arrested by the incurved arms.

In many even less naturalistic works the conjunction and interplay of forms is, if anything, even more evident. In one of their more geometric examples, the Igbo mask (p. 124) has a rectangular slab with two narrow triangles cutting horizontally across it, and a tall and narrow rectangular slat rising above it. The triangles of negative space cut into these forms work against them, and simultaneously lighten them. The Afo headpiece (p. 129) is another remarkable example, with its system of silhouette curves in opposition to each other, and enhanced by being mounted on a three-dimensional dome. What is more, the upper curves give a sense of rapid forward movement in tension against the backward pull of the spiral horns. There is similar contrast and tension in the juxtaposed elements of the Flores threshold (pp. 234–35), where the *naga*-dragon moves powerfully in a double rightangle across a sea of spirals.

No one will pretend that tribal artists uniformly turned out works of the highest order. As in all cultures, then and now, the majority of what was produced was trash, even if it corresponded to local, potentially superb stylistic models. The greater sculptors and painters were recognized as such by the people they lived among: they were no more anonymous craftsmen than the artists and architects of medieval Europe or Asia. If some of their labor, for ritual reasons, was carried out in secrecy, some—especially large-scale projects—had to be done very much in public with the aid of apprentices: as happened in Europe in the studios of Rubens and so many others. Besides, many works were commissioned from popularly acknowledged experts; it is inconceivable that, in small villages or towns, the names of the artists were not known to their next-door neighbors. In fact, the names of many tribal artists of this century have now been recovered, and it is not too late for research to trace many more from

previous generations, as well as details of their lives. Some of them at least, gossip tells us, shared the eccentricity for which artists of other cultures are notorious. Personalia—even mere names—are not to be dismissed; they bring us a little closer to humanity. But, in the end, what has our examination of a few of their works shown us? What is there in common in the age-old torrent of sculptural images?

The greatest pieces of tribal art show once again that sculpture in nearly all of human history has sought roughly the same goals: power, social good, aesthetic delight. It has used much the same plastic devices everywhere. Like their co-workers anywhere else, the tribal sculptors used the conjunction of forms, the balances of mass and space, no matter what the subject or the goal, to achieve their intentions. They and their works stand not at the periphery of the world's art, but at its center.

AFRICA

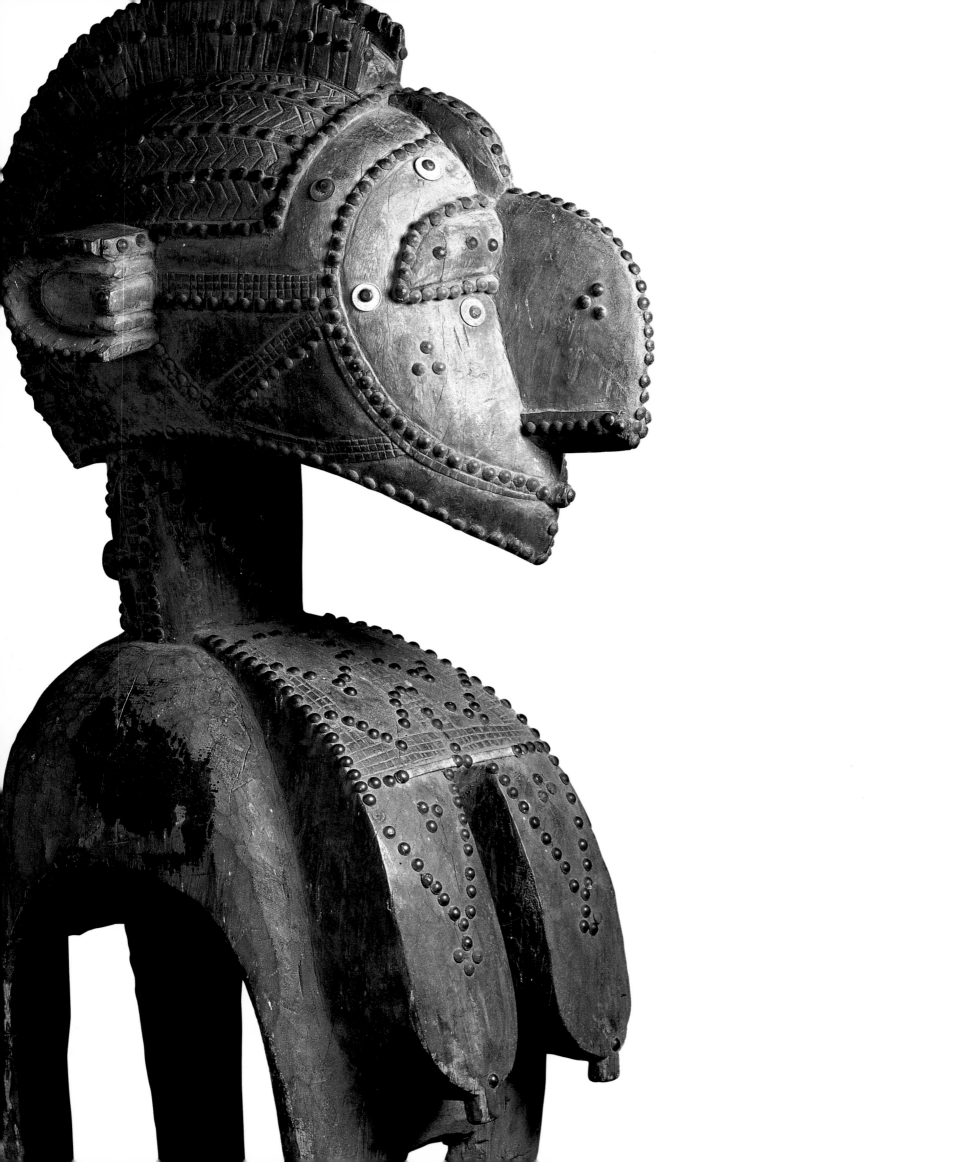

SHOULDER MASK, *D'MBA, NIMBA*

Guinea, Baga
Wood, upholstery nails, coins, h. 135 cm.
Collected by Emil Storrer. Formerly Josef
Mueller collection (1950)
BMG 1001-1

HEADDRESS, *BANSONYI*

Guinea, Baga Fore
Wood, pigments, mirror, h. 215 cm.
Formerly Mendlebaum collection,
Brooklyn (circa 1960)
BMG 1001-21

The vast mask shown opposite represented the abstraction of an ideal of the female role in society. She was seen not as a goddess or other ethereal being, but as the vision of a woman at the zenith of power, beauty and affective presence—a universal mother honoured for bearing many children and rearing them successfully. The thrusting forms and capacious volumes of the carving convey magnificently this vision of beneficial fecundity, even the braided coiffure recalls patterns of planting and thus the nourishment of society. It was worn on the shoulders of the dancer, the remainder of his body being covered by layers of raffia. *Nimba* was danced at festivals for the rice harvest, at marriages, births, funerals and ancestral rites.

Another headdress worn with a shaggy costume resembling an old-fashioned haystack is the long sinuous snake form pictured above, worn perched on the head of the dancer. It represents A-Mant-nga-Tshol (master of medicine) among the Baga Kakissea (according to Frederick Lamp), and is only second in rank among other Baga groups, where it is known as bansonyi and by other names. The spirit was manifested as a tall colourful serpent who appeared to the elders among some Baga groups—amongst other groups two or three serpents would engage in mock combat, representing village lineages. The serpent is also associated with the rainbow, the sources of rivers, life and death, the beginning and the end, the perpetuation of lineages.

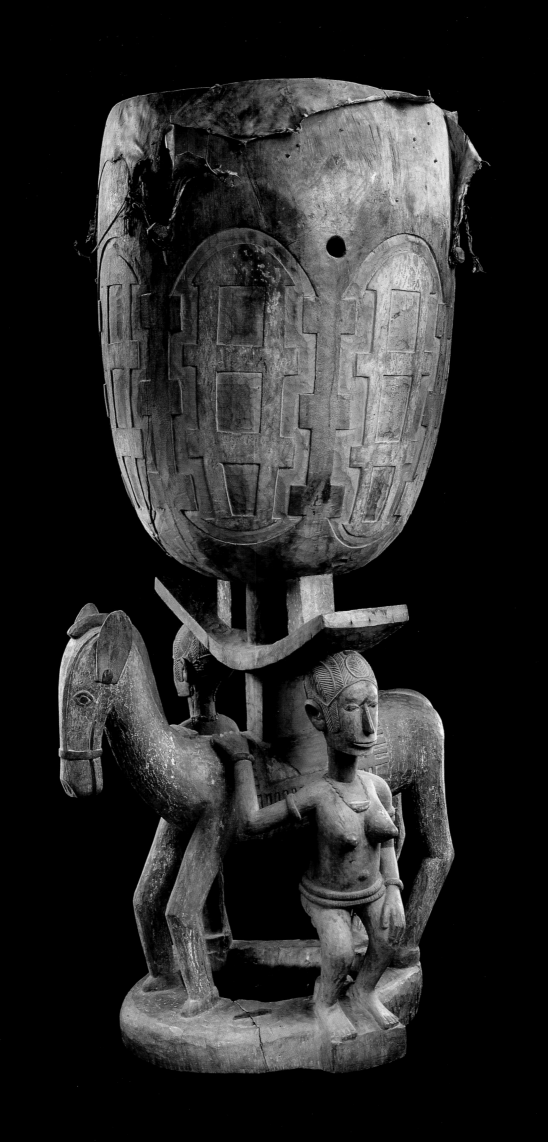

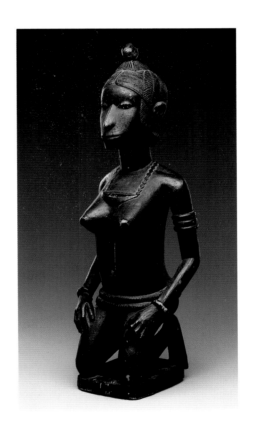

DRUM, *TIMBA*

Guinea, Baga
Wood, hide, h. 172 cm
Formerly Josef Mueller collection (1955)
BMG 1001-14

FIGURE

Guinea, Baga
Wood, h. 66 cm.
Formerly Maurice de Vlaminck and Josef
Mueller collections (before 1939)
BMG 1001-3

Along the coast of Africa, especially West Africa, the people seem to prefer to dance to drums—further inland flutes, lutes, xylophones and idiophones find more favour. Apart from the Akan, the Baga appear to be the only group of people who embellished their large drums with elaborate caryatids. Drums similar to the one opposite were played by men only, usually to accompany dances performed at the initiation rites of ma Tsol (or Ka-Bene-Tshol), during which children were introduced to the great python spirit, Mant-nga-Tshol. The drums also performed at weddings, at funerals and at sacrifices to the ancestors. The drums played by women were smaller and less elaborately carved. Besides the female figures, the supports were often carved as horses, which were regarded with awe.

The female form, so important in Baga art, manifests itself in various carvings—small figures with heads that resemble the nimba (d'nmba) from the northern Baga, and in larger figures with long, straight noses and of a more naturalistic form from the southern Baga, such as the kneeling figure above. She represents an initiated woman but Frederick Lamp was unable to find an informant who could clarify the role of such carvings. A layer of red paint is visible beneath the black surface patina—the color red is used against witchcraft and manifestations of evil, being the color of fire and therefore repellent to witches.

This charming figure caught the eye of the painter Maurice de Vlaminck, from whom Josef Mueller acquired it before 1939.

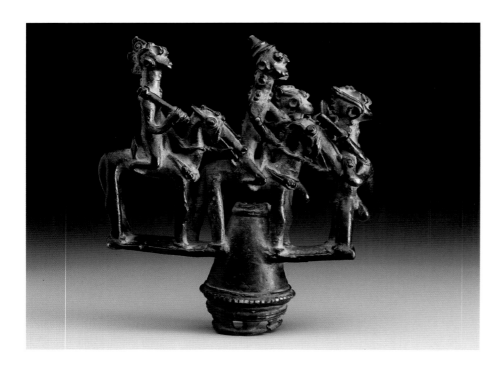

It was the Portuguese Professor Avelino Teixeira da Mota who discovered in 1960 a group of iron staffs with cast bronze finials, which were used as insignia by the Soninke chiefs in both religious and secular rites. The Soninke of the area no longer cast metal and Ezio Bassani has observed similarities between the figures on these finials and elements in the sculpture of the Dogon and Bambara of Mali—he has plausibly suggested that the staffs may have derived from the ancient empire of Mali, which flourished between the eleventh and fifteen centuries. The bronzes, known as *sono*, fall into two groups, those probably cast during the seventeenth century or earlier, of which the above is one, and a later group where the modelling is more crude.

A very large mask is worn by the Baga and neighbouring Nalu, known by some as *banda* and by others as *kumbaduba*. Frederick Lamp was told that it represented a powerful spirit which only appeared to privileged elders during rituals designed to prevent the villagers from misfortunes, such as the depredations of crocodiles and attack. It also appeared at marriages, harvests, planting and the new moon. The motifs—both animal and human—appear to relate to life forces involving the sea, earth, air, mankind and the role of animals.

The dance is astonishingly vigorous, so the dancer beneath the cape of raffia which falls to his knees, is always a young man. One movement is a rapid shuffling of his feet whilst he remains in one place enveloped in a cloud of dust. He then imitates such roles as a predator bird, a serpent or a fish, but in the greatest spectacle of all he goes into a spin, twirling the headdress in a series of figures eight plunges and puts it back on his head without missing a beat.

STAFF FINIAL, *SONO*

Guinea-Bissau, Soninke (Mandingo)
Iron, bronze, h. 135 cm. (the groups of
riders 17 cm.)
BMG 100132

MASK, *BANDA*

Guinea, Baga or Nalu
Wood, fibre, l. 159 cm
Formerly Andre Lhote collection. Exhibited
in 1935 (African Negro Art at the Museum
of Modern Art, New York)
BMG 1001-24

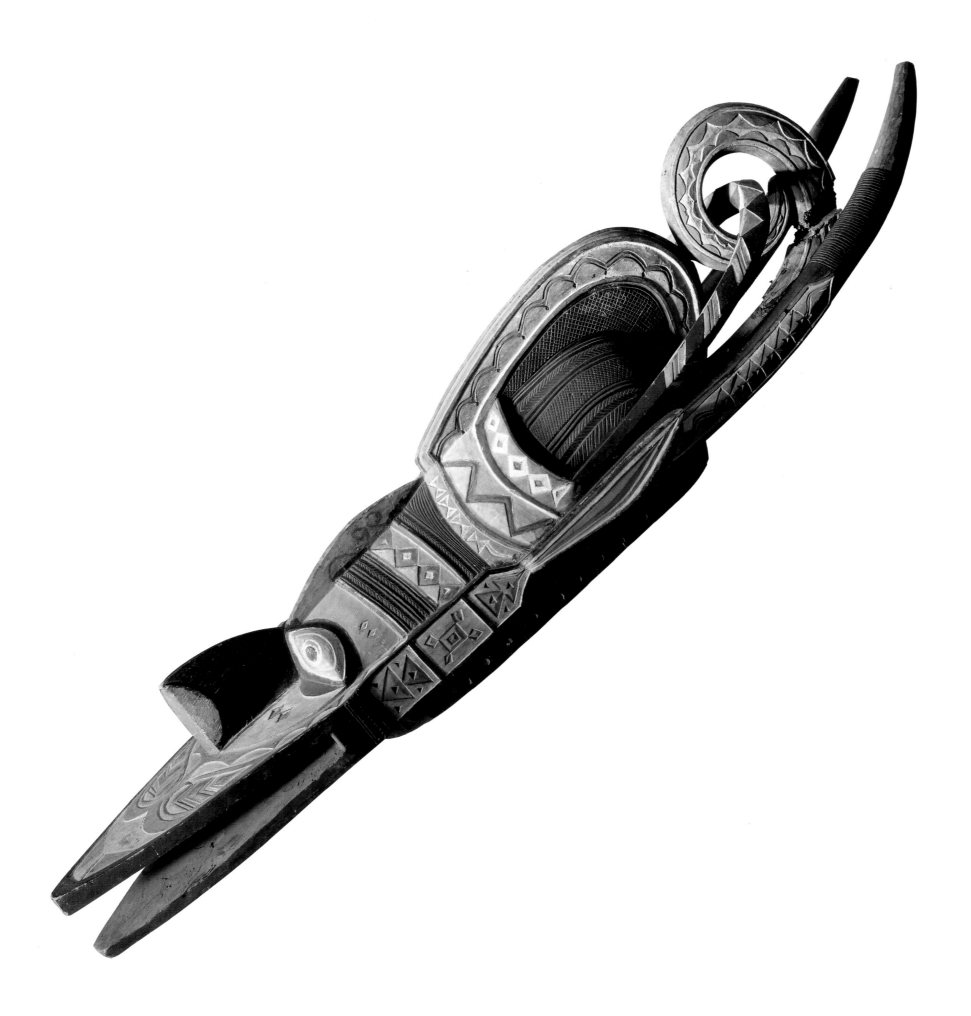

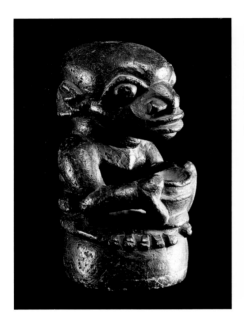

Many small soapstone figures have been found in the fields of western Sierra Leone. Their rounded forms and distinctive bulging eyes resemble those of the figures on the fine ivory vessels carved by the Sapi for the Portuguese during the late fifteenth and early sixteenth centuries, so they were most probably carved by the Sapi before the Mani invaders drove them to the coast and on to the islands by 1540. The Mende may have used them as crop gods. Most figures have suffered damage from the beatings which they would have suffered after a crop failure.

Further inland in Sierra Leone, amongst the Kissi, similarly-carved stone figures are found which they call *pomtan* (s.*pomdo*). The forms of these are more angular than those of the *nomoli*, and there is often a greater use of cross-hatched surface decoration. The carving above shows a figure on a quadruped, probably a horseman who holds the thick rope-like reins of his steed, but it has been suggested, rather improbably, that it

might be an antelope of which the figure holds the horns. The original use for which *pomtan* were carved has not been recorded.

Also found when clearing the fields are large stone heads, called by the Mende *mahen yafe* (Spirits of the Chief) (see opposite). They also have the distinctive bulging eyes of the Sapi *nomoli*, and their original use is no longer known. William Siegmann records that they are normally presented to chiefs or Poro Society elders, who use them in divination, believing them to be associated with spirit forces. Siegmann also observes that the elaborate coiffures found on the heads, and the jewelry which includes earrings and nose rings, are similar to those described in early sources as worn by the Sapi aristocracy. The head appears to be gagged, but Siegmann does not think it represents a sacrificial victim so much as a chief who is ritually bound at his installation—a practice which persists among the Temne who are descended from the Sapi.

FIGURE, *NOMOLI*

Sierra Leone, Sapi
Soapstone, h. 19 cm.
Formerly Josef Mueller collection (before 1939)
BMG 1002-2

FIGURE, *POMDO*

Sierra Leone, Kissi
Soapstone, h. 27 cm
Formerly Josef Mueller collection (before 1939)
BMG 1002-3

HEAD, *MAHEN YAFE*

Sierra Leone, Sapi
Soapstone, l. 24 cm.
BMG 1002-1

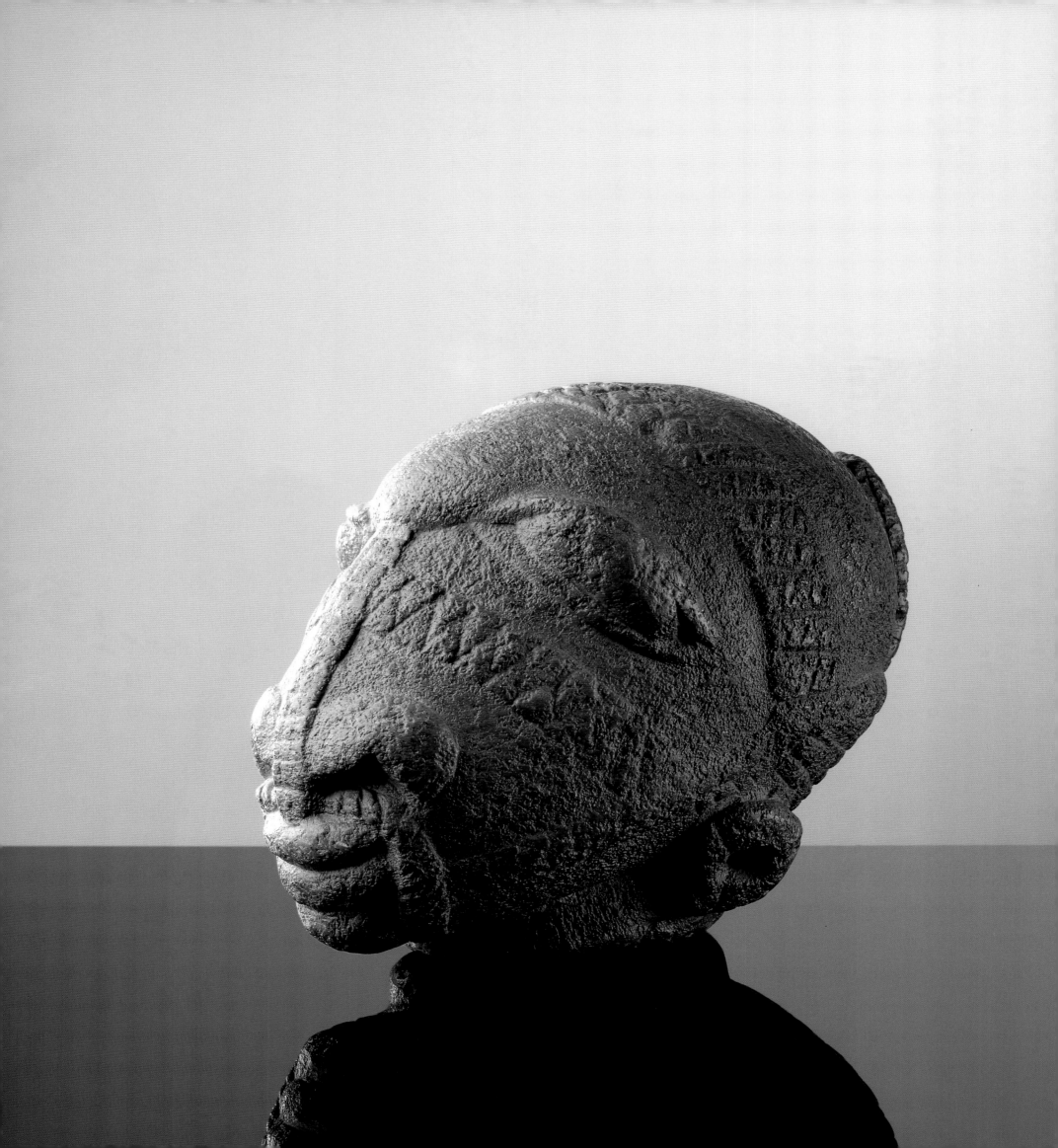

The rare beaten brass mask above is peculiar to the Temne of northern Sierra Leone. It is a fine example of the *aron arabai*, or "mask of chieftaincy". The mask is worn by a masker who appears as the embodiment of the guardian spirit of the ruling families in the chiefdom only during various stages of a new chief's installation. During a new chief's installation the masker acts as a kind of go-between through whom the new chief takes possession of the chiefdom. Throughout the last four days of the preparatory stages of the installation process (during which the chief-to-be has been kept in ritual seclusion) the masker goes around "buying " the chiefdom by taking gifts from the chief's family to various occupational groups. Then, on the fifth day, the masker leads the new chief from the forest into the town to appear in public for the first

time. He also leads the celebrations that continue over the next four days. Then he disappears and is not seen again.

Although the striking helmet mask opposite was apparently collected on the Sierra Leone/Liberia border, perhaps in Gola or Mende country, it has been identified as a rare *gondei* mask of the Mende. The *gondei* masker belonged to the women's Sande initiation society and accompanied the stately *sowei* masker. The mask's boldly carved features contrast sharply with the refined canons of *sowei* masks, which express Mende concepts of feminine beauty. Whereas the facial expression of the typical *sowei* mask is demure and composed, the eyes downcast and the mouth a discreet slit, the *gondei* mask illustrated opposite possesses disturbing red-ringed eyes and a "voracious" open mouth.

MASK, *ARON ARABAI*

Sierra Leone, Temne
Brass, h. 29 cm.
BMG 1002-16

MASK, *GONDEI*

Sierra Leone, Mende
Wood, h. 36 cm
BMG 1002-17

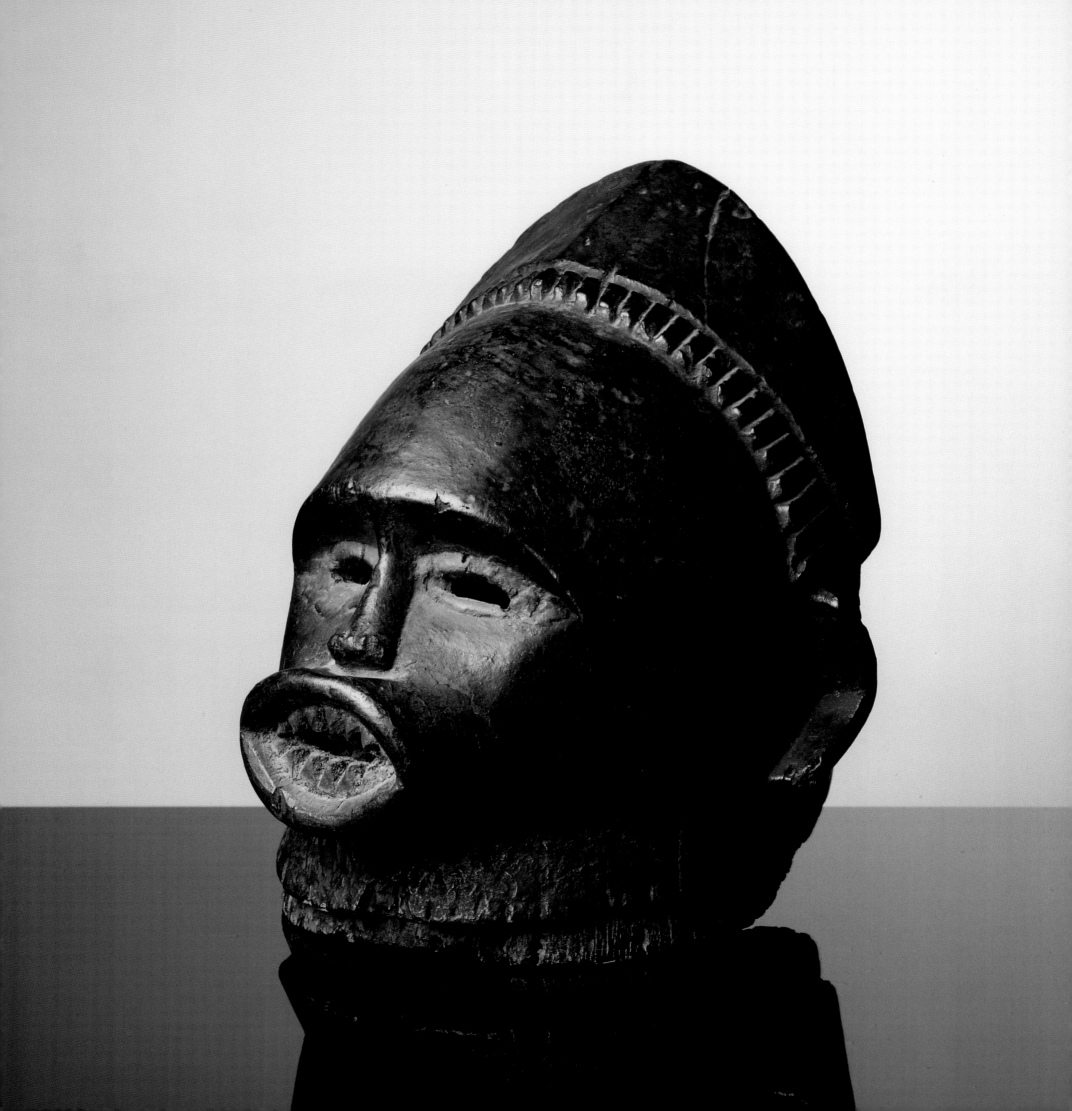

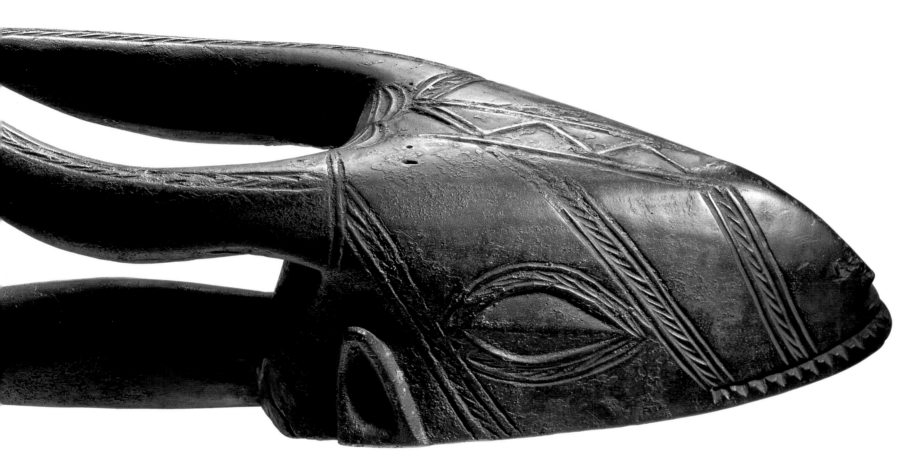

SPOON

Liberia, Dan
Wood, h. 86 cm.
Formerly René Rasmussen collection (circa 1960)
BMG 1003-15

Spoons amongst the Dan peoples of Liberia and the Côte d'Ivoire are the possessions of well respected women. These women, known as *Wakede*, are recognised for their provision of generous hospitality, especially at festivals. The spoons are known as *Wakemia* or *Wunkirmian*, "feast acting spoon". During the festivals women that own these spoons are in charge of the gathering of food and the organisation of the cooking. The completion of this task gives her the right to parade before the villagers brandishing her spoon.

The owner of the large spoon illustrated above would have been greatly envied—the woman would have been "she who prepares the cow's head". She also would have been honoured for her talents as an organiser who knew how to direct the preparations for a ceremonial meal so that everyone was served at the right moment. She would have made it a point of honour to serve an abundance of rice from her own stores, and have added the flesh of a sheep or goat of her own to that of the feast's cow. Her *largesse* is emphasised by the generous depth of the bowl of this splendid spoon, and by the breadth of the horned head. The handle of the spoon is carved as an horned animal, perhaps a goat—a reference to the food prepared for the festivities that celebrate the productive labour of men or boys' circumcision. The head is carved with its horns gracefully extending to the bowl of the spoon: the upper surfaces of the spoon extend this image of grace, being carved with intricate herringbone design motifs.

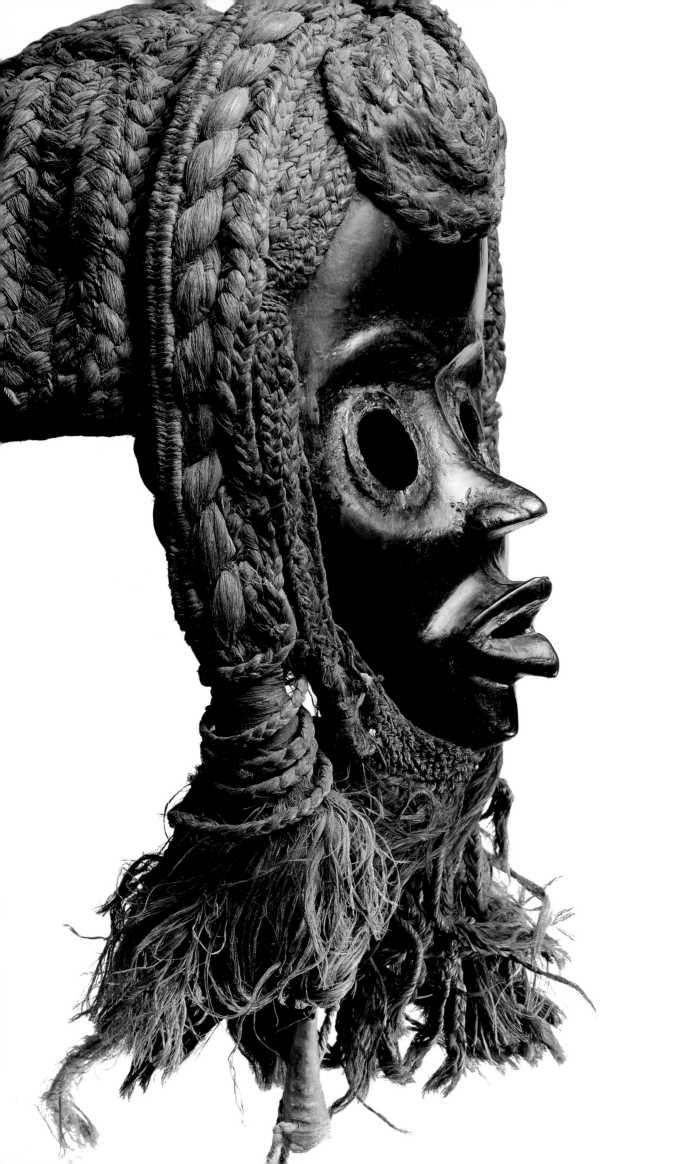

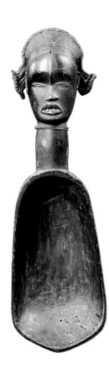

MASK GO GE

Côte d'Ivoire, Dan
Wood and fibre, h. 36 cm
BMG 1003-14

SPOON WAKEMIA

Liberia, Dan
Wood, fibre and metal, l. 60 cm
Formerly Josef Mueller collection (before 1942)
BMG 1003-1

The Dan carve a series of wood face-masks to be worn with various costumes for their masquerades. The mask illustrated opposite is given a high forehead, concave face, and large circular eyes. The traits suggest that it has a northern Dan origin—though the protruding mouth is symptomatic of the masks produced by the southern Dan. The eye-holes give a clue to its identity and place in the Dan hierarchy of masks. The fact that the circular eyes are so large means that the wearer has a wide field of vision. This is a characteristic of the racer mask, *gunye ge*, and also of *zakpei ge*, which watches over cooking fires during the dry season. The elaborate coiffure of this mask is not, however, commonly found on either of the above types. Rather it is a feature of the much rarer *go ge* mask, which is an extremely important type and is sometimes known as the "kings" mask. *Go ge* is a large

mask that appears in villages to announce the death of the king or high ranking person.

The handle of the ceremonial spoon above is sculpted in the form of a woman's head and resembles certain features of the Dan masks that represent women. The head is divided by a medial groove, the eyes are almond shaped and the mouth is full of teeth.

The headdress is of slanted and herringbone grooves, and the top of the figure is adorned with braided fibre. The bowl of the spoon is an elegant convex shape and is decorated with narrow bands of incised design—there is a beautifully balanced reconciliation between bowl and handle.

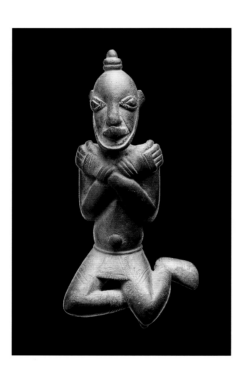

In the first half of this millennium a remarkable civilisation flourished in the region of the inland Niger delta, along the southern border of the Sahara desert. Its two most famous towns were Djenne and Timbuktu. Here wealth drawn from the trans-Saharan trade enabled citizens of the empire to establish institutions of learning and to develop the arts to an extraordinary degree. Terracottas were produced in considerable numbers and wooden sculpture flourished. On a lesser scale the metal-smiths produced highly accomplished works in cuprous alloys by the lost wax process of casting. The skill of the bronze-casters is seen in the magnificent small pendant above, which represents an image quite as powerful and dramatic as the larger works in terracotta and wood. It depicts a bearded man wearing a decorated loincloth and bracelets, seated with his legs to one side in a remarkably free pose. His arms are crossed over his chest. This jewel of a casting was made probably between the twelfth and the sixteenth century.

In the realm of terracotta sculpture, the powerful artistic impulse of the "Djenne culture" (so named because art-works from the site of ancient Djenne were the first to become known) was echoed in varying degrees in the more distant outposts of the Mali empire. Related styles of terracotta modelling emerged, some of them still only imperfectly known. The example opposite, of a seated man, is in the so-called "Bankoni style", named after the region between Bamako and Segu where several works in this style have been found. Thermoluminescence dating indicates that this sculpture was probably made in the fifteenth or sixteenth century.

PENDANT

Mali, Djenne region
Bronze, h. 9.6 cm.
BMG 1004-125

FIGURE

Mali, Segou region
Terracotta, h. 44.3 cm.
BMG1004-131

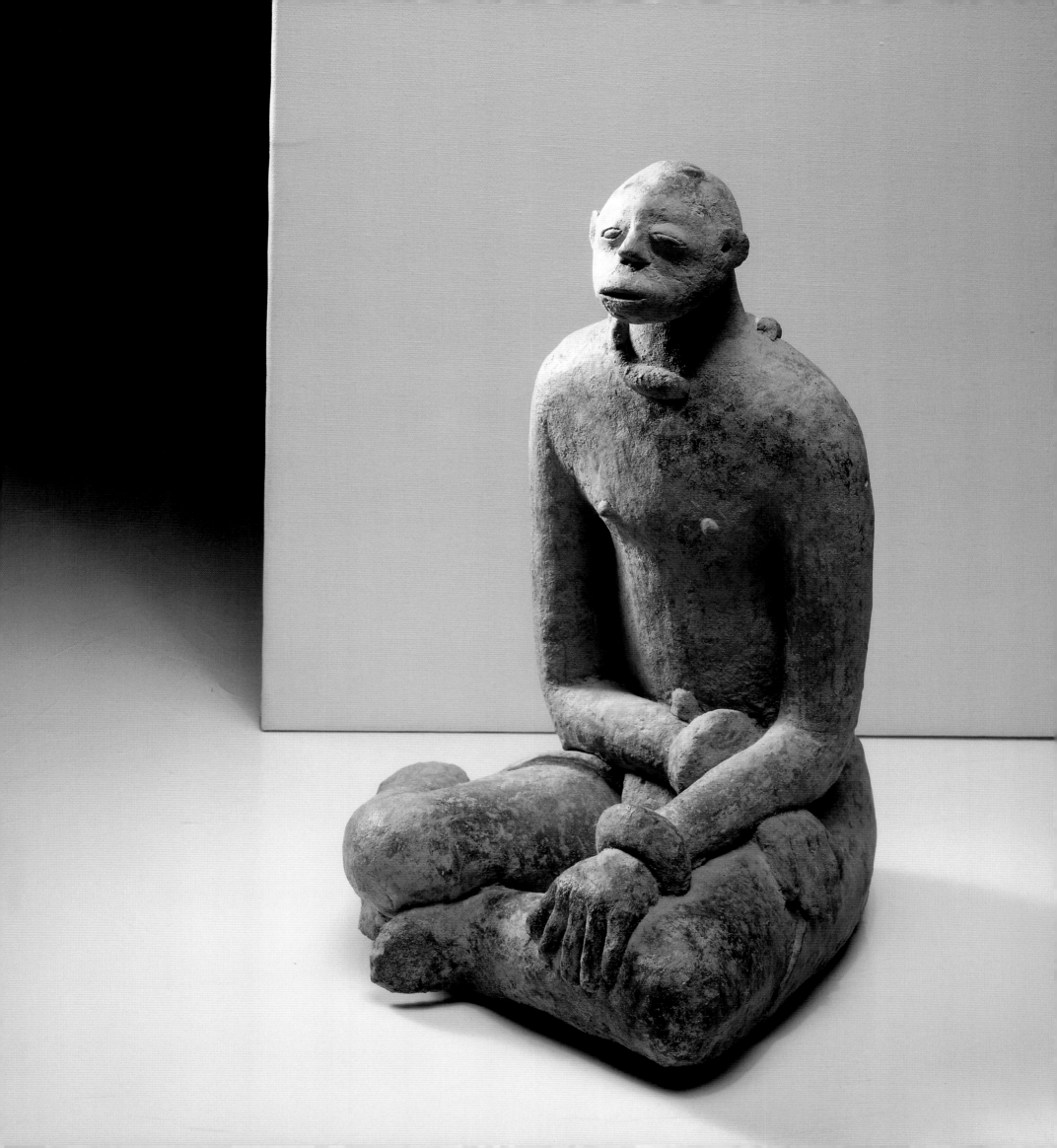

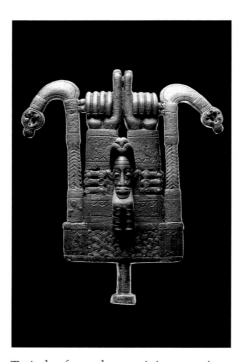

In the mid-fourteenth century the Arab traveller Ibu Battuta crossed the Sahara desert and left an account of the splendour and pageantry of the royal court of Mali, which was at that time able to command the services of a variety of highly skilled artists and craftsmen. The small ornament illustrated above was in all probability made for the royal court. It exhibits astonishing skill, being cast in several pieces; the central portion is of cuprous alloy, perhaps a tin-bronze, and the two "wings" are of red copper. The surface of the ornament is further adorned with no fewer than fifty-nine inset metal plugs, some of red copper and others of silver. Its complex icono-graphy remains uncertain, though the motif of two upraised arms with the hands clenched recurs frequently among ancient wooden sculpture attributed to the Tellem, the Dogon and the Soninke. The ornament may date to around the thirteenth to fifteenth century.

To judge from the surviving remains, the empire of Mali at its height between the eleventh and fifteenth century had an extraordinarily rich and varied material culture. While the royal court adopted a veneer of Islamic civilisation, the common people—to judge from the statements of a number of Arab authors—remained firmly attached to their age-old rituals and superstitious practices. Al-Bakri, in the eleventh century, mentioned a cult of serpent worship, and evidence of this may exist in the numerous terracottas from the Djenne region depicting human figures festooned with snakes. The enigmatic sculpture opposite is further remarkable for the halo-like disc behind the man's head. Clearly intended to be viewed from in front, this statue gives the impression of being a religious figure from a cult shrine or altar.

ORNAMENT

Mali, Djenne region
Bronze, copper, silver, h. 11.4 cm.
BMG 1004-85

FIGURE

Mali, Djenne region
Terracotta, h. 37 cm.
BMG 1004-128

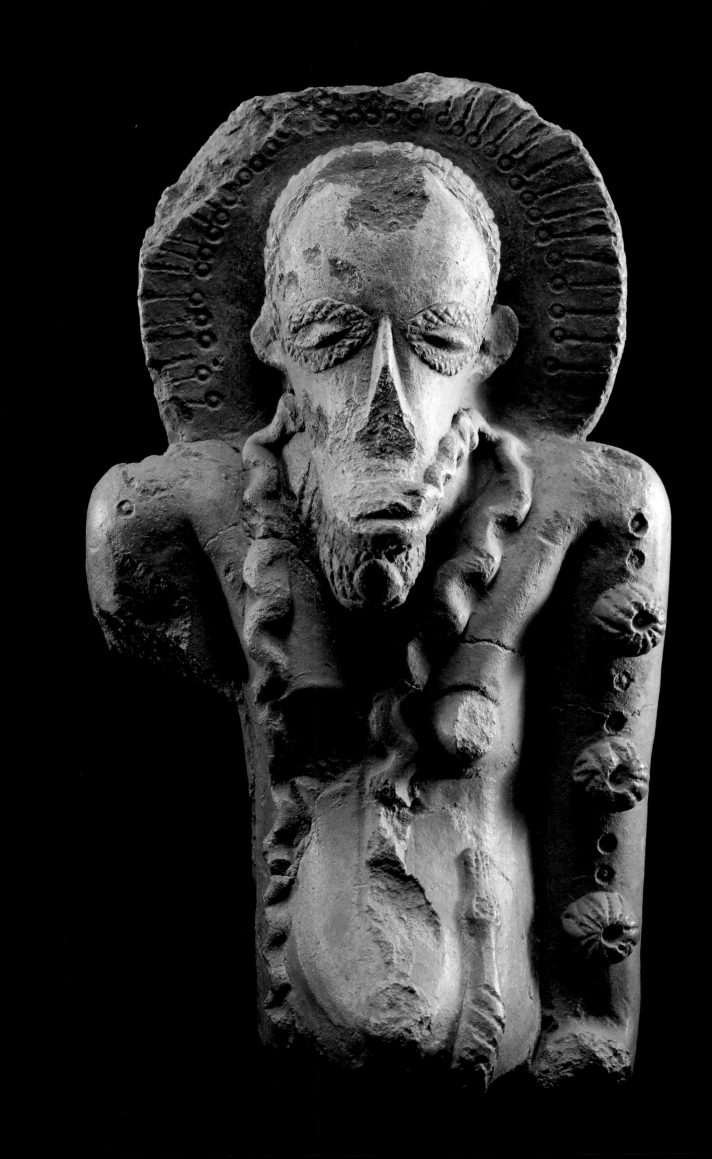

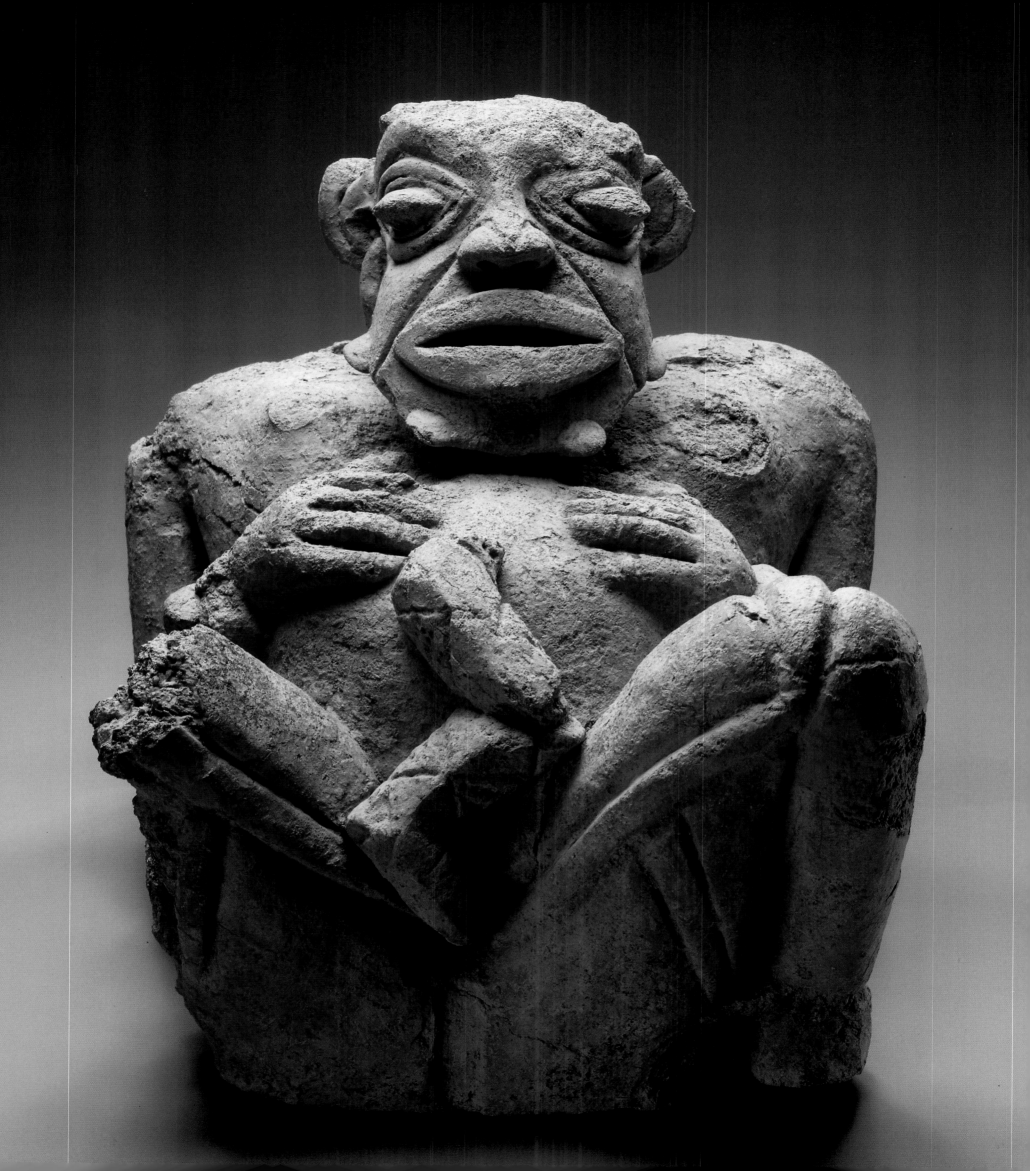

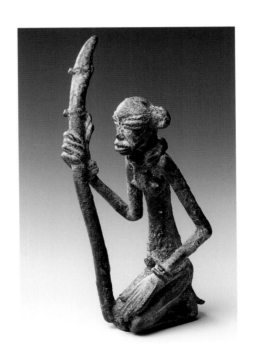

FIGURE

Mali, Djenne region
Bronze, h. 9.8 cm.
BMG 1004-143

FIGURE

Mali, Inland Niger Delta region
Terracotta, h. 39 cm.
BMG 1004-95

Among the wealth of terracotta statues which have emerged from the Djenne region in recent years (usually from the clandestine pillage of sites), there are some whose themes may shock. The sculpture opposite shows in the most direct terms a scene of parturition: the mother with swollen belly and legs spread apart is giving birth to a creature which, from its stylised zigzag form, appears to be a serpent. We may surmise that this was a shrine figure for the serpent cult, possibly associated with rituals to ensure fertility. It dates probably from the twelfth to the fourteenth century, when the terracotta art of the Inland Niger delta was at the apogee. It is fired to a characteristic orange-red color, and its surface, following centuries of burial, is thickly encrusted with the pale brown clay of the region.

The art of casting cuprous metals may have been known in the Inland Niger delta region as early as the eleventh or twelfth century. Castings tend to be small, possibly indicting a restricted metal supply, and they occur in a variety of styles about which we still know very little. The figure above has been published as Djenne by Marie-Thérèse Brincard, but this is entirely conjectural. In the present state of our knowledge we can only speculate as to when, by whom and for whom this bronze may have been cast. Such ignorance does not detract from the merits of the superbly modelled casting, which depicts a kneeling figure with left hand extended over the thigh and right hand holding a staff, or possibly a weapon. The curves of the torso, legs and staff provide a subtle contrast to the angularity of the figure's arms.

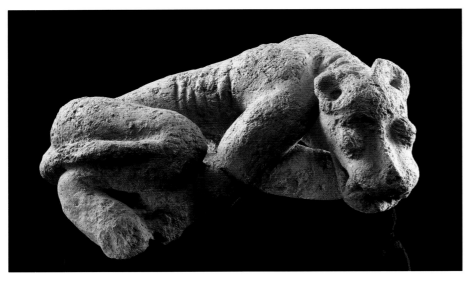

Sites in the region of Djenne have produced many terracottas of animals, and reptiles, ranging from coiled serpents a few centimeters across to large animal figures, including lions, of astonishing size and weight. The relatively small feline shown above may represent either a lion or a leopard, or perhaps a lesser member of the cat family such as a cheetah or serval. It is depicted in a crouching pose, naturalistically rendered.

The purpose of such zoomorphic figurines is not clearly established, but it has been suggested that they represent semi-divine beings which were worshipped in special sanctuaries. If so, they would be evidence of the survival of pre-Islamic animist cults among the common people of the region. Thermoluminescence dating suggests that this example was probably made between the twelfth and fourteenth century.

This large terracotta depicts a curious quadruped with a pointed, mitre-like projection on its head. It may represent a chimerical animal, or alternatively a horse or donkey, or even a ram or a ewe. A group of about ten such animals, found together, is said to have come out of Mali in the 1980s. Made between the fourteenth and the sixteenth century, they are not in the classical style of the Djenne region, and presumably come from a site elsewhere.

When Ibn Battuta visited Mali in the mid-fourteenth century he observed that when the ruler, Mansa Suleiman, sat in state, two mares and two rams were brought out before him to guard against the evil eye. He further noted with disapproval that many people of the region ate dogs and donkeys. Unfortunately he is silent on the possible role of these animals, and representations of them, in religious rituals, and the function of these terracottas remains unknown

FELINE ANIMAL

Mali, Djenne region
Terracotta, l. 18 cm.
BMG 1004-90

QUADRUPED

Mali, Inland Niger Delta region
Terracotta, h. 74 cm.
BMG 1004-157

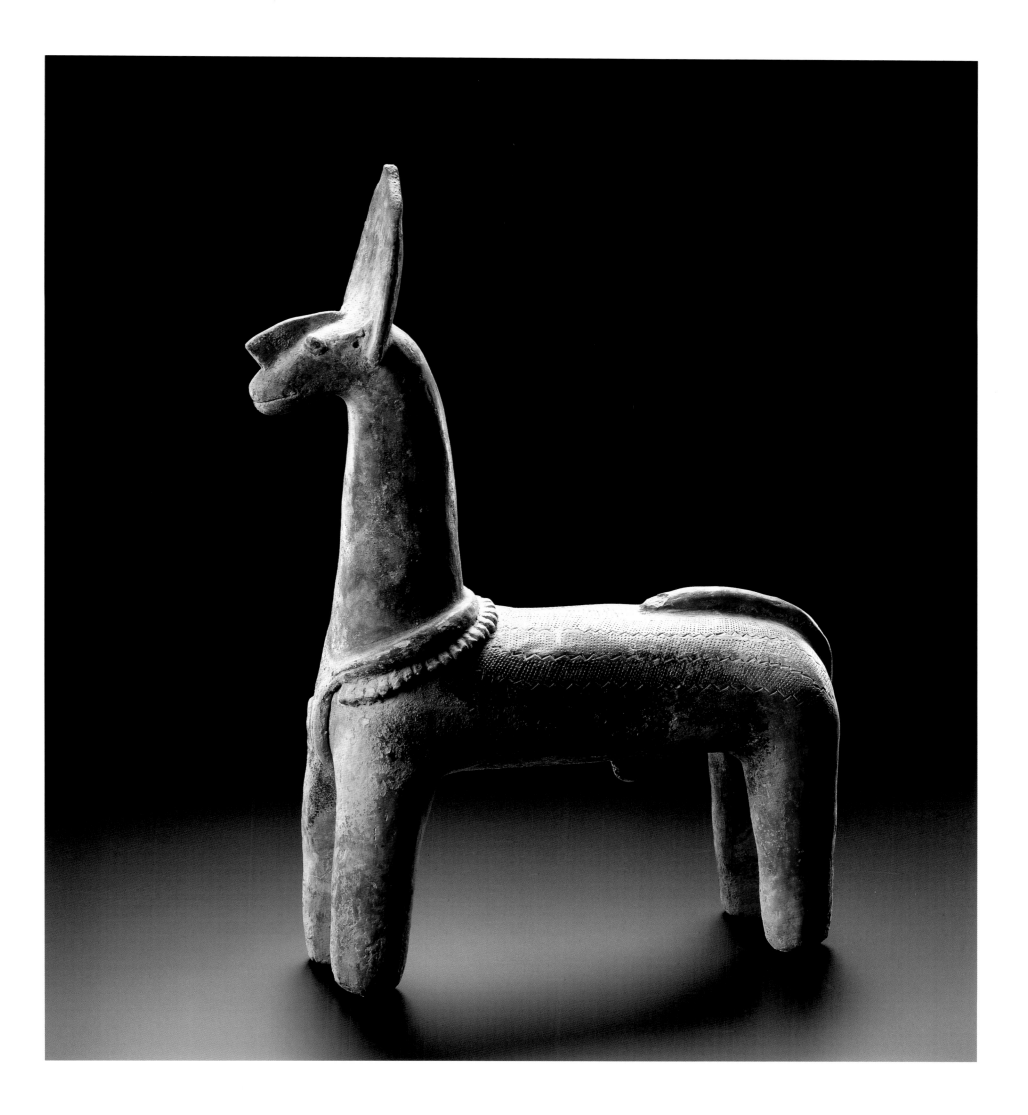

The bound captive is a recurring theme in African art and the cast bronze figure shown above has bonds about both his ankles and wrists. It was acquired from the Dogon in the 1960s, but it is a larger casting than others found in the area, so some people have questioned that it originated there. However the Dogon are smiths of some repute, so there is no valid reason to look elsewhere for the origin of this haunting figure.

Germaine Dieterlen thinks that it could be the representation of a slave in irons: enemies taken in battle were chained in this way and put on show in the courtyards of the victorious village's chief.

Standing figures with arms upraised were often carved by the Dogon, who may well have borrowed the gesture from the previous occupants of the spectacular Bandiagara escarpment— a people generally known as the

Tellem. The Dogon are thought to have migrated to this area of eastern Mali between the twelfth and fourteenth century: a radio-carbon test of the figure opposite yielded a date for the wood of around the fifteenth to the seventeenth century. The figure has a fluency of form that is also found amongst their neighbours, the Bambara, but the reddish sacrificial crust of eggs and flour mixed with the laterite dust of the area is unmistakably Dogon. Dieterlen writes that figures with upraised arms always represented the beseeching of Amma to send the rain necessary for all life, and that it also was a gesture of contrition for an infringement of ritual law that caused the drought.

STATUE

Mali, Dogon
Bronze, h. 21.8 cm.
BMG 1004-129

STATUE

Mali, Dogon
Wood, h. 76 cm.
Formerly Emil Storrer and Josef Mueller
collections (circa 1950)
BMG 1004-3

The life of a Bamana farmer is austere—extremely hard, like iron—and their iron staffs reflect these properties. Iron smelting was the prerogative inherited by certain families of blacksmiths, whose power was regarded as even more essential than the heat of the furnace to deal with such an intractable metal. The figure on the staff above is a representation of a noble women, *horon*, and may represent *Gwandusu*, the female ancestor of the Bamana. This type of iron sculpture is owned by blacksmith lineage groups. The sculpture was cast and then the features chiselled on to the surface. The elaborate three part coiffure was known as *kobidani*, a word that implies beauty in design.

The roan antelope, an animal much venerated by the Bamana farmers of the tough Malian landscape, inspired dance headdresses worn by the masqueraders as they re-enact the myths of the first agriculturists. These dance crests are known as *tyi wara*, and the context for the performance of the dances is the initiation of young men into the *Tyi Wara* society. Pairs of costumed dancers appear, wearing the crests on their heads: one represents the male antelope, such as the carving opposite, and the other the female. However, each is also the respective symbol of the sun and the moon, and woe betide any person who comes between them when they dance. The crest here is carved in the upright style of the northern Bamana—the southern style is more vertical and often includes other animals in the carving. There is a stunning resolution between the curve of the horns and the grace of the head and neck of this fine sculpture—it is clearly the work of a master carver and has been ascribed to the workshops in Segou near the Bani River, and dated to the late nineteenth or early twentieth century.

STAFF FINIAL

Mali, Bamana
Iron, h. 53 cm
BMG 1004-6

HEADDRESS, *TYI'WARA*

Mali, Bamana
Wood, h. 73 cm.
Formerly Antony Moris and Josef Mueller
collections (before 1939)
BMG 1004-36

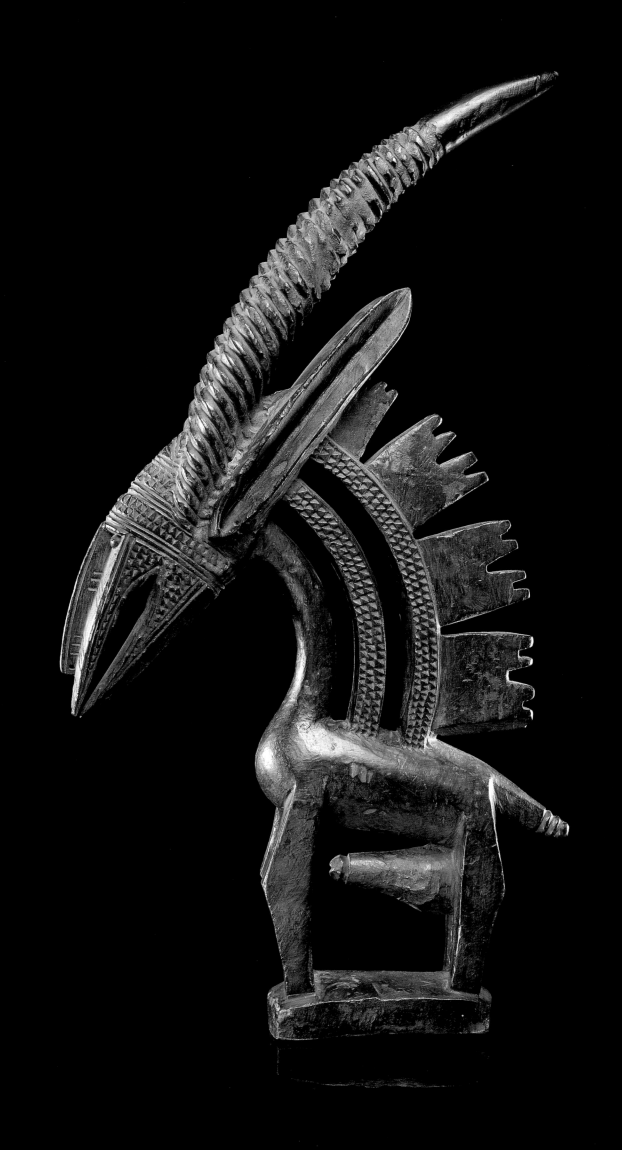

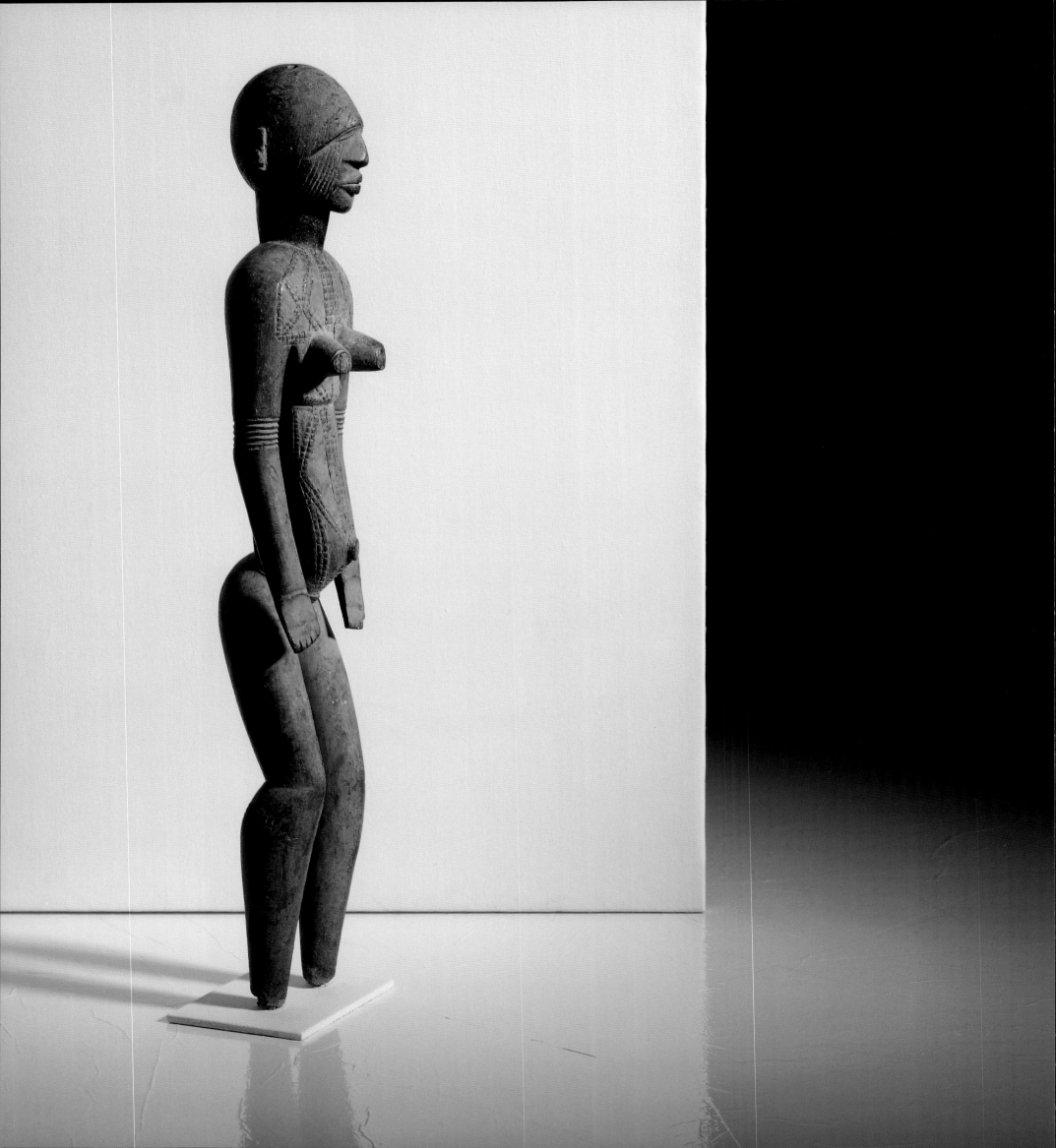

FIGURE

Burkina Faso, Nuna
Wood, h. 83 cm
BMG 1005-4

MASK

Burkina Faso, Bwa
Wood, h. 203 cm
Formerly Emil Storrer and Josef Mueller
collections (circa 1953)
BMG 1005-10

The figure illustrated opposite is carved in the style of the Nuna of southern Burkina Faso—it is probably from the town of Leo. Wooden figures such as the one opposite are owned by diviners, known as *vuru*, who are said to be able to control a number of the spirits that inhabit the bush that surrounds each village. These spirits are made visible in these sculpted forms which are placed on shrines in the deepest recess of the diviner's house. Sacrifices are made to them, in order to gain the protection of the spirits for the diviner's clients.

To the west of the "Gurunsi" live the Bwa, who extend into Mali, their territory lying within a loop formed by the Black Volta River. There is a remarkable diversity in Bwa masking styles. Such plank masks as that above were created and used by the Bwa people of the Kademba region of southern Burkina Faso, who call themselves *Nyaynegay*. The dramatic plank masks of the south are used in initiation, to instruct young men in the proper moral order of the world and also provide blessings and prosperity to those who own them. This mask, known as *Nwantantay*, is associated with the nature spirits that control the flow of water.

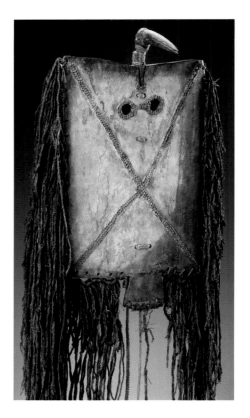

The Tusyan are a small ethnic group living around Orodara near Banfora in south-western Burkina Faso. They have an initiation society, the *Lo* or *Do*, somewhat akin to the Senufo *Poro*. Each initiate wears a rectangular plank mask, *loniake*, surmounted by bush-cow horns or by a crest, representing the protective spirit of his clan. In the example above, the crest is the head of a hornbill, probably the Grey Hornbill (*Tockus nasutus*). When not in use, the masks are sometimes hung under the outer eaves of the houses, where they can be seen quite openly.

An ancient theme in the art of the Middle Niger region, the figure opposite of the nursing mother is notable among the Senufo. The above figure, of a mother suckling twins seated on

a traditional stool, has seen much traditional use, being oiled and painted. According to Anita Glaze, such figures were Poro society sculp-ture, and she also associates them with the *wambele* masquerade. But Tim Garrard informs us that this does not hold good in the Tyebara region around Korhogo. Instead, they are associated with the *tyekpa*, the women's Poro society of the Fodonon sub-group, as found, for instance, in the villages of Lataha and Waraniene. Here the figures are brought out on the heads of older *tyekpa* members, for the funeral of a deceased woman. The statue is placed in the compound of the dead woman where the *tyekpa* members dance around it. Some-times it is accompanied by subsidiary sculptures including a cockerel or hen.

MASK

Burkina Faso, Tusyan or Siamou
Wood, fibre, abrus seeds, cowries, kaolin h.
67 cm.
BMG 1005-11

FIGURE

Côte d'Ivoire, Senufo
Wood, h. 65 cm.
Formerly Emil Storrer and Josef Mueller
collections (1952)
BMG 1006-5

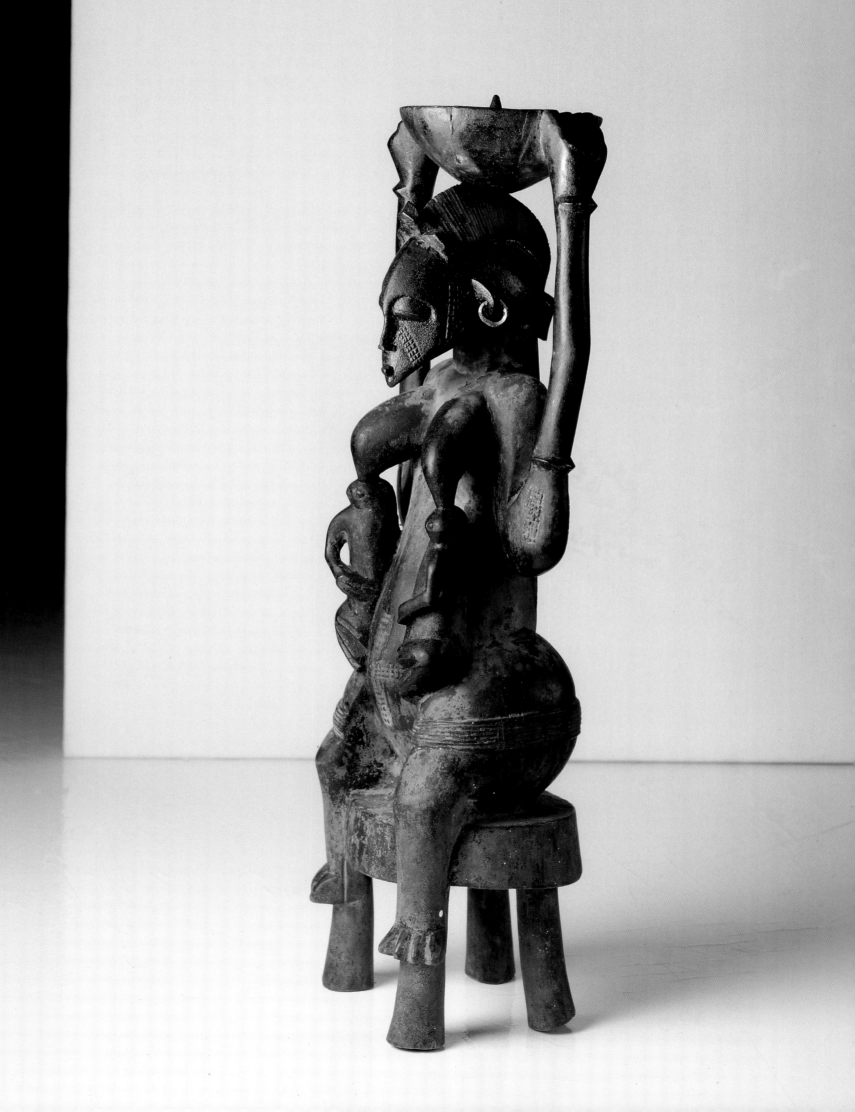

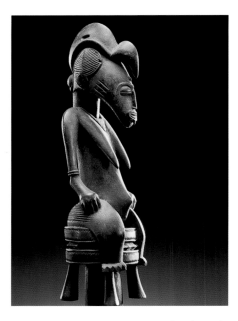

The Senufo have farming in their blood: they hoe, plough and cultivate with fanatical zeal, and take to the fields at the slightest opportunity. The competitive spirit is fostered by periodic events at which adolescents and young men from different quarters of the village (or from neighbouring villages) compete to hoe a field. The winner is declared champion cultivator (*tegbaon* or *sambali*) for that season, and awarded a trophy in the form of an elaborately carved staff. Often this is topped by the figure of a beautiful maiden, as the one above, in recognition of the fact that the champion will quickly obtain a good wife. This delightful custom is being supplanted by football, but the staffs are still highly prized, being fine works of art with the sculptor exercising all his skill to ensure that it will be widely admired.

Almost fifty years ago, French missionaries obtained a collection of superb Poro sculptures from sacred forests in the Fodonon village of Lataha. Among them was the female figure above, originally part of a ritual pestle (called a "rhythm pounder" in the literature). The Fodonon did not make these sculptures, there being no carvers in the village. Instead, they commissioned them from sculptors in the Koko quarter of Korhogo, some 14km. distant. Informants in Lataha and among the sculptors of Korhogo suggest that this important piece was probably carved by one of the chiefs of the Korhogo sculptors. The last such chief, Fobe, died in 1994 aged about eighty. The pestle is thought to have been made by one of his two predecessors in office (the second of whom was his uncle). Such pestle statues are variously called "a child of Poro" (*poro pia*: Tyebara, *pombia*: Fodonon) or "a bush spirit" (*ndeo*, plural *ndebele*). The latter name has been corrupted to *deble* in much of the literature, the plural form being wrongly used even when referring to a single statue. The ordinary Senufo name for a pestle is *sedine* or *dol*.

STAFF
Côte d'Ivoire, Senufo
Wood, h. 164 cm.
BMG 1006-27

STATUE
Côte d'Ivoire, Senufo
Wood, h. 118 cm.
Collected by Father Clamens (in 1951).
Formerly Emil Storrer and Josef Mueller collections (circa 1952)
BMG 1006-1

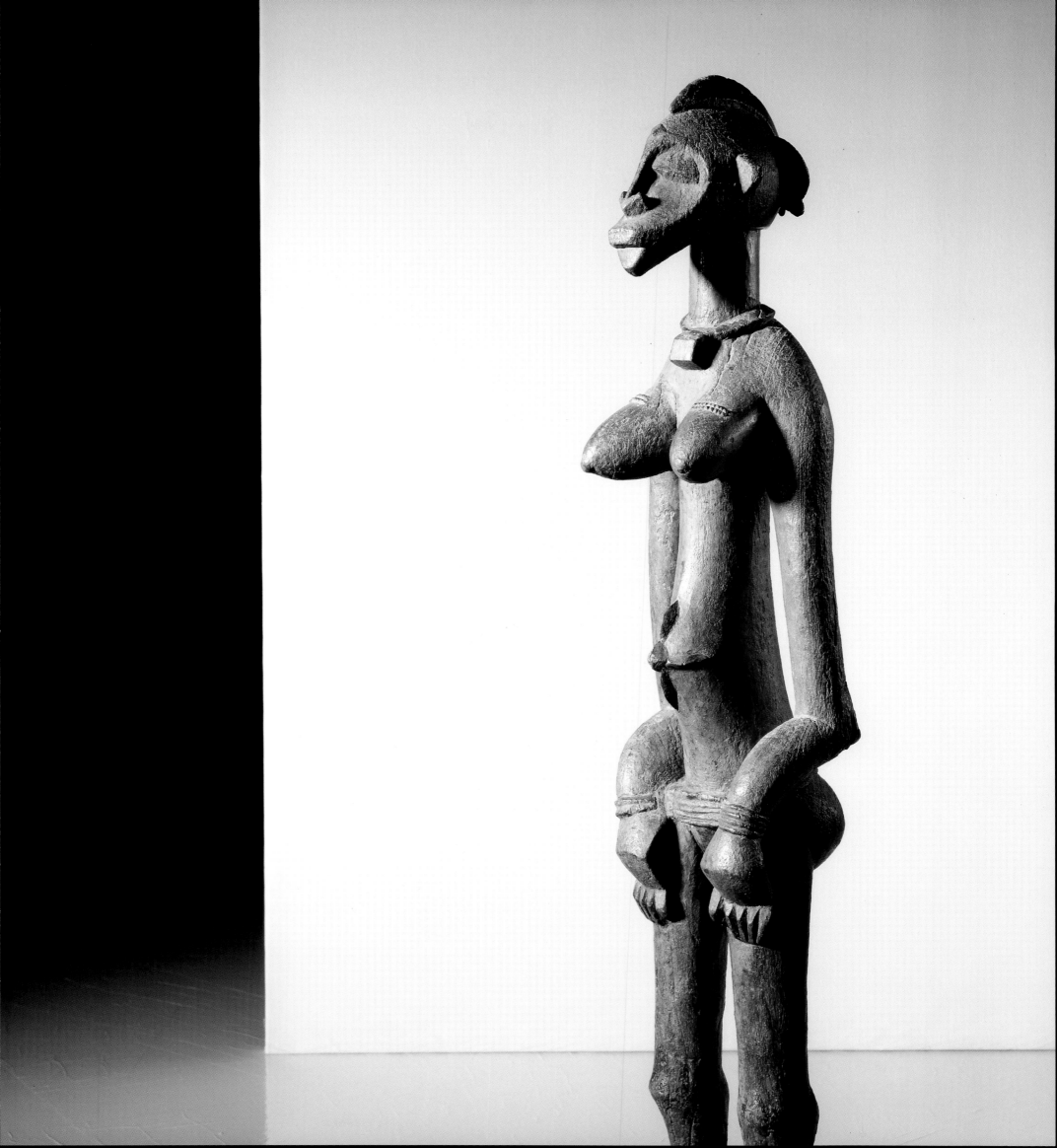

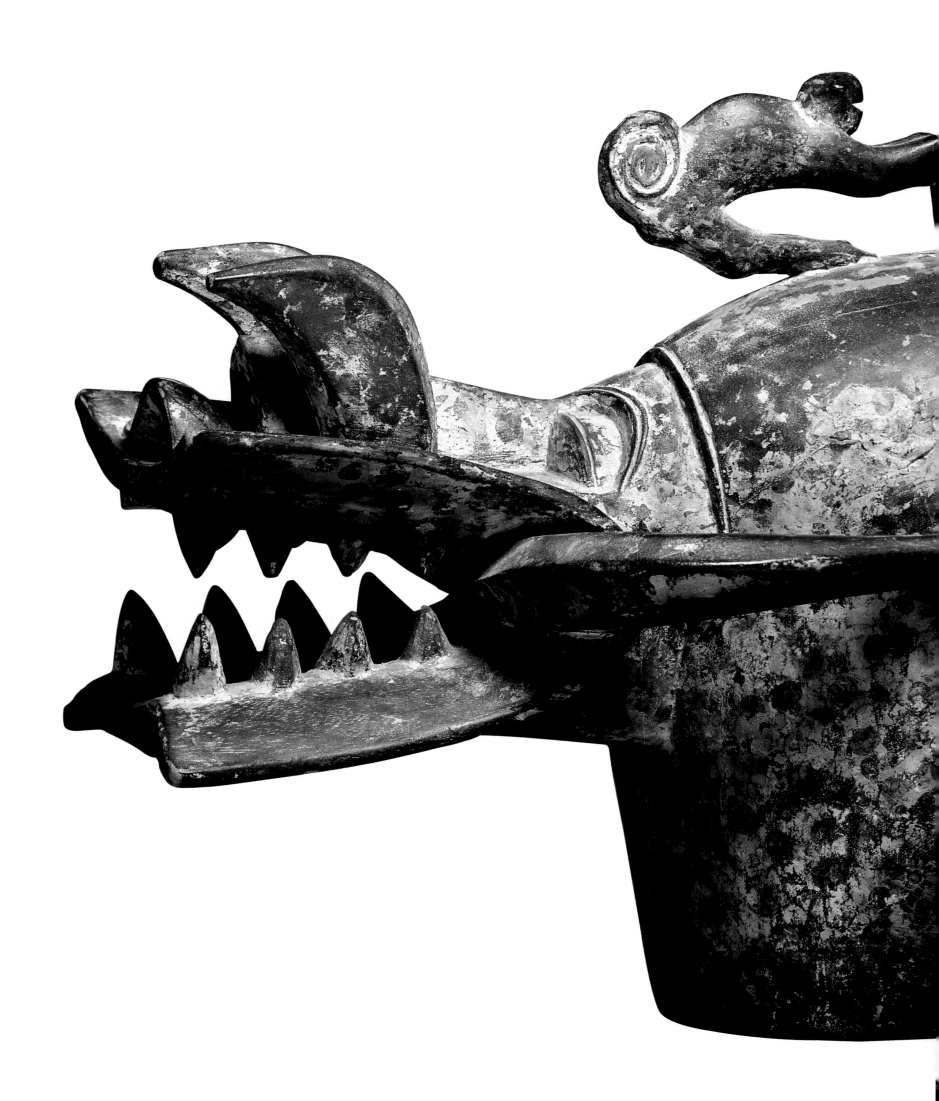

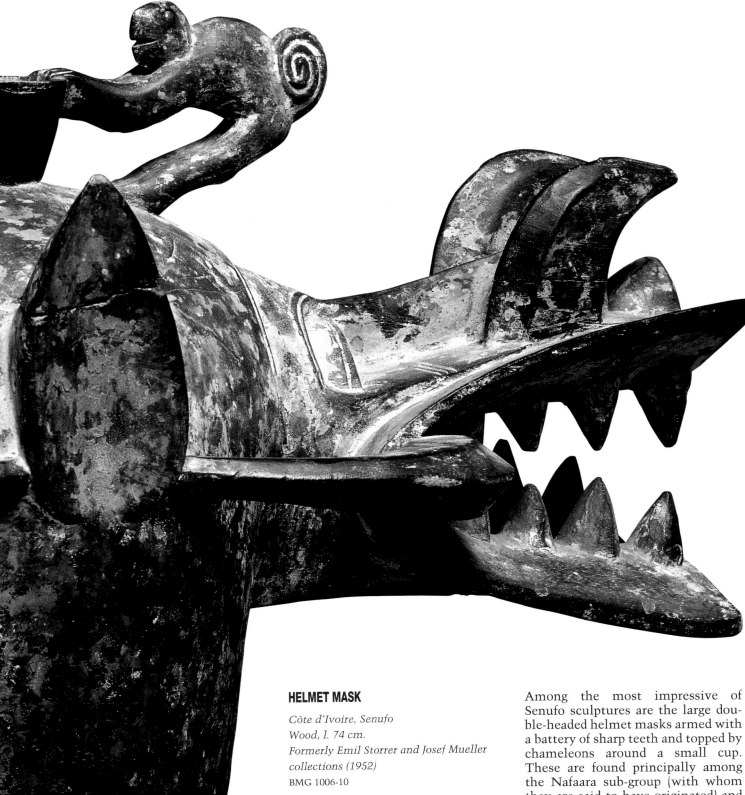

HELMET MASK

Côte d'Ivoire, Senufo
Wood, l. 74 cm.
Formerly Emil Storrer and Josef Mueller
collections (1952)
BMG 1006-10

Among the most impressive of Senufo sculptures are the large double-headed helmet masks armed with a battery of sharp teeth and topped by chameleons around a small cup. These are found principally among the Nafaara sub-group (with whom they are said to have originated) and their neighbours, the Tyebara.

Such masks do not form part of the Poro complex and have no connection with the sacred forest of Poro. They are commissioned (usually in pairs) by an individual proprietor, who brings together a group of young men to serve as masqueraders and musicians, and trains and initiates them into the secrets of the masks.

Each masquerader wears the wooden mask together with an all-enveloping sack-like costume of painted cloth. He appears at major funerals and other moments of crisis in the community, and is greatly feared.

The masquerader, wearing both the wooden mask and his cloth costume, is called a *wao* (plural *wambele* or *wabele*) and the whole troupe of performers are commonly called "the *wambele*". But despite frequent statements to the contrary the wooden mask itself, taken in isolation, is not called *wao* or *wambele*. Its correct name is *wanyugo* (plural *wanyuyi*) "the head of the *wao*".

These masks have their own ceremonies and rituals and are credited with magical powers. Among the Nafaara they are said to be able to emit a swarm of bees, and even to be able to make a corpse stand up and work with a hoe. In the literature they have sometimes been called "firespitters", but this is erroneous. The ability to spit fire belongs to another even more terrifying kind of helmet mask, the *korumbla*, which belongs to the Poro societies.

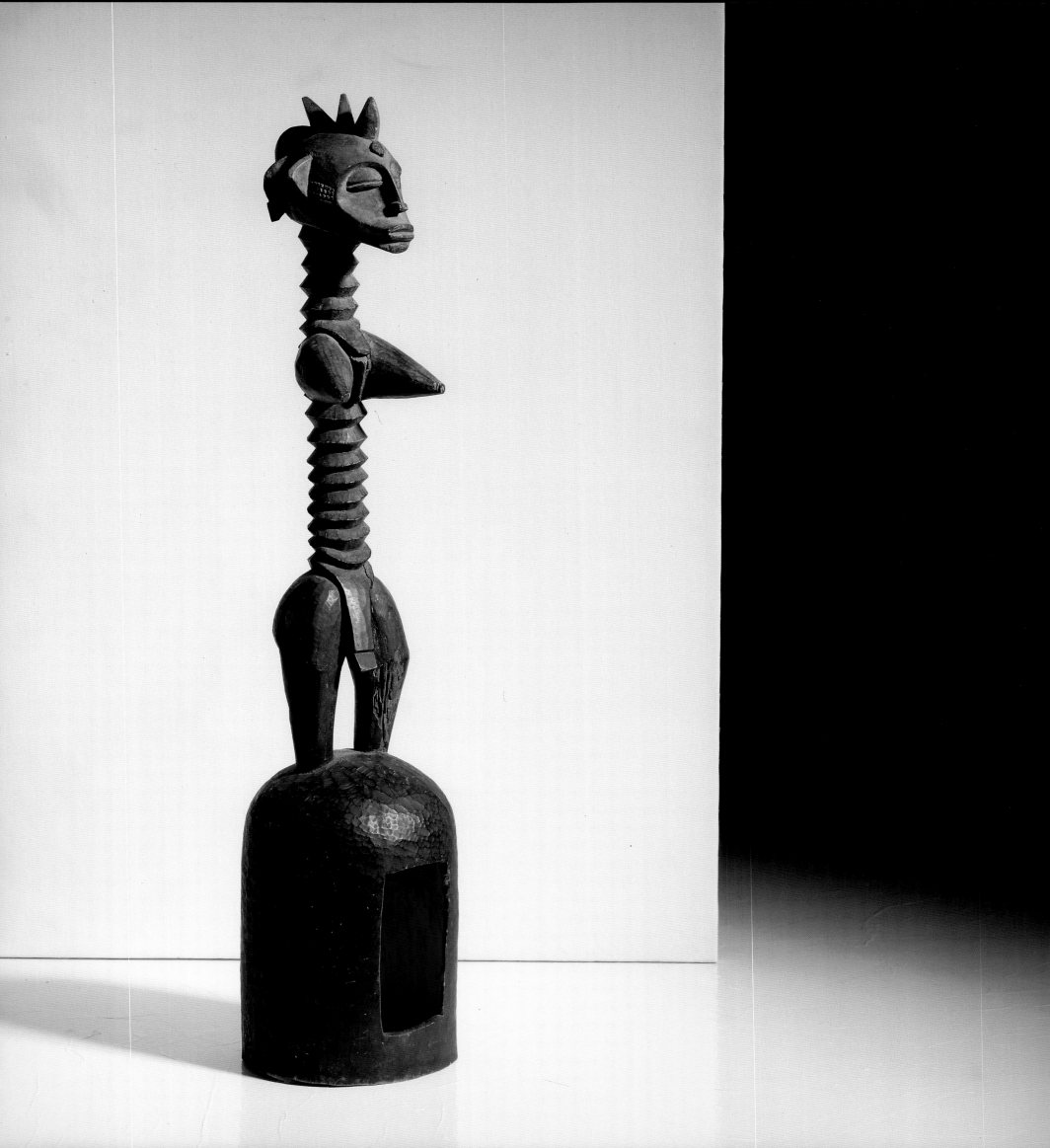

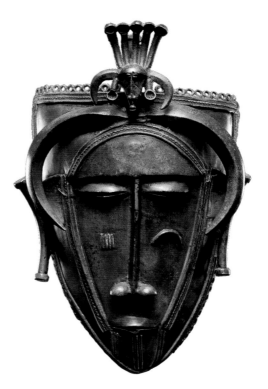

HELMET MASK

Côte d'Ivoire, Senufo
Wood, h. 103 cm.
Collected in 1951 in Lataha, formerly Emil
Storrer and Josef Mueller collections (circa
1952)
BMG 1006-36

MASK

Côte d'Ivoire, Diula
Brass, h. 25 cm.
Formerly William Moore collection, Los
Angeles
BMG 1006-52

The first pair of these dramatic helmet masks was obtained by the scholar Maesen in 1939 from the sculptors' quarter of Korhogo. Others came to light in the following decade, and the very fine example illustrated opposite entered the Josef Mueller collection around 1952. It had been photographed outside the sacred grove of the village of Lataha in 1951 by Father Clamens. Its facial features closely resemble those of the ritual pestle discussed earlier (page 43), and both may well be from the same Korhogo workshop.

In pre-colonial times small communities of Diula established their own villages among the Senufo. They had a well known masquerade, the *Do*, at which a number of different maskers danced publicly. The principal masks were called *Do muso*, "the woman of

Do", and there were others representing such characters as a sheep or hornbill. They often danced in pairs. Sometimes these masks were cast in metal rather than carved in wood. Some are of tin and others of brass—when polished they glittered in the sun and were said to represent silver and gold respectively. The mask above, being of brass, represents the "gold" element in the pair. It is perhaps the most perfect known example of a Diula metal mask, and was formerly in the collection of the collector William Moore. It is said to have been collected more than three decades ago in a Diula village east of Korhogo. Diula metal masks have not been made for many years, the *Do* society being today largely moribund. This example probably dates from between the late eighteenth and the mid-nineteenth century.

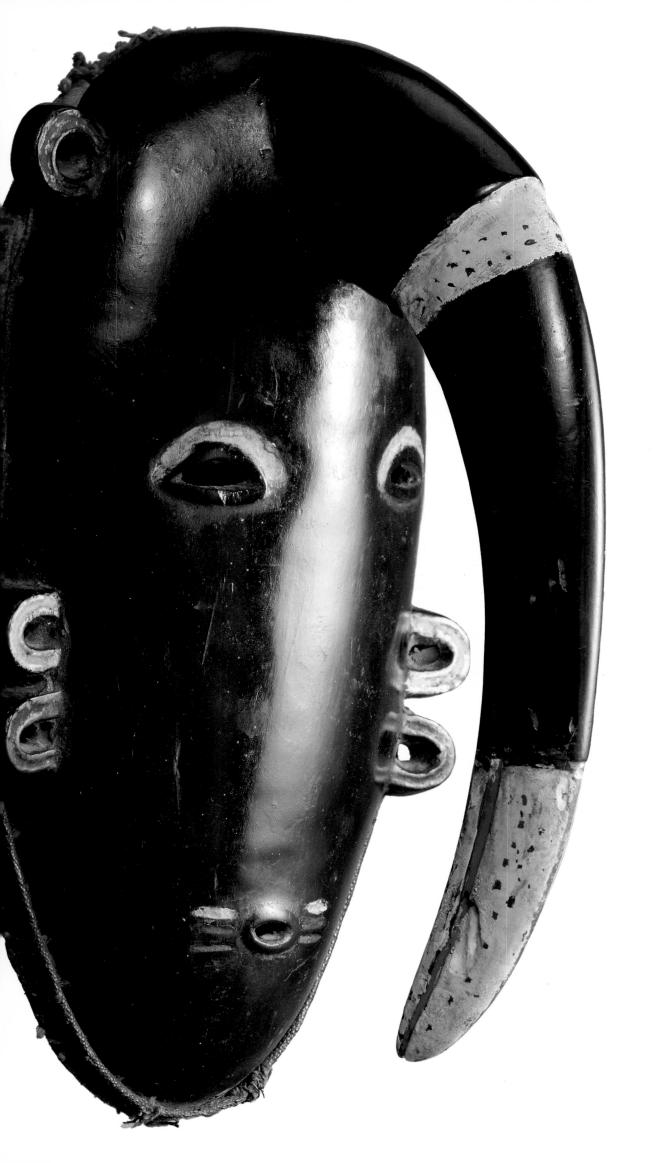

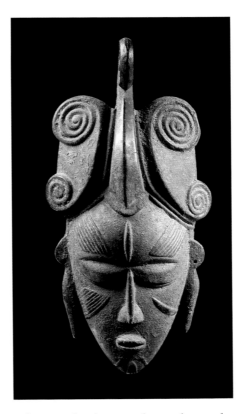

MASK

Côte d'Ivoire, Ligbi
Wood, h. 29 cm.
Formerly Charles Ratton collection

BMG 1006-38

MASK

Côte d'Ivoire, Ligbi
Wood, h. 28.8 cm.
BMG 1006-56

The mask shown above from the Bonduku region of eastern Côte d'Ivoire is a classic example of the *Do* masquerade form. Its delicate carving is intended to emphasise the beauty of the face and the intricate perfection of the coiffure. Of particular interest are the two appendages extending downwards from the ears. On the masks of Kong they descend almost to the chin; and among the Senufo, who copied this form for their *kodoliyehe* masks, the original ear-ornaments have become mere appendages to the chin, held by the masquerader to steady the mask while he dances.

The *Do* masquerade is ever popular among many Muslim communities. René Bravmann investigated it among the Ligbi of the Bonduku region, while Tim Garrard later traced its ramifications at Kong and among the Diula of the Jimini and Senufo regions. The masquerade incorporates a varied cast of characters, one of which is the hornbill called *yangaleya* by the Ligbi and *magangono* by the Diula of Kong. This mask is generally in the form of a humanoid face with a long beak-like protrusion extending downwards from the forehead. The Ligbi example shown opposite is well documented, having been photographed by Bravmann in 1967 in the Ligbi village of Bondo-Dioula, north-west of Bonduku. This mask form became known even to the Senufo, who copied it to produce a variant of their famous *kodoliyehe* masks (also called *kpeliyehe*, corrupted to *kpelie* in the literature).

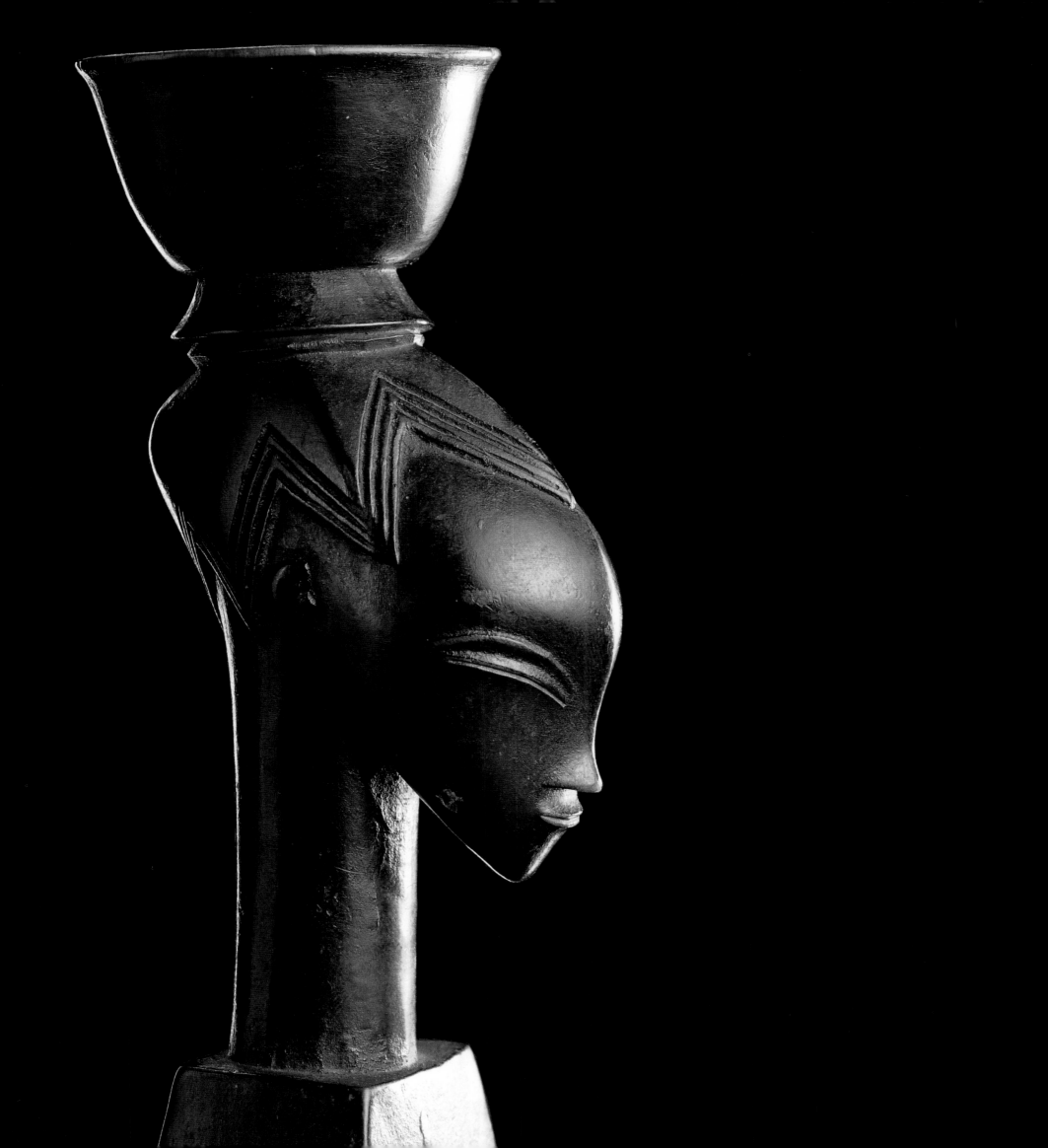

HEDDLE PULLEY

Côte d'Ivoire, Guro
Wood, h. 21 cm.
*Formerly Felix Feneon, Dr. Stephen-
Chauvet, Charles Ratton and Morris Pinto
collections*
BMG 1008-10

Heddle pulleys are found on weaving looms throughout West Africa. They hold a spool over which goes a string connecting the two heddles, thus allowing the weaver to alternately raise each half of the warp threads under which the shuttle is passed. Guro heddle pulleys were commonly carved with human heads, animal heads, animal figures and miniature replicas of the more important masks. Masks amongst the Guro are objects of supreme aesthetic value, and their reproduction on heddle pulleys underscores the fact that artistic elaboration of pulleys was undertaken for purely aesthetic reasons. The heddle pulley faces the weaver on his loom as he works. It therefore occupies a good position for an object of aesthetic contemplation and, as such, it would have helped inspire the weaver to work to a high aesthetic standard. The exceptionally elegant heddle pulley illustrated here, depicting the head of a young woman bearing a bowl, represents a favourite theme of the "Master of Bouaflé". The distinctive stylistic features of this object, including the rounded curve of the forehead, the zigzag hairline, the oblique slit-like eyes with echoing brows, the long, thin nose and the discreet thin-lipped mouth, are also typical hallmarks of this particular carver.

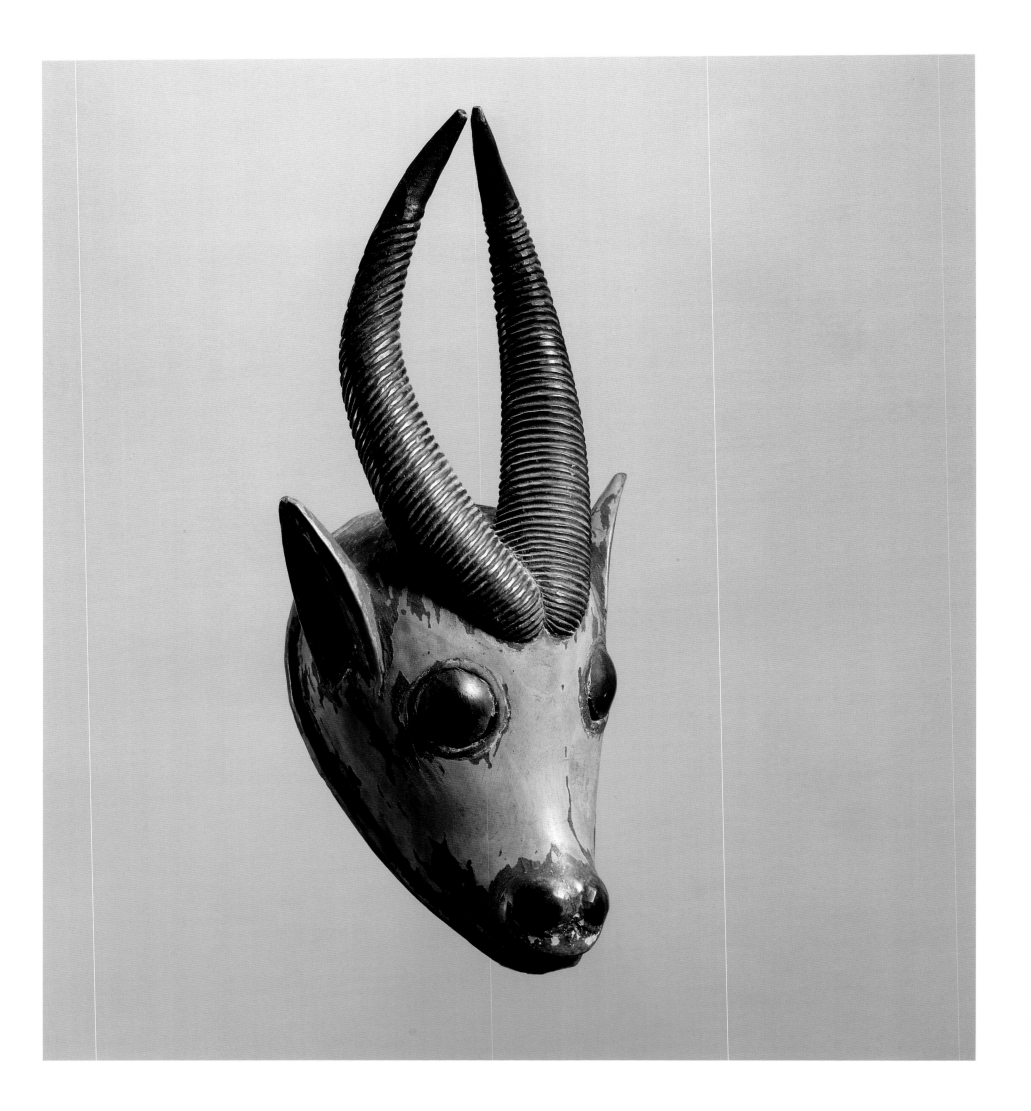

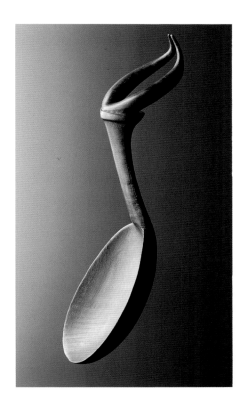

MASK

Côte d'Ivoire, Guro
Wood, h. 33 cm.
Formerly Josef Mueller collection (before 1942)
BMG 1007-25

SPOON

Ivory Coast, Guro
Wood, l. 18.5 cm.
Formerly Josef Mueller collection (before 1939)
BMG 1007-90

Je masks belong to the male society responsible for performing various functions to do with the maintenance of social order and political control. They are shared by both the Guro and the Yohure, but they show considerable regional differences. A Guro myth relates that the *je* "spirit powers" (personified by the *je* masks) first met with a group of women who denied their request for water. Later they met with the men who offered them palm wine. In return for this hospitality the myth relates that *je* formed an alliance with the men. Women are not allowed to see the *je* masks and must hide themselves away in the houses when the masker arrives to perform in the village. *Je* maskers wear any one of a variety of different animal- or human-like masks, each of which has its own special function. The mask illustrat-

ed opposite represents a waterbuck (*Kobus deffasa*). Its special role is to light the fire over which the *je* maskers leap at the end of the funeral rites for prominent society elders.

The elegantly decorated handle of the Guro spoon illustrated above suggests that it was not an item of everyday use. Such spoons were owned by important lineage elders who looked after them as treasured possessions and used them only in sacrificial rites associated with the cult of the ancestors. The shape of the horns that grace the handle of the spoon is typical of certain members of the tragelaphine group of antelopes—the horns may be intended to represent those of the kob (*Kobus kob*).

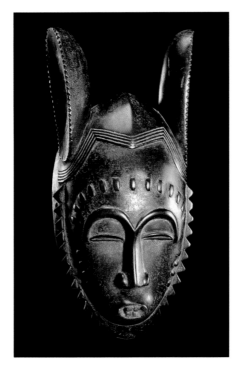

The refined details of the mask illustrated above display great craftsmanship. Although of a type no longer in use, this mask has been identified by Yohure villagers as a "particularly attractive" member of the *je* mask series of the men's initiation association. The mask successfully combines animal and human features in an emblematic evocation of one of the "spirit powers" of the bush which the Yohure call *yu*. As intermediaries between man and god (*Bali*), *yu* are sacrificed to during times of peril and when there is a threat to the social order. The *je* masks, as evocations of *yu*, are considered to be extremely powerful objects and very dangerous to touch outside their ritual context. Mythological sanction absolutely prohibits women from seeing the masks and from attending the funeral rites at which they appear.

The mask illustrated opposite is called *lomane* or *loman* in the Namanle language. The mask is an example of one of the seven mask types which make up the *je* masquerade corpus of the Yohure male initiation association. The *lomane* mask symbolically represents one of the *yu*, or "spirit powers", and it is worn by a masker who only performs in the context of funeral rites for men. The *lomane* masker's performance involves dancing around the displayed corpse accompanied by purificatory incantations, occasionally bending over the corpse in order to touch it with the mask. The rite is intended to remove the mystical dangers precipitated by death, to restore order in the play of supernatural forces and to re-establish unity in the community. At the same time it marks the dead man's passage to ancestorhood.

MASK, *JE*

Côte d'Ivoire, Yohure
Wood, h. 31 cm.
Formerly Emil Storrer collection (circa 1950)
BMG 1007-23

MASK, *LOMANE*

Côte d'Ivoire, Yohure
Wood, h. 43 cm.
Formerly Josef Mueller collection (before 1942)
BMG 1007-60

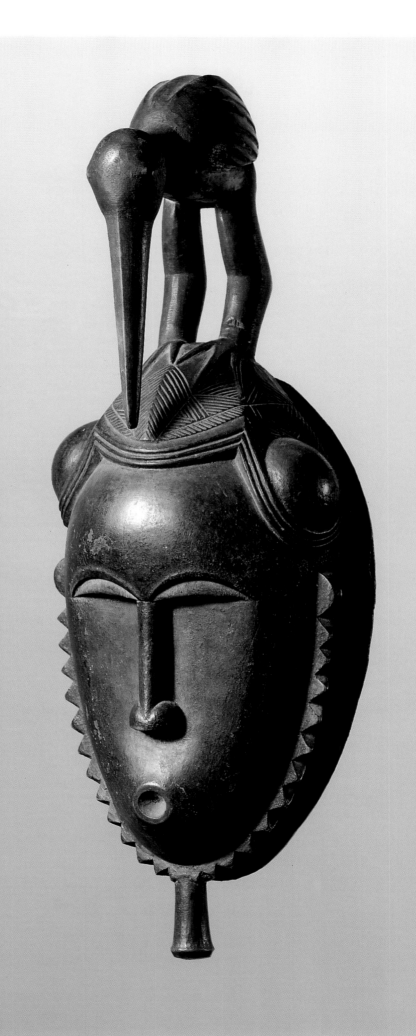

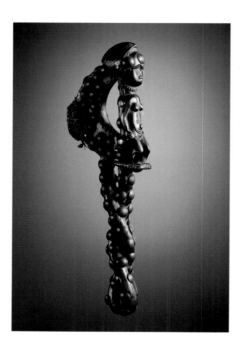

The use of sound to communicate with the spirit world is an important aspect of much ritual performance. Among the Baule a wooden tapper was used to strike an iron gong (*lawle*) during various rituals including divinatory seances, certain masked dances and ceremonies in which spirits were addressed or admonished. The head of the highly decorated and unusual tapper illustrated above is fitted with a pad of fabric which served to soften the tone that the instrument produced when tapped against the bell. The muted sound of the iron bell was intended to arouse the spirits without incurring their displeasure. The seated female figure carved between the points of the crescent on the head of the striker above closely resembles a female *asie usu*, or divinatory statuette. The nature of the figurative elaboration of this tapper and the rich decoration of brass studs suggests that it would have belonged to a powerful medium diviner, *komyenfwe*.

The carved door is a very widely occurring architectural feature in Africa. Where doors are intended to restrict access to secret paraphernalia they may be carved with esoteric designs ostensibly to ward off the uninitiated. The carved door illustrated opposite is from a Baule house. Its delightfully conceived design of two fish swimming freely in their watery domain may relate to a proverb, or it may represent the carver's own decorative idea. Doors divide inner, more private, spaces from the exterior public space: decoration on a door helps to enhance the symbolic qualities of the spaces between which it stands.

GONG STRIKER

Côte d'Ivoire, Baule
Wood, brass studs, cloth, h. 26.7 cm.
Formerly Helena Rubinstein collection
BMG 1007-219

DOOR

Côte d'Ivoire, Baule
Wood, h. 146 cm.
Formerly Josef Mueller collection (before 1939)
BMG 1007-3

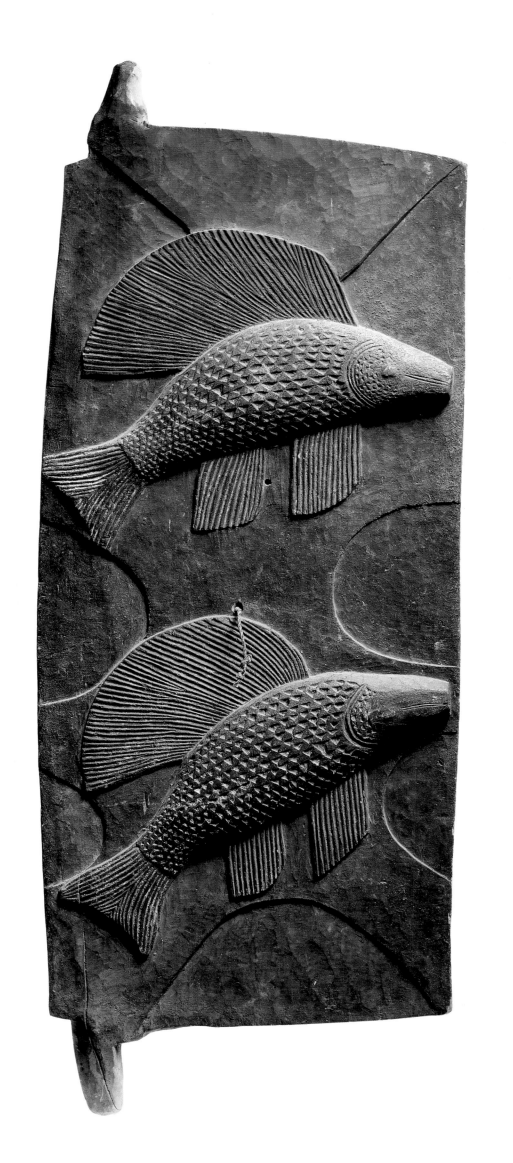

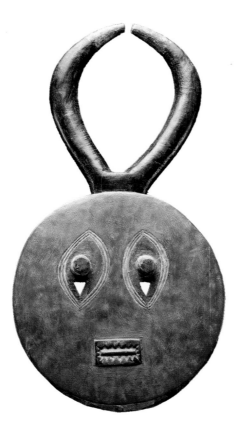

Baule masks are often hierarchically graded by type and come in pairs which display distinctive facial features. The mask illustrated above is an unusually fine example of the male *kplekple*, the most junior mask type that appears in the *goli* masquerade series. It is worn for the *won* dance, when it is the first to appear, performed by the least accomplished dancer because of its low status in the group. It is a humorous mask which is said to represent a disobedient child. As is the case with a number of masks in the *goli* series, the songs that accompany the *kplekple* are sung in the Wan language, which suggests that this particular masking tradition is a relatively recent introduction from the West.

Baule "small face masks" of various types were worn by youths in masquerades performed essentially for entertainment which go by different names including *Gbagba*, *Ambomon* and *Adjemble*. The masquerade began with a series of dancers wearing masks portraying domestic animals. These were followed by a series of performers wearing masks portraying animals that were hunted: the final series of maskers impersonated human characters. The masterfully rendered twin mask illustrated opposite represented a rare type of "small face mask" which belonged to the human characters series. Twins are an apt subject for a festive mask because twin births are greeted with joy among the Baule.

MASK, *KPLEKPLE BLA*

Côte d'Ivoire, Baule
Wood, h. 42 cm.
Formerly Charles Ratton collection
BMG 1007-21

MASK

Côte d'Ivoire, Baule
Wood, h. 29 cm.
Formerly Roger Bediat collection (circa 1935)
BMG 1007-65

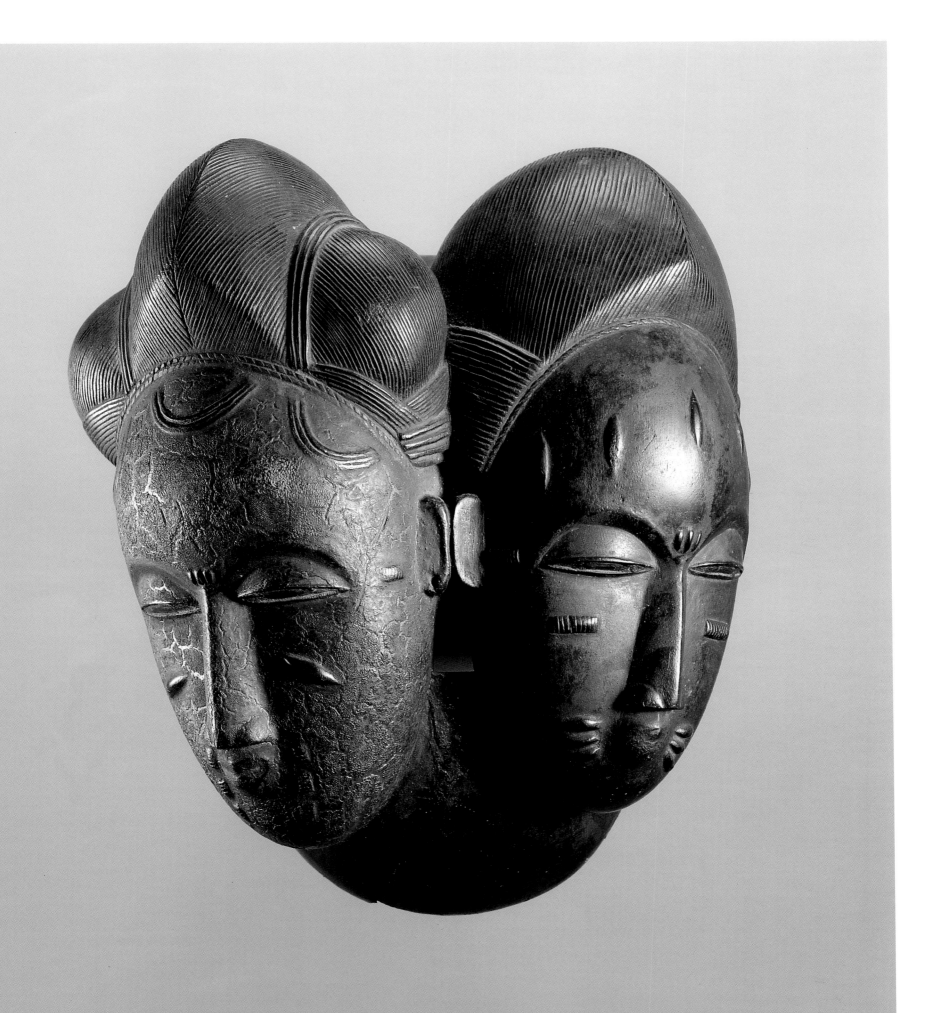

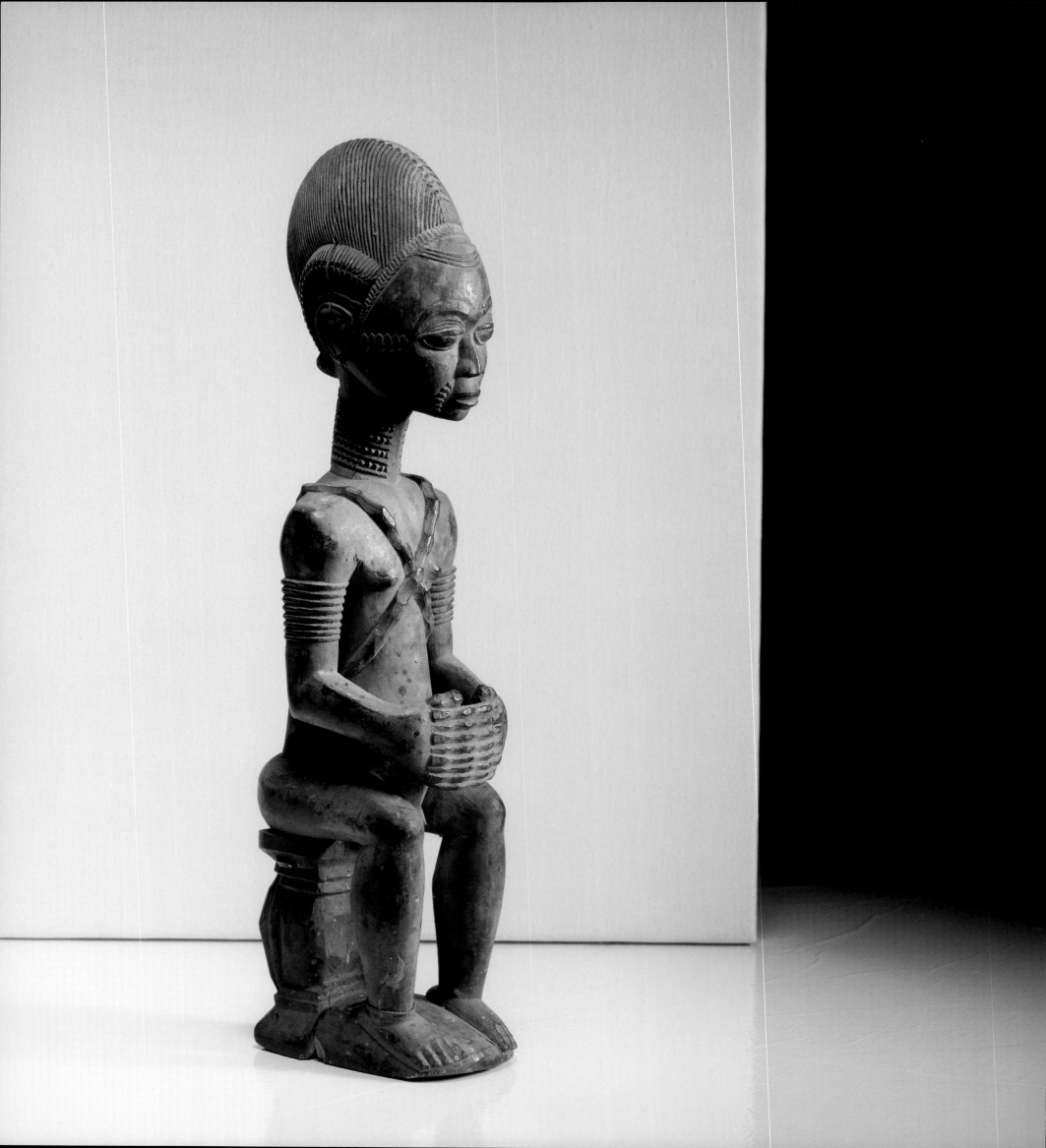

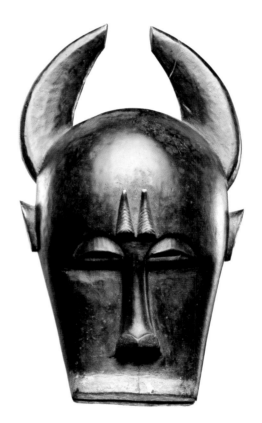

STATUE, *ASIE USU*

Côte d'Ivoire, Baule
Wood, h. 44 cm.
Formerly Josef Mueller collection (before 1939)
BMG 1007-105

MASK

Côte d'Ivoire, Baule
Wood, traces of kaolin, h. 38 cm.
Formerly Antony Moris and Josef Mueller collections (circa 1939)
BMG 1007-28

Among the Baule divination is performed by mediums called *komyen-fwe*. During their seances they become possessed by spirits through which they are able to foretell future happenings and to disclose the hidden causes of disease and misfortune. The finely carved female statuette, *asie usu*, illustrated opposite wears crossed strings of beads typical of those worn by mediums during their public seances and it probably relates to the idea of control of spirit powers. The *asie usu* figure serves as a kind of dwelling place for the possessing spirit and constitutes an important item of the medium's paraphernalia. The medium must always take care not to do anything to annoy the spirit and in this context it may be significant that the *asie usu* illustrated opposite appears to possess an attitude of supernatural composure.

The powerful Baule buffalo mask illustrated above is of a type which belongs to a class of "small face masks" which may portray a variety of animal and human characters including domestic animals, hunted animals, twins and foreigners. Youths wearing masks representing one or other type in the "small face mask" class come on one after another, each to perform a little drama along with other unmasked participants. The buffalo masker belongs to a series of animal-hunting dramas in which unmasked, costumed youths mime the hunting and eventual killing of the masked animal character.

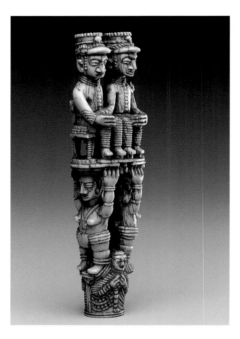

The Lagoons carvers of Côte d'Ivoire produced intricate carvings in both ivory and wood, some perhaps commissioned by Europeans, but mostly by chiefs. When Lagoons chiefs appear in public on ceremonial occasions they carry staffs, the finials of which are sometimes covered in gold leaf and whose imagery relates to their wealth and political power. The two men depicted on the finial above wear military uniforms, but they may be no more European than the women below them who wear traditional hip beads and loincloths. Monica Blackmun Visona has tentatively suggested that the finial may record an alliance between two Lagoons leaders, sustained by the support of their female relatives and ancestors.

The precise provenance of the figure opposite is unknown, but it is the work of a Lagoons artist. Similar figures are still used in various ways by the Akan-speaking Lagoons groups of Côte d'Ivoire—for instance in "spirit-lover" cults and that of the deceased twin. Widespread in Lagoon societies is the belief that when people are born into the world they leave behind a spirit counterpart, or "lover", in the otherworld. This counterpart may become jealous and cause his or her earthly part impotence, infertility or other misfortune. As part of the cult individuals lavish attention on beautiful images of their spirit counterparts. The figure opposite may have been used in this manner or by a medium diviner. In either case it would have been consecrated to serve as a dwelling place for a spirit. The spirit associated with the figure would be aroused by the diviner to communicate with the supernatural world and the figure's visual presence during seances would undoubtedly have helped to legitimate the diviner's special powers of communication. The figure's generous curves articulate dominant Lagoons conceptions of mature feminine beauty.

FINIAL

Côte d'Ivoire, Akye, Gwa or Abure
Ivory, h. 16.3 cm.
Formerly Antony Moris and Charles
Ratton collections (before 1939)
BMG 1008-3

FIGURE, *NKPASOPI*

Côte d'Ivoire, Akye, Abe, Gwa or Kyaman
Wood, brass, glass beads, h. 24.5 cm.
Formerly Josef Mueller collection (before
1939)
BMG 1007-12

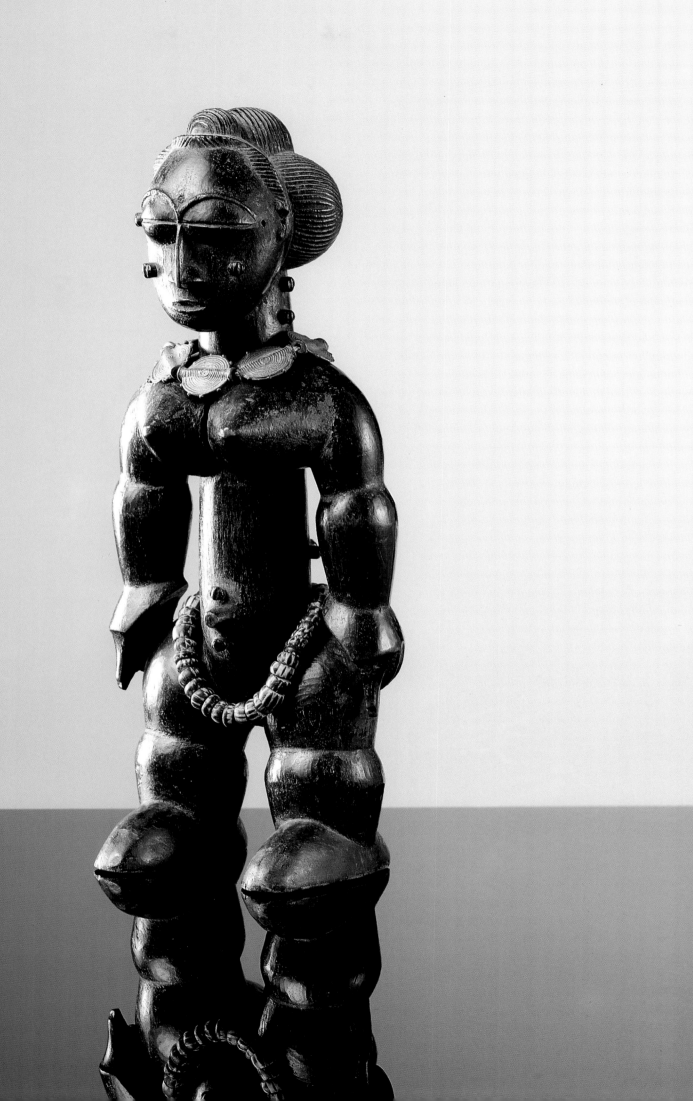

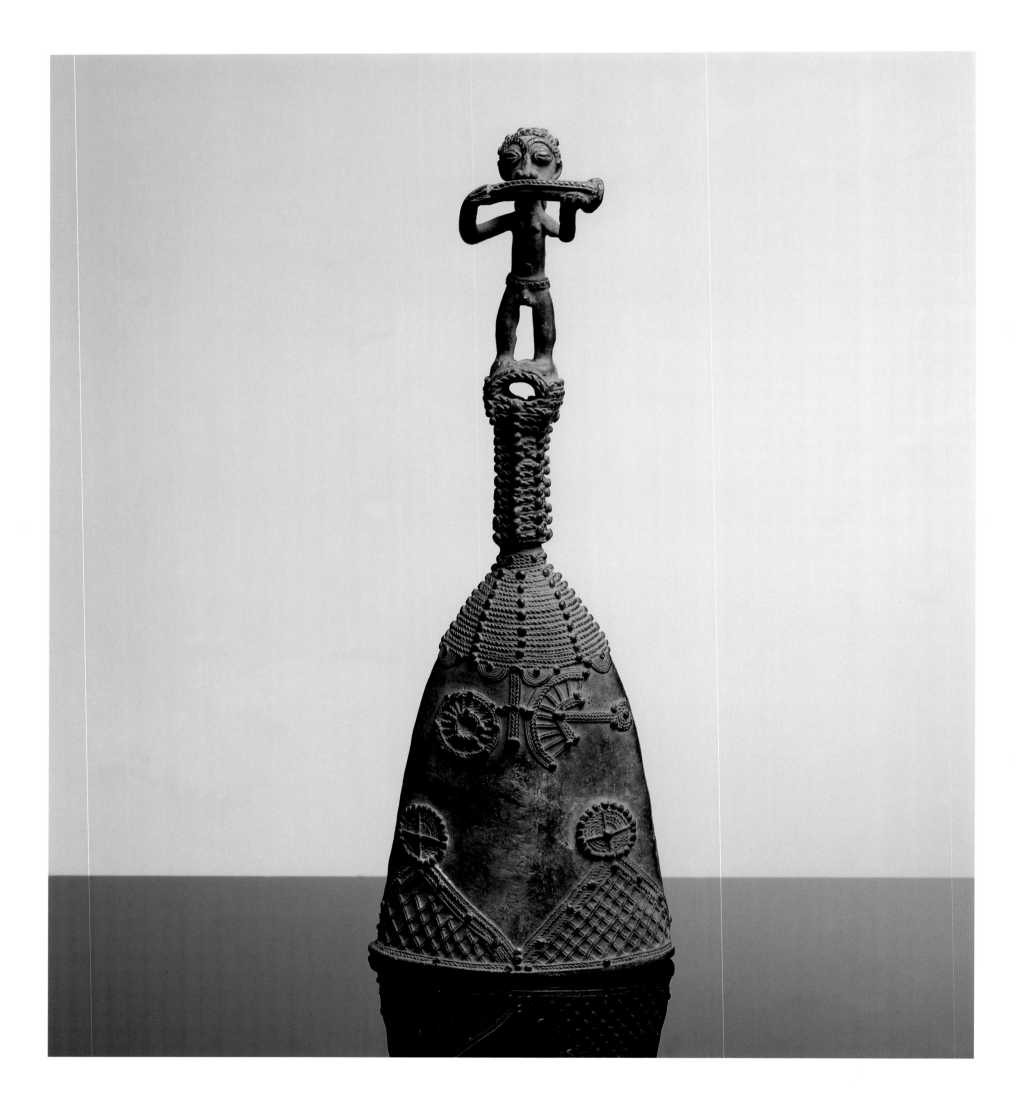

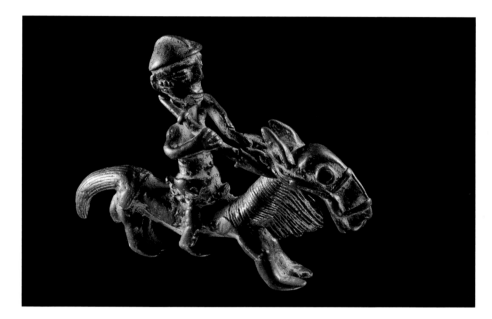

GONG

Côte d'Ivoire, Akye
Brass, h. 31.5 cm.
BMG 1007-181

GOLDWEIGHT, *NTANSA*

Ghana or Côte d'Ivoire, Akan
Brass, h. 10.7 cm.
BMG 1008-7

Lost-wax casting processes were highly developed among the Akan—both gold and brass were caste. The wax original for the royal gong shown opposite would have been modelled over a shaped clay core and the relief ornamentation achieved using lengths of wax rolled out into fine threads. The horn-blowing figure perched on the handle of the gong represents a theme often used for Akan goldweights—gongs and horns were popular no doubt because they were used at public festivals attended by a chief and his retinue. The gong opposite was collected in Alepé near the Comoé River(cf. André Blandin), and since it was published copies have appeared in the markets of Abidjan.

Akan oral traditions reveal that the kings of Bono, an early northern Akan kingdom, rode horses, *aponko*. Although horses imported from the north were known in more southerly Akan states, such as Asante and Akwamu, they were unable to sur-vive long in the more moist, southern regions because they lacked resistance to the parasites carried by the bush-loving tsetse fly. The horse was a powerful symbol of wealth and status, but a number of Akan goldweights depict horsemen without saddle or bridal, which suggests that the subject may have been rather exotic to the model-makers. The fact that the weight illustrated above represents a relatively realistic treatment of a horse and its trappings may indicate that the model-maker was from a northern region, where horsemen were a reasonably familiar sight. Among Akan groups the heaviest goldweight owned by chiefs was called *ntansa* which had a theoretical weight of 211 grams. The weight illustrated above weighs 210 grams, which makes it an accurate *ntansa* casting that may well have come from the treasury of a chief.

Around the beginning of the seventeenth century a distinctive terracotta art developed in the most southerly Akan states of the Gold Coast (Ghana). Heads and full figures have been found (rarely in the northerly Asante and Brong regions) made in a variety of styles and sizes, representing an illustrious deceased such as a chief, together with his attendants. It is possible that the original source of inspiration may have been the statues brought to the coast by early Portuguese missionaries. Some of the finest of these terracottas, such as that opposite, come from long-abandoned sites around the confluence of the Ofin and Pra rivers, where the old forest kingdoms of Wassa and Twifo became wealthy by trading gold to the coast. The sculptures are usually found broken, and all too often only the head is collected. These memorial figurines served in a variety of contexts: placed around the grave of a chief, carried in procession at festivals, or removed to

a remote and sacred place in the bush to be fed and given libations during memorial ceremonies.

This unique and splendid bronze is a *tour de force* of lost wax casting. It represents a wicker cage (probably for poultry), on which a cockerel and hen are perched, with a chameleon at the side. Although initially alleged to have come from Komaland in northern Ghana, there is not the slightest evidence of this. The Komaland region has numerous burial mounds some centuries old—unfortunately extensively plundered—which have yielded many terracotta figurines, but no documented proof of cast bronze, and the fine condition and patination of this piece makes it unlikely to be an excavated piece. The style of the threadwork decoration and animals strongly suggests a provenance in south-west Burkina Faso—perhaps in the territory bounded by the towns of Bobo-Dioulasso, Diebougou, Gaoua and Banfora.

HEAD

Ghana, Southern Akan
Terracotta, h. 24 cm.
BMG 1009-6

CAGE

Burkina Faso (?)
Brass, h. 27 cm.
BMG 1009-130

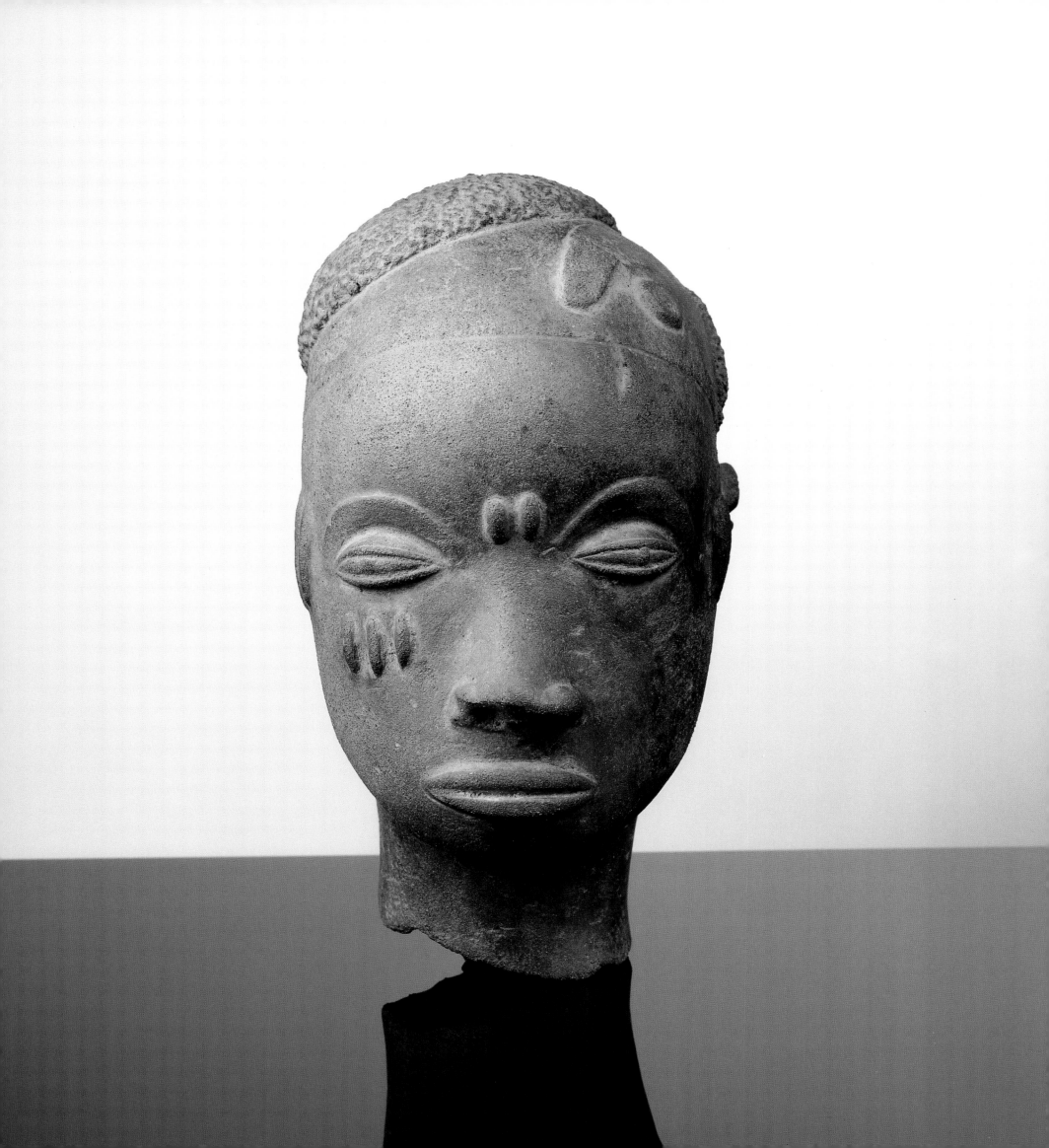

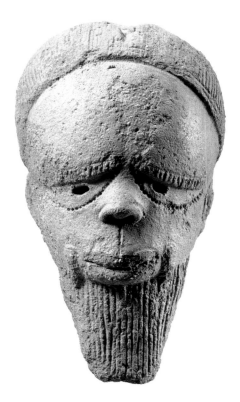

The terracotta fragments discovered in alluvial deposits during tin mining operations to the west of the Jos Plateau in Northern Nigeria revealed the existence of a group of craftsmen working at a date much earlier than had been hitherto suspected. Thermoluminescence tests have procured dates between 500 BC—AD 500. The modelling of the heads (the remainder of the figure has usually been fragmented by river action) shows a remarkable delicacy and sensitivity, with typically triangular-shaped eyes, pierced pupils and nostrils, full lips and broad noses being the chief characteristics they share.

A small group of terracotta sculptures were found which were reported to come from Sokoto State. Thermoluminescence dates from four of them indicate that they are contemporary with Nok sculptures to the south-east of Sokoto. Although they appear to share the same stylistic tradition as Nok, they have some elements that set them apart. The hair of the head above is dressed as six knobs at the top and nine elements over the nape of the neck: there are the remains of a Nok-style moustache. Typical of Sokoto style are the eyes, the lower edges of which are indicated by a row of impressed dots, and the heavy brows which, overhanging the eyes, give the face a rather sombre expression, a frown which belies the mouth, which with its upturned corners, might otherwise be construed as a smile. The head has been approximately dated to 620 BC—AD 120.

HEAD

Nigeria, Nok
Terracotta, h. 30 cm.
(Monique Barbier-Mueller collection)

BMG 1015-103

HEAD

Nigeria, Sokoto
Terracotta, h. 22 cm.
BMG 1015-93

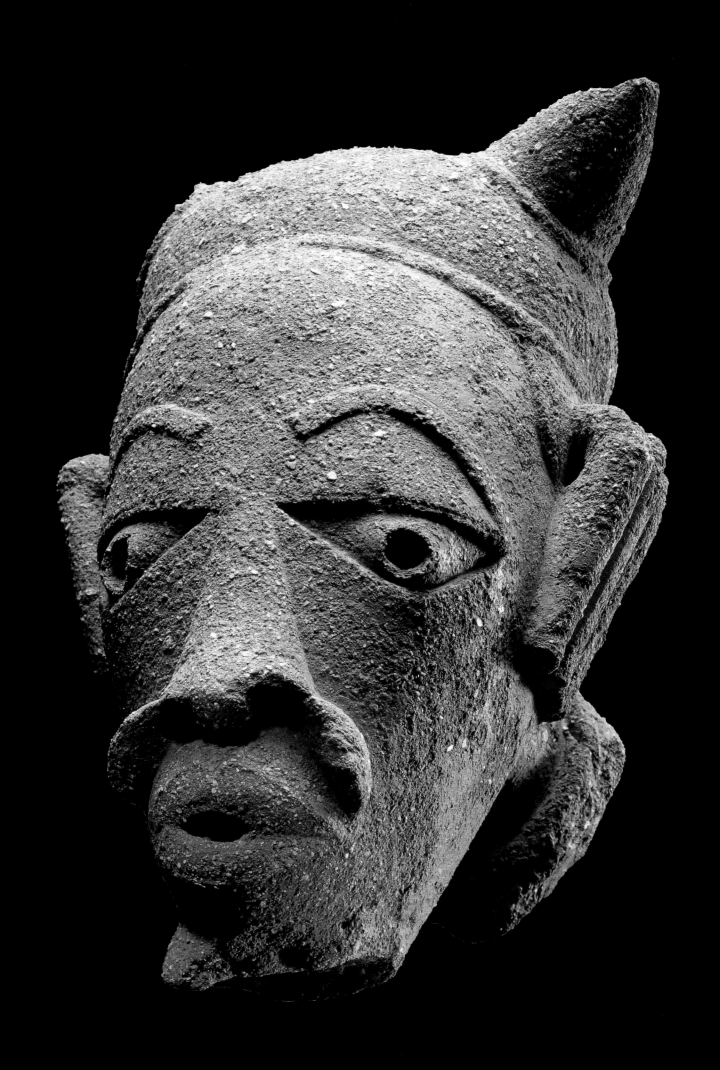

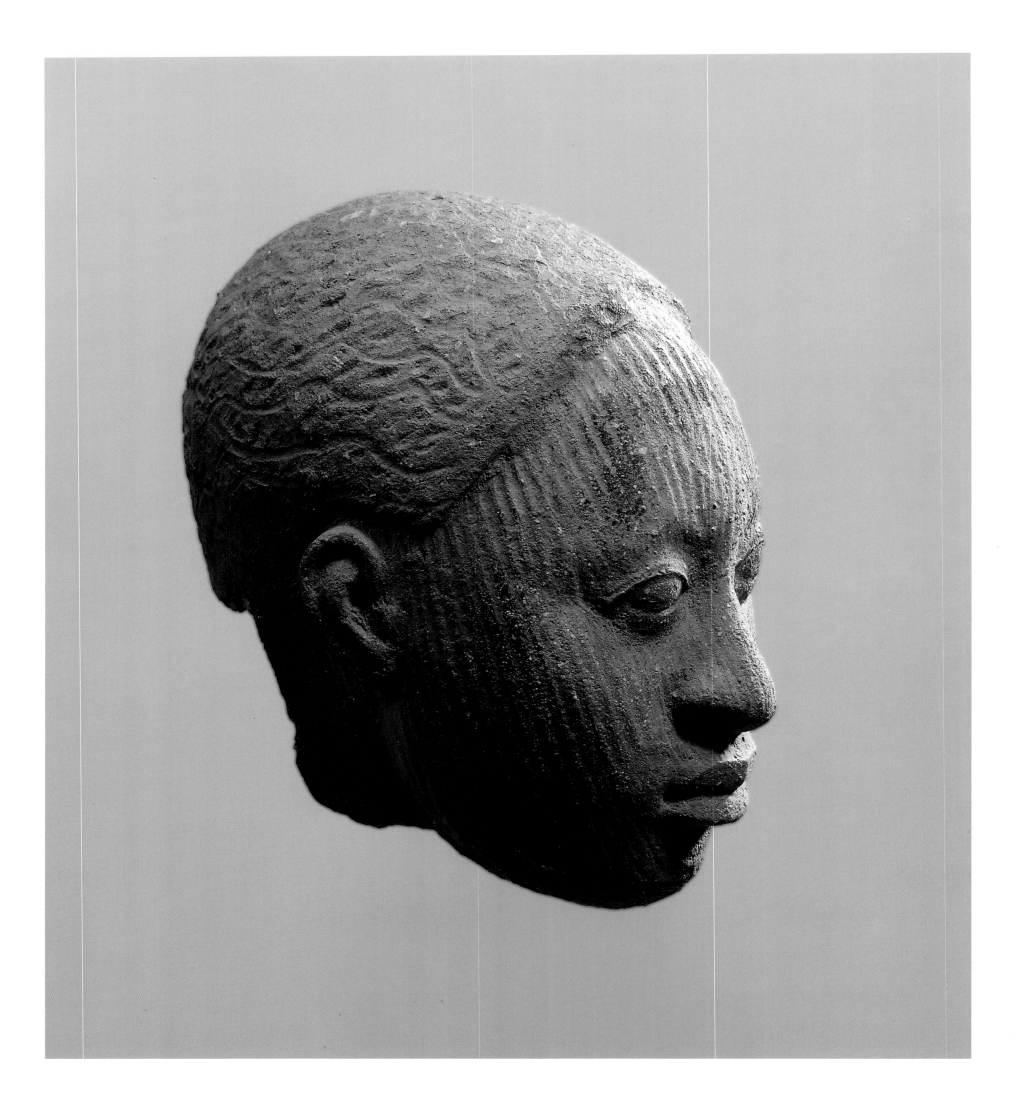

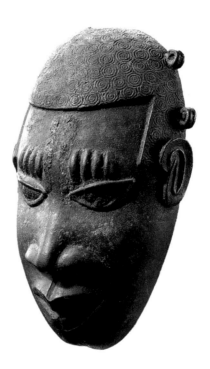

HEAD

Nigeria, Yoruba, Ife
Terracotta, h. 17 cm.
Formerly Roger Bediat collection (before
1935)
BMG 1011-119

PECTORAL MASK

Nigeria, Yoruba
Bronze, h. 17.9 cm.
Formerly Count Baudouin de Grunne
collection
BMG 1011-104

The city state of Ile Ife is considered by the Yoruba to be their spiritual and cultural metropolis. The ruler of Ife is considered as a divine king, and many other powerful city states, such as Oyo and Owo, have traditions that their founders derived from Ife. The present dynasty of Benin City also derives from Ife and the heads of Obas (kings) were sent to Ife for burial until 1880. The artistic influence of Ife amongst the Yoruba is undeniable and underestimated. Brass casting there may have originated as early as the tenth century, but reached its apogee from twelfth century until the sixteenth, when casting came to an abrupt end.

The head on the opposite page has been broken from a full-length figure similar to many found in the forest groves in Ife, where they were the focus of cults associated with divinities who seem, like those of ancient Greece, to have been at one time human beings. The striations on the face probably show scarifications.

The military influence of the powerful city state of Benin was greatest during the sixteenth century, when other states paid allegiance to the Oba (king) from beyond the frontier of Dahomey (now called Benin) in the west to across the Niger river. All brass casting was in the service of the Oba, making Benin art a royal one.

Pectoral masks in the form of a human face very similar to the one above have been found this century in neighboring treasuries, which indicate they could well have been gifts to influential chiefs from the Oba of Benin to reaffirm their allegiance to him. The sensitivity of the modelling and thin casting would indicate a sixteenth century date.

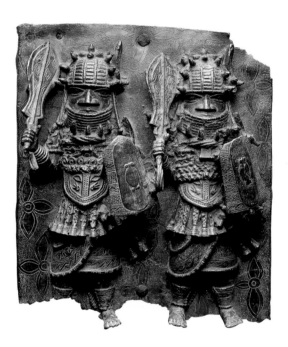

When reports of visits to Benin city were recorded by the Dutchman Olfert Dapper during the middle of the seventeenth century, stated that the pillars of the palace of the Oba were covered by hundreds of rectangular bronze plaques. They depicted the Oba and his court at ceremonies and at princely pursuits—later they were used as a valuable reference for points of etiquette and dress by subsequent generations, as confirmed to William Fagg and R.E. Bradbury by Chief Osuma in 1959, who remembered being sent on such errands as a page at the Court of Oba Ovonramwen. The plaque above shows two warrior chiefs in battle dress. Their dance swords, *eben*, indicate that they are at court because, as a gesture of respect to the *oba*, when they dance the *eben* is held aloft, spun rapidly and touched to the ground. The leopard teeth necklaces and feline faces embroidered on the surcoats are references to power. The background has engraved stylised

river leaves, *ebe ame*, references to Olokun, god of the sea, with his associations to overseas trade and the resulting increase of wealth in Benin after the arrival of the Portuguese.

The bronze castings which were placed on the altars to honour previous Obas (kings) in the palace at Benin City included heads, because, as the seat of man's spiritual powers, heads were considered of great importance in Benin rituals. The head on the opposite page is a very thin casting, only 1mm. thick in places, which must have been cast between 1480 and 1550, perhaps by the Oba Esigie, for the altars of his father Ozolua, or by his son, Orhogbua, for him—Esigie was himself a renowned brass caster. The heads for the altars increased in size and weight during the seventeenth century and thereafter, with the increased import of brass from Europe, and the form became stylised as the power of the court atrophied.

PLAQUE

Nigeria, Benin City
Bronze, h. 40 cm.
Formerly Louis Carré, Ernest Ascher and Josef Mueller collections (before 1939)
BMG 1011-101

HEAD

Nigeria, Benin City
Bronze, h. 21 cm.
Formerly Peter Schnell collection, Zurich
BMG 1011-121

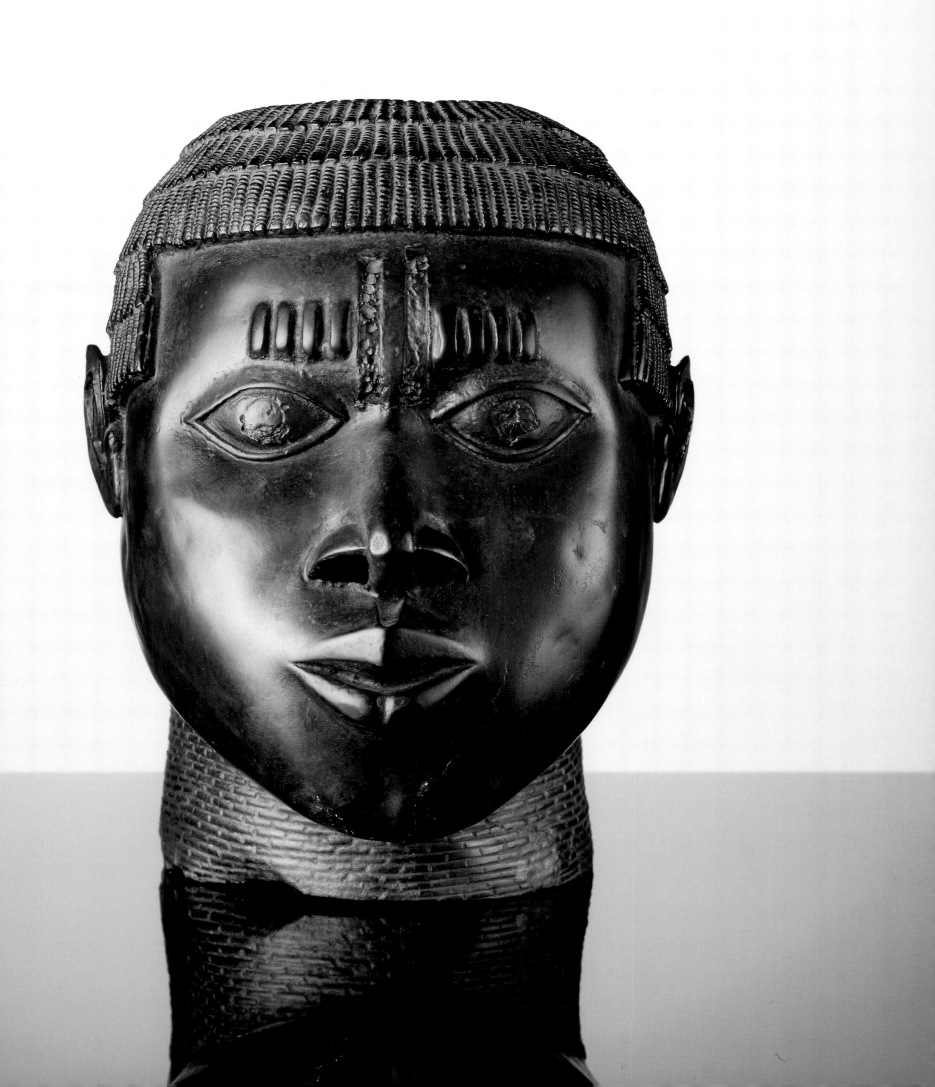

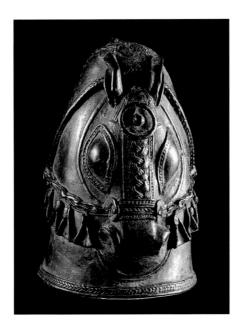

The complexities of the allegiances to Benin City are reflected once more in the portrayal of a horse's head in the form of a bell. Horses do not long survive the ravages of the tsetse fly in tropical rain forest, but were used to great effect by the savannah people to the north, as the fastest means of transport and as a means of subjugating their southerly neighbours. The *Alafin* of Old Oyo was justly proud of his detachment of cavalry.

The fine detail of the head and its trappings are intricately modelled and brilliantly achieved, but where this *tour de force* was cast is a matter for speculation.

Between twenty and thirty bronze rings exist, decorated with gruesome scenes of severed heads, the purpose for which no one has been able to explain satisfactorily. On the ring opposite two decapitated human sacrificial victims lie prone: the heads are gagged to prevent them cursing their executioner, for such a curse would prove fatal. There is a figure of a Yoruba king in a conical crown, and what appear to be staffs for the Oshugbo (Ogboni) cult beside one head. The presence of the staffs would support the generally accepted view that Ijebu is the likely place of origin for the group of rings of which this forms part, which are smaller and thicker than the others. Susan Vogel deduced that they might have been made to record the installation of Yoruba kings and been sent to Ife to demonstrate their allegiance, but Nevadomsky has suggested that some were made for ancestral altars, perhaps for those to honour Oba Ehengbuda of Benin, who was renowned for his command of herbal medicine and occult forces. Fagg also suggested they might have found a place on the altars as a base for a severed trophy head. A hinged example might even have been worn by the slave of a king, because the wearing of metal is a symbol of subjugation.

BELL

Nigeria, Yoruba
Bronze, h. 13.4 cm.
BMG 1011-120

RING

Nigeria, Yoruba, perhaps Ijebu
Bronze, d. 19 cm.
BMG 1011-106

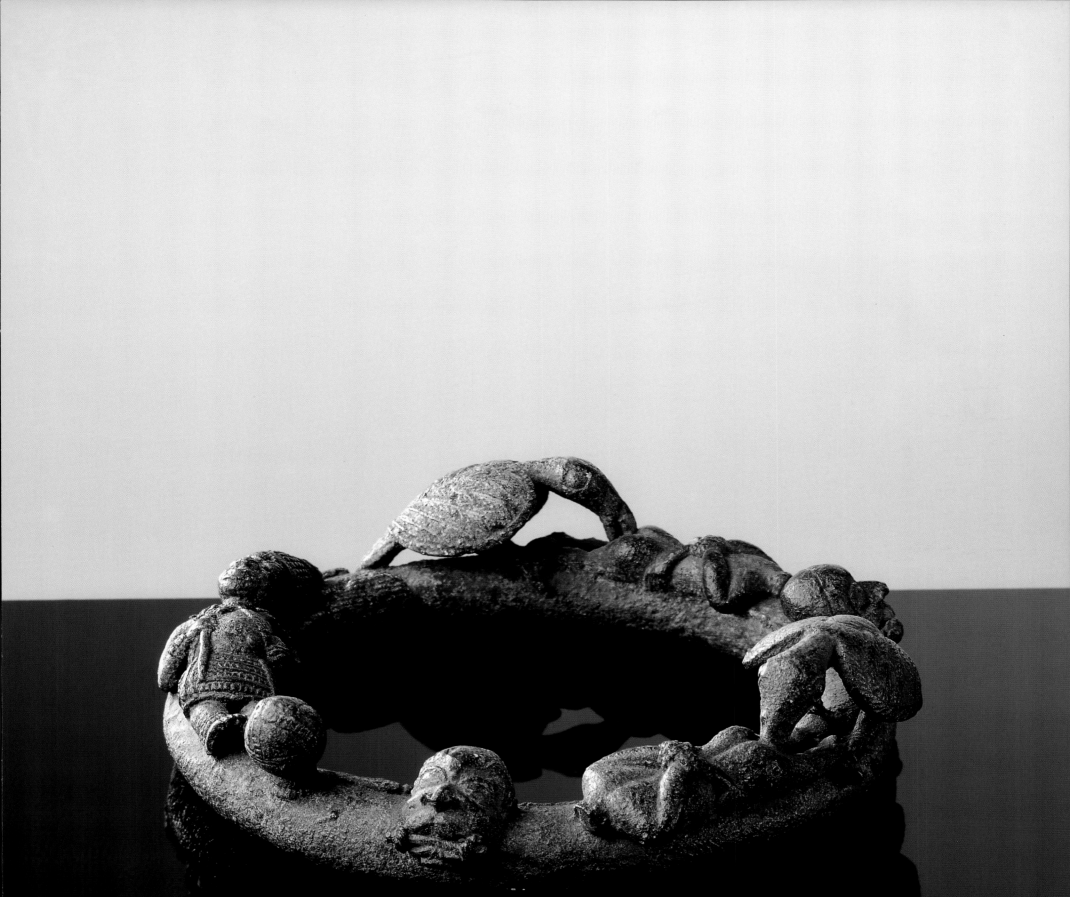

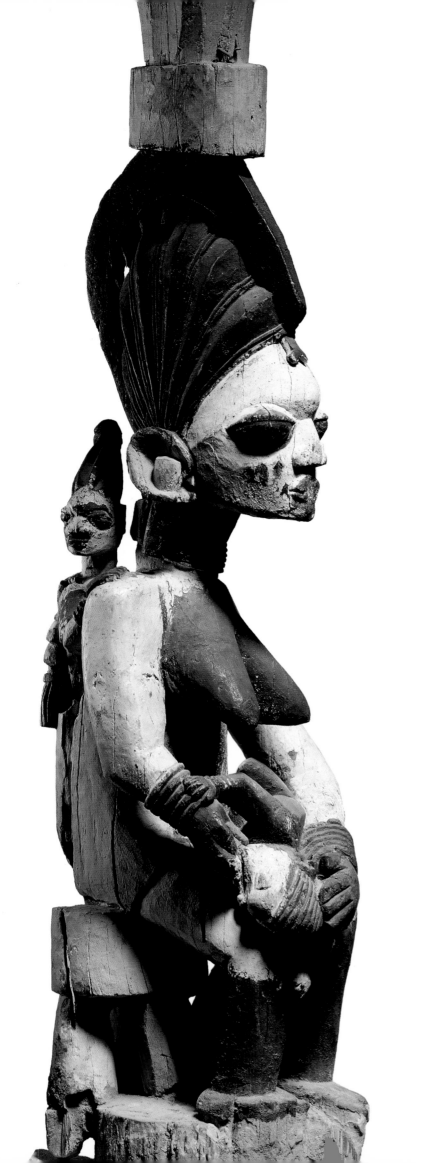

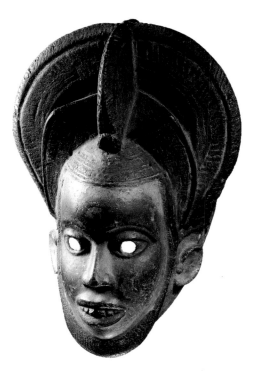

VERANDA POST

Nigeria, Yoruba, Osi-Ilorin
Wood, paint, h. 142 cm.
BMG 1011-2A

MASK

Nigeria, Igbo (?)
Wood, h. 36.2 cm.
BMG 1011-75

The verandas to courtyards of Yoruba houses have wide slanting roofs which are supported at intervals by wooden posts. In the houses of the rulers, the priests and the prosperous, they are usually carved, especially in north-eastern Yorubaland, where sculpture tends towards the monumental. The post to the left was commissioned by Atobatele of Iporo, a northern Ekiti village between Ishan and Otun, from the sculptor Oshamuko of Osi-Ilorin, sometime between 1920, when Atobatele became headman, and his death in 1928. Oshamuko died in about 1945.

Oshamuko had been apprenticed to the master-carver Areogun, whose work his closely resembles (he in turn taught Areogun's son Bandele), but one way to differentiate their styles in maternity figures is that Oshamuko places the child's head lower than its buttocks.

African artists are dependent on their public in much the same way as those in the Western world—if their clients are not pleased, commissions decline. So they tend to work within generally accepted artistic canons. But occasionally a talented sculptor introduces his own idiosyncratic style which finds favour and he receives commissions from beyond his usual area of influence. Gabriel Akpabio was an itinerant Igbo artist who undertook commissions for a number of clients in towns of south-eastern Nigeria. Keith Nicklin and Jill Salmons who attribute the mask above to him, came across his work in the Ogoja area, north-west of the Cross River, and surmised it was probably by the same carver who was also known as Gabriel Nwokafor Obianyo of Uke, who died in 1985, but who did not work in the Cross River area after the Biafran war.

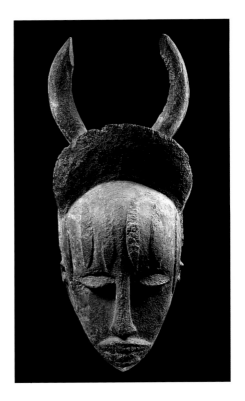

The Urhobo, who live to the south of Benin City, carve wooden masks to be danced at festivities to placate the water- and land-based spirits which are inherent in all nature. The mask above, typical of those found in southern Urhobo villages, is carved with the crescent diadem and horns of the hair style worn by eligible young women when they are presented to the village, which might also explain the demure expression. The mask would have been danced with that of Ohworu, a powerful water spirit adopted from the Western Ijaw.

A monumental sculpture, larger than life, the powerful image opposite depicts Emetejevwe, niece of Owedjebo, who founded the town of Erherhe on the Warri River. As a wife of the *onotu*, the leader of the warrior age-grade, she was associated with the military struggle preceding the establishment of a new town, but as a nursing mother she mirrors the hopes of future generations and the destiny of the town. It was probably carved about 1875. The posture she assumes is a classic Urhobo dance pose, with arched back, bent knees and elbows drawn: the carved bracelets and anklets represent the ivory ornaments worn by the aristocracy and emphasise her royal demeanour, just as the beaded bands at her chest and knees associate her with prominent titled elders. Her hair is dressed in a style called *ighueton*, worn by women who have recently given birth. The white kaolin, *orhe*, of which the carving was previously covered, is a sign of purity and spirituality, elevating the statue to the realm of the sacred ancestors.

MASK

Nigeria, Urhobo
Wood, h. 46 cm.
BMG1012-2

FIGURE

Nigeria, Urhobo
Wood, chalk, h. 142 cm.
Formerly Philippe Guimiot collection, Brussels
BMG1012-8

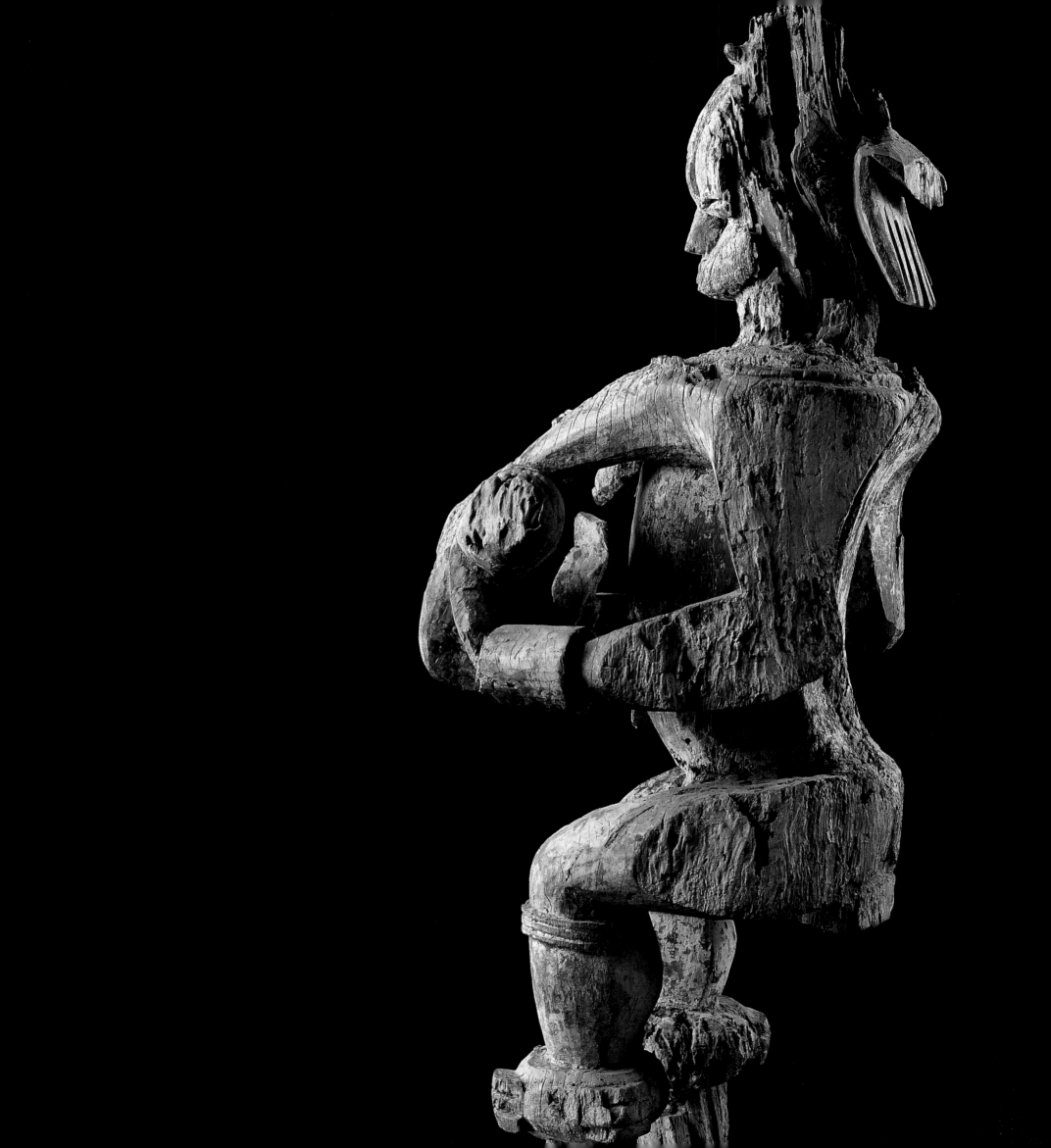

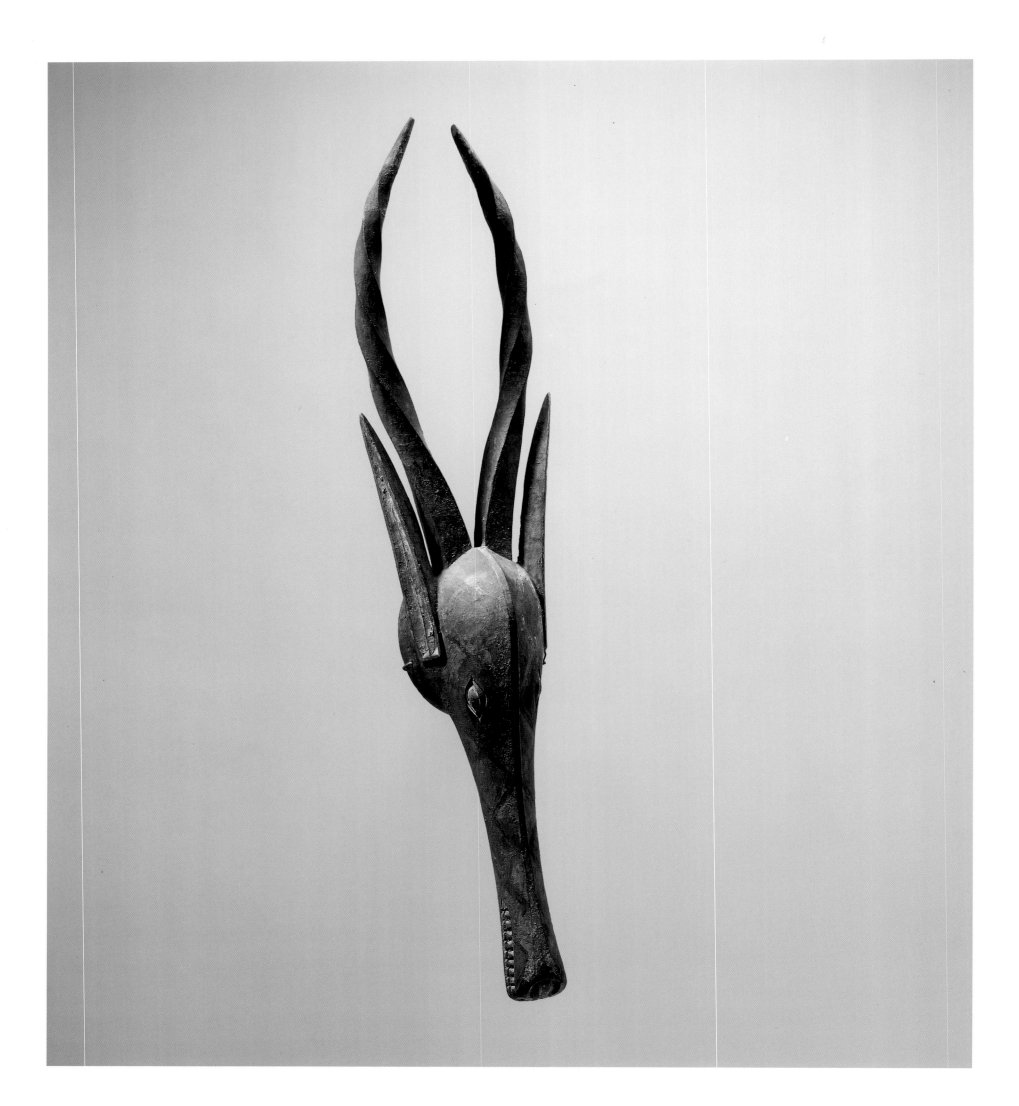

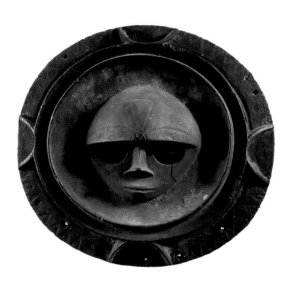

HEADDRESS

Nigeria, Central or Western Ijo
Wood, l. 67.8 cm.
BMG 1012-35

MASK

Nigeria, Eket
Wood, d. 28 cm.
Formerly Jacques Blankaert collection,
Brussels
BMG 1014-66

When asked about the features of headdresses such as the one illustrated opposite, Ijo informants usually respond that they replicate the appearance of particular water spirits encountered in visions or dreams. They explain that such spirits can assume a variety of shapes: some resemble people, some appear in the form of animals—especially fish—and some combine aspects of both. Unlike bush monster masks, which often serve as public demonstrations of a secret society's ability to confront, harness or control potent powers, most of the "acquatic monsters" represented by masks are considered relatively harmless—like people, the spirits enjoy playing with their friends. Such play includes pursuing spectators, some of whom provoke the masks to attack them because they consider the chase as part of the fun. The mask opposite combines elements from the aquatic world—fish, crocodile and snake—with human and even land animals (the horn or tusk is an unusual feature). The reddish color may be significant—camwood is believed to contain medicinal properties and can signify spiritual potency.

Jill Salmons has suggested that the circular shape of the dish-like mask above may contain references to the full moon, and the four lunate forms about the border to new moons. P. Amaury Talbot in the 1923 recorded the importance of the lunar symbolism amongst the Eket, an Ibibio-speaking people. Mother Earth, *Eka Abbassi*, is identified with the moon "whence she sent fertility to the children of men by means of a great white bird, which, on reaching the earth, laid a gleaming egg".

When Salmons was shown a small round face mask on a circular board in the area where the Eket march with the Oron, in 1974, she was told it was called *Enyi Ima* (the face of love), and that it was used in a masquerade of the *Ekong* society. She later found that such masks were also used in the *Abubon* play, especially in the port of Eket.

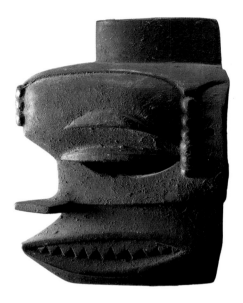

The mask above is unusual from several points of view. The small size might mean that it was worn by a child, but, more probably, it formed part of a larger ensemble. The keloid scarifications carved at the temples and at the center of the forehead are typical of those found in the whole Ibibio-speaking area, but the wedge shape is not. The long, slender, pointed nose suggests an Ogoni influence, but the deciding factor would seem to be the narrow horizontal raised band that is carved from the base of the nose to below the ear. This feature is found on other sculptures from the Eket area. P. Amaury Talbot illustrates a figure used by the *Ekkpo Njawhaw* (or *Ekpo Onyogho*) Society, with this narrow ridge across the face.

The Annang are regarded as the most artistically prolific of the Ibibio-speaking peoples in the Cross River area. Keith Nicklin and Jill Salmons have not only attributed the mask opposite to the Chukwu school of sculptors in Utu Etim Ekpo, near Abak, but have suggested that it might be from the hand of Akpan Chukwu himself. The crisply delineated borders of the eyes and lips are typical of his work, as well as the treatment of the volumes of the nose and chin. Chukwu died in the early 1950s, but the present mask is carved in a style he favoured in the 1920s and 1930s.

The mask could have been danced either as *mfon* (the maiden or fair spirit) in *Ekpo*, the men's ancestor cult, or in a more secular play: without the remainder of the costume and context we can only speculate on the role it might have taken.

MASK

Nigeria, Eket
Wood, h. 15.9 cm.
BMG 1014-94

MASK

Nigeria, Annang-Ibibio
Wood, h. 23 cm.
BMG 1013-2

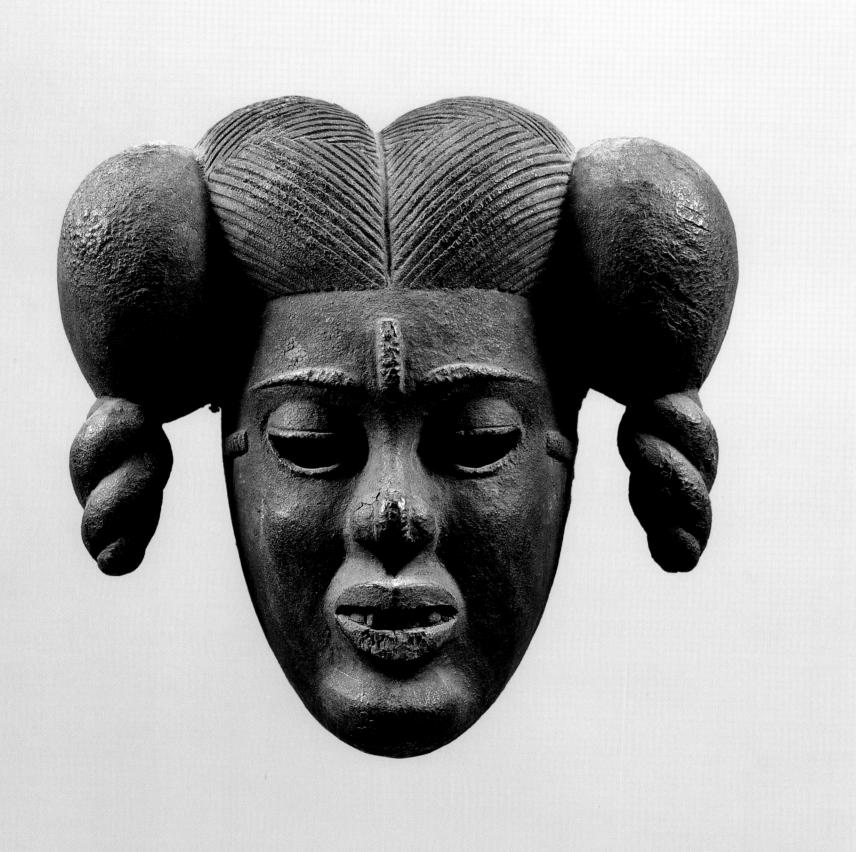

The Leopard Spirit Cult (called *Ngbe* by the Ejagham) is a non kin-based association who meet to discuss warfare, hunting, the moral instruction of the young and social control. They also meet for feasting and merrymaking. There are various grades, or sub-associations, in the *Ngbe* into which the men of the village buy themselves, and shown here is an emblem of a grade, which would have been placed on the wall or pillar of the lodge which leads to an inner sanctum where the sacred paraphernalia is stored.

On the woven cane base of the emblem on the opposite page there are attached the skulls of various animals eaten by lodge members during a feast, and therefore potent "medicine". The feast was probably given to establish a particular grade in a lodge, or in respect of the initiation of new members into a grade. The two brooms are seen as instruments used to sweep away hostile magical substances. The two drums resemble those used in *Ngbe* masquerades and song cycles, and are also used to accompany announcements made by the *Ngbe* town crier, thus symbolic of the important legislative powers of the association.

CLAN EMBLEM

Nigeria, Ejagham
Wood, skulls, vegetable matter, h. 110 cm.
BMG 1015-72

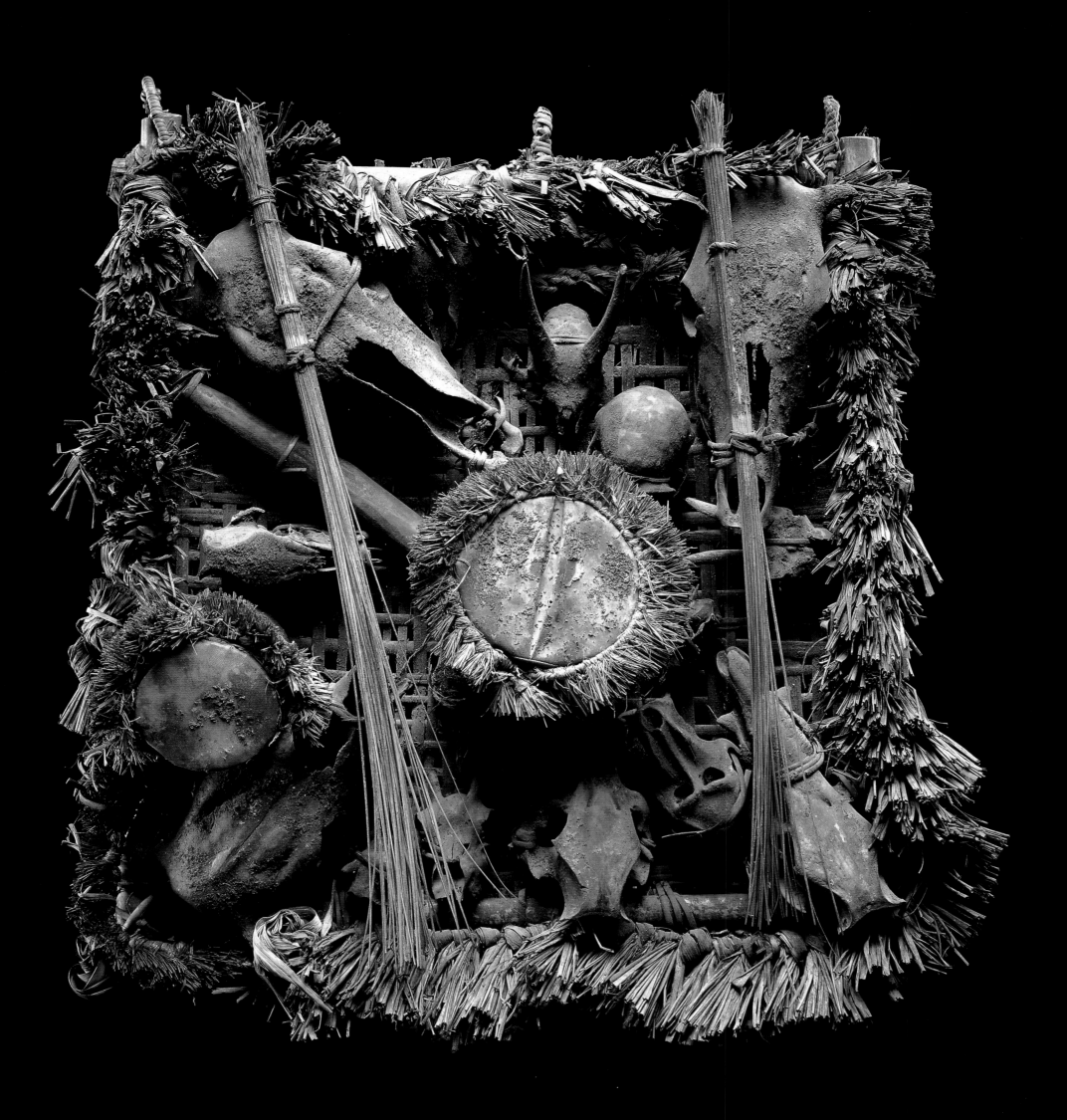

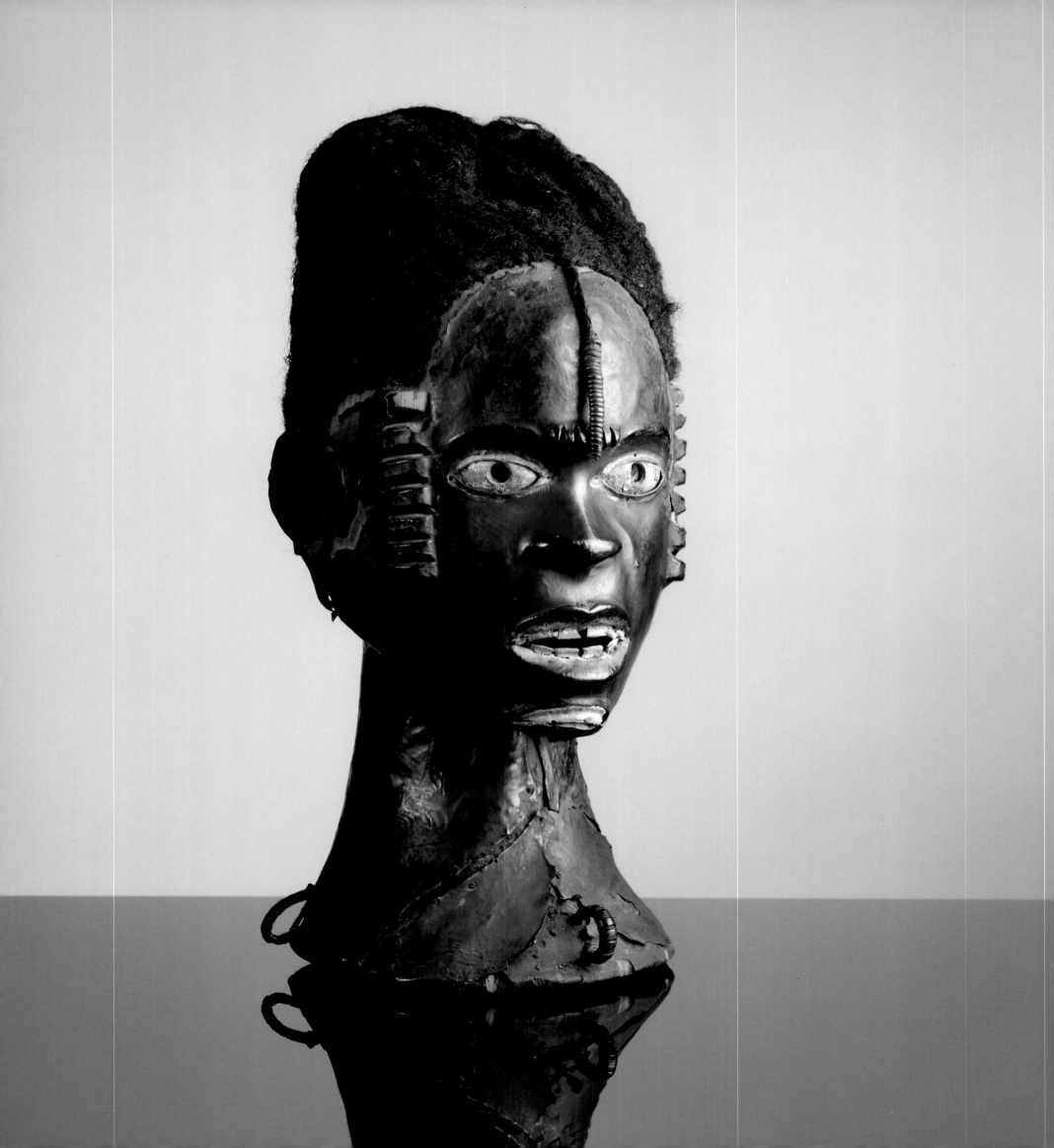

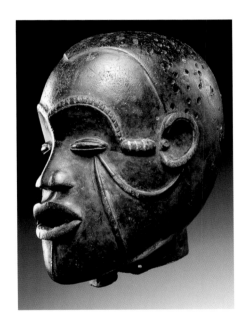

HEADDRESS

Nigeria, Ejagham
Wood, skin, hair, copper, h. 33.5 cm.
BMG 1015-50

HEADDRESS

Nigeria, probably Boki
Wood, h. 20.5 cm.
BMG 1015-54

The groups who used skin-covered helmet masks and dance crests in the Cross River region were said to use human skin during the days when they practised head-hunting, but later antelope skin replaced the human variety (it is apparently difficult to tell them apart). In fact often human skulls were used as a base for a headdress, and the Museum's collections contain two such crests. Ekpo Eyo has suggested that the crest opposite probably represents a marriageable girl, ideal both in terms of beauty and gentility. The realism is exceptional, even to the insertion on the head of neatly braided human hair. The notches at forehead and temples represent keloid scarification, the notch on the chin further scarification, and the painted decoration on the cheeks probably indicates *nsibidi*-like tattoos. Eyo has also proposed that the crest was used in an Ejagham women's society, worn by she whose role it was to oversee the education of girls when they attained puberty, in preparation for marriage.

Another mask from the Cross River region, the finely carved headdress above, is probably from the Boki (or Bokyi), a group who have the Leopard Spirit Cult. The concave eye sockets, notched brows and curved scarification marks across the cheeks from the lower lid are found in a double-headed headdress from that region (indeed a hole at the back of the head of this crest led some people to speculate that it might be half a double headed headdress, but this is unlikely). The holes with which the cranium is pierced are to receive inset human hair, or perhaps even porcupine quills and feathers. The inset teeth are missing from the mouth which has finely-sculpted lips.

The spirit to which the Leopard Society ministered was not thought of as an actual leopard, but its character was described in leopard symbolism—fierce, aggressive and unpredictable.

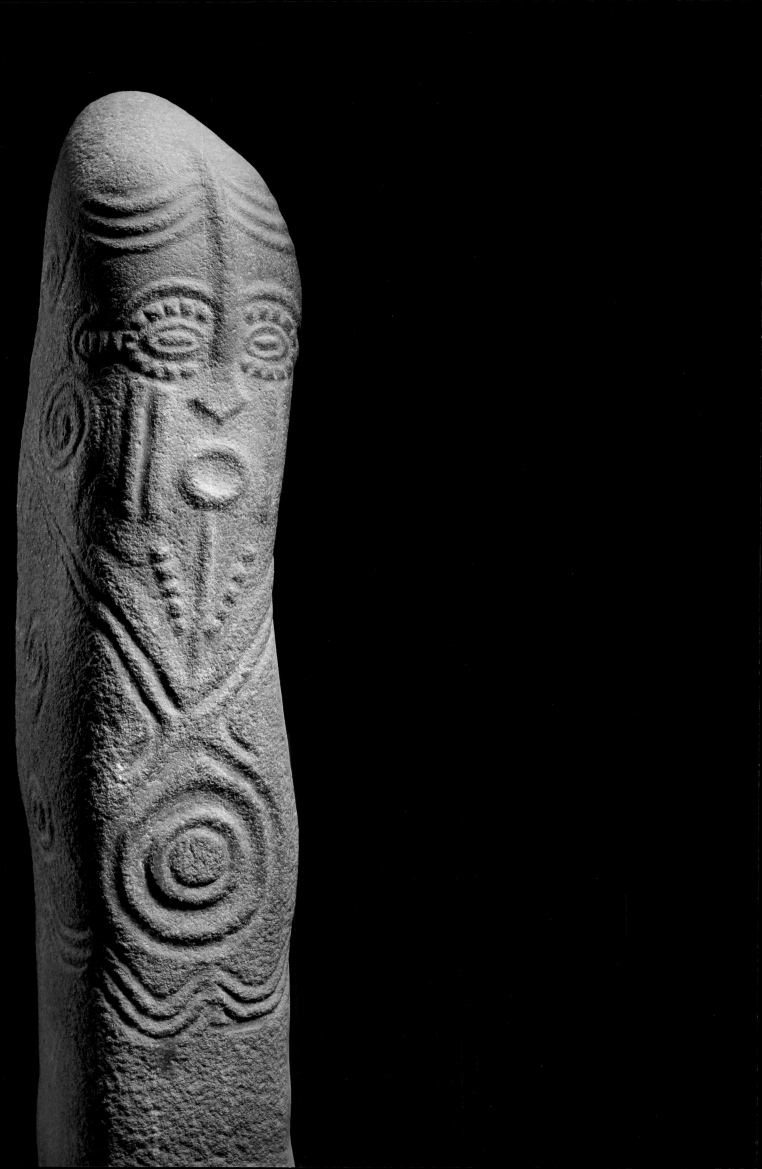

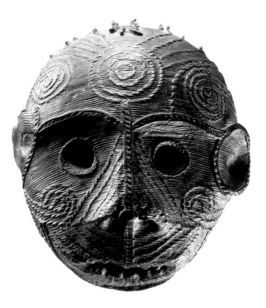

MONOLITH, *ATAL*

Nigeria, Abanyom, from Nkarasi
Stone, h. 114 cm.
BMG 1015-9

HEAD

Nigeria, Cross River
Brass, h. 16.7 cm.
BMG 1015-68

The carved stone monoliths from the Middle Cross River area are unique in Africa. Previously called *akwanshi* and believed to be memorials to sacred ancestors, recent research by Ekpo Eyo has revealed that they represent historical legendary figures, and a more appropriate appellation for them is *atal*. (*Akwanshi* are smaller uncarved stones which represent dead members of the clan.)

Numbering over three hundred, *atal* vary in height from three to six feet, and are found in abandoned and present-day villages of the Bakor Clan (the Bakor language is a variant of Ejagham). Generally carved from water-worn boulders, often phallic in form, many show anthropomorphic features, as in the case of the stone opposite, where the three grooves below the hairline probably represent a stocking cap worn by the chiefs of the Ejagham and other south-eastern Nigerian groups. Because the *atal* do not represent lineage heads or known people, dates are impossible to calculate, and the only archaeological date

yielded so far is AD 200, at Alok (Nnam sub-clan).

The decorative elements in the small brass castings found in the Cross River area and in the Upper Benue River valley are very similar, which may reflect the migration of such people as the Tiv from the former to the latter. Keith Nicklin has noted that the concentric circle on the forehead of the head above reflects body decoration in the Cross River area, and recorded a brass head seen by him in the shrine of the tutelary deity *Ojokobi*, in a Yakur settlement near Obubra. The guardianship of this shrine entitled the holder, *Obol Lopon*, to rule over the local community. He thinks the head was cast in the seventeenth or eighteenth century, a date that has been corroborated by a thermoluminesence test on a core sample taken from just inside the head.

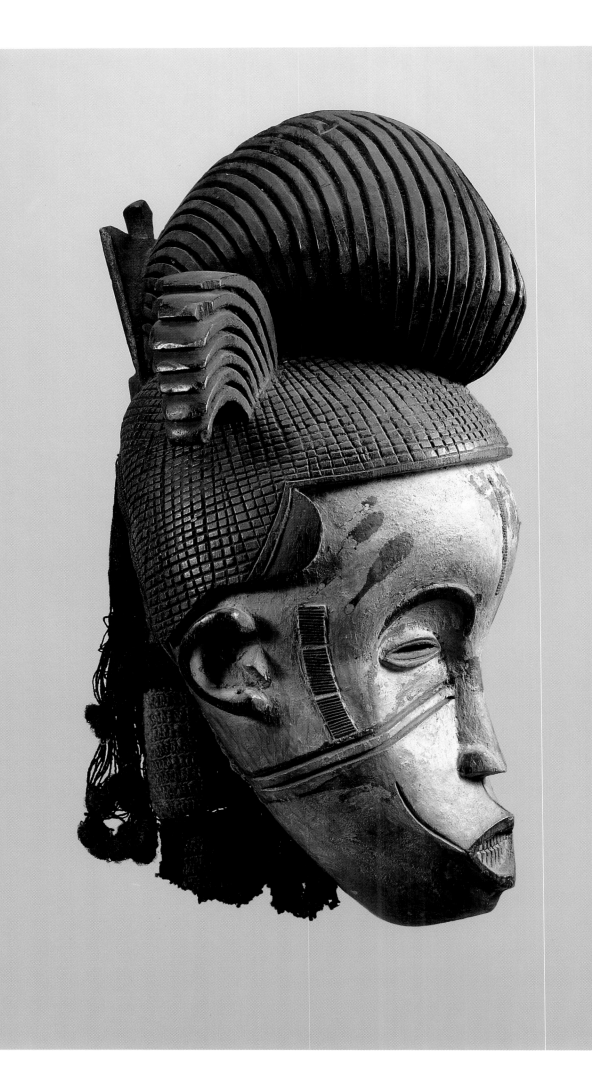

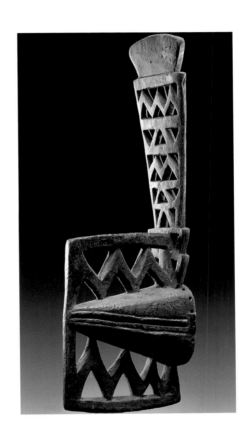

MASK

Nigeria, Igbo, probably Izza sub-group
Wood, h. 45.5 cm.
BMG 1014-65

MASK

Nigeria, Igbo
Wood, h. 68.2 cm.
BMG 1014-92

Okperegede is a masquerade danced annually during the dry season festivals by the Izza and other north-eastern Igbo groups, to the sound of a zoomorphic slit drum of the same name. From four to nine characters take part (all danced by men), who play roles ranging from the satirical to the stately, the most important of which is Asufu—a legendary warrior.

The mask opposite, which is slightly larger than life size, represents a female character, probably *Nwamma* (child of beauty), who would have danced lightly, yet vigorously, to rapid drumbeats, periodically posturing coquettishly with her head on one side. At the end of the dance, when she would have performed opposite vigorous youths, Asufu would appear to protect her from the flirtatious displays. The mask is carved in a light, fine-grained wood: the prognathous jaw and open mouth with carved teeth are characteristic of carvings from this area. The diagonal cheek marks and keloids at the temples recall the tattoos and scarification still worn by Igbo elders.

The Igbo carvers of Uzouwani and the neighbouring south-western Nsukka area have evolved a series of remarkable and elegant abstractions for their masquerades. The carved wooden masks have a conical projection for a face, enclosed within a pierced rectangle with a similarly-decorated panel above—the components of such geometric elements are usually variations of this form.

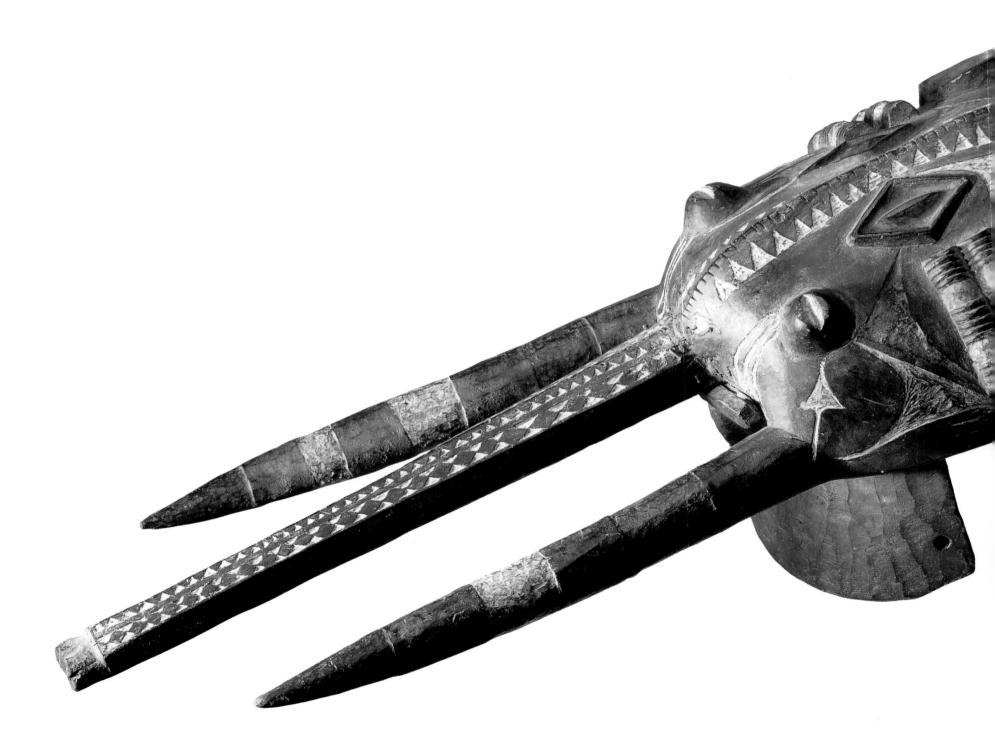

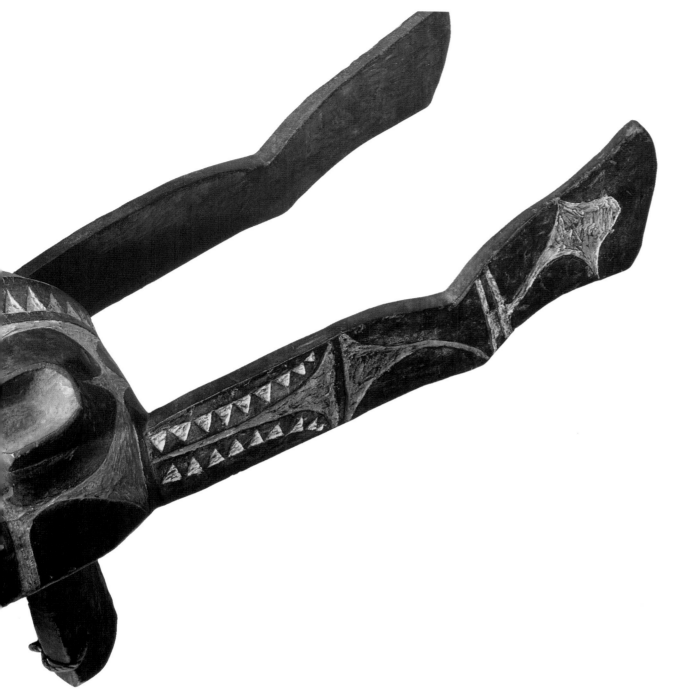

HEADDRESS, *ITROKWU*

Nigeria, Idoma
Wood, l. 165 cm.
BMG 1014-112

A massive structure, worn on the head horizontally, *Itrokwu* is a masquerade headdress which belongs to a men's society of the same name. The elephant and python elements on the mask shown here are symbols of power and monumentality rather than direct references to the animal and reptile: new initiates to the society are made to consume vast quantities of yams and millet beer, as well as smoke a large pipe of tobacco, so everything is conceived on a monumental scale.

Itrokwu is a destructive and fast-moving masquerader, threatening the audience who keep a respectful distance. It is worn with a cloak of indigo cloth of a type used for burials (*ochicidi*), and is followed by an attendant carrying a stool which indicates royal associations—other attendants fan it with branches to try to cool its power and avert danger. The footwork of the dancer is very rapid, unlike that of other chiefly masqueraders, who move in a stately fashion. It was originally attributed to the carver Ochai of Otobi by Roy Sieber, who saw it being danced in 1958, but Sidney Kasfir discovered, in 1986, that it was more probably from the hand of Ochai's successor, Oba, who was born at the turn of this century and died in 1971. She thinks the mask was carved in the 1950s.

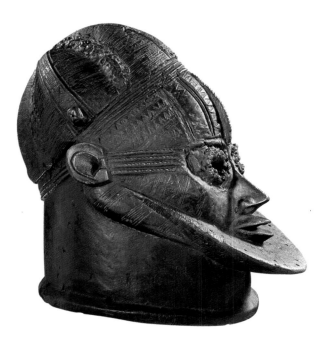

In the Igala capital, Idah, on the left bank of the river Niger, most of the royal masquerades, which are known collectively as *Egwu Ata* (The King's Maskers) wear black helmet masks with red and yellow cloth costumes. They appear at the royal festivals of *Ocho* (an inaugural hunting feast) and *Egwu* (a celebration for the royal ancestors) and on other state occasions, when they dance and posture to entertain spectators. Crowd control is an important part of their performance. The mask above, for *Epe*, is brought out by *Ogbe*, the most senior of palace officials. The set of four lines between the eye and ear ethnic scarifications. The eyes are embellished with a circlet of applied abrus seeds *(Abrus precatorius)*, and on the crown are the remains of a band of these seeds.

The statuette opposite has often been said to be an *anjenu* figure, associated with the women's cult of water-spirits. Sidney Kasfir disagrees, pointing out that all the *anjenu* figures that she has seen on altars are only about half the size of this one. She also analyses the morphology of this sculpture: the scarification marks on the face are entirely Idoma (Akweya style), whereas the scarification marks or paintings on the body are unusual. She comes to the conclusion that it depicts an *ekotame*: these images, 'spirits with breasts', are when in use adorned with various jewels, as seen here.

MASK

Nigeria, Igala, Idah
Wood, abrus seeds, h. 31 cm.
BMG 1014-120

FIGURE, *EKOTAME*

Nigeria, Idoma
Wood, cloth, metal, pigments, buttons, h.
79 cm
BMG 1014-9

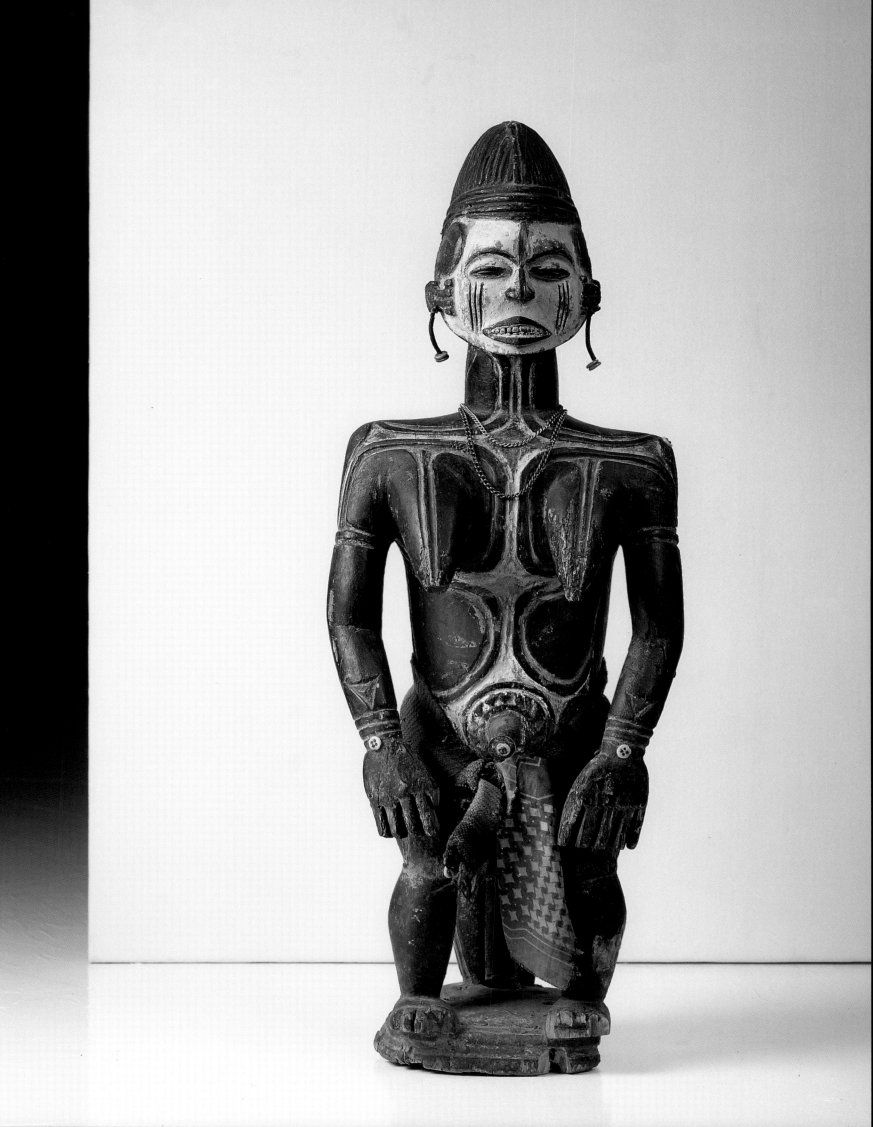

HEADDRESS

Nigeria, probably Mama
Wood, l. 53 cm.
BMG 1015-2

HEADDRESS, *EKPESHI*

Nigeria, Afo
Wood, abrus seeds, h. 24.8 cm.
BMG 1015-87

From the western shores of Africa to Lake Chad, along the savannah that flanks latitude 10 and parallel to the southern coast, the people tend to carve theriomorphic dance head-dresses for their masquerades—all of them with horns and projecting snouts of various shapes about a central element. The cluster of these peoples in the Plateau area of Nigeria have evolved perhaps the most simple crests of this type, where the horns are conceived as a circle and the mask is coloured red.

Amongst these people, each small group of whom bears a different name, Arnold Rubin recorded the *mangam* masquerade, which is danced to enlist the aid of the ancestral spirits to ensure a successful harvest, amongst other activities. It should not be presumed that the headdress opposite represents an animal, but rather it invokes the power of the bush cow (buffalo). Henry Moore was inspired by a mask of this form to create his **Moon Head** of 1964, which was illustrated in William Fagg's **Nigerian Images** (1963, confirmed to Alan Wilkinson by William Fagg).

The Afo, who also live on the Plateau, carve a different form of crest to top their costumes for their masquerades. The rare headdress above represents a chameleon on a cockscomb (or porcupine quills), with a pair of horns at the base. The chameleon, with its magical power to change colour, plays an important part in the Afo mask repertory. The headdress was worn by a drummer, *ekpeshi* (featherman), after whom the mask is named, and would have been danced on the fourth and seventh days after burial ceremonies. Elsy Leuzinger also described how, in the past, Afo headmen would visit neighbouring villages accompanied by masked retainers.

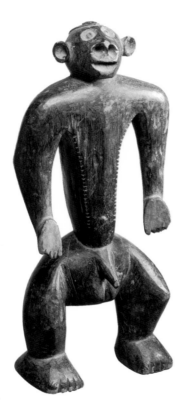

Arnold Rubin has noted that during the early years of this century the area on the southern Plateau between Pankshin and Shendam was regarded by traders and administrators as a stronghold of lawless, war-like cannibals. This stigmatisation, if true, would seem to have precluded more constructive forms of interaction amongst its peoples, who appear to share a healing association variously called *Komtin*, *Komtoeng*, etc. Allowing for local variations of usage, the usual form appeared to be that an individual afflicted with a certain illness would seek the intercession of the association in the form of divination, herbal remedies, curing rites and performances of its songs and dances. A recovered patient would throw a feast for the troupe, and usually become a member him-self. The central symbol of each association was a carved wooden figure. The figure above has previously been attributed to the Montol people, but the style was distributed beyond the Pankshin-Shendam area. For instance it is found amongst those living around Wamba, where figures with massive shoulders and a powdery-red surface have been found—although no information for their use has been recorded.

The Tiv migrated from the Cross River area on the Cameroon border to live amongst the Idoma with whom they share a predilection for carving maternity figures. But the Tiv also carve tall male figures which probably served as village guardian spirits, *ihambe*.

FIGURE

Nigeria, perhaps Montol
Wood, pigment, h. 48 cm.
BMG 1015-4

FIGURE

Nigeria, Tiv
Wood, h. 110 cm.
BMG 1015-1

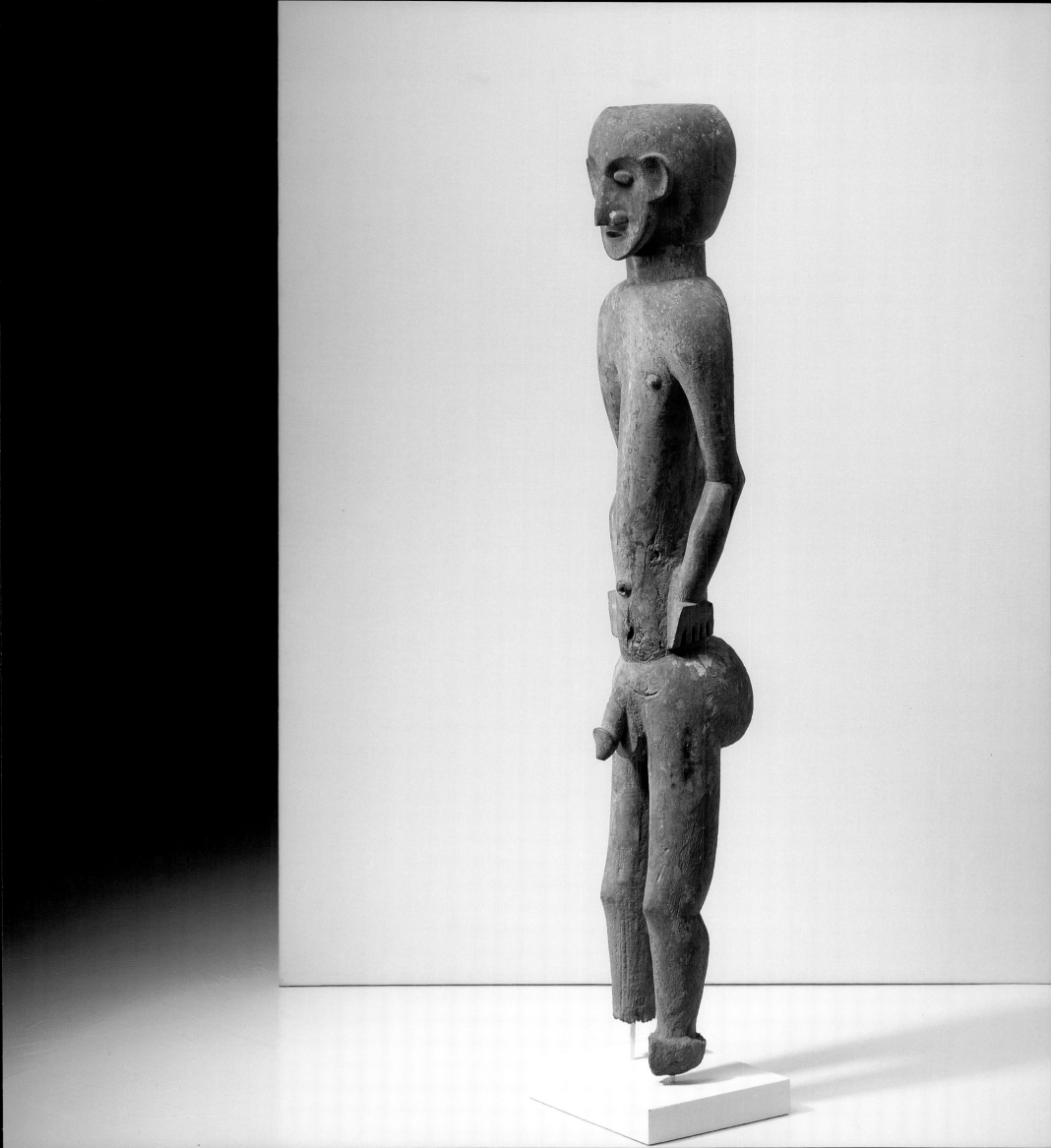

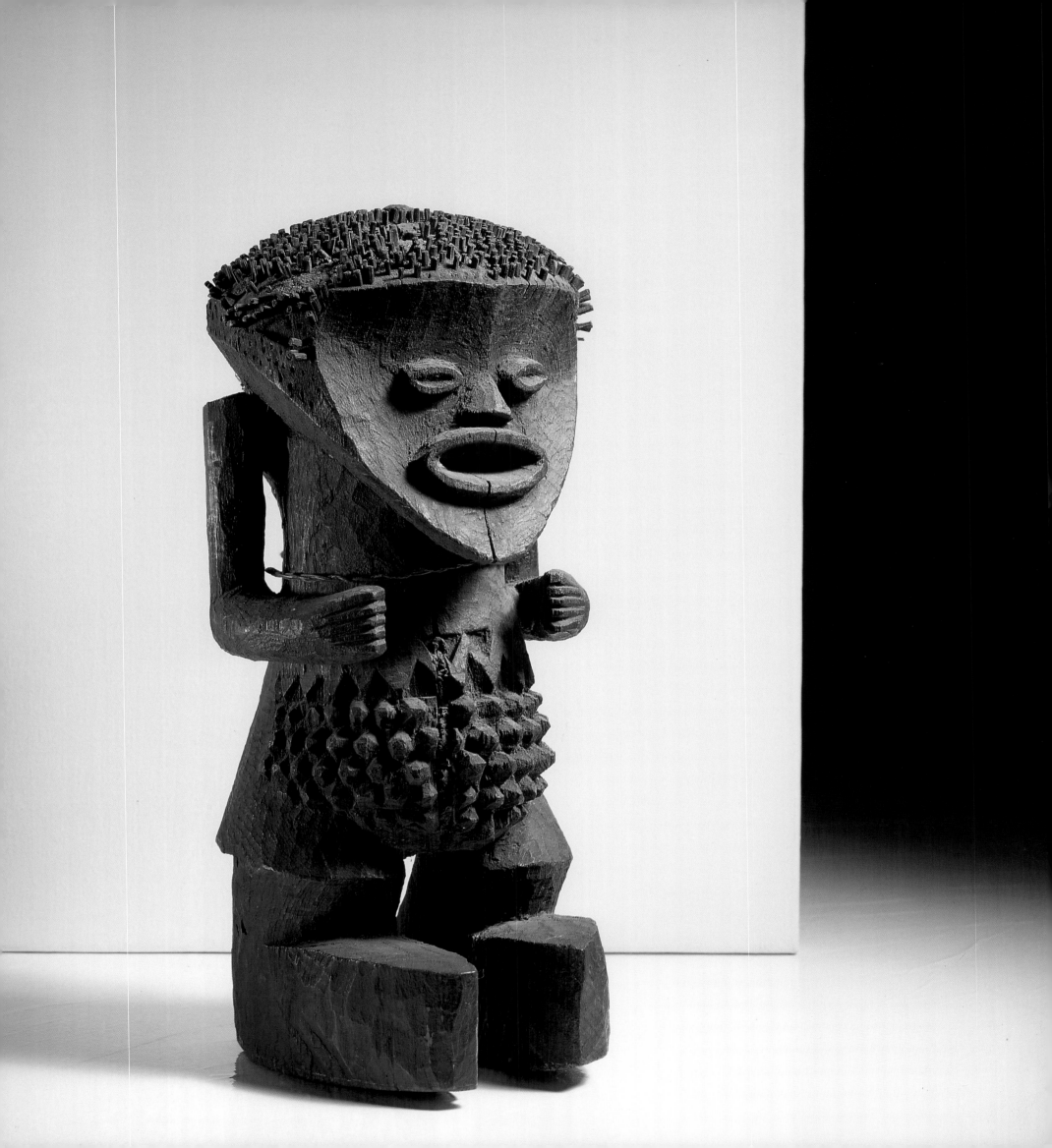

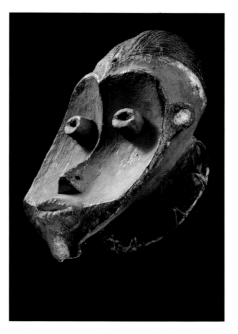

FIGURE, *TADEP*

Nigeria/Cameroon, Mambila
Wood, pigment, h. 45 cm.
BMG 1015-3

MASK

Nigeria/Cameroon, Mambila
Wood, pigment, h. 30 cm
BMG 1018-76

In the Donga valley on the border of Nigeria and Cameroon live the Mambila, Mfumte and Yamba (Kaka), whose stylistic parallels found in their figurative sculpture are evident in this fine example. The carving opposite has the distinctively expressive triangular face of Mambila *tadep* figures but the pronounced ovate eyes and mouth, the pegged hair and the apparent scarifications on the abdomen suggest that it could as well have been carved by a Mfumte or Yamba.

Such figures were used in healing rites and to deter thieves. Gilbert Schneider also links them to the promotion of fertility. The present figure has a hole at the back in which a piece of cloth has been inserted. The wide range of uses to which such a figure may have been employed was probably determined by the "medicines" in the possession of the owner, and how it was activated, rather than by any specific stylistic characteristics of the sculpture itself.

The term *suàgà* among the Mambila refers to both a pair of masquerades and a system of related sacrificial oaths. The recent adoption of Christianity and Islam have somewhat inhibited the performance of *suàgà* and the production of sculpture, so few examples of mask and figures remain in Mambila villages, yet *suàgà* is still performed as a dance, as "medicine" and as an oath. David Zeitlyn found that, in the Cameroon village of Somié, the masquerades occurred in a biennial cycle, alternating with *ngwun*, a rite concerned with relations between the population and the chief.

Head crests with recognisably human features, such as in the example above, are much more rare than other types of *suàgà* masks. An application of red, white and black pigment is usual on Mambila masks.

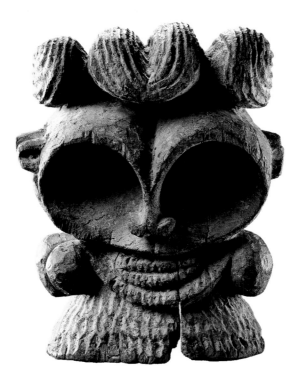

The cluster of kingdoms in the Cameroon Highlands called the Bangwa (for convenience by colonials) have close cultural ties with the Bamileke to the east of them, but the dramatic Night Society masks appear to be indigenous to them. When Robert Brain studied the masks in the 1960s he discovered they were considered too dangerous to be placed on top of the head, so instead the masquerader wore a fibre net as part of his costume and carried the mask in his arms or on his shoulder. Awe-inspiring, terrifying, symbols of the secular and supernatural power of the chiefs and his servants, those who handled the masks had to take strict ritual precautions—an outsider who came into contact with them might suffer such afflictions as dizziness or spit blood. The distorted features express the fury or lust of a human being transformed into a supernatural one.

The *Kungang* is a society which the Bangwa adopted from the Bamileke and which still exerts a powerful influence over both communities today. The figure opposite represents a *magné*, a mother of twins about to give birth—the head of one child is appearing whilst the other remains within. The long attached braid of hair and fibre is reminiscent of those attached to *Kungang* Society masks. The power of this statue would have been invoked to cure infertility.

The members of this secret society also use statues called *lekat*, which have swollen stomachs and which are considered agents powerful enough to harm witches and criminals. The encrustations represent numerous libations over a long period of time which render the figures efficacious. They are seldom sold because they are still used.

MASK

Cameroon, Bangwa
Wood, h. 41.5 cm.
BMG 1018-65

FIGURE, *MAGNÉ*

Cameroon, Bamileke
Wood, hair, raffia, h. 82 cm.
BMG 1018-78

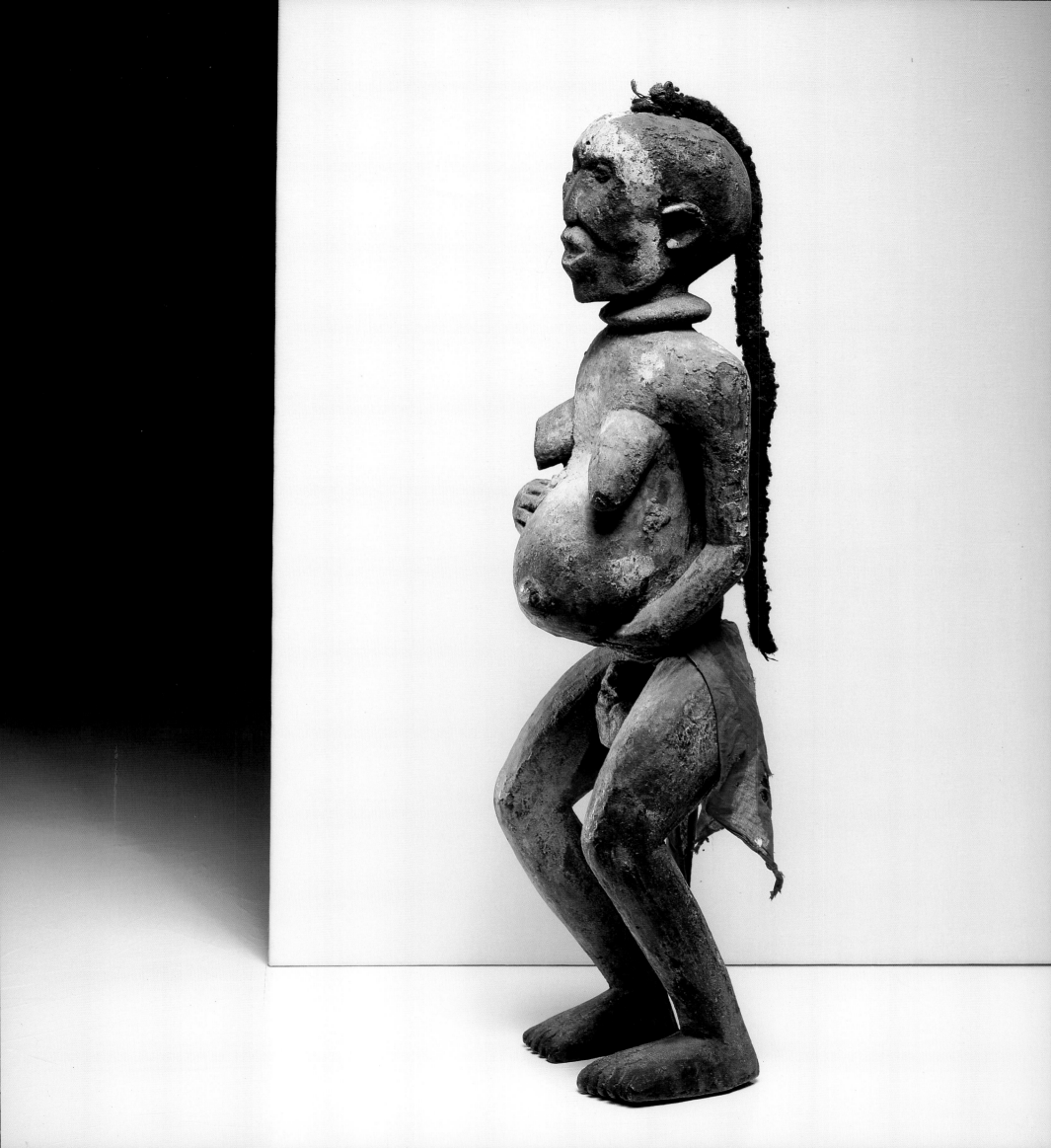

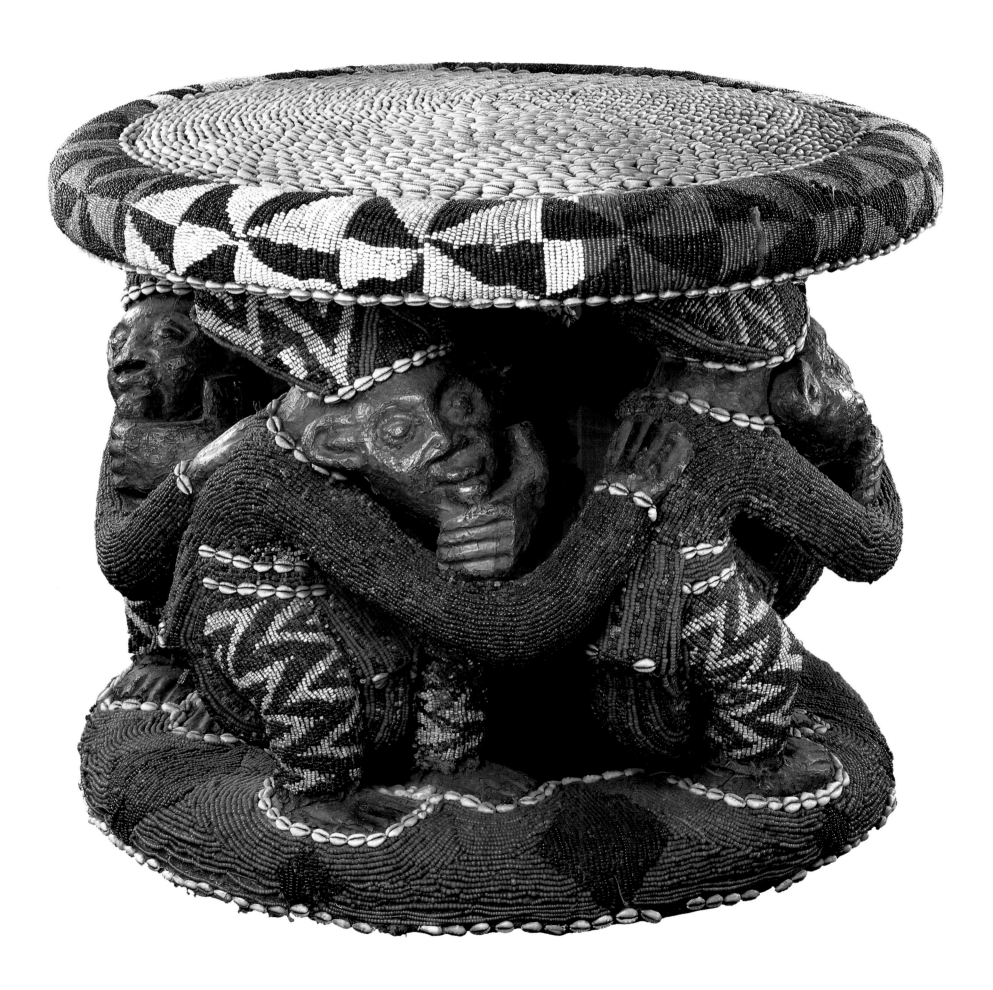

SEAT

Cameroon, Bamum, Foumban
Wood, beads, cowries, copper, h. 57 cm.
Formerly Mfon Njoya, Captain Glauning
(1906), Arthur Speyer and Charles Ratton
collections (1936)
BMG 1018-73

THRONE

Cameroon, Bamum, Foumban
Wood, beads, cowries, copper, h. 120 cm.
BMG 1018-21

Another vital artistic center of the Western Cameroon was Foumban, the capital of the Bamum in the Bamenda Highlands. There the Mfon Njoya encouraged artisans to produce prestige objects. He recognised the power of the Germans and made a number of generous presentations to Captain Glauning, the administrator of his district, especially after Glauning had restored to him the head of his father which had been taken in battle by the Nso. Among his gifts was the stool opposite, which may have been carved by Nji Nkomé, who made the remarkable throne for the Kaiser in 1908.

The caryatids are servants who hold their left hands before their mouths as a sign of respect, their faces covered with beaten copper panels and the whole decorated with coloured beads within cowry-shell borders. The seat is covered with cowries.

Another seat—this time it is carved as a chair reminiscent of the *ru-mon-juono*, a bamboo and raffia chair favoured by the Fulani. Again from Foumban, probably from the workshop of Nji Nkomé, it would have been made to the order of Mfon Njoya. Seats of this type do not appear to have been intended for his use but that of the Queen Mother, Njapndounke, second only to him at court and the only other person authorised to use such a throne. Pierre Harter mentions a photograph, taken in 1912, of the Mfon seated on his monumental throne with, to his right, a stool with leopard caryatids reserved for his mother and, to his left, the German merchant Rudolf Oldenburg, seated on a chair of this type with carved caryatids. The two-headed serpents are a royal emblem.

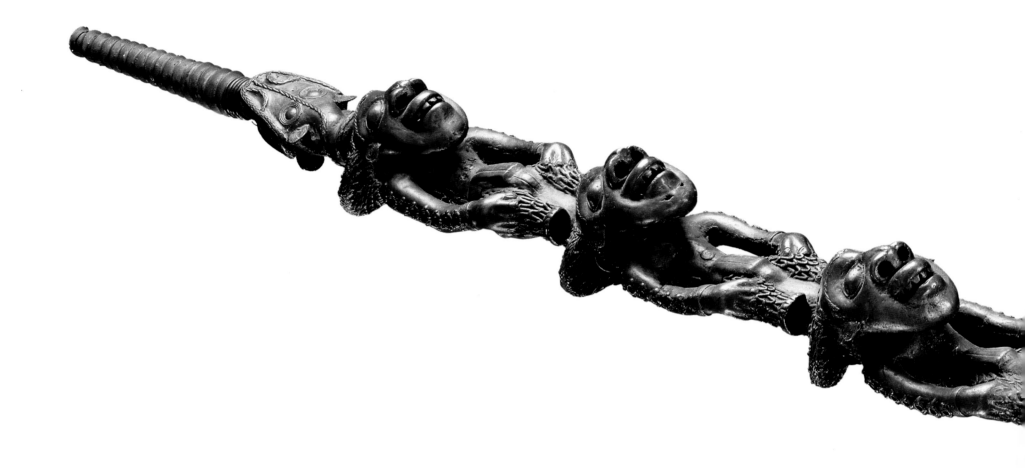

Nothing could better demonstrate the talents of the artists that Mfon Njoya had gathered at his court in Foumban than the magnificent pipe illustrated here, another sumptuous gift from the Mfon to Captain Glauning, again no doubt to thank him for recovering the head of his father from the Nso in 1906. The pipe bowl, finely crafted in terracotta as a head with puffy cheeks and surmounted by a headdress of chameleons, was probably made in the village of Mamarom, just outside Foumban, but the four brass figures which encircle the wooden stem would have been cast in the capital. The use of metal for pipes was restricted to the Mfon, and the size would have reflected the social status and therefore the importance of the owner. Pierre Harter also mentions that the Mfon had to smoke his pipe not only in the palace, but when he travelled among his people, because the smoking of it

was regarded as a rite that would make both the fields and the women fertile.

The history of the kingdom of Bamum during the nineteenth century was well recorded by the Germans: thus we know that Mfon Njoya inherited his throne as a minor, following the death of his father, Nsa'ngu, in a particularly bloody battle against the Nso. For a time Bamum was governed by his mother, a formidable woman. Njoya was an enlightened ruler who encouraged the arts, and even devised his own alphabet as a method of communication with his allies against mutual enemies. Glauning was killed in an action against the Tiv in 1908

PIPE

Cameroon, Bamum, Foumban
Wood, terracotta, brass, l. 170 cm.
Formerly Mfon Njoya, Captain Glauning
(1906), Arthur Speyer collections
BMG 1018-8

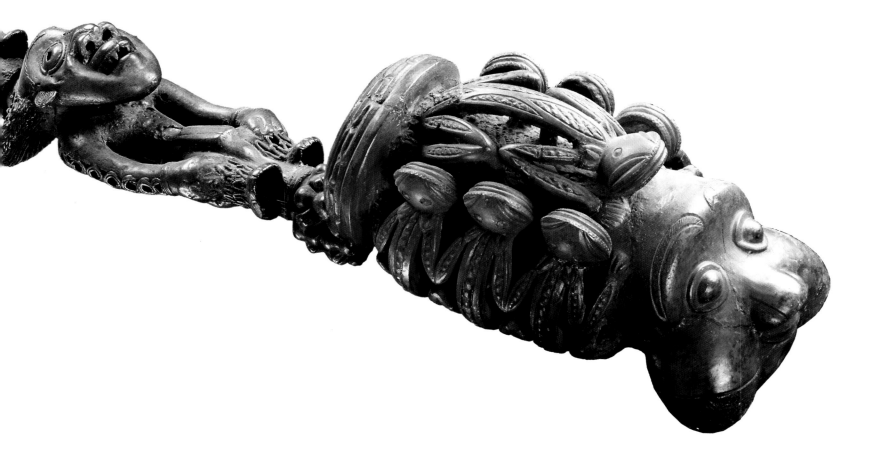

The Duala, who live on the Bay of Cameroon at the mouth of the Wuri river, were fond of holding regattas, when there would be races between great canoes paddled by large numbers of oarsmen. The art of these people is seldom reproduced in the literature, even though the canoe prows and the support panels to their stools are pierced and carved with figures, animals, birds and reptiles that are almost calligraphic in conception. The headdresses repeated some of these forms, but with a geometric stylisation, as seen in the mask opposite. These rare bovine mask headdresses, all collected late last century or at the beginning of this one, were used by members of the *Ekongolo* Society in masquerades to honor the ancestors. All the headdresses are conceived in this rather two-dimensional way: the tongue in this instance is formed from a triangle of hammered iron.

The Duala painted their canoe prows, paddles and masks in vibrant hues of scarlet, yellow, black and white.

HEADDRESS

Cameroon, Duala
Wood, paint, iron, l. 76 cm.
Formerly Josef Mueller collection (before 1942)
BMG 1018-2

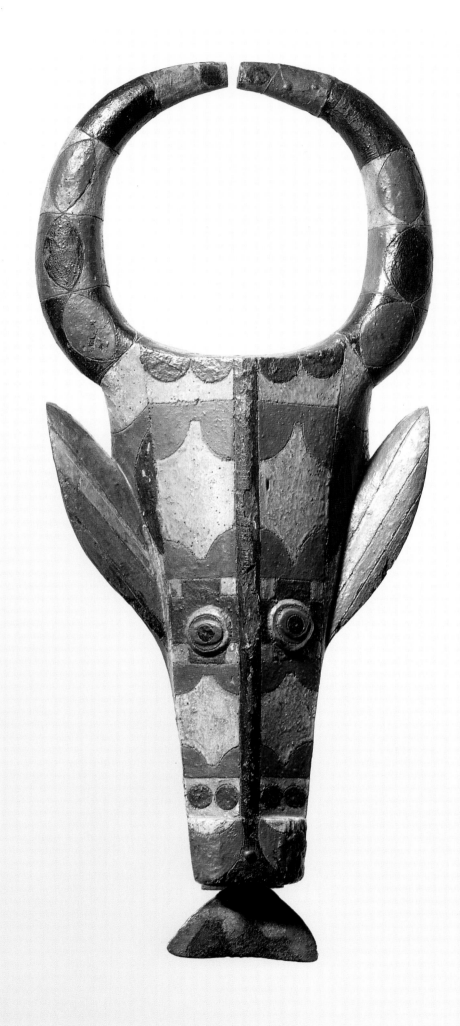

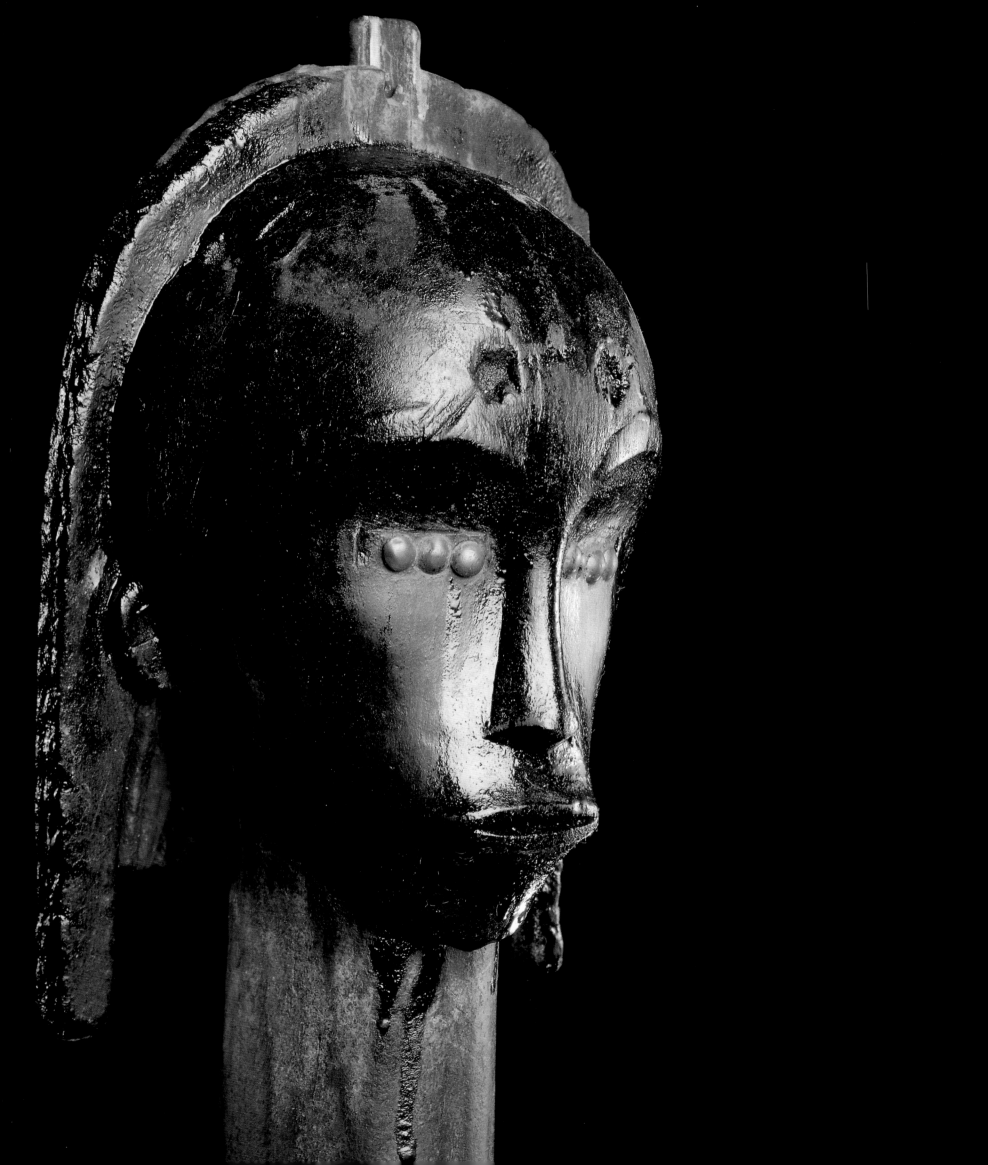

HEAD, *NLO BYÉRI*

Gabon, Fang, Nzama-Betsi
Wood, nails, palm oil, h. 36 cm.
Formerly Josef Mueller collection (before 1939)
BMG 1019-13A

FIGURE, *EYEMA-O-BYÉRI*

Gabon, Fang, Ntumu
Wood, nails, h. 54 cm.
Formerly Josef Mueller collection (before 1939)
BMG 1019-34

The inveterate and original traveller, Mary Kingsley, observed during her quest in Gabon for "fish and fetishes" that the Fang were expanding rapidly from the north-east of the country, and she thought they would reach the coast before the end of the century, absorbing or decimating the people in their way. With a reputation as fearsome cannibals (a severed head dripped blood over her bed on one occasion), the Fang carved heads and figures of mystical serenity and beauty to serve as guardians of ancestral relics. They were inserted into boxes and baskets made to contain the skulls and certain bones of venerated forbears to place in the family shrines. The insertion stick was placed in such a way that many figures sat on the edge of a cylindrical box with their legs dangling over the sides. The heads, such as that opposite, are thought by some to predate the figures, but there is no way to confirm such a hypothesis, though they are more rare than the figures.

Both heads and figures were exhibited during the initiations and propitiatory rites of the *Byéri* cult, serving as symbolic substitutes for skulls during these rituals. Regarded as members of the family, their use seems to reflect a similar inconsistency of relationships, some being lovingly oiled and cared for, others often showing evidence of neglect. The figure above is missing the legs below the top of the thighs—and the insertion stick. The upholstery-nail eyes, a remarkable three in the head opposite, would have gleamed in the dark: feathers, usually from the eagle or turaco, would have been suspended from the hole at the top of each head.

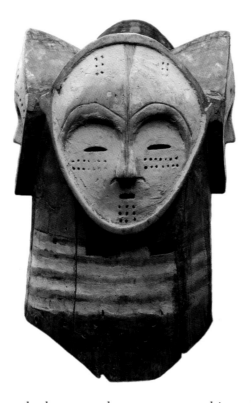

The Fang migrated across Gabon from southern Cameroon during the last century and their use of carved wooden masks during ceremonies appears to date from later still—the end of the nineteenth century and the first quarter of the present century. Louis Perrois, quoting Panyella, records that multi-faced helmet masks, such as the one above, were danced by men in a ritual linked to the *Byéri* ancestral cult, and that they are often still used for a dance of rejoicing called *Ngontang* (*ngon* means young girl). To dance *Ngontang* the masquerader underwent an initiation during which he swallowed medicine to gain lightness of movement, rubbed his body with protective potions, wore talismans and abstained from sex. White is the color of the spirits of the dead and it is sometimes difficult to know whether a mask represents a white skinned man or an ancestor.

The Mabea of southern Cameroon are not related ethnically or linguistically to the Fang, but absorbed much of their culture when the Fang moved towards the coast. Originally an advance group of the Maka migration from eastern Cameroon, the Mabea were forced to move to between Yaounde and the Gabonese border by the Baya, who were themselves displaced by the Fulani. The reliquary figures they carved are very similar to those of the Fang, but taller. Although they appear to have been used in much the same way, the figures were never anointed with lashings of oil, but rather were decorated with brass anklets and bracelets, as with the figure opposite. Others have applied metal panels.

HELMET *MASK, NGONTANG*

Gabon, Fang
Wood, h. 54 cm.
Formerly Josef Mueller collection (before 1942)
BMG 1019-23

FIGURE, *EYEMA-O-BYÉRI*

Cameroon, Fang, Mabea
Wood, metal, h. 70 cm.
Formerly Charles Ratton and Josef Mueller collections (before 1939)
BMG 1019-5

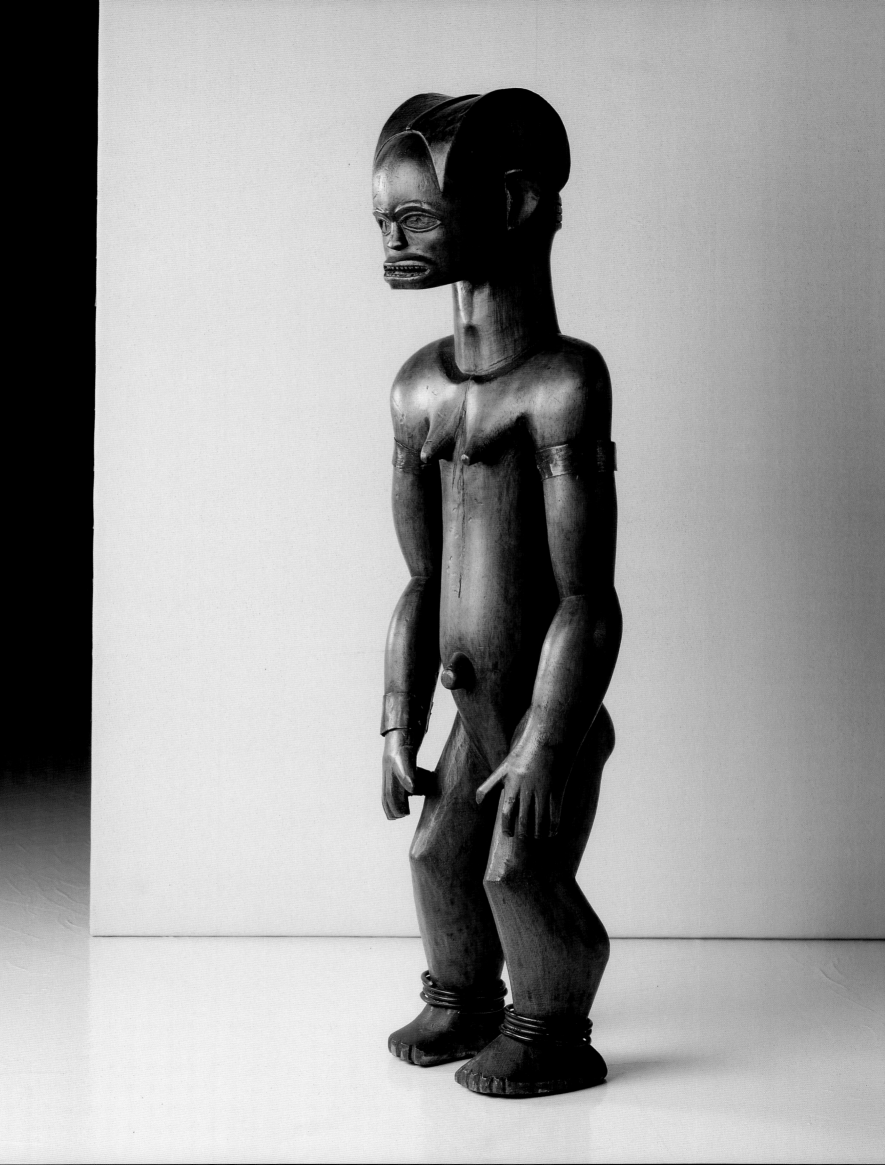

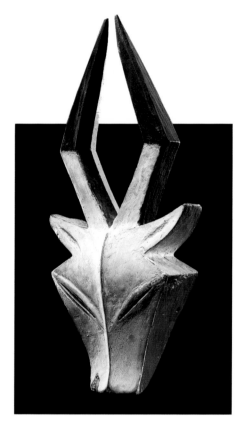

To the east of the Fang, straddling the northern part of the Gabon's border with Congo Brazzaville, live the Kwele, who carve face masks of four forms, none of which appear to have been worn in the normal manner and many of which do not have pierced eyes. The backs of Kwele masks are all carved with a curiously thick edge—in contrast to the tapered border usually found on face masks—which would be explained by the fact that they were never intended to be worn by a dancer. In fact it appears they were carved for display, although they were often held during ceremonies. Raoul Lehuard, who made some researches in this area, was informed that masks were commissioned after the birth of a boy child and represented a nature spirit who would accompany the child when he entered the bush school at about eighteen years of age.

The four mask types represent three animals and a man, *pibibuze*. The animal masks—the gorilla, the elephant and the antelope—tend to be carved in a stylized geometric manner. The antelope shown above is a particularly elegant example of this *genre*. The famous mask opposite represents a man, *pibibuze*. It is carved with great sensitivity and a real feeling for proportion. *Pibibuze* were often carved within a heart-shaped border resembling horns that frame the face, but the mask opposite does not appear to have ever had such a border—however, illustrations of it might have inspired carvers to produce a number of superficially similar masks, which appeared on the market in the decade 1955–1965

MASK

Gabon, Kwele
Wood, h. 38 cm
Formerly André Fourquet collection, Paris.
BMG 1019-49

MASK, *PIBIBUZE*

Gabon, Kwele
Wood, h. 25.4 cm.
Formerly Tristan Tzara collection.
Exhibited in 1931 (African masks selected
by Charles Ratton) and in 1935 (African
Negro Art at the Museum of Modern Art,
New York)
BMG 1019-80

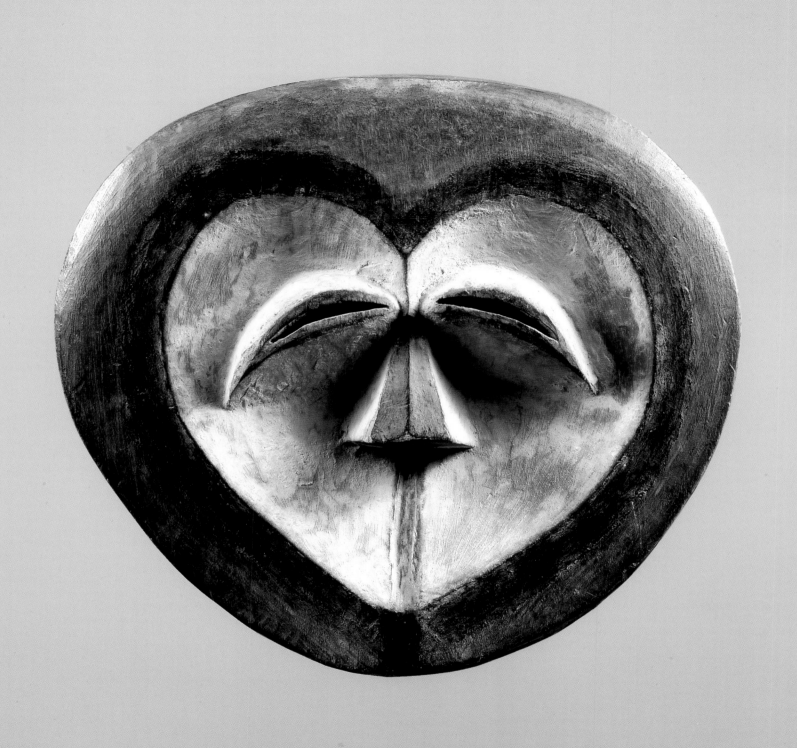

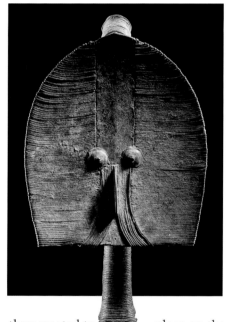

To the south of the Kwele live the Mahongwe who also carved reliquary figures, guardians of the skulls and bones of venerated ancestors, in a most original and abstract form. The concave oval forms, completely covered with thin applied strips of brass, were truncated towards the base, part of the reverse and the pierced base were left uncovered. They invariably have a sharp nose and convex disc eyes. Each figure is a symbolic portrait, reflecting but not copying reality, its symbolism only understood by the initiates. They are considered dangerous to handle because of their role in former funeral rites, which have not been practised for over sixty years. Most of the figures came to light twenty years ago, having been hidden from missionaries and an anti-witchcraft cult known as *Mademoiselle*.

The various peoples who live in north-eastern Gabon are loosely described as Kota. The reliquary figures they created to place on the baskets containing the skulls and bones of venerated ancestors were of a very stylised, two-dimensional form, overlain with sheets of beaten brass and copper, leaving the reverse and the lenticular base uncovered. The radiating short spokes that frame the face of the remarkable figure opposite, and the large disc eyes, are most original decorative elements. Louis Perrois thinks it was carved in the Obamba/Minduma region of the upper Ogowe River during the nineteenth century. Formerly it was thought that the gender of such figures would be female if the face was concave and male if convex, but this does not appear to be consistent: Janus-faced figures had more importance and ritual value than the others, but they relate more to magical or religious efficacy than to a distinction between male and female.

FIGURE, *BOHO-NA-BWETE*

Gabon, Mahongwe
Wood, brass, h. 38 cm.
Formerly André Fourquet collection, Paris

BMG 1019-68

FIGURE, *MBULU NGULU*

Gabon, Kota
Wood, brass, copper, h. 41 cm.
Formerly Olivier Le Corneur collection,
Paris
BMG 1019-4F

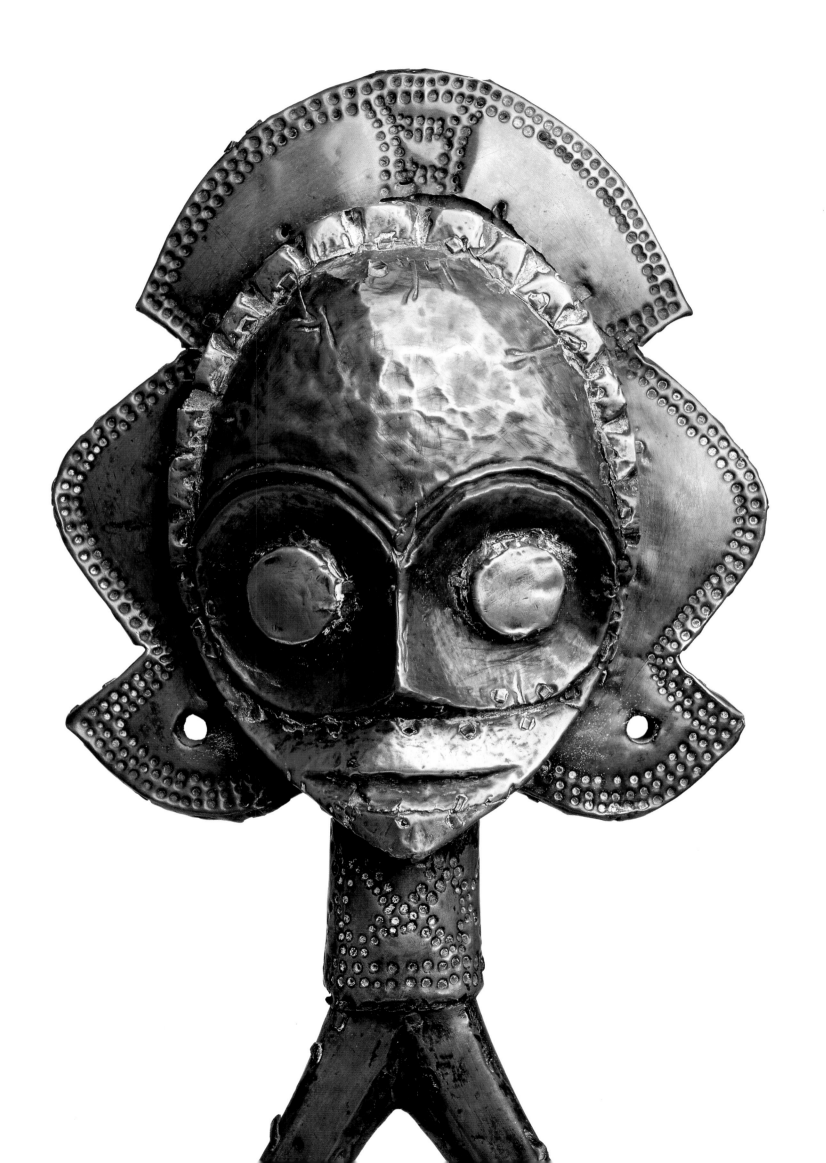

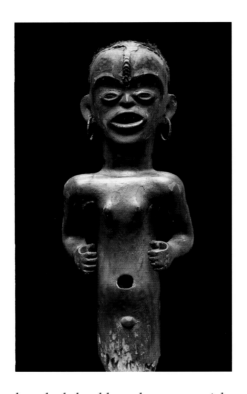

Among the Tsogo and Sango of southern Gabon the male initiation society, *Bwiti*, is the center of social and religious life. The cult house, *ebandza*, serves not only *Bwiti* but also other associations such as *Kono, Ya-Mwei* and *Ombudi*. The *ebandza* symbolises man in the cosmos—thus a part of it may be considered to correspond to a member of an association, or even a human organ, and, by extension, the objects which decorate the cult house, such as altars, posts and lintels, are a pretext for symbolic ornament. The reliquaries they carve to surmount the baskets of remains (which can include shells and ornaments as well as frag-ments of bone and skulls) of venerated forebears, called *mbumba bwiti*, are housed in the *ebandza*. These figures are treated naturalistically, with carved open mouths, oval eyes,

hunched shoulders, the arms at right angles so the hands are held forward: they are truncated below the abdomen and coloured red, such as the figure shown above.

The head opposite is also a *mbumba bwiti*, of a type found among the Sango and the Duma as well as the Tsogo. Louis Perrois observes that the use of metal on Tsogo sculptures is discreet, but more extensively used on the reliquaries than on other carvings. The circular eyes on the present piece are unusual, as is the rectangular neck, but the open mouth, winged brows and the projecting ears are typical of carvings from the Tsogo. Perrois remarks that although masks are used by the Tsogo in many traditional ceremonies, the *mbumba* have practically all disappeared.

HALF-FIGURE, *MBUMBA BWITI*

Gabon, Tsogo
Wood, h. 38 cm.
Formerly Marc and Denyse Ginzberg
collection, New York
BMG 1019-83

HEAD, *MBUMBA BWITI*

Gabon, Tsogo
Wood, copper, h. 36.8 cm.
Collected by Baron Rang des Adrets
(between 1927 and 1936)
Formerly Sommer collection
BMG 1019-53

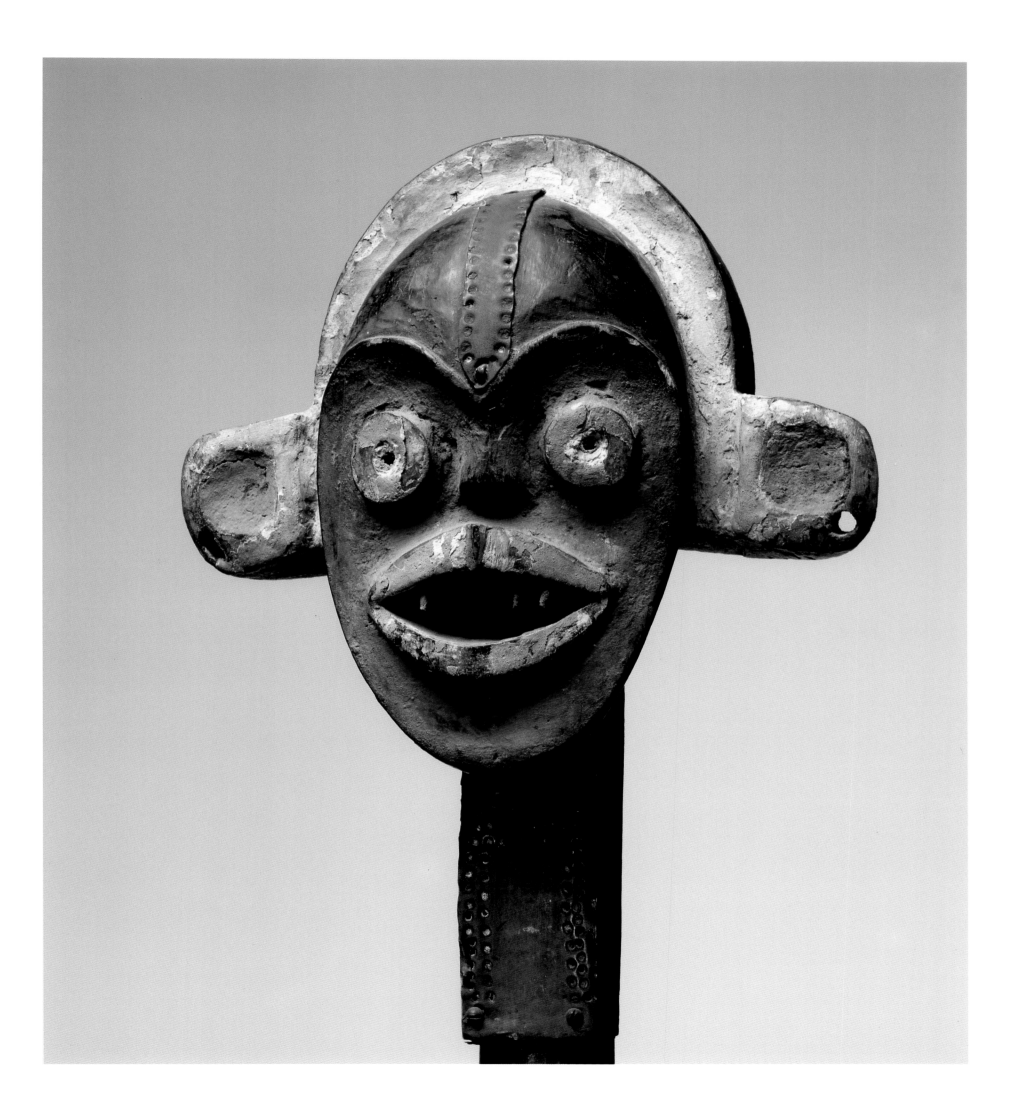

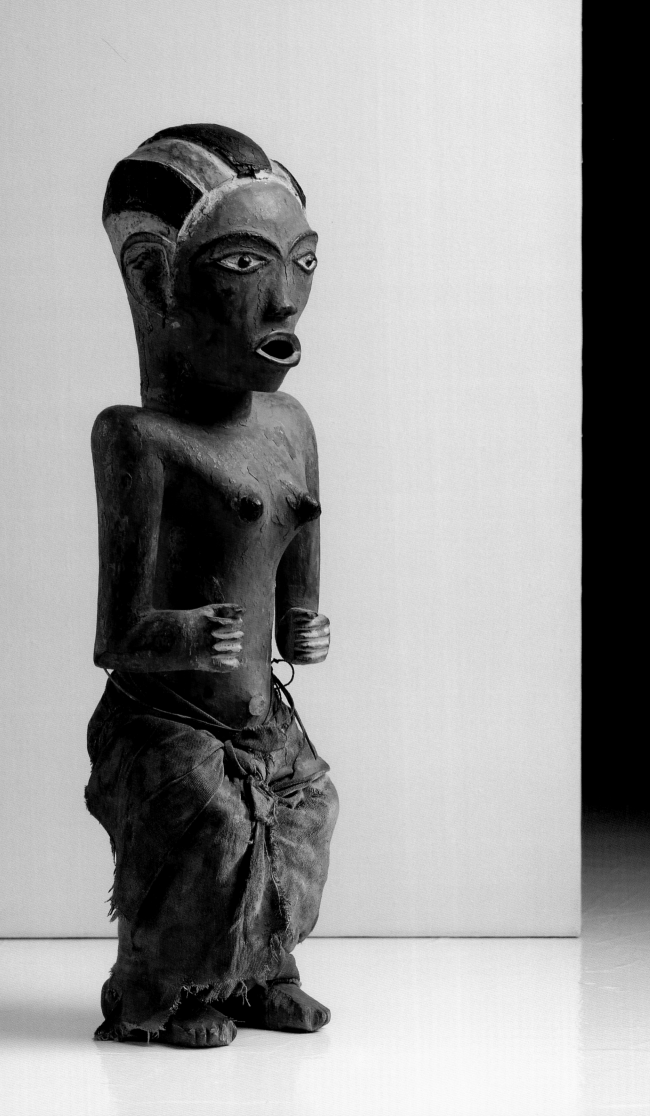

FIGURE, *GHEONGA*

Gabon, Tsogo
Wood, cloth, h. 53.4 cm.
Collected at the end of the last century.
Taken to Sweden before 1904
BMG 1019-64

FIGURE, *MBUMBA BWITI*

Gabon, Sango
Wood, brass, basket with skull fragments,
h. 48 cm.
Formerly HH. Prince Saddrudin Aga Khan
collection
BMG 1019-77

Louis Perrois describes the *gheonga* figures he discovered among the Tsogo as commemorative figures which have for the most part a secular rather than a religious function. They are stored in the the sacristy of the cult house, *ebandza*, and may acquire a prophylactic power if treated with appropriate substances accompanied by efficacious incantations. In general such figures, he tells us, are poorly sculpted, but that to the left is an exceptionally fine example It is typically Tsogo in treatment, with its hunched shoulders, forearms held forward to create a tension heightened by the flexed legs and open mouth—even its banded coiffure adds to its dynamism.

The reliquary figure above is typical of the art of the Tsogo's neighbors, the Sango. Their reliquary figures, on the baskets containing fragments of bones, skulls and other paraphernalia, are also called *mbumba*, but they are covered with brass sheets in a similar fashion to those of the Mahongwe and Kota. However their form is always smaller and more slender than those of the Kota, each with a lively expression. The *mbumba* of the Sango are never dull or stylised, but are exquisite, jewel-like confections. Perrois relates how the rituals associated with the *mbumba* included propitiatory offerings to the forebears of the lineage: skulls would be exhibited and identified to the young initiates before being anointed with blood (usually that of a chicken) and replaced in the baskets.

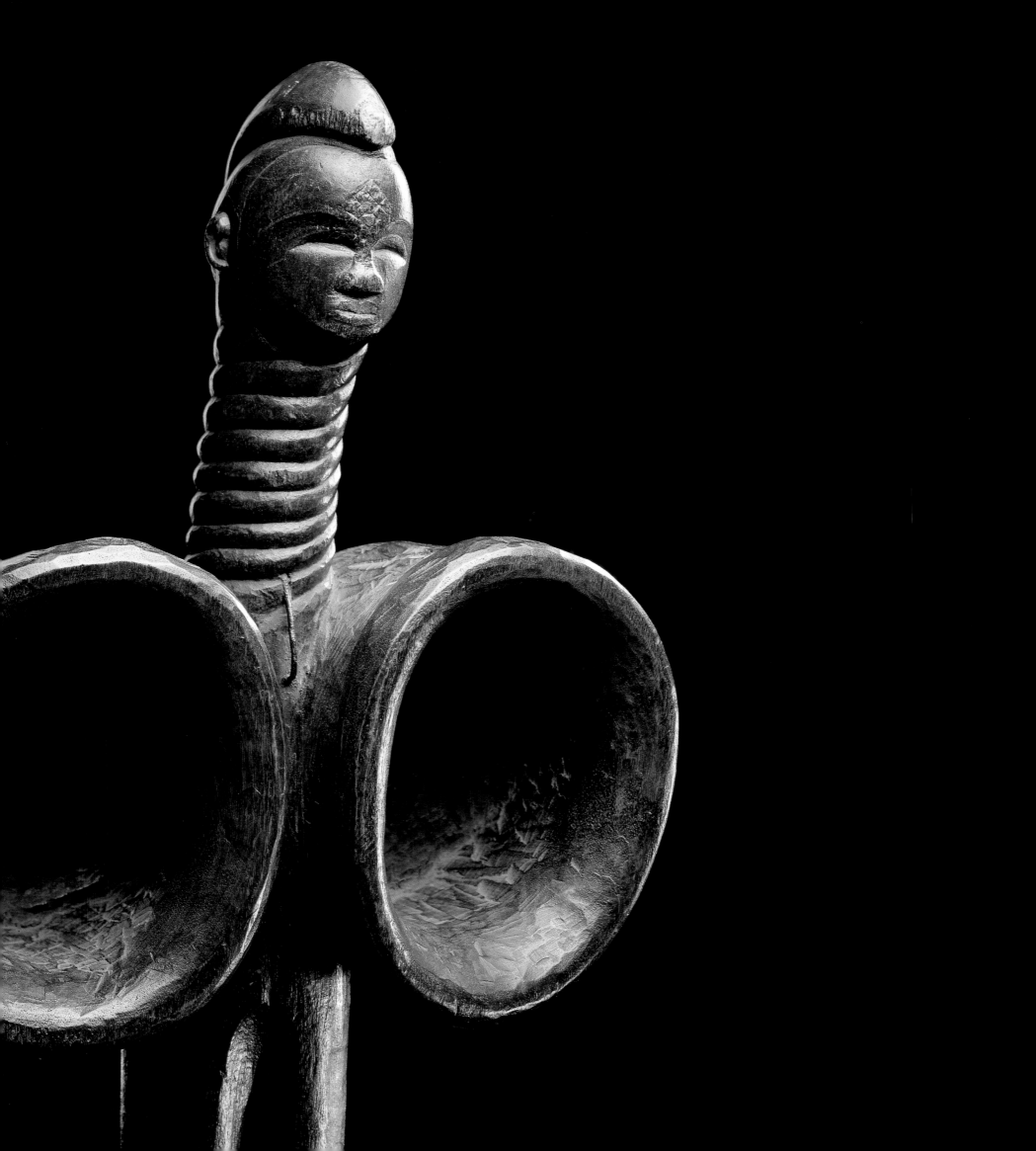

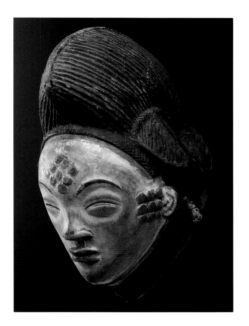

BELLOWS, *OKUKA*

Gabon, Lumbo
Wood, h. 62 cm.
Formerly Antony Moris and Josef Mueller
collections (1938)
Exhibited in 1935 (African Negro Art,
Museum of Modern Art, New York)
BMG 1019-21

MASK, *OKUYI*

Gabon, Lumbo
Wood, h. 28 cm.
Formerly Josef Mueller collection (before
1942)
BMG 1019-31

South of the Sahara the most commonly used form of bellows has two long nozzles, the tips of which are inserted into the fire, the other end terminating in two bowls which are covered by skins with two attached sticks which may be expanded and depressed alternately and rapidly to create the draught necessary for a hot fire. Seldom are they decorated, in spite of being an important tool of the trade. However, the bellows shown opposite have been elevated to a symbolic figurative sculpture by the carving of a fine head on a ringed projection. Louis Perrois writes that among the Tsogo bellows play a part in *Bwiti* rites, when it is explained to the neophytes that they symbolise both man and woman—the two chambers being the testicles, the nozzles a penis and the hole through which the air is drawn the vulva, through which life emerges.

It is for the white-faced masks similar to the one above that the peoples of the Ogowe River area—such as the Shira, Punu and Lumbo—are well known. The narrow eyes under slender arched brows give the masks an oriental expression, enhanced by the blackened coiffure which may be carved as one or three grooved lobes, imitating a former practice when women bolstered their braided hair with fibre stuffing. Such masks, called variously *okuyi*, *mukuyi* or *mukudji* depending on the district, were danced at funerals. They are commemorative portraits of male and female ancestors, the dancers often performing impressive acrobatics on stilts as they proceed through the village. Women and children prefer to hide from them, although there is apparently no prohibition against the masks being seen by them

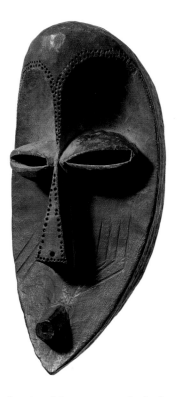

For years it was believed that the mask above, or one very similar to it, had provided Pablo Picasso with the inspiration for the famous series of paintings and sketches for *Les Demoiselles d'Avignon* of 1907—certainly Alfred Barr, a director of the Museum of Modern Art, New York, believed so, because it was purchased by that Museum for that reason. But William Rubin, researching the exotic influences on the art of Picasso for the exhibition *Primitivism* (1984), deduced that it was unlikely that such a mask was either in the Trocadéro Museum (later the Musée de l'Homme), or in the collections of such friends of Picasso as Derain, Matisse and Vlaminck, by 1907. Rubin does not deny that when Picasso saw the masks at the Trocadéro he recognized something

already in his own mind—he is recorded as saying: "If we give a form to these spirits we become free". Undeniable is the beauty of the present mask, which was collected before 1930 by Aristide Courtois, an administrator, in the village of Etoumbi on the upper Likuala River.

The mask opposite was in the collection of the painter André Derain. It was probably carved by a subgroup of the Teke called the Tsaayi for a masquerade which may have been introduced to the area during the middle of the last century. Early masks of this type are very rare. A decorated disc, it was held in the teeth by means of a fibre strand before the face of the masquerader.

MASK

Pop. Rep. of Congo, Mahongwe (?)
Wood, h. 35.5 cm.
Formerly Aristide Courtois (before 1930),
Charles Ratton and Museum of Modern
Art, New York, collections
BMG 1021-33

MASK

Pop. Rep.of Congo, Teke-Tsaayi
Wood, h. 49 cm.
Formerly André Derain, Charles Ratton
and Josef Mueller collections
Exhibited in 1931 (African masks selected
by Charles Ratton) and in 1935 (African
Negro Art, The Museum of Modern Art,
New York)
BMG 1021-20

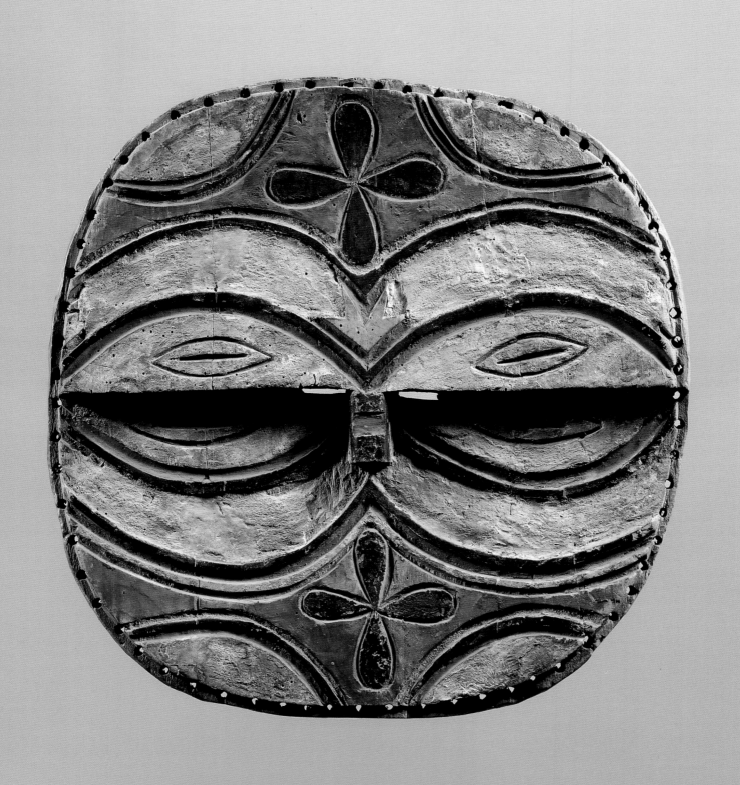

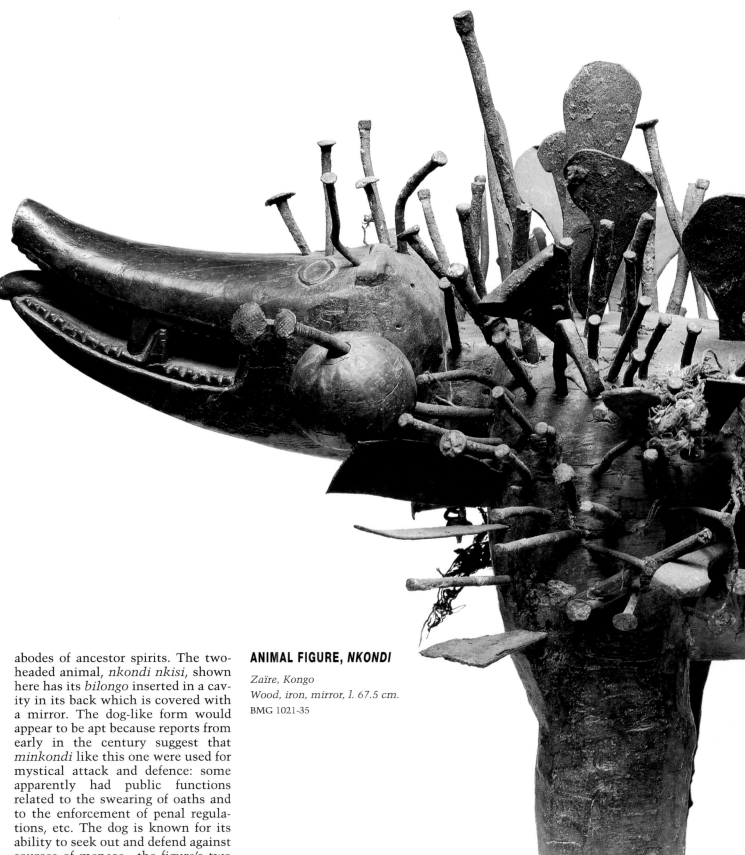

Minkondi (sing. nkondi) constitute a specialised and rare (though well known) type of artefact belonging to a broad class of ritual objects known throughout much of western central African as *minkisi* (sing. *nkisi*). *Minkisi* are essentially mad-made containers imbued with efficacious spiritual entities which are able to influence at a distance events in the everyday world. The particular personality and powers of an *nkisi* derive from its magical charge, *bilongo*, which is prepared by the ritual expert, *nganga*, from a mixture of mineral, animal (including human) and vegetable substances. The intended effect of this preparation is to capture the spirit of a dead ancestor so that it can be lodged in the *nkisi*. The binding materials of *bilongo* commonly take the form of kaolin collected from stream beds and earth taken from tombs, because these are substances which are linked with the

abodes of ancestor spirits. The two-headed animal, *nkondi nkisi*, shown here has its *bilongo* inserted in a cavity in its back which is covered with a mirror. The dog-like form would appear to be apt because reports from early in the century suggest that *minkondi* like this one were used for mystical attack and defence: some apparently had public functions related to the swearing of oaths and to the enforcement of penal regulations, etc. The dog is known for its ability to seek out and defend against sources of menace—the figure's two heads may therefore symbolise vigilance and supernatural sensory powers. The many iron nails and blades hammered into this *nkondi* indicate that it was much used. The appropriate way of activating the avengeant power of an *nkondi* such as this one was for the *nganga* to hammer a sharp metal object into it.

ANIMAL FIGURE, *NKONDI*

Zaïre, Kongo
Wood, iron, mirror, l. 67.5 cm.
BMG 1021-35

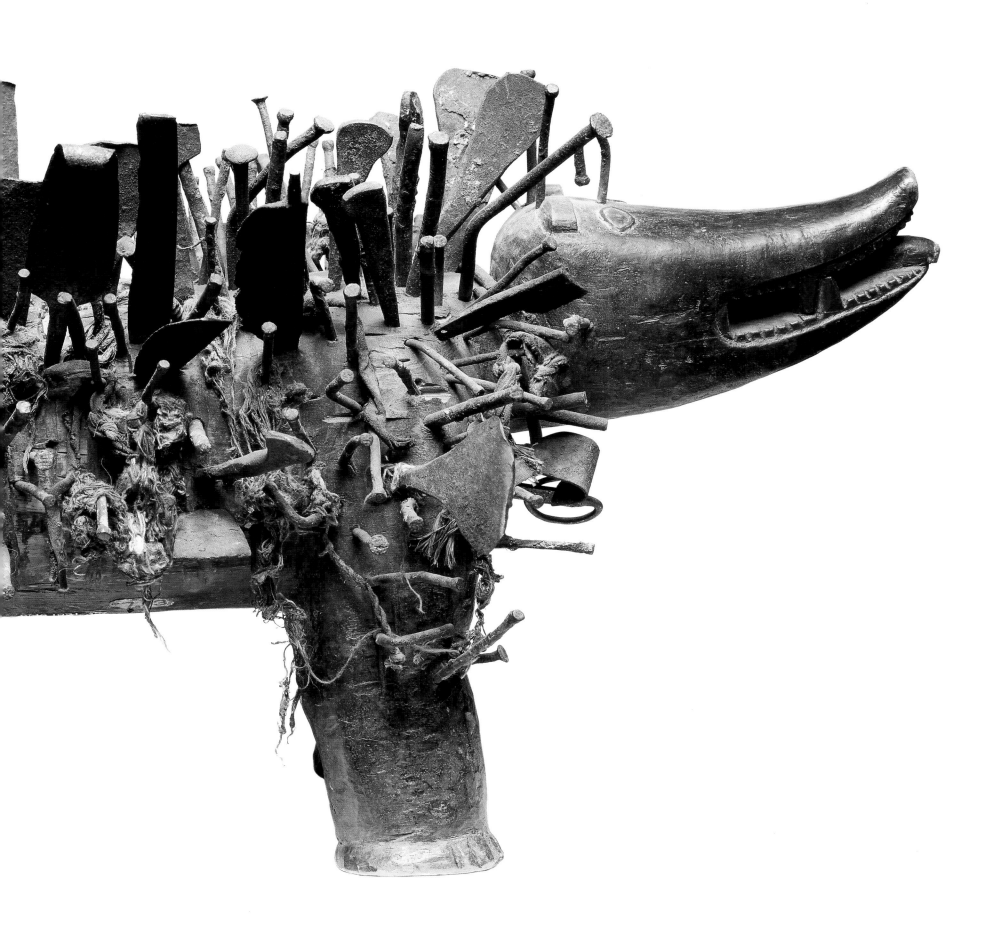

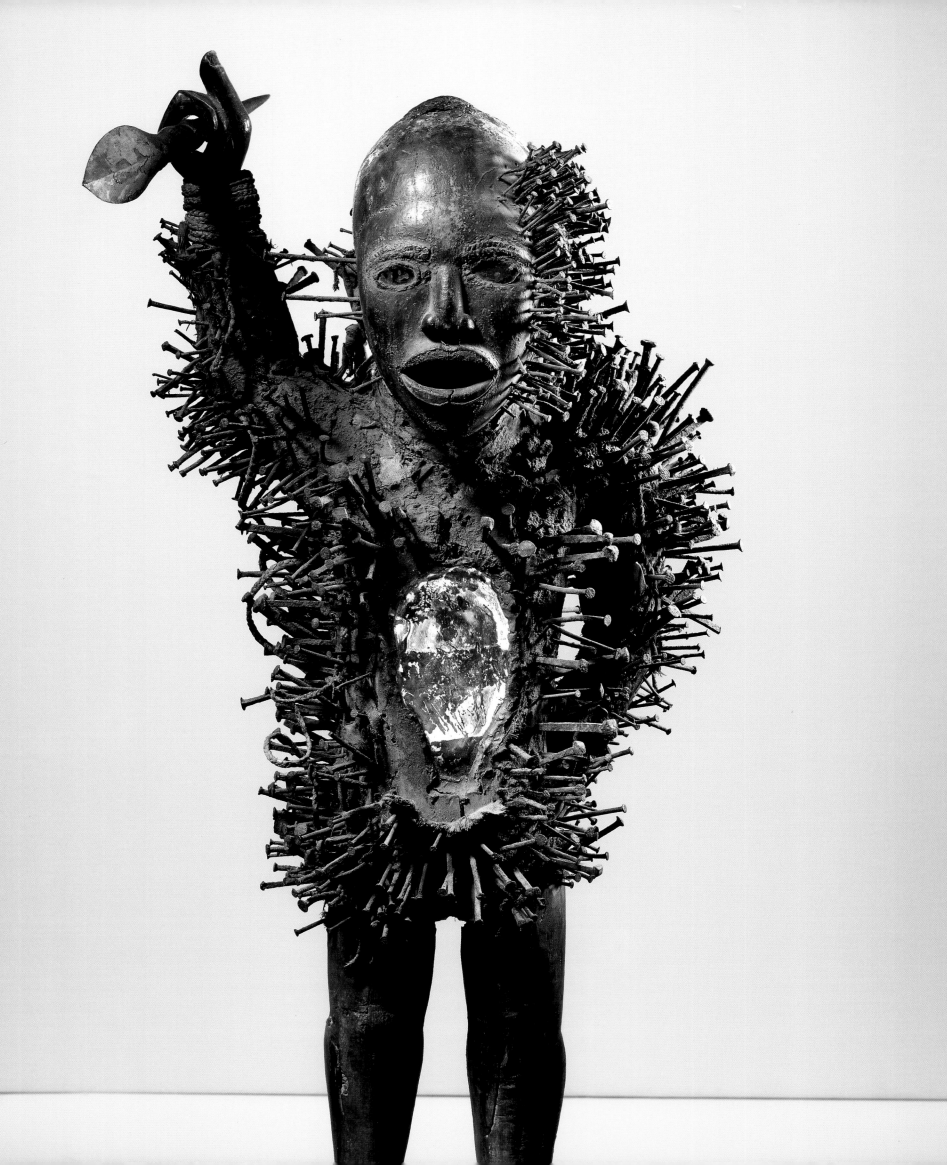

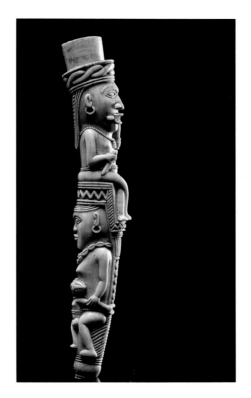

FIGURE, *NKONDI*

Zaïre, Kongo
Wood, nails, iron, cloth, h.97 cm.
Formerly St. Peter Clavier Sodalität
Mission, Fribourg (circa 1905), and Josef
Mueller collections
BMG 1021-5

SCEPTRE

Zaïre, Yombe
Ivory, h. 31 cm.
Formerly Charles Ratton and Josef Mueller
collections (circa 1938)
BMG 1021-18

The formal imagery of *minkondi* relates neither to the particular spirits lodged within them nor to their victims. Instead, it relates to what an *nkondi* is supposed to do. The raised spear and open mouth of the impressive *nkondi* opposite are threatening gestures which may have helped to convince people of its devastating efficacy. The threatening imagery and numerous nails express both menace and counter-menace.

Some *minkondi* were carved with features such as ears which are rendered in naturalistic detail. They are known to have been activated by insults or by the firing off of gunpowder in front of them. As in the case of *minkondi* that were activated by having nails hammered into them (like the one illustrated opposite) such actions served to arouse the "anger" of the *nkondi*. The *nganga*

(ritual expert) directed this "anger" against, for example, the author of his client's grievance, by singing an invocation. The directed "anger", or avenging power, was then "engaged" by the client's words and by his act of licking the bilongo ("magical charge") of the *nkondi*.

The top of the chief's sceptre above may originally have been fitted with a ball of potent, magical substance, effective in countering subversive forces. It also might have been used as a fly whisk, with animal's hair attached. It is decorated in characteristically realistic style, the upper section, appropriately enough, with a chiefly figure seated on a throne. The female figure with child carved beneath represents a very common Yombe theme, perhaps derived from statues of the Madonna and Child.

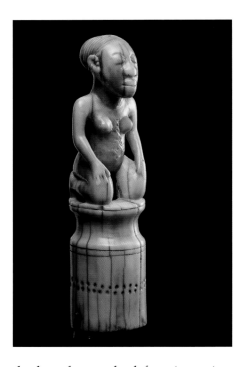

In 1482 when the Portuguese dropped anchor in the estuary of the Congo River they found a large and flourishing kingdom whose capital was to become San Salvador. Treaties with the king were made and missionaries arrived to convert the people. It is difficult to judge the impact of the crucifixes and statues on the carvers in the area. Certainly the art of the lower Congo is very naturalistic and there are many representations of maternity figures which are likely to have been influenced by statues of the Madonna and Child. The exquisite ivory kneeling figure above demonstrates such a naturalism. It would have been the finial to a cane or fly whisk, both symbols of high office. Zdenka Volavka has written that the scarification on the torso of the female is a sign of marriage and the bracelet on the left wrist a sign which conveys complicated semantics, mementoes codified into myths.

To the north of the Congo peoples live the Bembe, best known for their miniature wood carvings of women and hunters, used as charms or placed in shrines, each activated by a magic charge inserted into the anus by the diviner, *nganga*. They also kept the bones of an ancestor in cloth-covered anthropomorphic figures, *mudziri*. The figure, *nkisi*, opposite would probably have been carved for a shrine to assist hunters, not only of animals, but also of sorcerers being tracked down. A *nganga* with the help of an *nkisi* was expected to ward off such evil influences. Three holes cut in the head and body probably held magical substances.

FINIAL

Lower Congo, Yombe
Ivory, h. 15 cm.
BMG 1021-27

FIGURE

Lower Congo, Yombe
Wood, h. 53 cm.
Collected (circa 1927)
BMG 1021-1

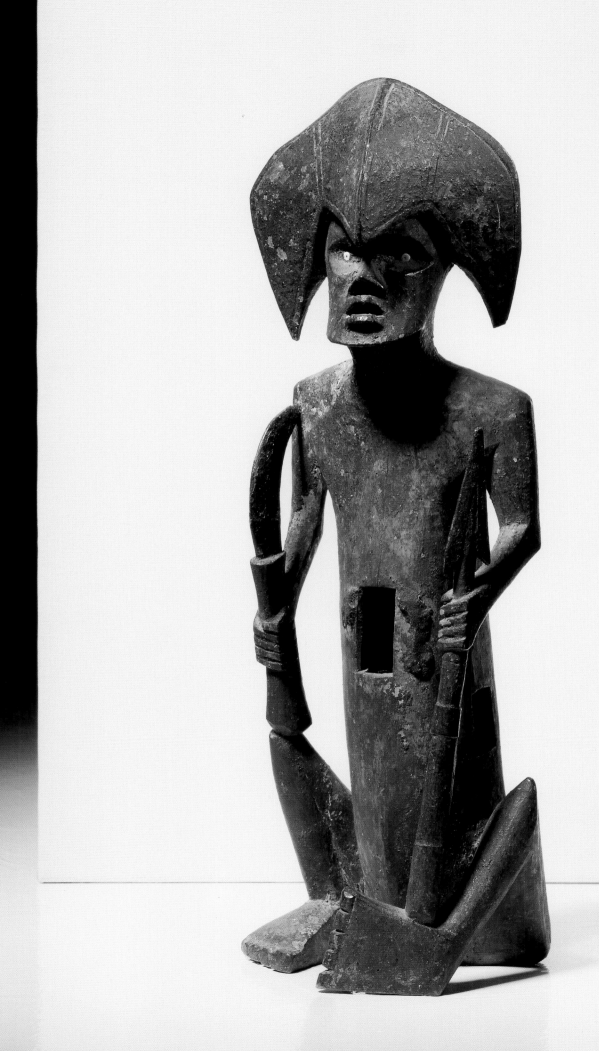

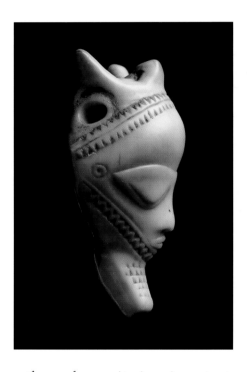

The Pende migrated from Angola to settle in Zaïre around the Loango River. They are not a single political unit—some absorbed certain Lunda religious and political elements, but they all share certain artistic traits such as the triangular cast-down eyes and winged shape for the eyebrows, which are evident in both masks and figurative carvings. Louis de Sousberghe describes a variety of about twenty mask types, used both for important functions at initiation rites, and in others which are more of a public entertainment. They can portray a variety of individuals found in village life—the drinker, coquette, spinster—as well as mysterious beings from the past. The carved wooden masks, known collectively as *mbuya*, are danced with cloth costumes which may also be overlain with a cape or skirt of raffia or leaves—another form of mask is made solely of fibres. A *kiwoyo*, such

as the mask opposite, is an important mask with chiefly references—the dancer holds a fly whisk of office: *mwawa* represents pride and both masks contain references to the elephant and its power. Frank Herreman relates that the *kiwoyo* is one of the masks to close the performance when the farming cycle was paired with the hunt—danced at the edge of the village to ensure the sunrise.

Women wear miniature reductions of the tools used by their husbands as amulets, but the men wear only a miniature mask on a cord about the neck. Carved of wood, ivory or nut, it may even be a reduction of a mask that has been danced successfully to restore them to health after an illness. The *mbuya* are charged with benign or malicious influences, and it is to benefit from or to avoid such influences that the amulets such as the one above are worn

AMULET, *IKHOKO*

Zaïre, Pende
Ivory, h. 6 cm.
Formerly Mrs. G. Duebi-Mueller collection
(before 1939)
BMG 1026-64-2

MASK, *KIWOYO OR MWAWA*

Zaïre, Pende
Wood, h. 53.4 cm
BMG 1026-216

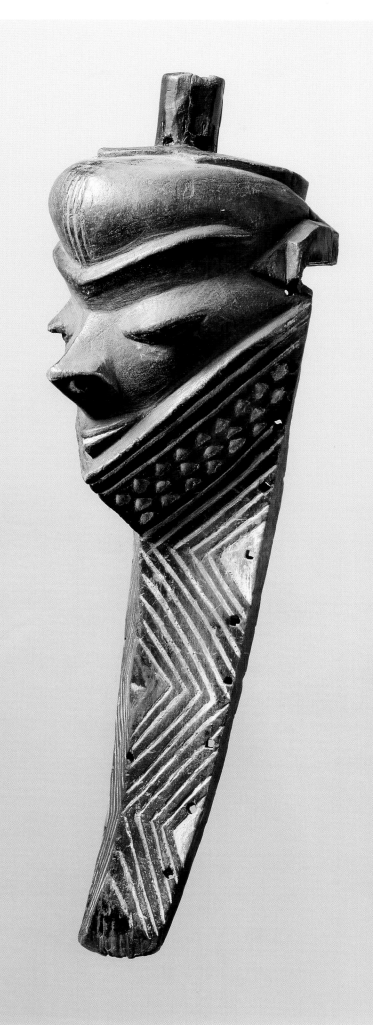

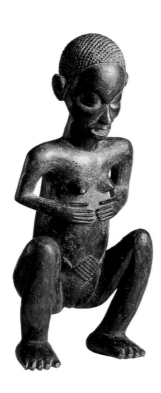

The Kanyok (also called Bena Kanioka, etc.) live to the south of the Luba Shankadi and to the north of the Lunda, in Zaïre. Their main town, Kanda Kanda, became a successful trading post at the end of the last century. Cornet has plausibly suggested that the sculptor who produced a number of carvings characterised, amongst other traits, by a neat cross-hatched coiffure with two knobs over the nape of the neck, may have been a Chokwe who was influenced by the local style and in turn influenced others. Many of his carvings are reminiscent of those found on Chokwe chairs—in fact the crouching figure (above) is a popular motif among the Chokwe and Lulua.

Masks play an important part in the lives of the Lwalwa, who live near the Kasai river where it forms the border between Angola and Zaïre.

Carved from *mulela* wood and reddened with the fruit *mukula* from *Bixa orcellana*, there are four types, three masculine and one feminine, two of the masculine, *nkaki* and *mvondo*, being almost identical, and sharing with the female, *mushika*, the long thin nose within a concave lenticular face. The fourth, *shifola*, has a short fat nose: *mushika* has an additional carved crest. Sculptors are a privileged caste of the community—a successful sculptor can accumulate wealth, become a chief and organise dances—and the Lwalwa are renowned dancers. In one dance, called *balongo*, young men between the ages of fifteen and twenty perform to two drums and two xylophones a vigorous sequence that terminates in a series of airborne somersaults. The masks are danced after an unsuccessful hunt to placate the spirits in the forest.

FIGURE

Zaïre, Kanyok
Wood, h. 31 cm.
Formerly Josef Mueller collection (before 1942)
BMG 1026-13

MASK

Zaïre, Lwalwa
Wood, h. 31.8 cm.
Formerly Vrancken collection, Brussels
BMG 1026-218

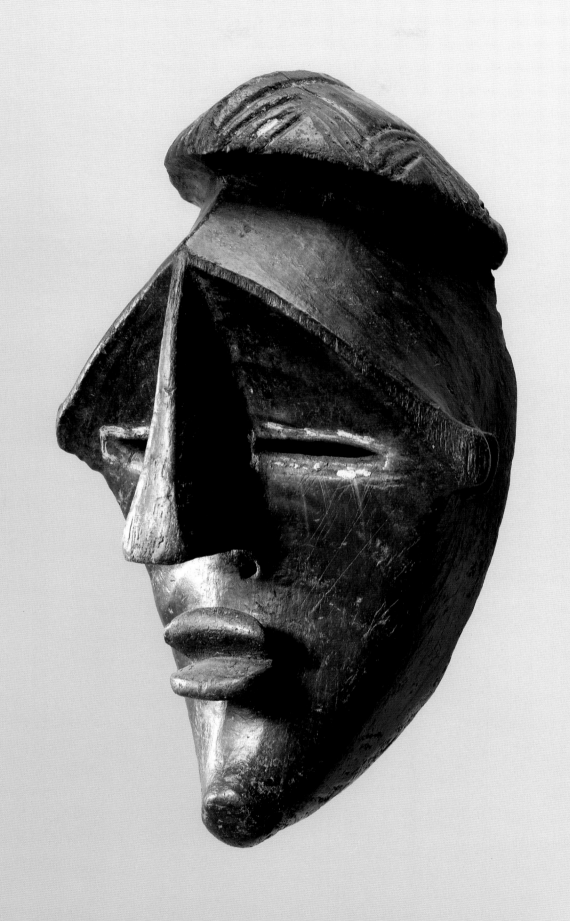

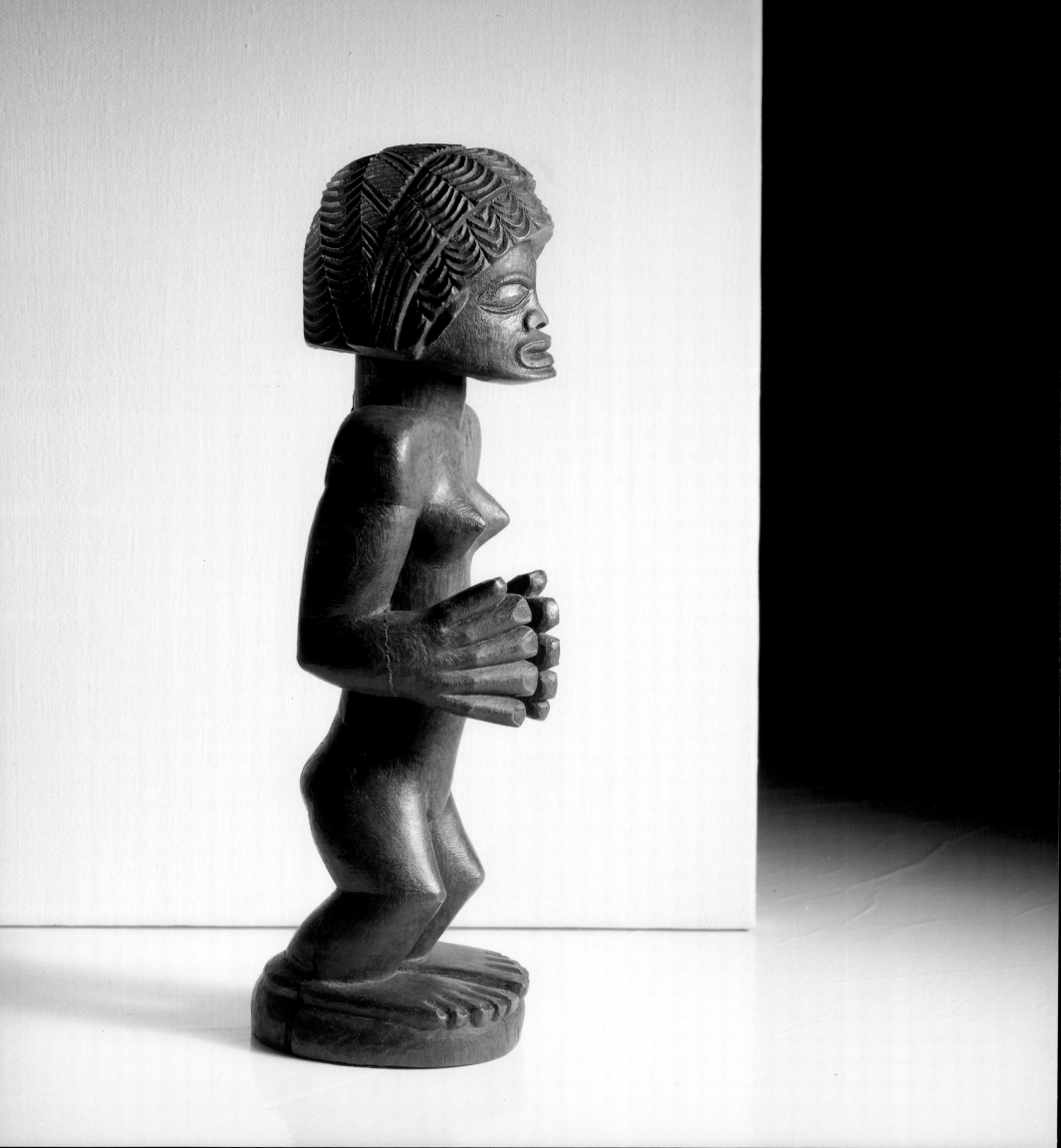

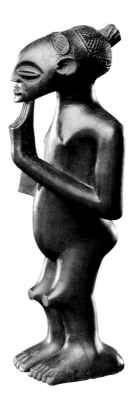

FIGURE, *NAMATA*

Angola, Chokwe
Wood, h. 33 cm.
Formerly Josef Mueller collection (before 1939)
BMG 1028-7

FIGURE

Angola, Chokwe or Shinji
Wood, h. 19.7 cm.
Formerly George Feher collection, New York
BMG 1028-37

The divine sovereigns of the Chokwe, who lived in the highlands at the headwaters of the rivers Kwango and Kasai, presided over courts which demanded elaborate regalia and carvings for their use. These were commissioned by them from their extremely gifted carvers, who managed to combine an expression of strength with an attention to detail that is without parallel in Africa; their achievements reached a zenith early in the last century.

Marie-Louise Bastin classifies the style of the fine carving opposite, of a *Namata* (the chief's principal wife), as a Mussamba sub-style. She also remarks on how carefully the sculptor has carved the finger nails, which reflects the care a chief would take of his hands. The lines of the coiffure reproduce the *mahenga* design, with its characteristic curves—such motifs having the force of ideograms, with allusions to the human, animal, vegetable and supernatural world

That the Chokwe people possess the most versatile as well as the most gifted carvers is evident in the curious figure above, where classicism and originality are combined. Marie-Louise Bastin thinks that the figure, which appears to have no sex, might be from the Shinji, a Chokwe-related group living in Angola on the right bank of the Kwango River. She also suggests that the figure may represent *Saishimo*, a spirit whose traditional stance is shown as holding his left hand to his mouth, whilst he wishes to declare his bitterness at being neglected. Cavities at the top of his head and at his abdomen for charged material would support this idea, as would the sexlessness.

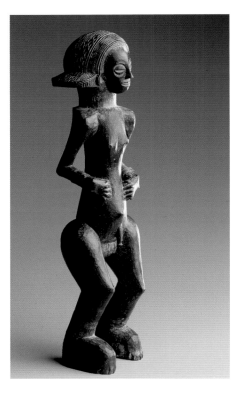

The Songo live to the north of the Chokwe and south of Malengue, a trading center for routes into the interior, well placed for contacts with early explorers. They have many cultural ties with their neighbours, the Chokwe, and the art of the two people is often difficult to tell apart.

The male figure above was collected in Malengue by Dr. Ramão between 1885 and 1895. Marie-Louise Bastin observes that the helmet-like hairdo is a stylised representation of the braided coiffures described by Max Buchner as worn by Songo women on his visit of 1879.

An early traveller recorded the Lwena as merry by nature, intelligent and cultivated. Living on the Upper Zambezi, they are another group who were founded by Lunda chiefs at the end of the sixteenth century, and share many cultural characteristics with their Chokwe neighbours. They earn their living mainly by catching and processing fish for trade. The Lwena also have a mask which represents a beautiful woman, *pwevo*, the headdress often composed of strands of hemp which fall each side of the face, as in the mask opposite. Teeth filed to points are regarded as an enhancement amongst the Lwena,— a compliment to a local beauty might be "Your teeth are like those of the *kasangi* fish in the river".

In Angola the *pwevo*'s dance is simple and graceful, but amongst the Zambian Lwena (or Lovale) the mask—more recently— performs in a spectacular manner some thirty feet above the ground, on a rope slung between two poles.

FIGURE

Angola, Songo
Wood, h. 28.5 cm.
Collected between 1885 and 1895.
Formerly Dr. Ramão collection, Lisbon
BMG 1028-36

MASK, *PWEVO*

Angola, Lwena
Wood, hemp, h. 19 cm.
BMG 1028-32

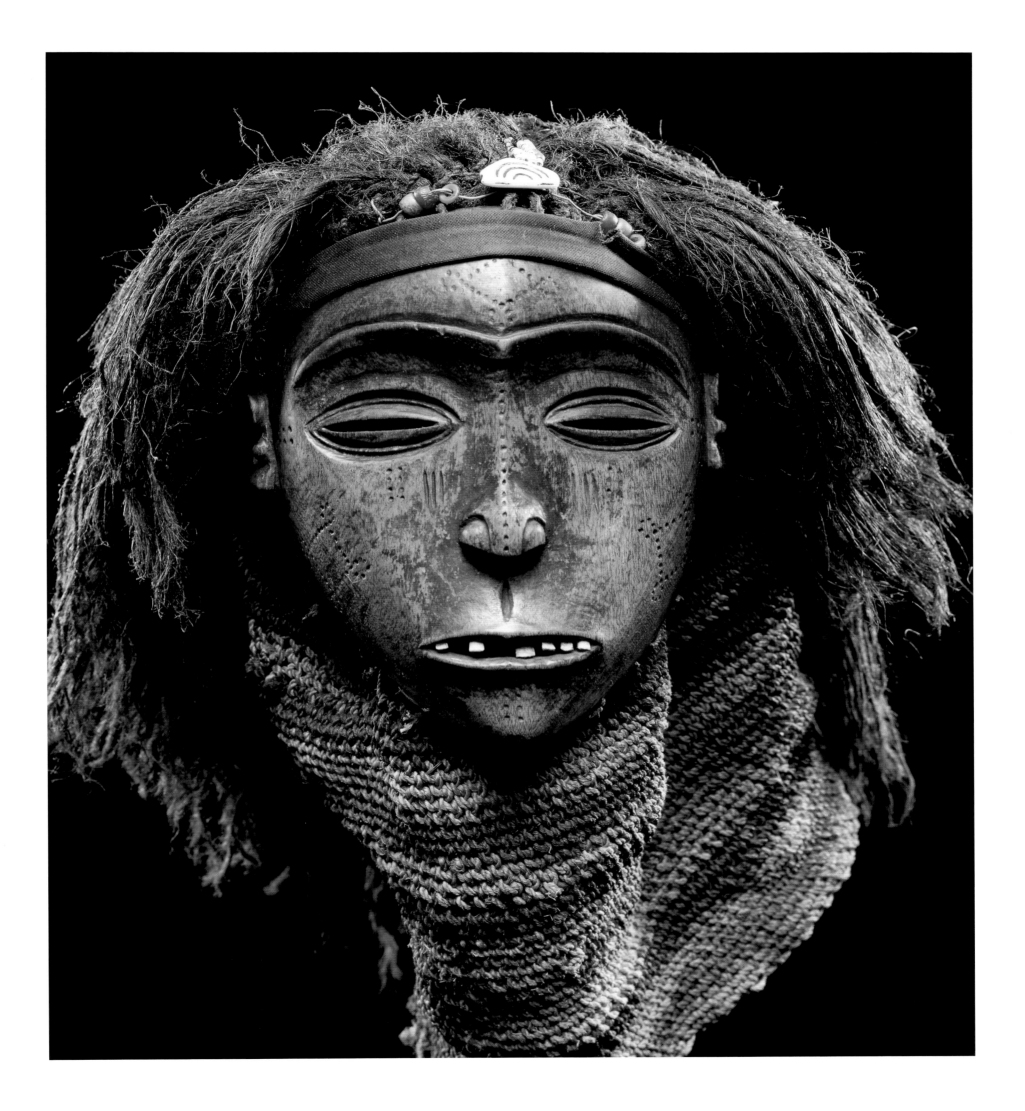

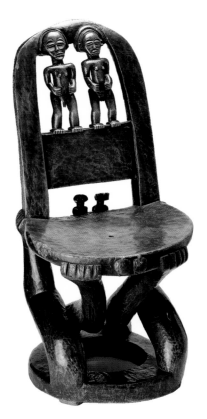

An important chiefly accoutrement among the Chokwe was a throne in the form of a lavishly decorated stool or chair. The Chokwe were receptive to the new ideas they received at the end of the eighteenth century, in their position on the trade routes from the coast of Angola into the interior, and soon adopted new forms from the Portuguese. The shape of the chair above is a particularly rare one. Carved from a single piece of wood, the crossed legs are reminiscent of the travelling "deck" chairs used by colonials. The four vertical notches at the rim above each support suggest fingers grasping the edge of the circular seat. The two figures beneath the arched back represent a chief, *Mwanangana*, and his chief wife, *Namata*; two smaller protec-tive spirits, *mahamba*, are carved on the back of the seat rim, facing out-wards.

The mask shown opposite, called *Sachihongo*, was worn with an elabo-rate costume knitted from thread made from the bark of the *musham-ba* tree (*Brachystegia bolchini*) and skirts of grasses and palm leaves. The wooden face mask would have had a crest of feathers and a fibre beard. The dancer represented a hunter who used bows and arrows (as opposed to the hunter with a rifle), an important character in the *Makisi* masquerade performed by the Mbunda during the second phase of circumcision rites, which involved preparations for the return to the village of the initiates, no longer as boys but as men.

CHAIR

Angola, Chokwe
Wood, h. 62.8 cm.
Formerly Marc and Denyse Ginzberg
collection, New York
BMG 1028-33

MASK, SACHIHONGO

Zambia, Mbunda
Wood, h. 42.5 cm.
BMG 1028-34

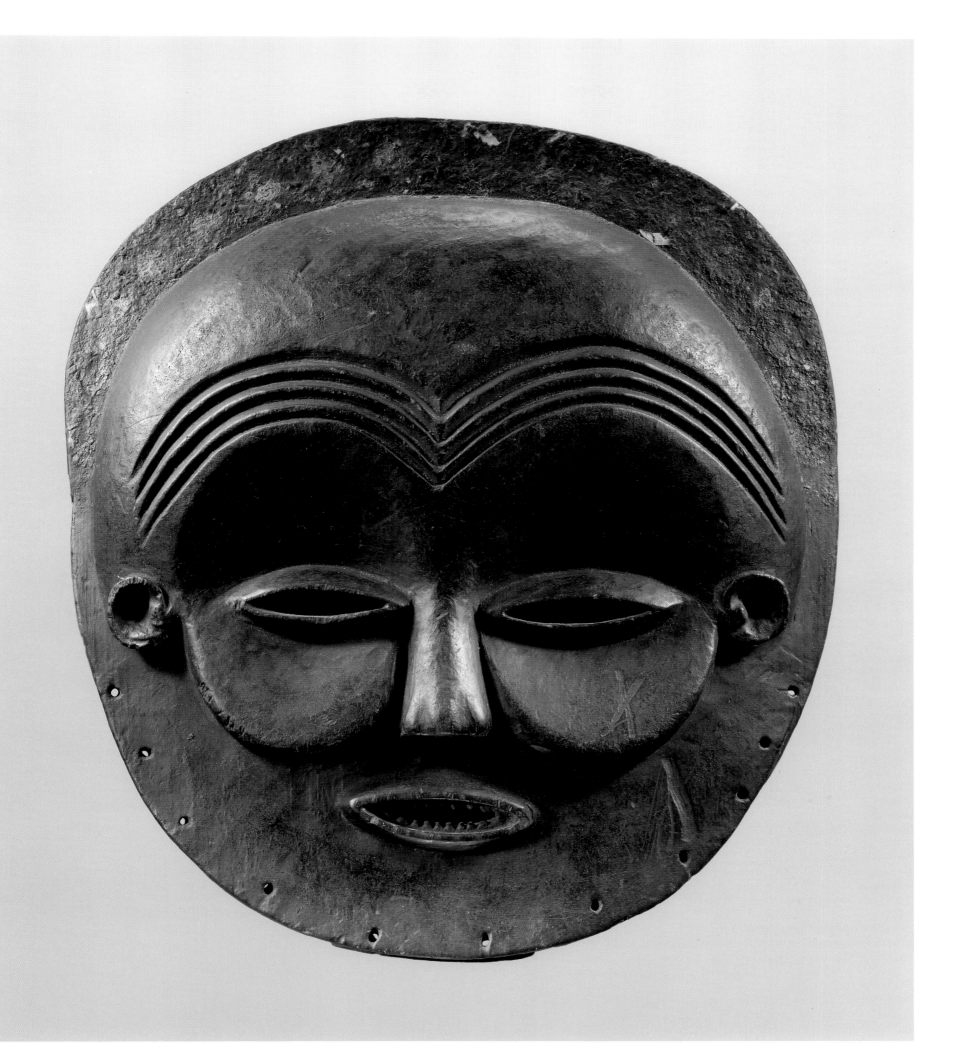

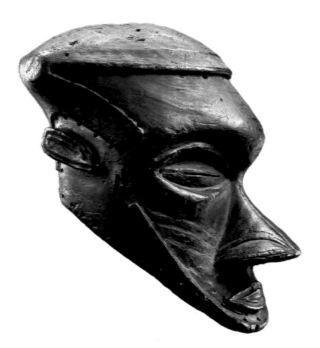

Between the Kasai and Sankuru rivers in Zaïre live a federation of eighteen linguistically related peoples called the Kuba. Their history relates that an ancestor-hero, Woot (or Woto) led them to the area and founded the dynasty over fifteen hundred years ago. Their ninety-third king early in the seventeenth century introduced the embroidered pile cloth for which they are now famous—the king wears meters about his waist on ceremonial occasions. The stratified system of chiefly hierarchies at court is reflected in the masquerades. The Kuba have about ten mask types of which only three are royal—*Mwaash aMbooy*, which represents a son of Woot, *Ngady mwaash aMbooy*, the sister-wife of Woot and *Bwoom*. It is the last type that is illustrated above. Originally said to have been given to King Miko Mi-Mbul in the seventeenth century by a pygmy, the mask represents a spirit. It is the first spirit seen by the initiates of the *Nkam* society, when

it represents the ancestor. It never appears at funerals. In performances at court it has the role of a commoner competing with the royal *Mwaash aMbooy* for the affections of *Ngady mwaash aMbooy*, the mask type illustrated opposite.

Masks which show evidence of age and use, such as these, are rare. Early period Kuba raffia pile cloth has been used in the construction of the headpiece opposite, coloured bark cloth for the neck covering. The complex pattern of triangles with which the face is decorated is very fine—the row of beads extending over the nose and lips is often a feature of Kuba royal masks. The *Bwoom* is always of a more simple form—the identification of the mask as a pygmy or hydrocephalic man is often cited to explain the enlarged forehead and broad nose.

MASK, *BWOOM*

Zaïre, Kuba
Wood, h. 40 cm.
BMG 1026-61

MASK, *NGADY MWAASH AMBOOY*

Zaïre, Kuba
Wood, fibre, cowries, beads, h. 32.4 cm.
BMG 1026-189

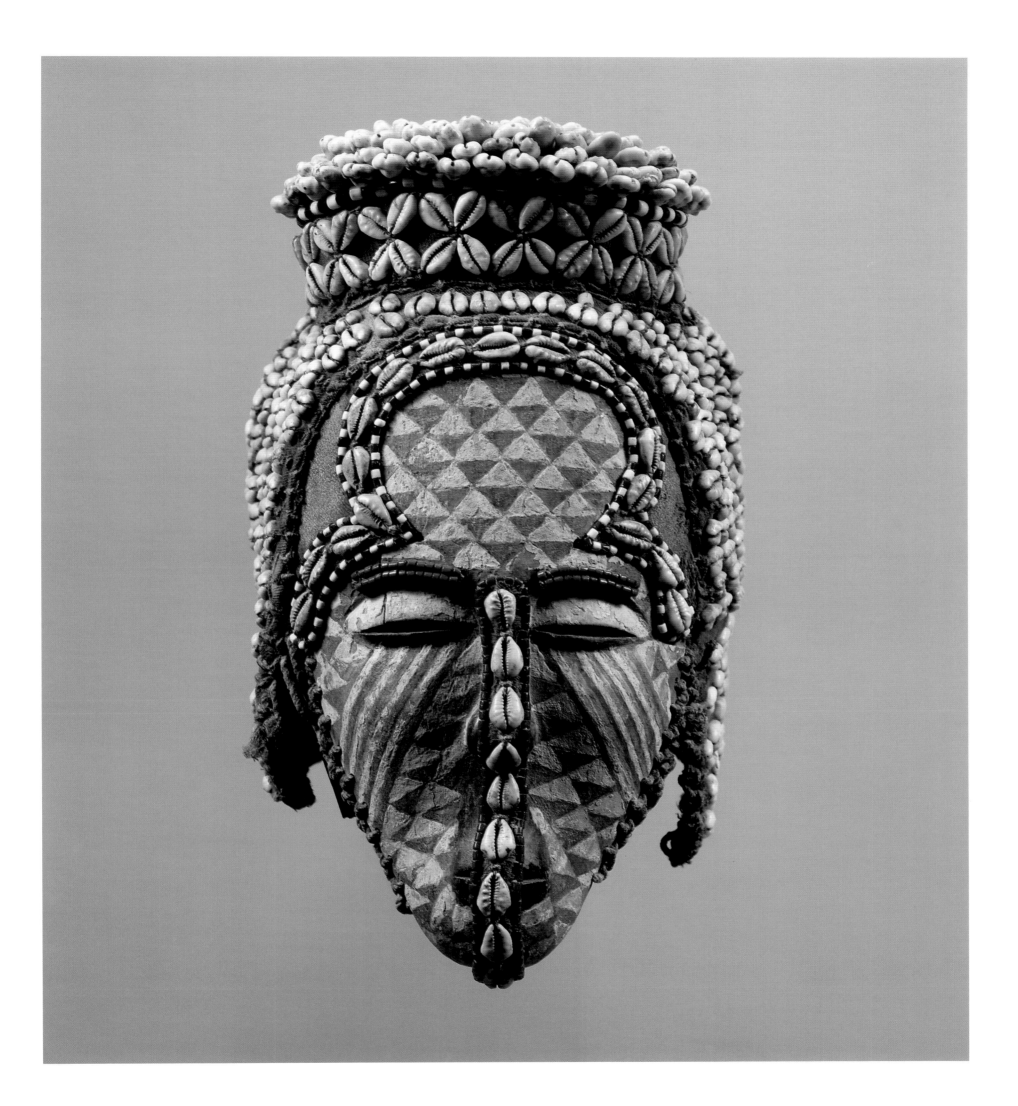

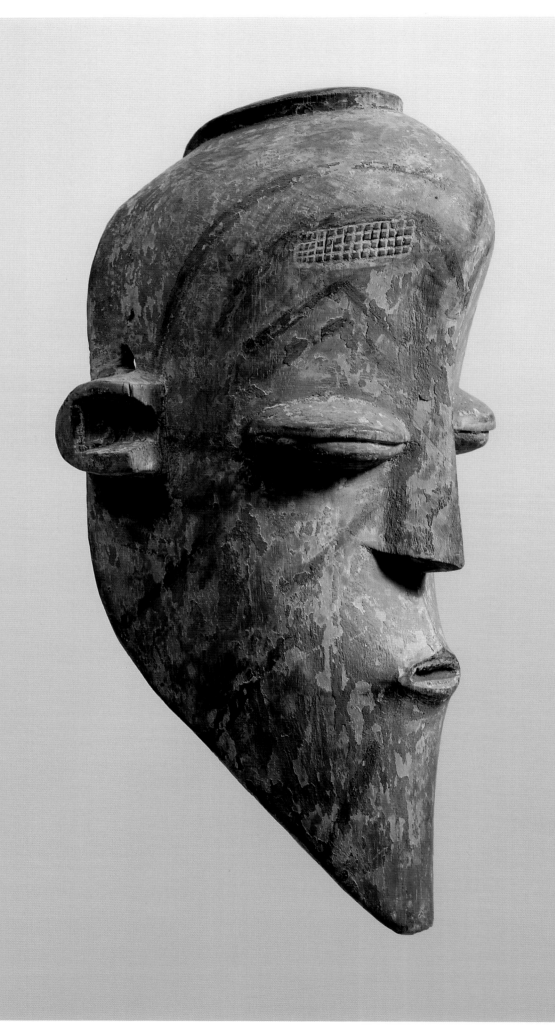

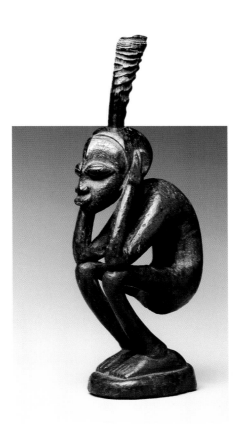

MASK

Zaïre, Lulua
Wood, h. 43 cm.
Formerly Charles Ratton, André Lhote,
Olivier Le Corneur collections
Exhibited in 1931 (African masks selected
by Charles Ratton) and in 1935 (African
Negro Art, Museum of Modern Art,
New York)
BMG 1026-30

FIGURE

Zaïre, Lulua
Wood, horn, h. 24 cm.
Formerly Essayan collection, Paris
BMG 1026-11

The Lulua share many social traits with the Luba to the east of them, and their geographical position on the Kasai river has exposed them to confrontations with the Kuba, Pende, Chokwe and Songye during vicissitudes in the history of those peoples—whose art also is reflected in many aspects of Lulua art.

The mask opposite, which formerly belonged to the artist André Lhote, is attributed to a carver of the Bakwa Ndolo, a sub-group of the Lulua. It represents a spirit of the dead, worn by a masquerader who performed during circumcision rites. The mask is not decorated with the profusion of scarifications so characteristic of the Lulua figures. It has traces of the black and white pigments which are used as references to the spirit world. A similar style of mask is found among the Nsapo, a Songye sub-group who were driven into Lulua territory during the second half of the nineteenth century.

The cursive form of the crouched figure was greatly favoured by the Lulua, who may have originated the style or borrowed the idea from their southerly neighbours, the Chokwe, who carved many charms and small objects as hunched figures. The Nsapo also carved crouched figures and the Songye influence can be seen in the figure above with the horn inserted in the crown of the head. The Songye invariably placed horns of the duiker, sitatunga and other antelope in a cavity at the top of the heads of their carved figures. The horns would have held charged substances activated by the diviner to perform a special function.

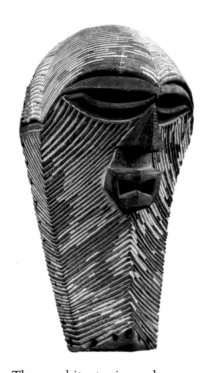

The Songye inhabit the Katanga and Kasai regions of Zaïre, surrounded on every side by the Luba and Luba-related peoples—in fact they may have been the first to emigrate into Zaïre from the north, followed by the Luba to whom they are related in culture and language. The *kifwebe* cult, which takes its name from the word meaning "mask" to the Songye, is thought to have been started at the beginning of this century, when its function was connected with the social control of women and children. Willie Mestach divides the "classical" style of *kifwebe* into three categories, the male *kilume*, with a high crest, the female *kikashi*, with a shallow crest or no crest at all, and the powerful *kia ndoshi*. The mask above is clearly of the female variety. Such masks as this one also appear with *mankishi* on the first day of a new moon.

The architectonic volumes so favoured by the Songye are also found in the carved figures, with their squared shoulders, large hands and massive feet. Known as *mankishi* (sing. *nkishi*), the statues served the well-being of the community or an individual as a benign influence, with anti-sorcery magical powers. The statues only performed under certain prescribed conditions to placate spirits: they are integrated into the community, fed, anointed and sacrifice to, as appropriate. Another purchase made by Josef Mueller before 1939 from the painter Maurice Vlaminck, the figure opposite reflects in its curious hairstyle the way the Songye formerly shaved the hair above their foreheads.

MASK, *KIFWEBE*

Zaïre, Songye
Wood, h. 34 cm.
BMG 1026-110

FIGURE, *NKISHI*

Zaïre, Songye
Wood, beads, metal, leather, h. 64 cm.
Formerly Maurice de Vlaminck and Josef
Mueller collections (before 1939)
BMG 1026-14

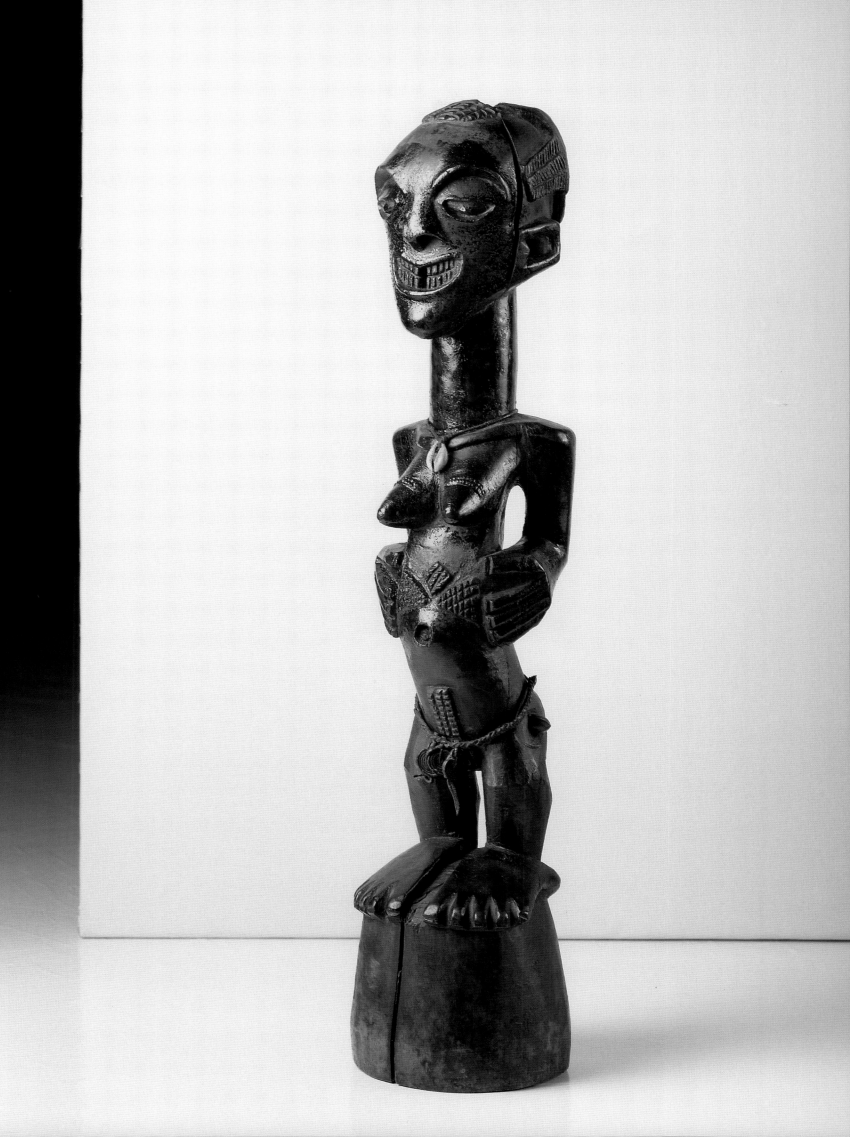

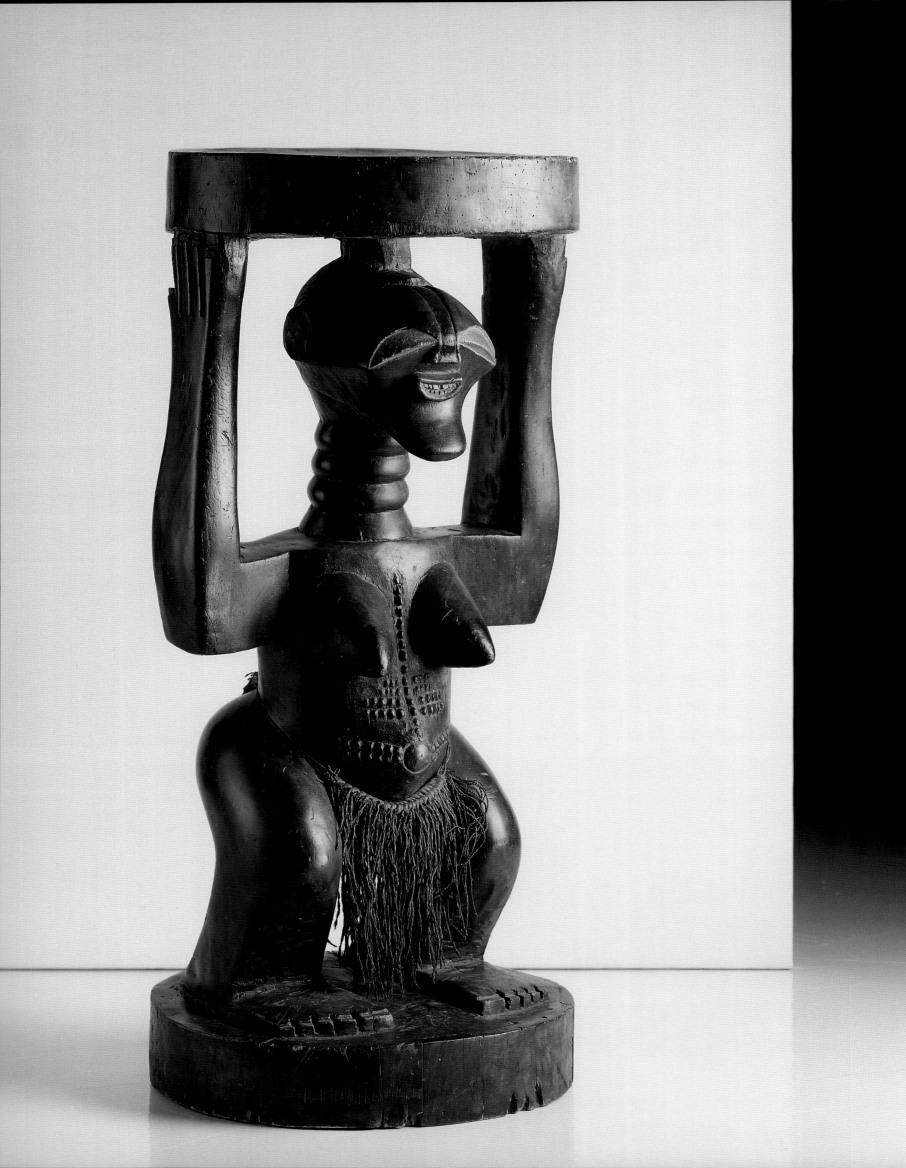

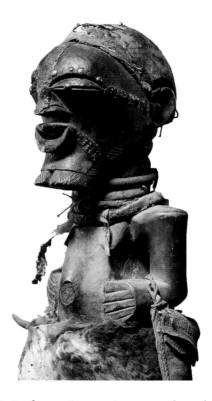

PRESTIGE STOOL

Zaïre, Songye
Wood, fibre, h. 69 cm.
Formerly Josef Mueller collection (before 1942)
BMG 1025-16

FIGURE, *NKISHI*

Zaïre, Songye
Wood, feathers, metal, beads, skin, h. 69 cm. (Restored)
Formerly Josef Mueller collection (before 1942)
BMG 1026-56

It is always interesting to see how far a carver working within the artistic canons of a society can stretch those limits and still produce a work that is accepted by his community. The architectonic qualities of Songye sculpture are evident in the magnificent prestige stool opposite, produced by a master-carver who worked between 1900 and 1925. Songye prestige stools are akin to those used by their neighbors, the Luba. J.D. Flam sees the figures as symbolic ancestors, a link between the living and the dead, an affirmation both of the power of the chief and of ancestral continuity.

Pictured above is another benign magical statue, *nkishi*. *Mankishi* were given the physical attributes of a man with the strength and social rank comparable to its mystical power. Thus its clothing and accoutrements reflect the power and status of a chief, smith, hunter or witchdoctor and the protuberant abdomen fertility and the continuation of the lineage. Spirits do not inhabit the figures, they project their power through the statues which are symbolic of the interaction between the living and the dead. The essence of mystical forces derives from the substances in horns inserted into the head or into the abdominal cavity—ingredients, *bishimba*, which are a secret of the diviner, the human intermediary. The guardians, *nkunja*, of the hut in which *mankishi* were stored near the center of the village, lived under restriction because they received messages through the statues in dreams or during possession.

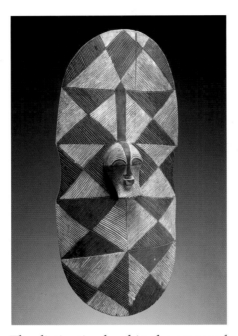

The distinctive head in the center of the magnificent shield illustrated above—and a detail of which is shown opposite, is modelled after the *kifwebe* mask form of the Eastern Songye, a form which was adopted by some of the neighboring Luba. In fact the artistic content of this shield, which was illustrated by Michel Leiris and Jacqueline Delange in 1967, proved so popular that it is believed many shields of a similar design to this one were carved after the photograph of it published by them in their book on African art. Such shields were hung on the walls of the huts where the *kifwebe* masks were stored—it is unlikely that they were used for combat, but rather served a symbolic purpose.

The smiths of the Songye, an industrious people, are also well known for the weapons they produce which are widely traded—a Songye axe has even been found in the Khami ruins in Matabeleland, Zimbabwe.

SHIELD

Zaïre, Songye
Wood, h. 76.5 cm.
Formerly Charles Vignier and Josef Mueller
collections (before 1939)
BMG 1026-111

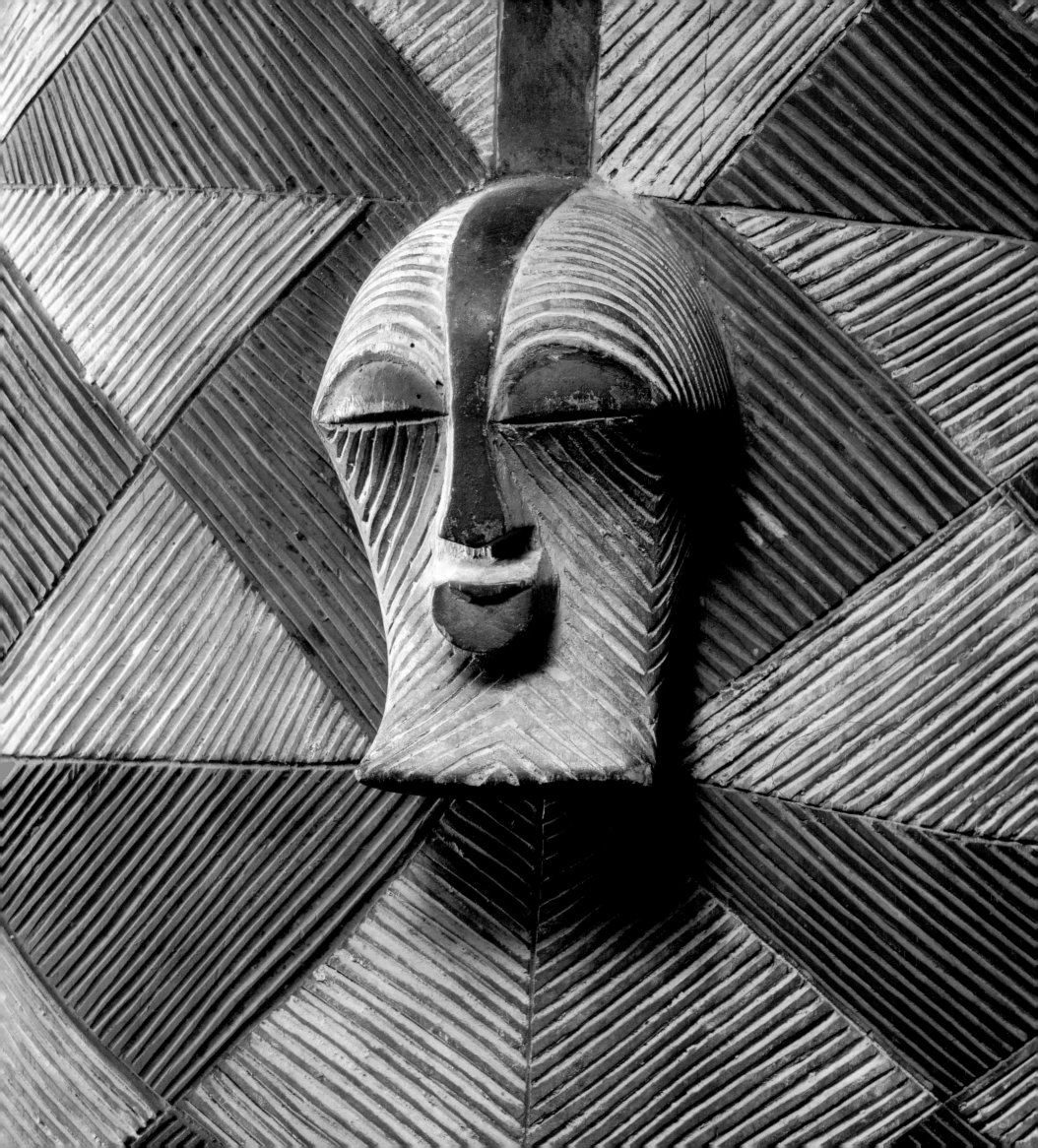

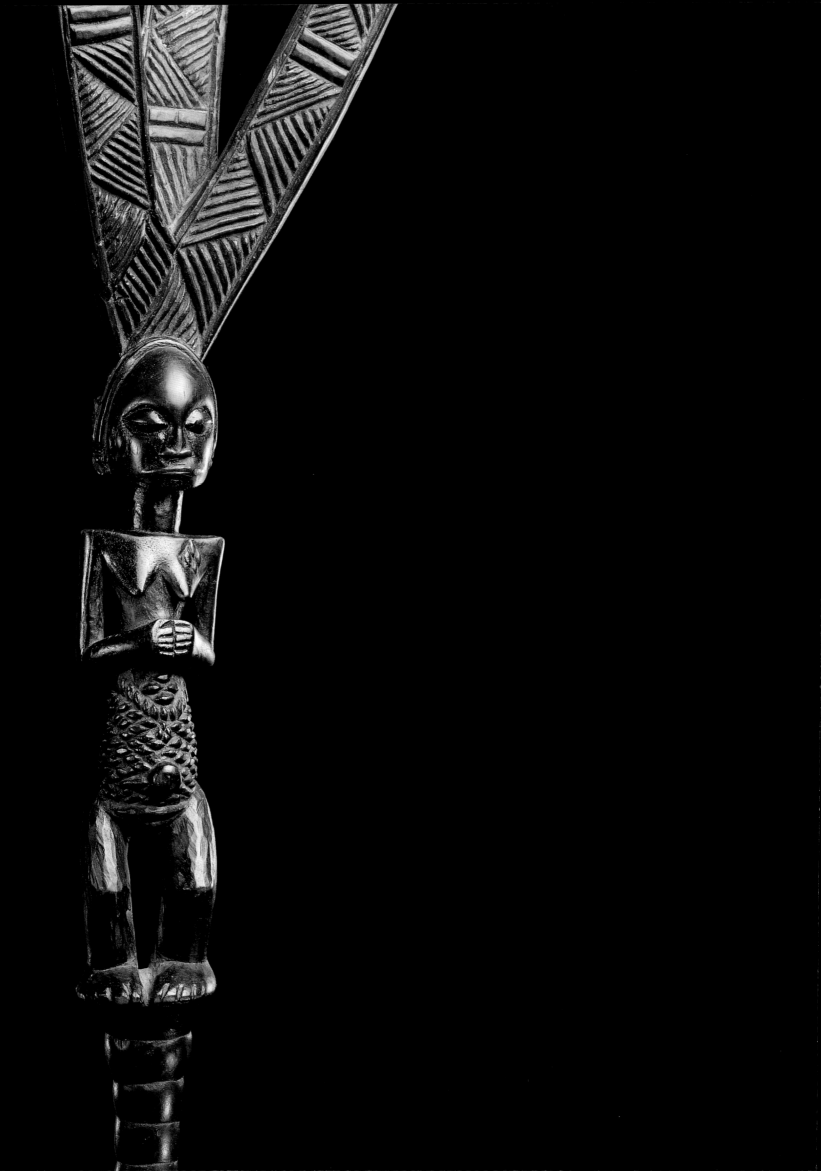

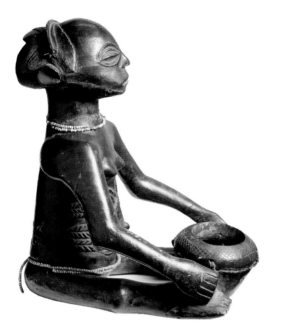

BOW-STAND

Zaïre, Luba-Hemba
Wood metal, h. 80 cm.
Formerly Geneviève Rodier collection

BMG 1025-1

STATUE

Zaïre, Luba-Hemba
Wood, beads, metal, h. 28 cm.
Formerly Josef Mueller collection (before 1939)
BMG 1026-116

The Luba are composed of numerous tribes in south-eastern Zaïre, of disparate origin and social organisation, who share an important cultural and linguistic entity, and had great influence on other peoples. Polly Nooter describes how treaties, alliances and debts were forged or settled through the exchange of insignia during the eighteenth and nineteenth centuries from Luba courts to outlying chiefdoms. However the bow-stands, like the one opposite, were never intended for public view, and certainly not outside the courts. They were kept in a shrine into which only the king and one official had access. These precautions were taken not only to ensure against theft, but to protect viewers from the tremendous power of the objects. Nooter also explains the complicated question of the presence of female figures in Luba art as the conceptualisation of Luba kingship as ambiguously female in gender. She quotes Ngoy Kasongo as saying "men are chiefs in the daytime but women become chiefs at night". Kings are reincarnated by female spirits after death.

Nooter describes how bowls held by female figures, such as the one above, are emblems owned both by royal diviners and kings and chiefs. They were sometimes kept at the door of the royal residence, filled with kaolin, the white clay associated with purity, renewal and the spirit world. Visitors were expected to take the kaolin to smear on their chests and arms, and to spread on the ground before the king as a gesture of respect. In the past such figures have been wrongly identified as *mendiantes*—beggar women. Nooter explains that the figure represents the wife of the diviner's possessing spirit, thus underscoring the role of the diviner's actual wife as an intermediary in the process of invocation and reinforcing the Luba notion of women as spirit containers in both life and art.

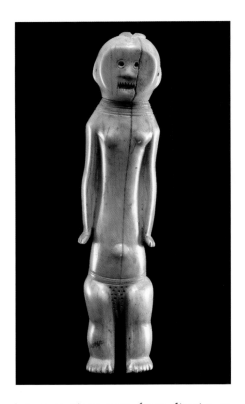

The *Bwami* association of the Lega, who live near Lake Kivu, is not a secret society because membership is open to all, but as an individual progresses up the ranks, his comprehension increases. The use of the ivory objects made for the association is restricted to members of the two highest grades, *yanino* and *kindi*. A *kindi* is not a ruler, a chief or an autocrat, but, to quote Daniel Biebuyck "the great one who is known among the good ones".

Ivory carvings, *maginga* (sing. *iginga*), whether individually or collectively held, are associated with the *lutumbo lwa kindi* grade, regarded as the "heart" of *kindi*. Each carving is associated with at least one aphorism, which identifies it and gives it a name. The semantics are usually incomprehensible to an outsider and interpretations vary from district to district. The figures are stylised in a variety of ways, the one above being cylindrical in concept, but they are never treated naturalistically.

The mask opposite is carved for a male initiate to the second highest grade of the *Bwami* association—*lutumbo lwa yananio*. Biebuyck reports that such masks are never worn in front of the face, but are held in the hand, under the chin, and so forth, in various rites—they were sometimes placed on a fence whilst their associations were explained to the initiates. The mask is not named for an ancestor, but suggests death and contacts between the living and the dead. The fibre beard, *luzelu*, is symbolically associated with elders and senior initiates.

FIGURE

Zaïre, Lega
Ivory, h. 19 cm.
Formerly Josef Mueller collection (before 1939)
BMG 1026-5

MASK, *LUKWAKONGO*

Zaïre, Lega
Wood, h. 18 cm.
BMG 1026-3

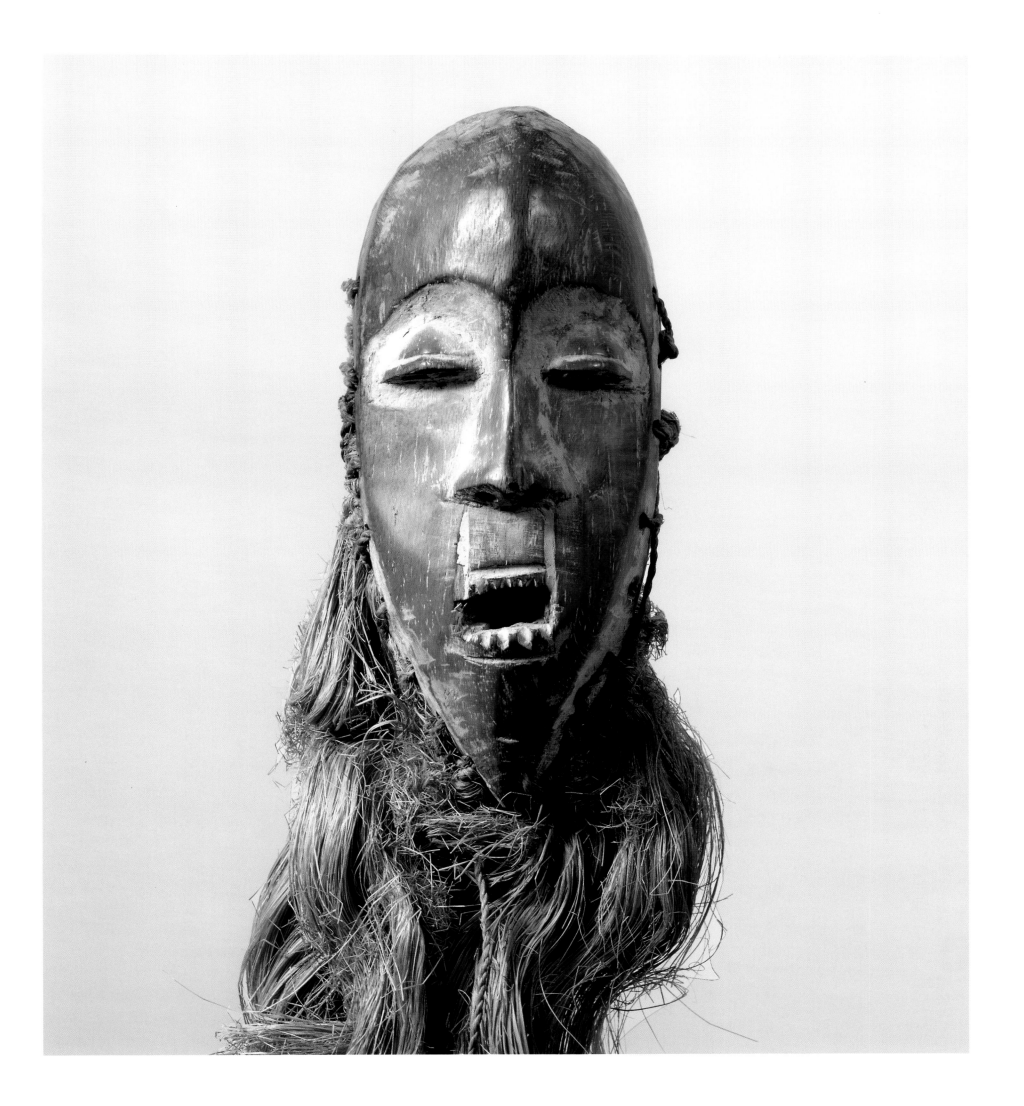

The Tabwa, who live to the west of Lake Tanganyika, appear to have used very few mask types and little is known about their masking traditions. The buffalo mask appears to have been the only animal mask carved by them, worn with a costume of animal skins and raffia. The mask shown here has handles cut in its sides to enable the dancer to hold it above his head as he performed. In previous times the buffalo was hunted by members of the *Bambwela* hunter's guild, and it retains an important cultural significance—for instance, in making a buffalo tail fly-whisk to ward off disease and magical attack, the aggressiveness and strength of the buffalo is invoked to ensure the whisk's efficacy. Buffaloes are feared for their unpredictability which is seen as an indication of their dual nature, a trait comparable with culture heroes and also chiefly authority. The buffalo mask itself may be called *kiyunde*, which is a term that can also relate to trans-

forming activities such as healing and iron smelting.

The mask above is decorated with crossed lines of upholstery nails which reproduce a pattern of facial scarifications popular among the Tabwa until early in the present century. The lines emphasise a spot above the bridge of the nose which is said to be the site of dreams, wisdom and "transforming vision". It is also a site of resolution and mediation between contradictory principles. This allusion to wisdom, transformatory power and mediation in the name and imagery of the mask suggests that the buffalo mask performances may have played a special role in rituals of chiefly empowerment. In any event the masks would have played an important role in one or more of the Tabwa rites of transformation.

MASK

Zaïre, Tabwa
Wood, cowries, upholstery nails, w. 73 cm.
BMG 1026-58

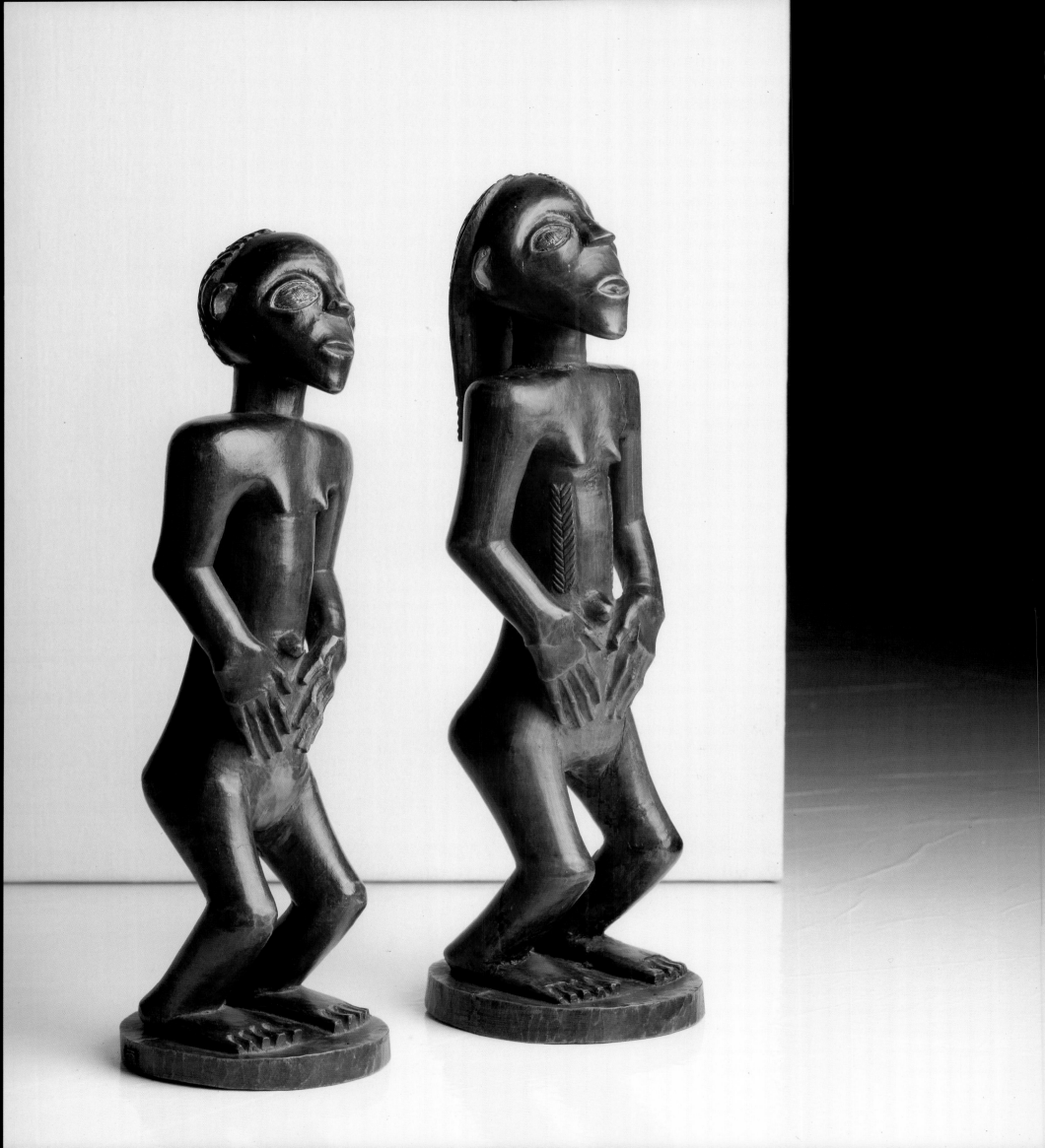

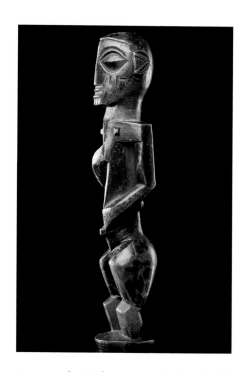

PAIR OF FIGURES

Zaïre, Tabwa
Wood, brass, h. 32 cm. and 30 cm.
Formerly André Fourquet collection, Paris
BMG 1026-157 A & B

FIGURE

Zaïre, Bembe
Formerly Marc and Denyse Ginzberg
Collection, New York
Wood, h. 27.7 cm.
BMG 1026-171

Among the Tabwa part of the chief's authority derived from his performance of rites associated with the cult of the lineage founders and other important ancestors. The two figures illustrated opposite are ancestor figures which would originally have stood in a shrine installed close to the house of a chief. They appear to represent a pair—a male and a female figure—but their genitals have been removed, apparently while in possession of a religious congregation during the first quarter of the present century. The taller figure with carved braided tress undoubtedly represents a male, because this hair style was a male prerogative. An interesting feature of this figure is the vertical line of keloid scarifications down the middle of the forehead and on each side of the thorax. The Tabwa have a generic term, *mulalambo*, for various lines which demarcate the symmetry of the universe. The mid-line of the human body is one such *mulalambo* and Tabwa perfected their bodies by emphasising this line with scarification marks. The line connects the head with the loins and divides the human body into left and right poles associated with opposed principles. It has its center at the navel which is the point of origin for individual identity. Many Tabwa ancestor figures are carved with their hands placed on the abdomen, which probably symbolises continuation of the lineage and the enduring link between deceased ancestors and their living descendants.

The remarkable angular figure illustrated above is probably a rare didactic sculpture used only in rites associated with the higher grades. Such figures may serve as emblems of rank and to help impress upon the initiates the high moral and philosophical principles of the association.

The peoples of north-eastern Zaïre have evolved elegant forms for the slit drums they play. The large drums, often zoomorphic in form, are placed on the ground and can produce tones of different pitch. Others, like the drum to the right, are portable and when struck with a rubber-covered wooden mallet produce tones of the same pitch. They are worn on cords tied to the lateral lugs and slung about the drummer's shoulders—generally carried by groups of players to provide a means of communication for military expeditions.

DRUM

Zaïre, Momvu
Wood. 81 cm. x 36 cm. x 9 cm.
BMG 1026-241

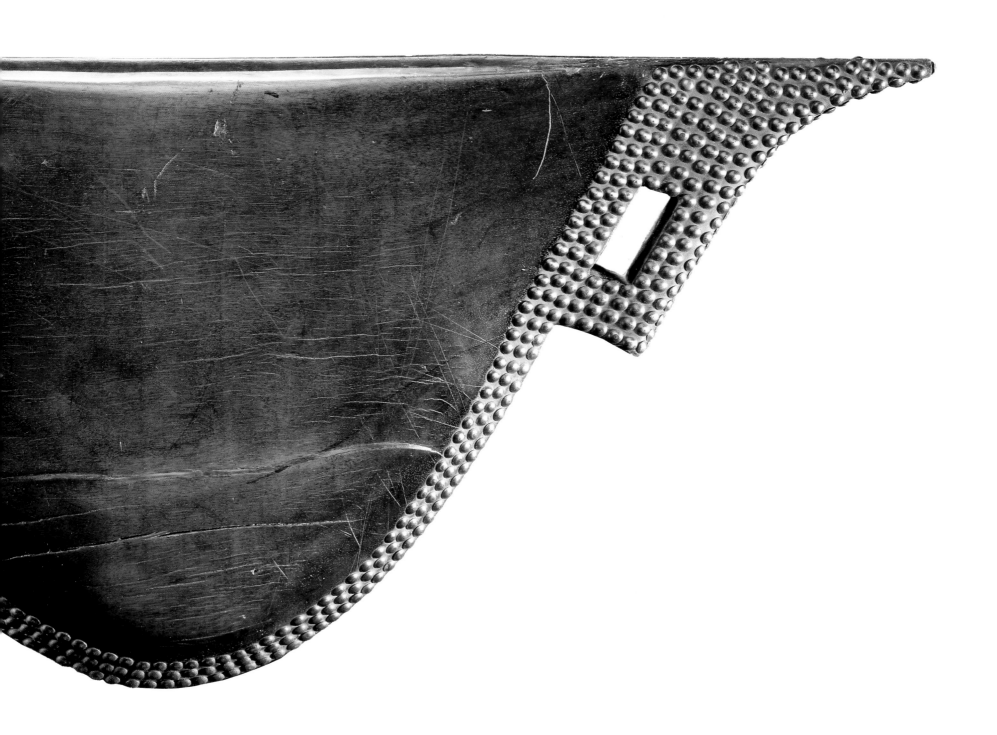

FIGURE

Sudan, Bongo
Wood, metal, h. 200 cm.
BMG 1027-1

The Bongo are a sedentary agriculturist people who inhabit Bahr-el-Ghazal province in the southern Sudan. Like the Konso, in neighbouring Ethiopia, they carved posts which they erected as memorials to deceased hunters and prominent elders in order to commemorate their achievements. They also produced such carvings to serve as gate-posts at the entrances to villages. One type of commemorative post took the form of a forked pole with notches cut into it to indicate the number of game animals the deceased man had killed, or the number of domestic animals he had owned. Posts of this kind were erected in a group at the grave site of the deceased. A report from the latter part of the nineteenth century describes another form of commemorative post used to create a procession of near life-sized, anthropomorphic figures near a Bongo grave which had been capped with stones. The outermost figure is described as having been the effigy of a chief, while the figures lined up behind it apparently represented the chief's wives and children. The figure illustrated here may have stood at a grave site, with other figures, and is probably the memorial effigy of an important Bongo elder. It is possible that, when originally erected, it would have been decorated with the deceased's personal ornaments and other marks of his status. The figure has unusual grace and possesses remarkable expressiveness, particularly in the concave, heart-shaped face with the forward-facing, hollowed-out ears and the small mouth with metal teeth. Such refinements are not typical of Bongo "pole" sculptures, which are often rendered in a very rudimentary style.

Vigango (sing. *kigango*) are erected by the Mijikenda as memorial posts for important deceased members of the *Chama cha Gohu* (Society of the Blessed), which admits only influential and successful male elders. The impetus for installing a *kigango* comes from a brother or male descendant of the deceased, who receives instructions in a dream from the spirit of the dead man. This may happen a long time after the deceased's burial and the *kigango*, which is provided as a resting place for his restless spirit, will not usually be erected at his grave. Most *vigango* are placed facing west and consist of a hardwood plank carved with a repetitive triangular design arranged in a variety of vertical and horizontal geometric motifs. *Vigango* are decorated with strips of coloured fabric and may be coloured with red, white and black pigments. They are said to represent the deceased *Gohu* members for whose spirits they are erected. They evoke respect and have considerable aesthetic value. The zigzag pattern of the *kigango* illustrated above is typical of the southern Chonyi of the Mijikenda.

Among the ancestors of the ancestors required an important elder to carve, or have carved, often while still alive, the memorial effigy that would stand by his tomb after his death. In the case of a warrior he would carve additional smaller figures to stand alongside his own effigy which represented the men he had killed in battle, and sometimes also members of his family. As can be seen from the figure illustrated opposite, Konso memorial effigies were typically rendered in a rudimentary, formal style which gave special emphasis to the headgear and other ornaments. Such details served to provide an accurate indication of the deceased's social status.

MEMORIAL POST, *KIGANGO*

Kenya, Mijikenda, Chonyi
Wood, h. 154.5 cm.
BMG 1027-14

EFFIGY

Ethiopia, Konso
Wood, h. 180 cm.
BMG 1027-88

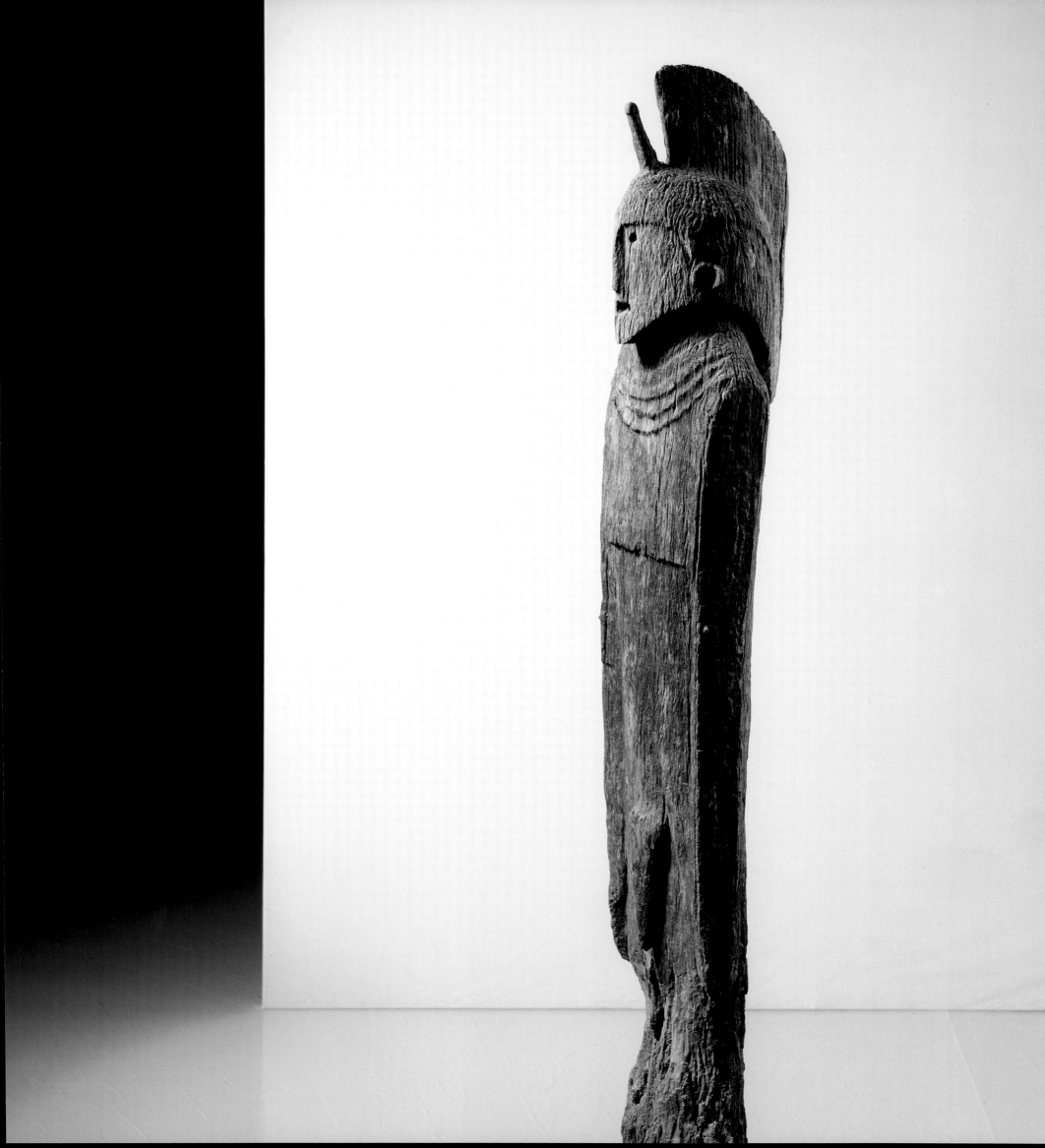

The pattern of weathering on the figure of the bearded elder illustrated above indicates that it would have surmounted a memorial post which the Zaramo of Tanzania are known to have erected over the graves of important elders. The figure is carved in a highly realistic style. It is said to have been collected near the village of Maneromango, about forty miles south of Dar es Salaam where this style originated before the First World War, encouraged by Lutheran missionaries. The figure is shown carrying a bush-knife, an axe and a gourd, which suggests that it was erected to commemorate an elder who was a successful farmer.

Among the Tanzanian Makonde, who live mainly in the southern districts of Newala and certain parts of Mtwara and Lindi, *midimu* (sing. *ndimu*) masked dancers played an important part in the male initiation rites. During initiation boys were traditionally taught the dances and secrets of the *ndimu* masker, which was an aspect of their adult male identity. *Midimu* maskers were said to be spirits whom the men fetched to dance in the village during the coming-out ceremonies that still take place at the end of the male and female initiation rites. *Midimu* face masks and costumes vary a great deal according to the type of animal- or human-like personage the masker is intended to personify. The mask illustrated opposite may represent a hirsute foreigner spirit because it lacks the characteristic Makonde facial tattoos (frequently applied with beeswax). The most fearful and exciting *midimu* are those which dance on stilts and which used to personify the malevolent spirits of tornadoes.

FIGURE

Tanzania, Zaramo
Wood, h. 36.8 cm.
BMG 1027-59

MASK, *NDIMU*

Tanzania, Makonde
Wood, pigments, fibre, wax, glass, h. 21.5 cm
Collected by Captain Seyfritz (circa 1906)
Formerly Linden Museum, Stuttgart collection
BMG 1027-2

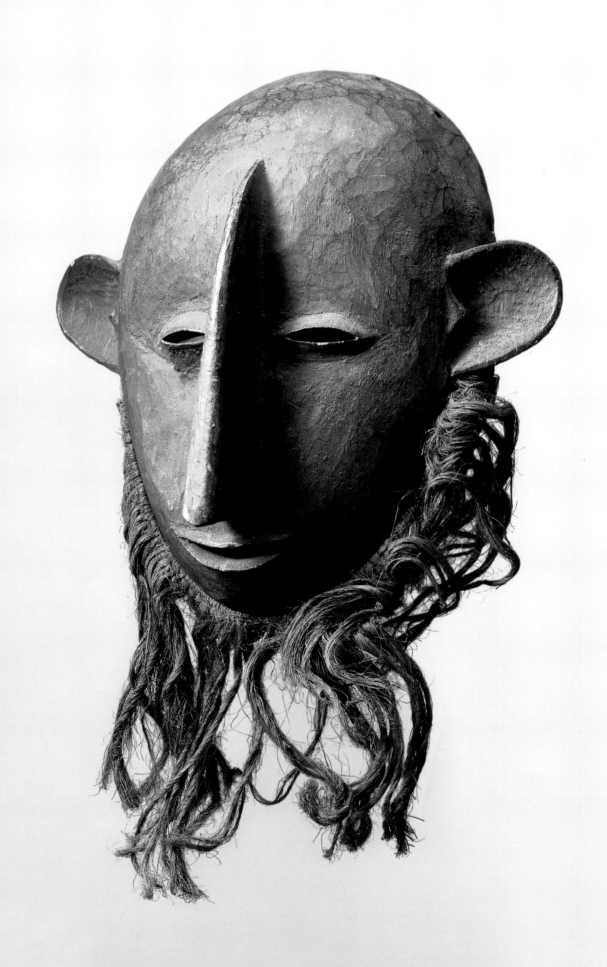

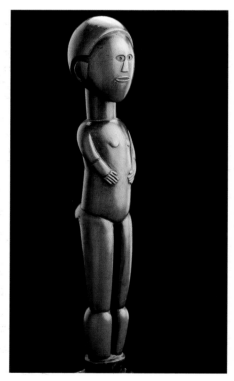 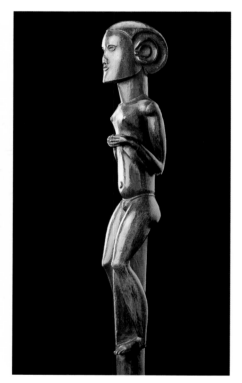

The objects created in pastoral communities were usually strictly utilitarian, but the chiefs often commissioned staffs with decorative finials. The figure on the staff illustrated above (left) is of northern Nguni origin, and the glossy patina shows signs of considerable use. That shown to the right above could also be Nguni. Both staffs are likely to have been carved during the nineteenth or at the very beginning of the present century.

The Sakalava on the western side of Madagascar carve funerary sculptures. The figure shown opposite, from a royal tomb in the ancient kingdom of Menabe between the Tsiribihina and Mangoky rivers, was probably made during the last century. The palisaded rectangle of a Sakalava royal tomb was embellished

with various kinds of figures, including, in pre-colonial times, many that were carved in sexually explicit forms. Popular themes included a pair of anthropomorphic figures that faced each other across the diagonal on opposite corners of the palisade. In the Sakalava region today the followers of royal ancestors are said to "make the ancestors great" by giving them praise names and an elevated place in the land. In their turn the royal ancestors are said to "bless" their descendants with fruitful lives. This mutually beneficial union of the ancestors with their descendants is celebrated in the sexual imagery of burial rites and of spirit possession. It is likely that the sexual imagery typical of pre-colonial Sakalavan royal funerary sculpture also relates, metaphorically, to this mutually beneficial union.

STAFF FINIAL

South Africa, Nguni
Wood, h. 34.5 cm. .
BMG 1027-60

STAFF FINIAL

Southern Africa (?)
Wood, h. 29.5 cm
BMG 1027-74

FIGURE

Madagascar, Sakalava
Wood, h. 103 cm.
BMG 1030-1

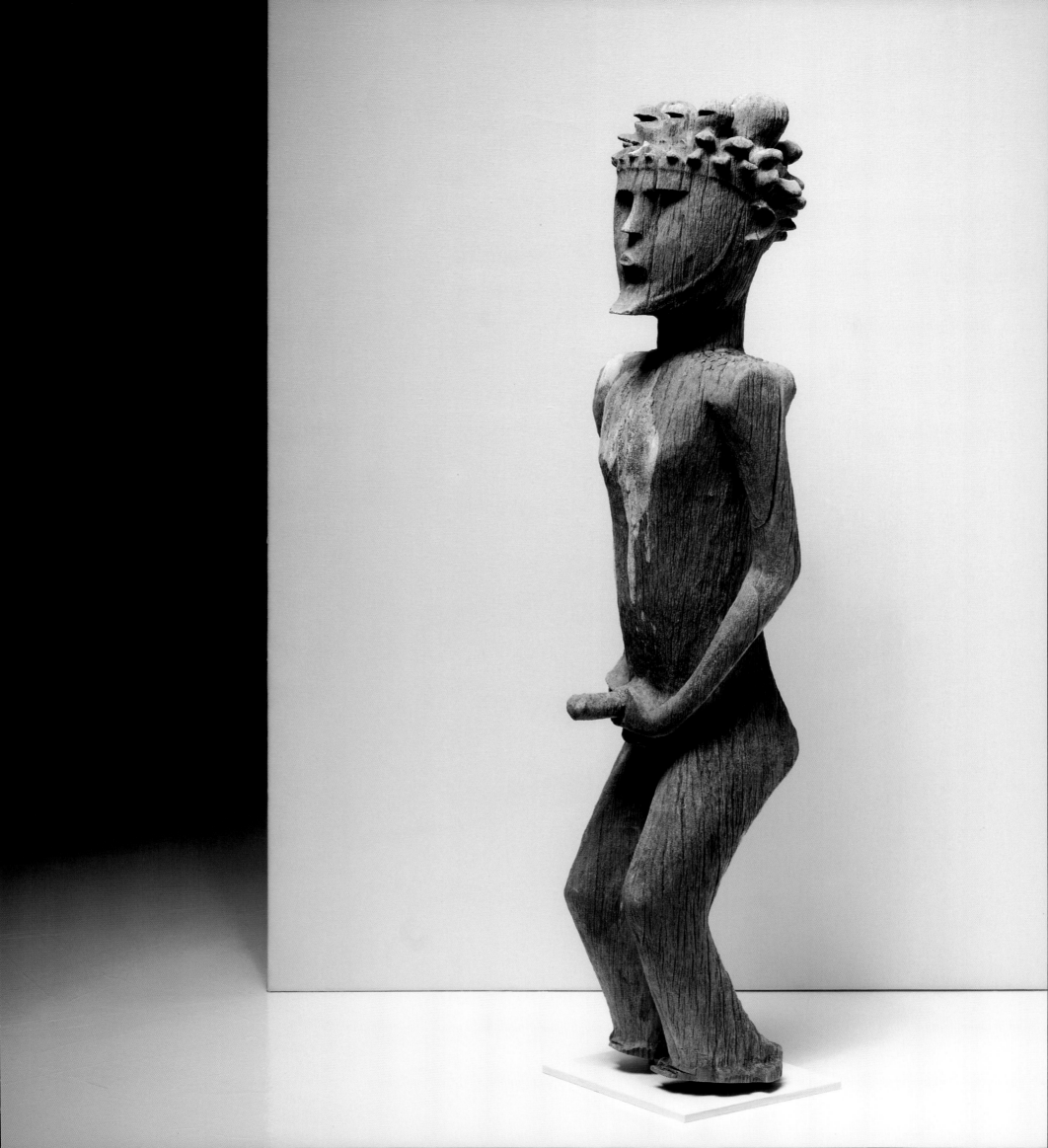

INDONESIA

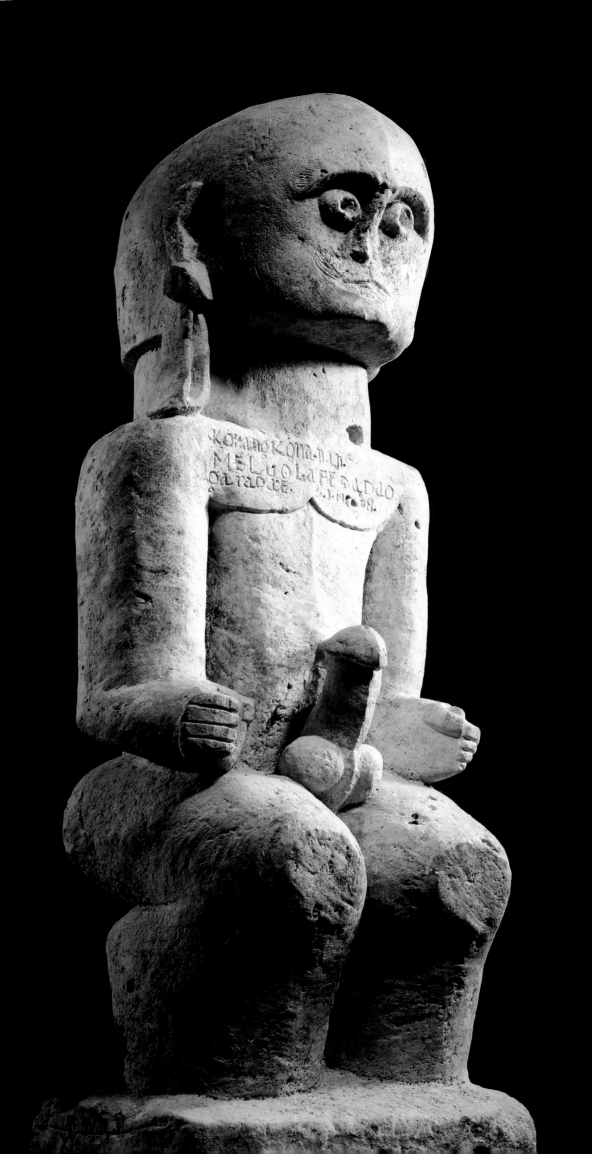

FIGURE, *GOWE SALAWA*

Indonesia, east-central Nias Island, Gomo region.
Limestone, h. 122 cm.
BMG 3261

The island of Nias is a land of hills crowned with villages, the most famous being in the south. They are great rectangular plazas surrounded by high, grandiose houses. The plazas are paved—but this is only a minor aspect of stonework in Nias. No other people in tribal Indonesia seem to have prized it as much, or used it to such spectacular effect. Enormous flights of stone stairs climbed up the villages; stone barriers stood in the middle of the plazas for young men to leap over in practising for war; there were carved stone thrones and, in the north, colossal figures of ancestors which stood up to three meters high.

Gowe salawa means literally, "vertical stone nobleman." Nias society was, in fact, divided rigidly into two ranks: nobles and commoners (there was also a class of slaves, useful work-animals, as it were, who had no social standing at all). The greatest houses belonged to paramount chiefs. They and other nobles had the right to own and wear gold ornaments, in quantities that deeply impressed early visitors to the island. At death the chiefs were commemorated with stone monuments, some weighing many tons, and requiring hundreds of men to drag them up the hills.

Such feats were essential to these competitive people, with their ambitions for rises in status and reputation in this life, and immortality in the next. To raise a stone monument ensured that its patron could claim the certainty of joining the company of his deified ancestors after death. The actual form of some monuments, such as this one from central Nias, was in fact said to be specified by a goddess, Silewe Nazarata. They were always revered, and often were moved to new villages when for some reason the sites were changed. The modern inscription on the chest of this one commemorates such a transition.

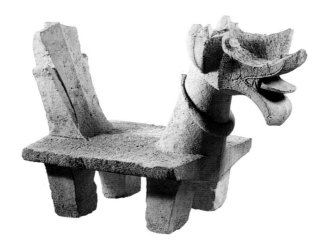

The Nias nobleman who wished to attain warrior status, and rise through the higher grades of society, effected this by offering *owasa*, "feasts of merit," that required the distribution of much gold and many pigs. They could also be given by commoners, but only on a modest scale, with modest results. In all of them the man's wife played a prominent role, and it was to her father that the richest gifts were presented. The making of the gold ornaments was accompanied by the decapitation of a slave.

The culmination of each ceremony was the installation of the couple on a sort of wooden platform, carved with an animal's head and a bird's tail, on which they were paraded through the village. For some ceremonies the platforms had three heads. These platforms were commemorated in stone versions, the *osa osa*.

Several types of *osa osa* exist, with rectangular or round platforms, and with the heads either of a hornbill or the mythical animal called *lasara*, or a combination of the two. The *lasara* combines the horns of the deer and savage fangs. The combination of bird and dragon symbolizes the unity of the supernatural and natural worlds.

CEREMONIAL SEAT, *OSA OSA*

Indonesia, central Nias Island
Stone, l. 107 cm.
BMG 3253-A

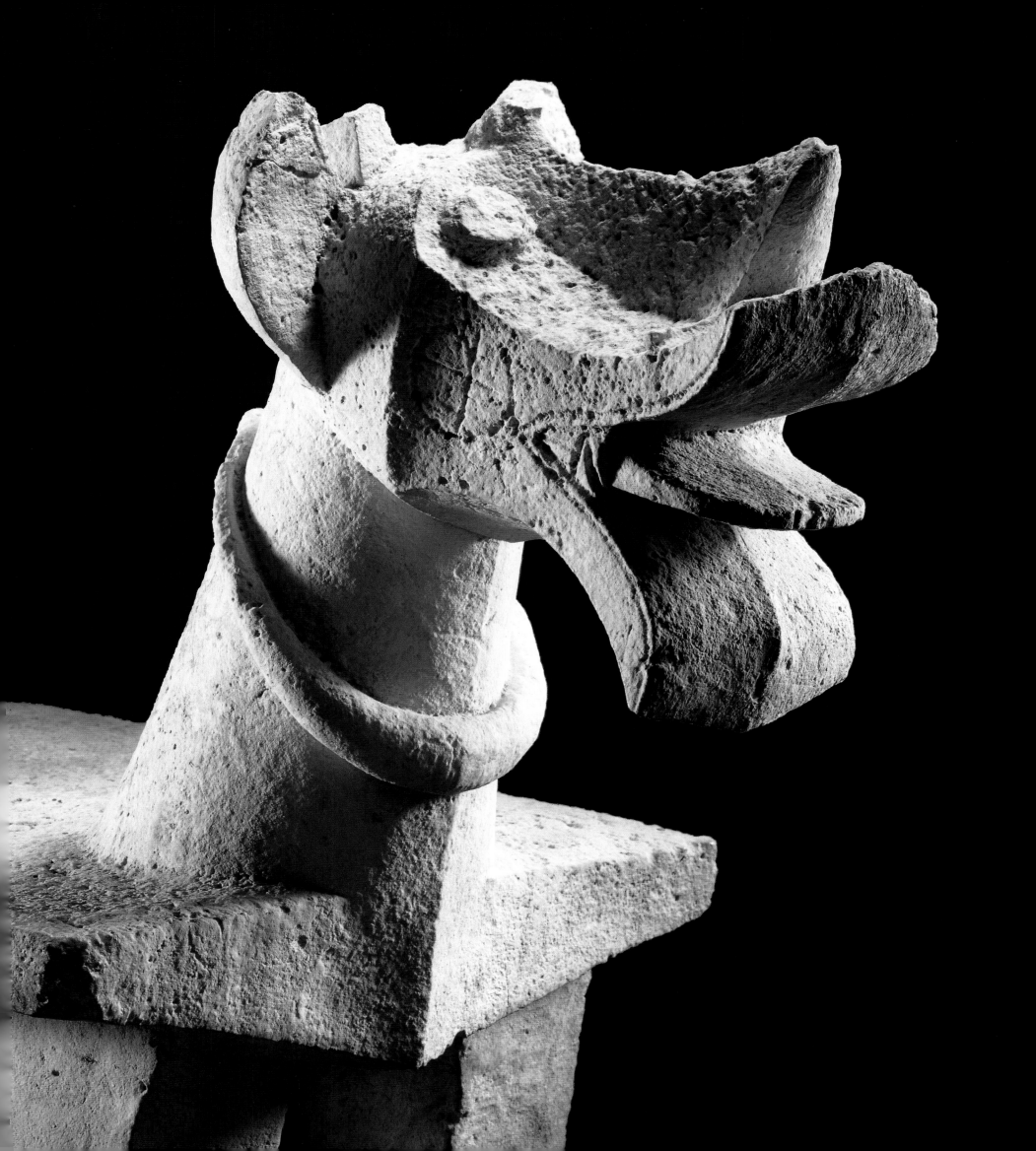

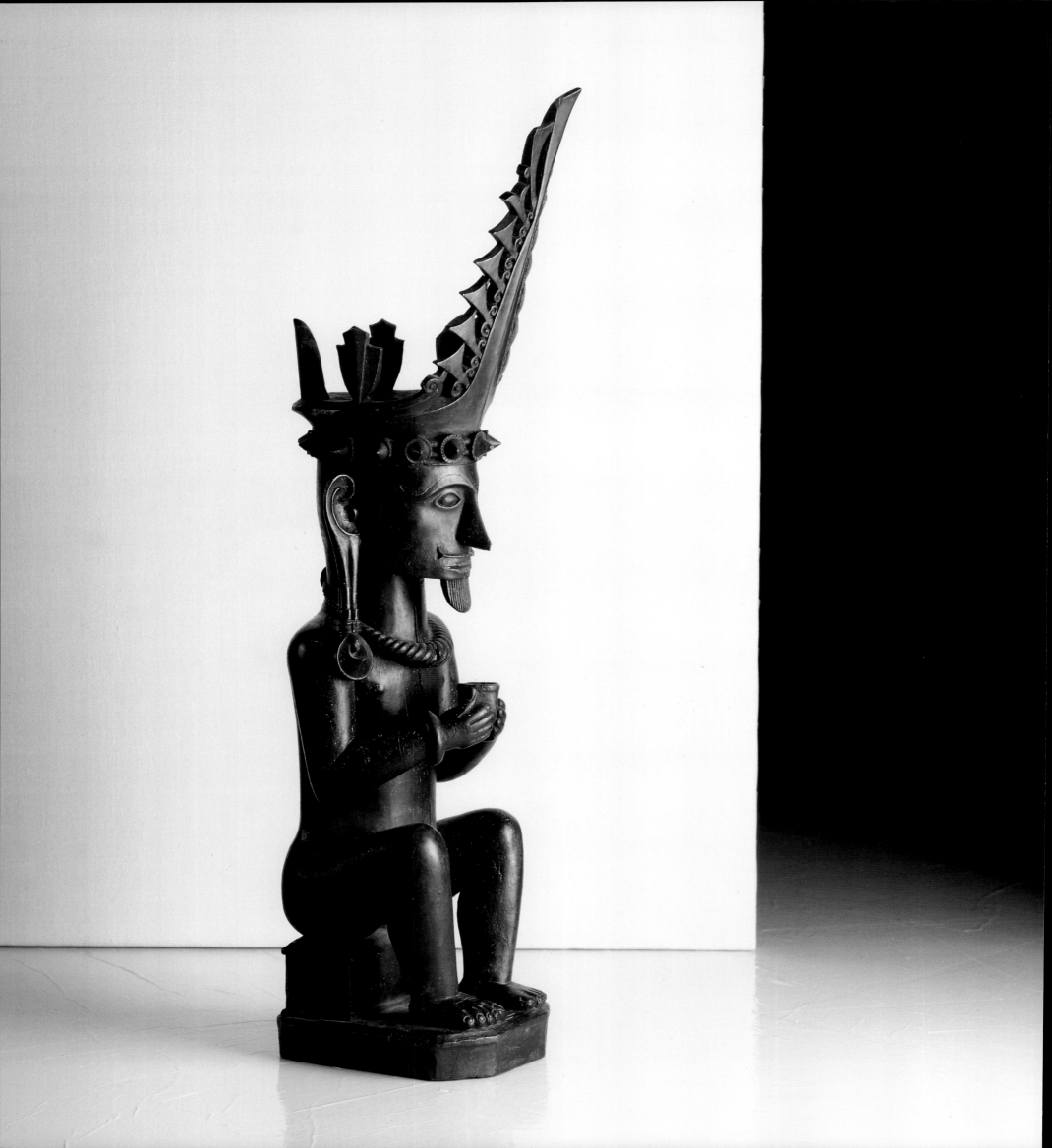

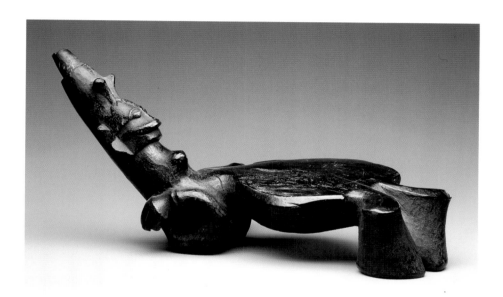

FIGURE, *ADU ZATUA* OR *ADU BA LAGOLAGO*

Indonesia, north Nias Island
Wood, h. 68 cm.
Formerly C. M. A. Groenevelt collection,
Amsterdam
BMG 3250-B

COCONUT GRATER

Indonesia, west central Nias Island
Wood, l. 41 cm.
BMG 3267

Adu is a general term for wooden figures of spirits, of which there are several types; they were carved in great numbers throughout Nias, and kept in the houses. One early writer indeed describes rooms so hung with them as to seem smaller and darker, and sometimes having walls collapse under their weight. Each area had its own style; and so did each of the two classes, commoners and nobles. Those of the commoners were small and crude, of "inferior" types of wood, and were tied together in rows. In all cases they were considered as at times the containers of ancestral spirits, and thus mediators between the ancestors and the living, individually or collectively, that could be consulted for their advice.

The north Nias carving style was relatively naturalistic in body proportions and the roundness of the limbs. Here the ancestor, evidently a highly important one, is shown seated on a stool, a regal posture [left]. The hands hold a small cup, and there is a bracelet on the right arm. One ear, the lobe stretched under the weight,

wears a gold ornament, and a gold torque-like collar hangs around the neck. A most striking feature is the elaborate, tall headdress. This is no confection of the imagination: such delicate crowns, made of gold leaf over fiber frames, were actually worn by great chiefs in north Nias.

The coconut grater [above] is a variant on an appliance widespread through Indonesia and the Pacific Islands. The adaptation of the human figure to the form of a stool is quite frequent. The operator sits on the stool, and grates the opened coconut on a shell or metal tip. (Once on the top of the figure's head, this is now missing.)

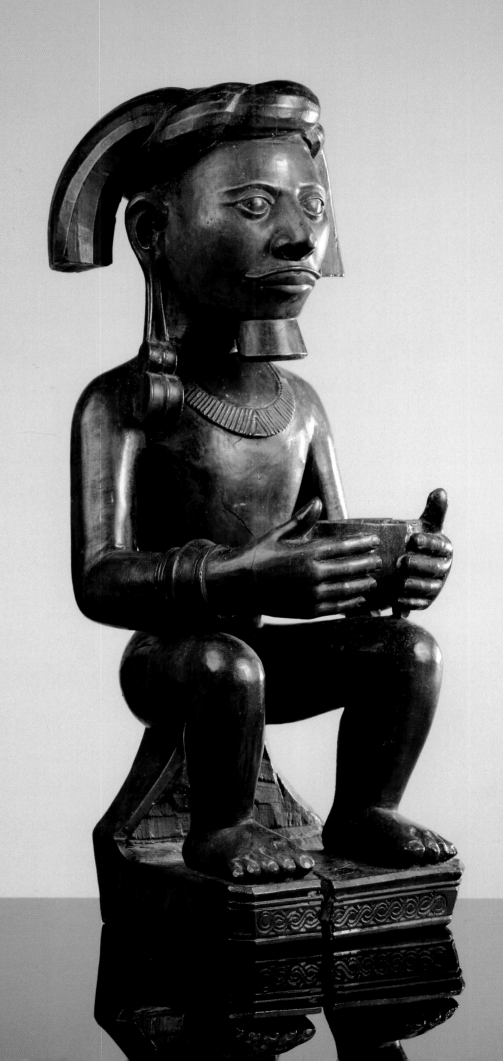

FIGURE, *ADU SIRAHA SALAWA*

Indonesia, Nias Island
Wood, h. 40 cm.
Stephane Barbier-Mueller collection
BMG 3250-C

FIGURE, *ADU ZATUA* OR *ADU BA LAGOLAGO*

Indonesia, north Nias Island
Wood, h. 27.5 cm.
BMG 3252-B

Another *adu* figure, again naturalistic in style, and again seated, holds a cup, and wears a single earring [left]. The types of bracelet and collar are markedly different from those of the preceding figure. Unlike the north Nias high crown, the headdress here resembles a turban or perhaps a complicated hairstyle.

A smaller but very similar figure [above], though without salient sexual characteristics, is shown to represent a woman by its having a pair of earrings in female style. Its elaborate ornamentation exemplifies the high prestige of noblewomen and their exalted positions in both living society and the world of the ancestors.

The Batak tribal groups in the high mountain plateau around Lake Toba, in the northern area of Sumatra, carved stone mainly for funeral monuments: enormous sarcophagi for their rajas but also figures seated, or riding mysterious animals.

The present two sculptures may come from a single ensemble. Both man and woman are nude except for their bracelets and ear ornaments. The woman [above] squats with her knees drawn up tightly to the body, her back strongly arched, on a small disc-shaped platform under which the stone extends in a plug. It was perhaps the cover of a bone container.

Riders frequently appear in Indonesian tribal art. Sometimes they are mounted on horses, animals highly esteemed not only as mounts but as

sacrifices and in gift exchanges, like the other prize beast, the water buffalo. The buffalo actually appears as the mount in certain very old stone figures in Sumatra which may date from the first millennium AD.

Here however the man rides on what appears to be an unusual type of *singa* [right]. The word *singa* itself is Sanskrit for "lion"—yet there are no lions in Sumatra. It applies here to a mysterious being which is a major motif of Batak art, large and small. Massive wooden *singa*s appear on the facades of Toba Batak houses, always with round eyes, spatulate noses, and everted lips from which issue a curling tongue. It seems to be a combination of buffalo and serpent, like the god Naga Padoha who supports our world on his back.

FIGURE

Indonesia, Sumatra: Batak, Western Toba area
Stone, traces of paint, h. 92 cm.
BMG 3138

RIDER ON A MYTHICAL BEAST

Indonesia, Sumatra: Batak, south of Pakpak area
Stone, h. 87 cm.
BMG 3137

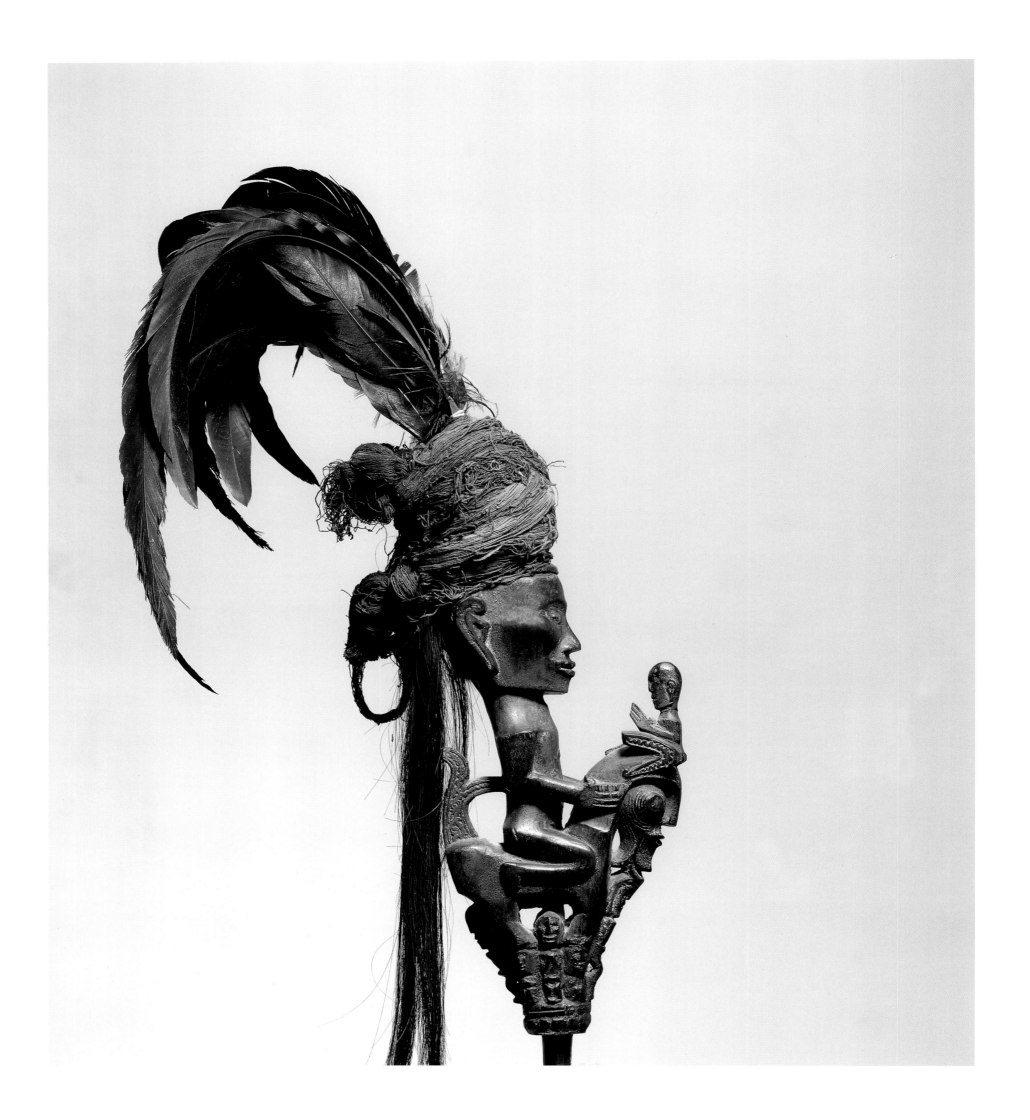

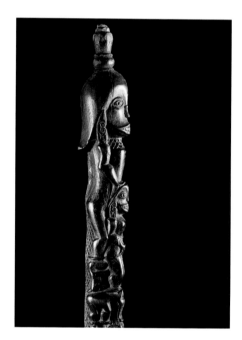
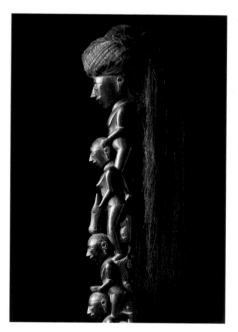

STAFF, *TONGKET MALEKAT*

Indonesia, Sumatra: Karo Batak
Wood, cloth, chicken feathers, figure h. 22 cm.
BMG 3139

STAFF, *TUNGGAL PANALUAN*

Indonesia, Sumatra: Toba Batak(?)
Wood, fiber, h. 123 cm.
BMG 3102-H

STAFF, *TUNGGAL PANALUAN*

Indonesia, Sumatra: Toba Batak
Wood, h. 189 cm.
BMG 3102-C

Two persons dominated Batak society: in the secular realm the raja, and in the supernatural the Toba *datu* (*guru* in Karoland), a man who combined ritual knowledge with magic powers. In practice raja and *datu* were often one and the same, as it took considerable wealth to pay for training as a *datu*. This priest-magician owned several items of essential equipment. First were manuscripts of spells, in characters derived from an archaic Javanese script, itself derived from Sanskrit, on bark sheets folded concertina-style. They are remarkable in that no other Indonesian tribal group developed its own form of writing. There were besides various containers for magic materials, and the superb carved staffs of office—all highly costly as their making was accompanied by many sacrifices, some of them human.

Each Toba *datu* owned two staffs, one called *tunggal panaluan* and one *tungkot malehat* (Toba spelling). The upper section of the *tongket malekat* (Karo spelling, information given by the *guru* Mendan Ginting. 91 years old in 1995). was carved with a single figure. *Tunggal panaluan* were carved with a column of surmounted figures of humans and animals, which refers to a myth about the staffs' origin. It relates that an incestuous brother and sister were devoured by a tree, as were animals and humans who attempted to save them, including four *datu*. Finally the tree was felled, and the first staff was carved from its wood. The decorations include fiber and feathers in black, white and red, the colors the Batak considered sacred. Magical substances were hidden in them. Their metal ferrules enabled them to be planted in the ground to demarcate ritual spaces. It is worth noting that one *tunggal panaluan* shown here [above right] has faces carved in the style of Javanese theatre masks.

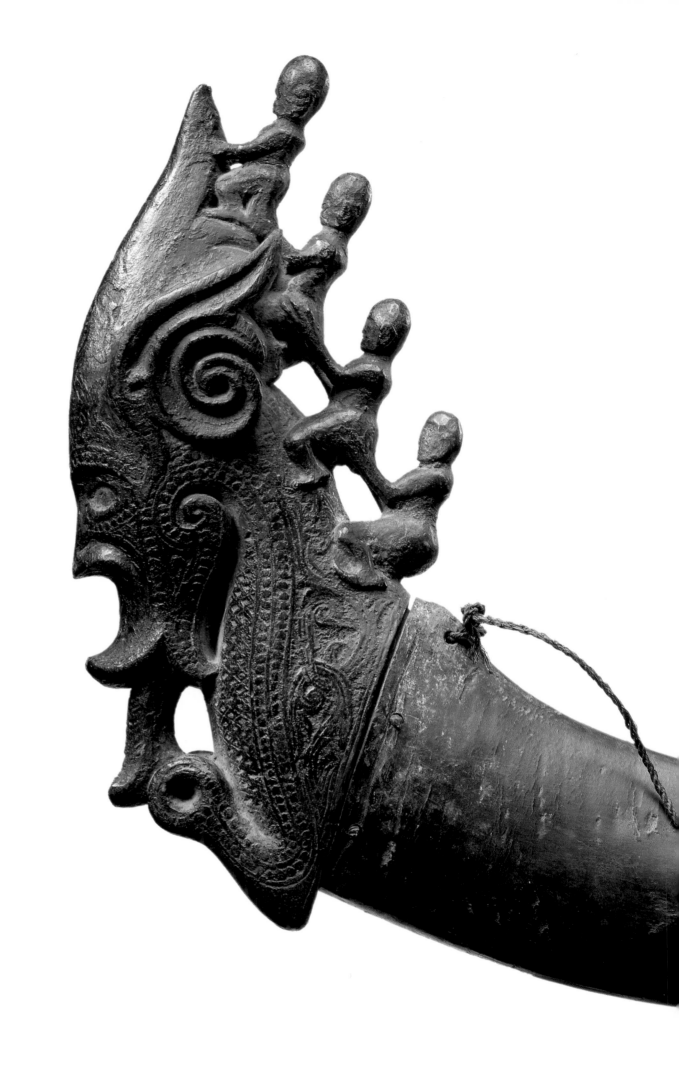

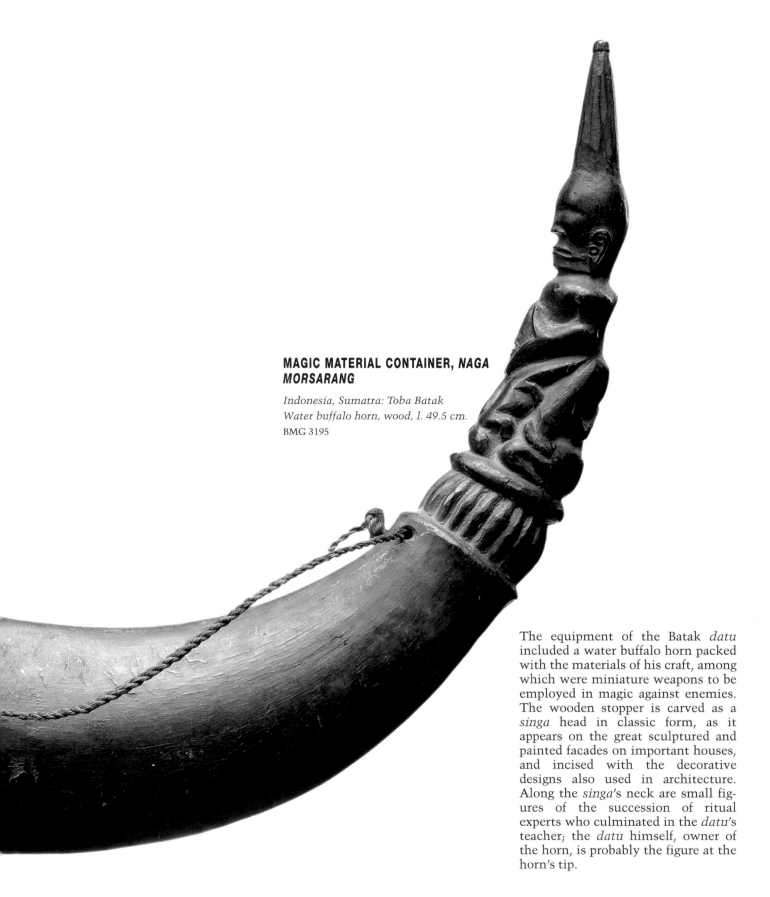

MAGIC MATERIAL CONTAINER, *NAGA MORSARANG*

Indonesia, Sumatra: Toba Batak
Water buffalo horn, wood, l. 49.5 cm.
BMG 3195

The equipment of the Batak *datu* included a water buffalo horn packed with the materials of his craft, among which were miniature weapons to be employed in magic against enemies. The wooden stopper is carved as a *singa* head in classic form, as it appears on the great sculptured and painted facades on important houses, and incised with the decorative designs also used in architecture. Along the *singa*'s neck are small figures of the succession of ritual experts who culminated in the *datu*'s teacher; the *datu* himself, owner of the horn, is probably the figure at the horn's tip.

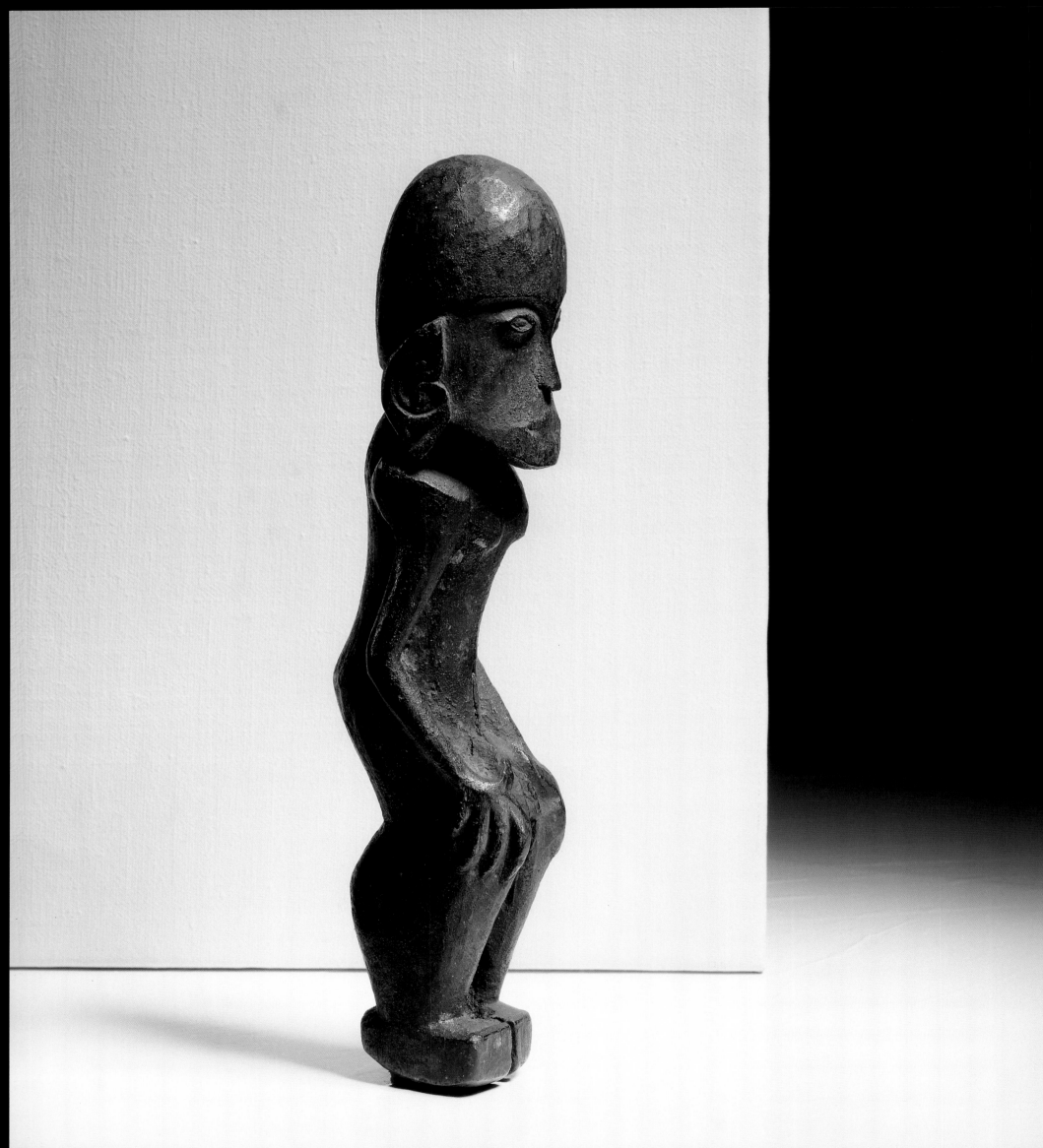

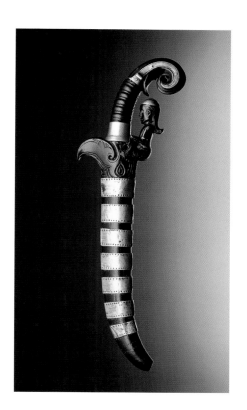

FIGURE

Indonesia, Sumatra: Toba or Pakpak Batak
Wood, h. 38.5 cm.
BMG 3180

KNIFE, *PISO RAUT*

Indonesia, Sumatra: Toba Batak
Wood, brass, l. 36.8 cm.
BMG 3186

The spidery, four-fingered hands of this female figure [left] recall the similar wooden hands carried by dancers at feasts held for the dead to appease their possibly dangerous spirits. She thus undoubtedly belongs to the spirit world. Unlike most figures made to ward off evil spirits, there is no aperture in the body of this one to hold magic material. The figure is, then, one of those made in pairs to represent deified ancestors (*debata idup*). These were kept in family houses with jewels and other heirlooms as part of the family treasure.

Special knives could also be part of the treasures, and had symbolic value [above]. "The knife with which one supports oneself" was the metaphoric name for the gifts given by the wife's family at marriage to the groom's family.

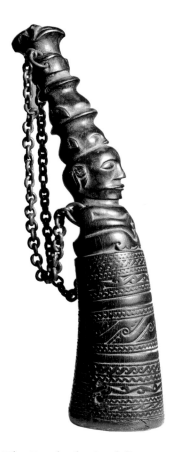

The *datu*'s equipment included pots containing perhaps the most powerful substance in his armamentarium, a concoction called *pupuk* used in healing rituals. The main ingredients of *pupuk* were the brain and viscera of a very young child killed for the purpose, besides other unsavory materials. It is perhaps a mark of the material's importance that the pots in which *pupuk* was stored were the Chinese ceramics so precious to the Batak [right]. Their small wood stoppers were carved as male or female personages riding on *singa*s or, as in this example, the horse-elephant version of the *singa*.

The Batak obtained firearms from the Muslim states to the north, or from the many foreign traders who visited the island to buy rubber and camphor. Shot holders and powder horns [above] are among the most richly decorated of Batak small utensils, and again show the engraved patterns used in architecture.

POWDER HORN, *PORPANGGALAHAN*

Indonesia, Sumatra: Toba Batak
Wood, buffalo horn, iron chain, h. 18.2 cm.
BMG 3174

CONTAINER, *GURI GURI*

Indonesia, Sumatra: Toba Batak
Wood, Chinese ceramic pot, cane, h. 14 cm.
BMG 3181

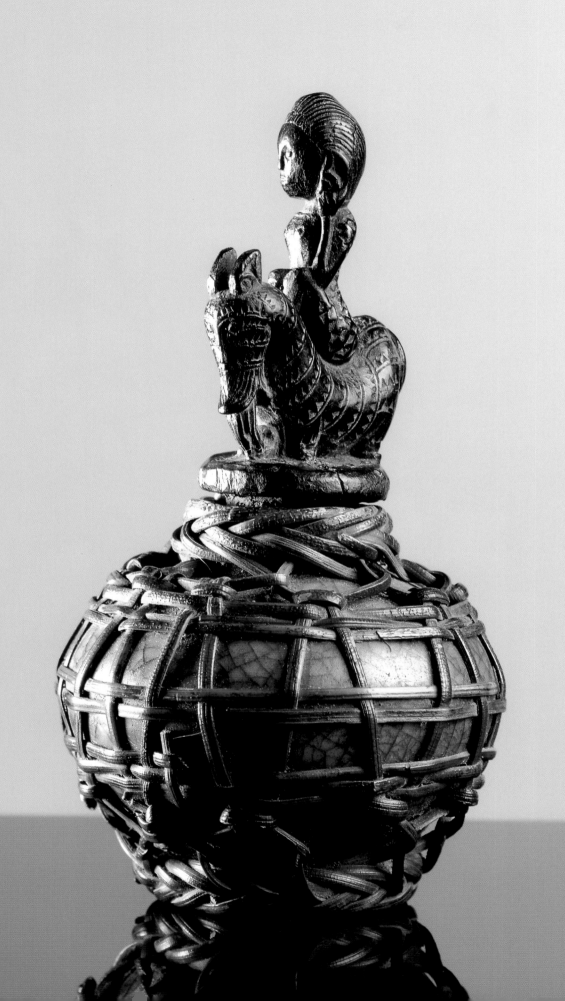

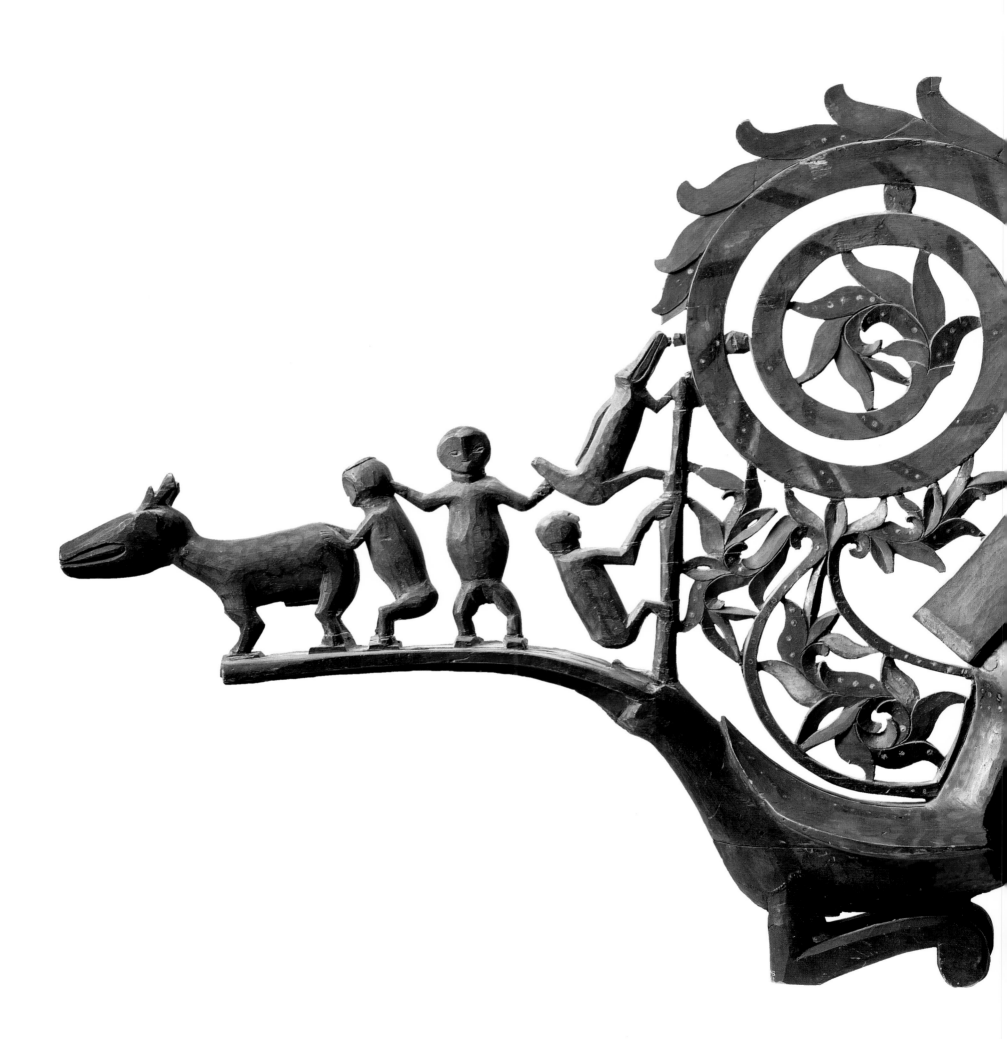

HORNBILL, *KENYALANG BURONG*

Borneo: Iban Dayak
Wood, paint, l. 173 cm.
Formerly Nelson A. Rockefeller collection
BMG 3464-B

Perhaps the major art of the Iban Dayak is the weaving by women of ikat textiles, the most important being the blanket-sized *pua*, the smaller *pua sungkit*, and the miniskirts called *bidang*. The Iban men were famous for their headhunting, and *pua* and *pua sungkit* were closely associated with its rituals. Recent research has shown, in fact, that ikat weaving was looked upon as its female equivalent.

Nevertheless the men excelled in the carving of wooden figures of hornbills. These were also associated with headhunting, as they were the messengers of Sangalong Burong, its patron god. The figures were carved in various sizes, large and small; but the bird is always shown in a crouched position—perching rather than in flight. The beak is enormously exaggerated, with the casque developed into a huge spiral tipped with a flower. The result is a long double curve which divides into two dramatically opposed curves.

In the past the carved hornbills were used in headhunting festivals. Today they still appear in pairs, small and large, during a ritual held to celebrate good rice harvests and ensure their continuance. The larger carving is hoisted on a tall pole so that its spirit will fly up to Sangalong Burong and intercede for his good will.

POST

*Borneo, Kalimantan: Dayak, probably
Kenyah or Kayan*
Wood, h. 156 cm.
BMG 3484

HANDLE OF A WEAVING IMPLEMENT

Borneo: Dayak
Deer antler, l. 17.3 cm.
BMG 3467

The post [left] is undoubtedly no more than a section of what was originally an enormous carved log. Its original purpose cannot be definitely stated. Its fine state of preservation suggests it was always under shelter—that is, it was an interior post in a longhouse. On the other hand it might equally be from one of the tall posts which supported coffins above ground.

Its exact provenance is similarly unknown, but a Kenyah-Kayan origin seems highly likely. One sees here the animal figure called *aso*, in three-dimensional form, its head reversed

to complete the sinuous curve of its arched back. The low relief which covers most of the rest of the surface shows the Kenyah-Kayans' mastery of layered and intertwining scrolls at its peak.

The Dayak passion for elaborate ornamentation extended even to their household objects and small tools, such as this handle for an implement used in weaving strips of cane [above].

Dayak longhouses often had something of the appearance of streets: a long row of private compartments opening on to a roofed public gallery which extended the length of the building. Their frameworks were huge wood columns. These, the interior walls, and the roof ridge were carved and painted in the flamboyant style of the Kenyah and Kayan group of tribes. The straight line is unknown to it; it is all curves: humans, animals and birds are shown in opposed curves, limbs terminate in a profusion of spirals, often overlaying each other—all to create an effect like a dense mass of jungle ferns uncoiling.

Among the more important house carvings were the doors to the chiefs' rooms, designed not so much for personal glory as for supernatural protection for the community. In this example, the upper half of such a door, the top element is the high relief mask of a spirit with huge ears, whose threatening teeth menace any evil influences [right]. Below, in low relief, is the contorted figure of an animal.

This, the so-called *aso*, or "dog," is a dragon-like mythical being somewhat akin to the *lasara* of Nias, the *singa* of the Batak, and other such creatures. Its image has sometimes been thought to derive from the dragons seen on Chinese ceramics which, like other tribal Indonesians, the Dayaks treasured.

The bowl [above] is probably a ceremonial object, even though many Dayak household possessions were also carved, often with the *aso* motif.

BOWL

Borneo, Kalimantan: Kenyah or Kayan Dayak
Wood, l. 40 cm.
Collected before 1914; formerly Herbert Rieser collection, London
BMG 3402

DOOR

Borneo: Bahau Dayak
Wood, h. 120 cm.
BMG 3412

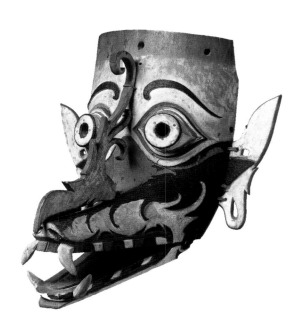

MASK, *HUDOQ*

Borneo, Kalimantan: Apo Kayan Dayak
Wood, paint, h. 59.5 cm.
BMG 3485

MASK, *HUDOQ*

Borneo, Kalimantan: Kenyah or Kayan
Dayak
Wood, paint, h. 26 cm.
Formerly R. Schmidt collection, before
1950
BMG 3416-B

The hudoq masks of the Kenyah and Kayan people embody a somewhat paradoxical nature. In the first place they are, naturally, spirits. Their images represent wild animals: one can trace in their forms the tusks of the wild boar, the beaks of birds, or the teeth of carnivores. They wear great mantles of banana leaves, are crowned with the tail feathers of hornbills, and carry lances. Thus they enter the village from the forest, silent except for an occasional unearthly laugh.

But, though they are creatures of the untamed world, the hudoq bring with them the prime necessities of civilization for settled human society. The masqueraders go to all the villages households distributing the seed rice for the next planting, and they are seen as the intercessors to the ancestors whose benevolence will ensure fertility and ample harvests. In this they perhaps resemble the hornbills of the Iban, which perform much the same role of intercession, and whose feathers the masks wear in their headdresses.

The masks themselves are complete expressions of Kenyah-Kayan art, both as painting and sculpture. They are assembled from as many separately carved pieces of wood, including movable jaws and pendants, as are needed to include all their projecting tusks and silhouette panels. Besides this they are profusely painted with the typical Kenyah-Kayan curls and spirals.

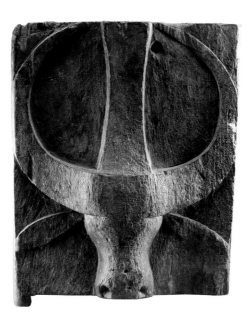

The Sa'adan Toraja of central Sulawesi live in a high, fertile valley dominated by a dramatic landscape of precipitous, naked limestone cliffs. They have developed an extraordinary wealth of rituals devoted to funeral rites. The final celebrations, which take years to prepare, involve a week of ceremonies which may be attended, in the case of a great man or woman, by thousands of people, and are sanctified by the sacrifice of hundreds of water buffalo.

At one time coffins in the shape of boats for nobles, buffalo for commoners, were placed in caves at the foot of the cliffs, accompanied by quantities of valuable burial offerings. At the end of the seventeenth century, Bugis soldiers from the coast in Dutch employ invaded Torajaland and looted these burials—an appalling crime in Torajan eyes. After seven years the Toraja rebelled and massacred the Buginese. Ever since, burials have been placed in almost inaccessible chambers chiselled out of the cliff faces, high above ground.

The small rectangular entrances to these chambers are closed with small wood doors. On them are carved stylized buffalo heads, commemorating the animals that have been sacrificed to accompany the deceased in the fields of the next world. The rectangular element between the horns possibly refers to the Tree of Life, or World Tree, of tribal Indonesian cosmology.

TOMB DOOR

Indonesia, Sulawesi: Sa'adan Toraja
Wood, horn, h. 103 cm.
BMG 3619

TOMB DOOR

Indonesia, Sulawesi: Sa'adan Toraja
Wood, h. 44 cm.
BMG 3608

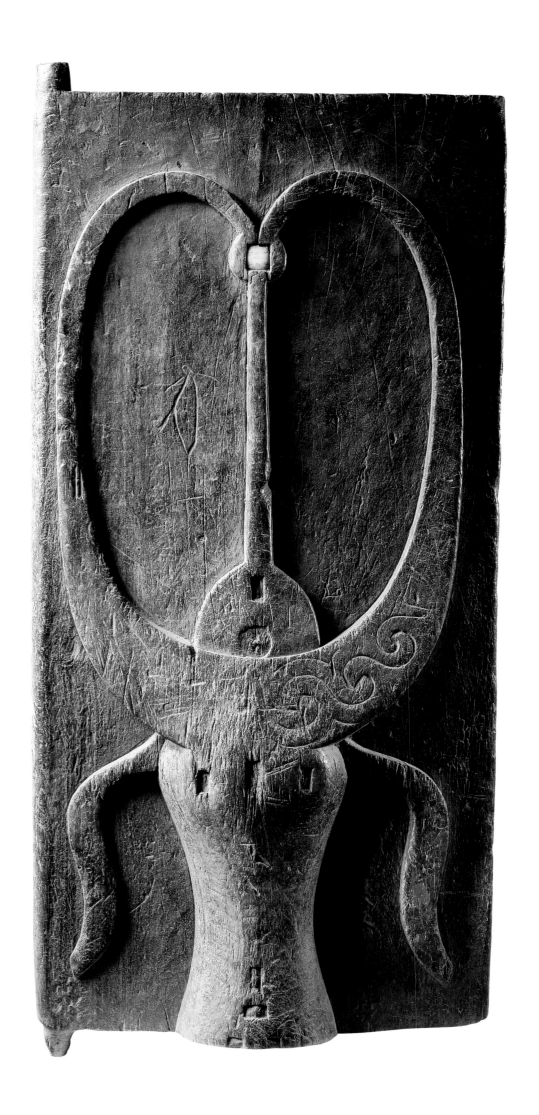

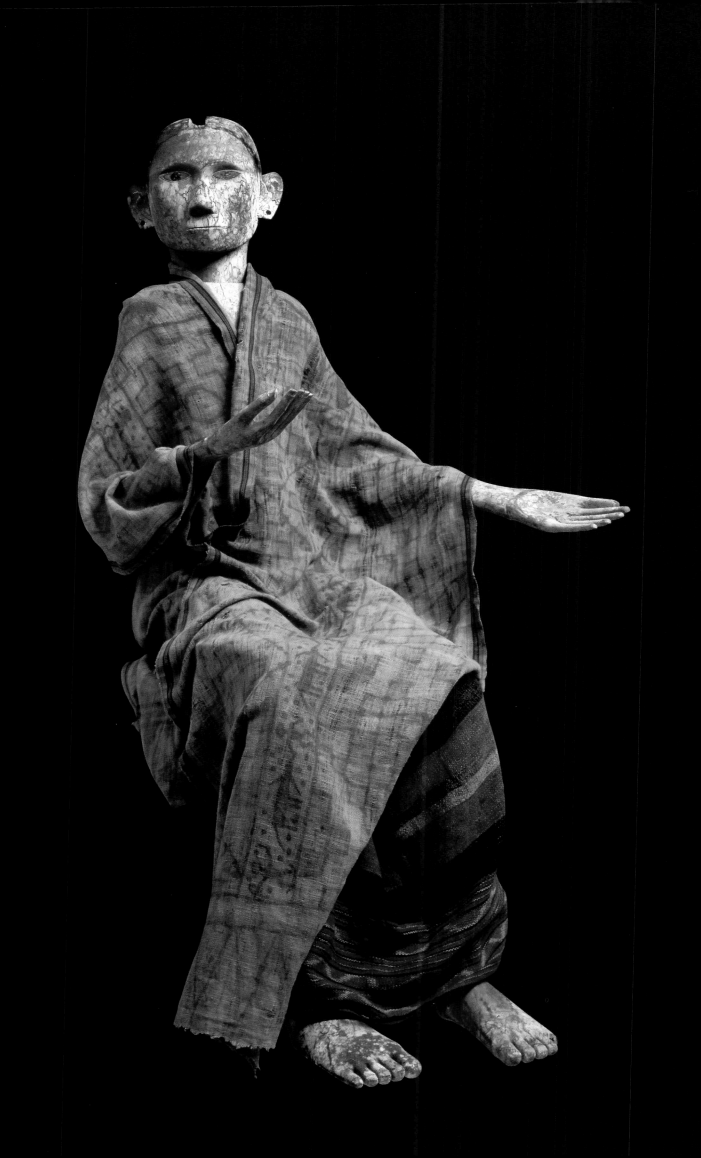

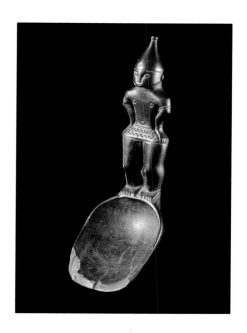

MEMORIAL FIGURE, *TAU-TAU*

Indonesia, Sulawesi: Sa'adan Toraja
Wood, paint, cloth, h. 105 cm.
BMG 3618

SPOON

Indonesia, Sulawesi: unknown origin
Wood, h. 16.5 cm.
BMG 3634

At death, a Toraja's body is wrapped in a huge cylinder made up of quantities of woven shrouds, decorated with gold leaf. The corpse is kept in the family house, for the death not is admitted: the person is simply said to be "ill" or in voluntary seclusion. The soul is dormant in this period. Meanwhile at least one agricultural season and harvest time is allowed to elapse, as a symbol of the continuity of the cycle of life. This, and sometimes many following seasons, allow time for the preparations for the final great events, including negotiations for huge food supplies for the expected guests, and the accumulation of sacrificial animals—buffalo, pigs and chickens.

At this time a commemorative figure, or *tau-tau* [right] is commissioned from an expert carver. Intended as a portrait, it is dressed in the dead person's clothes, then laid beside the body. When the last ceremonies begin, the *tau-tau* is set upright on its feet. The soul is now awake once more and is facing south-ward to Tondok Bombo, the land of the dead to which it must make its way when it has been released by the ultimate ceremonies that are now about to begin.

Tau-tau have been carved for many years, perhaps centuries. Few of great age still remain, but those that do are in a highly formalized style. More recently made *tau-tau* have greater realism and a certain air of pathos, enhanced by the gestures that can be made by their jointed limbs—as can be seen in this figure of a noble-woman. At the last they lead the funeral procession on the way to the burial cliffs, where they are installed in rock-cut chambers behind wooden balconies. They are still to be seen there, standing in crowded, silent rows.

Unlike Toraja spoons, for example, which merely have a plain bifurcated handle, this one [above] has a sturdy but elegant little figure, of great assurance, wearing a pointed cap. Known to be from Sulawesi, its exact provenance is uncertain.

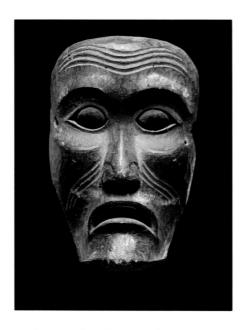

The Sasak of the island of Lombok do not have a happy history. They were conquered and colonized by the Balinese in 1740, and again by the Dutch in 1894 as a sideshow of their conquest of Bali. The Sasak inhabitants also fell under strong pressures from Muslim neighbors, and now profess a somewhat halfhearted version of Islam. Most of their work, as in the exquisite small wood carvings used as handles for daggers and lime spatulas, is distinctly Hindu-Javanese in its decorative features.

Rare exceptions are seen in the mask [above], which in its general shape and powerful features recalls, if only faintly, the masks of the Batak or Timor. So does the stone figure [right], the largest known sculpture from the island, with its bent fingers, staring face and exposed teeth.

The island of Flores is essentially a narrow mountain chain running from east to west, fringed with a shallow seaboard. This formation has served in the past largely to isolate its many cultures from each, furthering their mutual distrust and their varying traditions. Ngada society, for instance, although based on a hierarchical social structure, has thus developed some distinctive traits of its own.

Notable among these is the society's adoption of two types of marriage, in which children are affiliated with either the mother's or the father's clan. Men and women have separate ceremonial houses.

Women's houses have carved inner thresholds. A low barrier beside the entrance, is cut from a single right-angled piece of wood to form a threshold and the lower parts of walls on either side of it. Several wood panels, mortised together, raise the height of the walls. They are covered overall with the beautiful scrolls which become an even more prominent feature to the islands eastward; these are partly, but not entirely, symmetrical. Through them, on each side, winds a serpent or dragon.

MASK

Indonesia, Lombok Island: Sasak
Wood, h. 21.5 cm.
BMG 3320-A

STATUE

Indonesia, north Lombok Island: Sasak
Stone, h. 105 cm.
BMG 3334

THRESHOLD FOR A WOMEN'S CEREMONIAL HOUSE

Indonesia, Sunda Islands, west central
Flores: Ngada
Wood, w. 155 cm.
BMG 3525-47

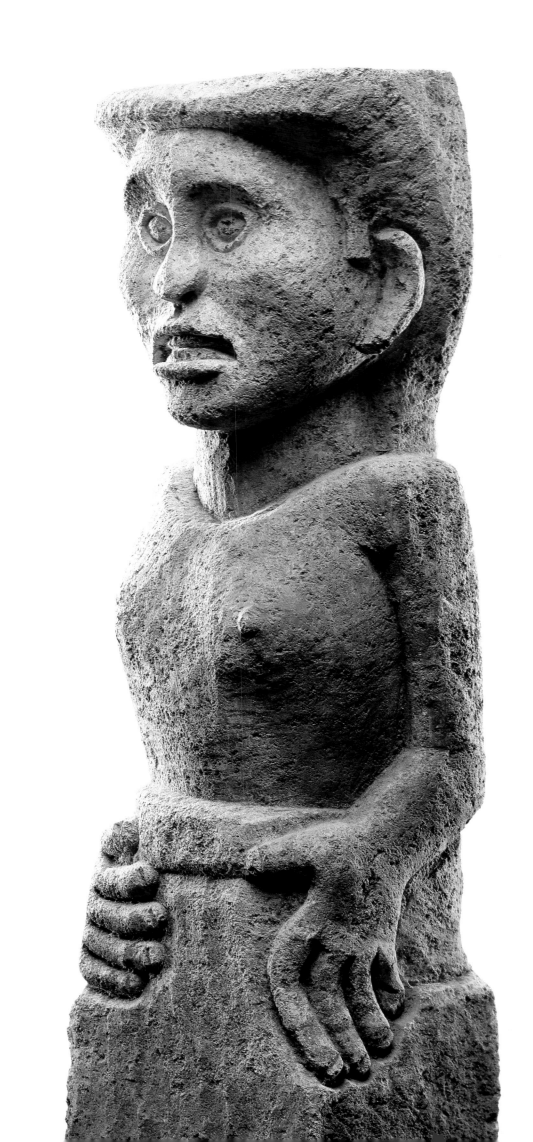

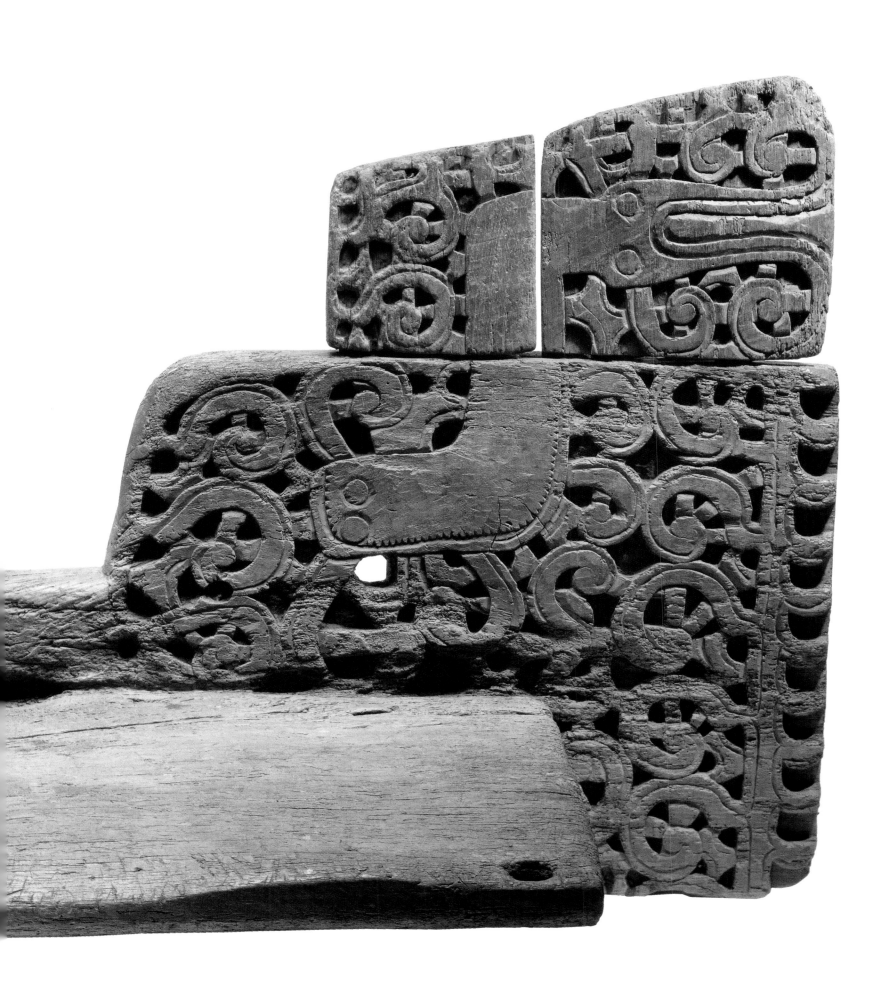

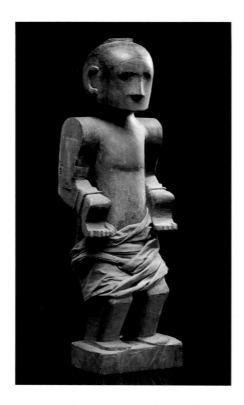

Among the Nage, village houses formed a circle around a sacred plaza; at its center stood a forked pole, an ancestor shrine to which buffalos about to be sacrificed were tethered. Men's ceremonial houses contained the animals' skulls, and had annexed shelters for the display of large carvings of horsemen.

Pairs of poles topped with figures of male and female ancestors [right] seem to have been used in several contexts. Sometimes they were set up on either side of a house entrance, as guardian spirits and as a token that the owner of the house had erected an ancestral shrine in the village plaza.

Little is known of the Ende figure [above], though no doubt it shows an ancestor. The style seems to be a localized one, using the curious feature of out-turned hands.

FIGURE

Indonesia, Sunda Islands, Flores: central Ende or Lio
Wood, paint, cloth, h. 61 cm.
BMG 3525-11

PAIR OF POST FIGURES (DETAIL), *ANA DEO*

Indonesia, Sunda Islands, Flores: Nage
Wood, total h. 150, 164 cm.; male figure 53.5 cm., female figure 56 cm.
BMG 3525-9 A, B

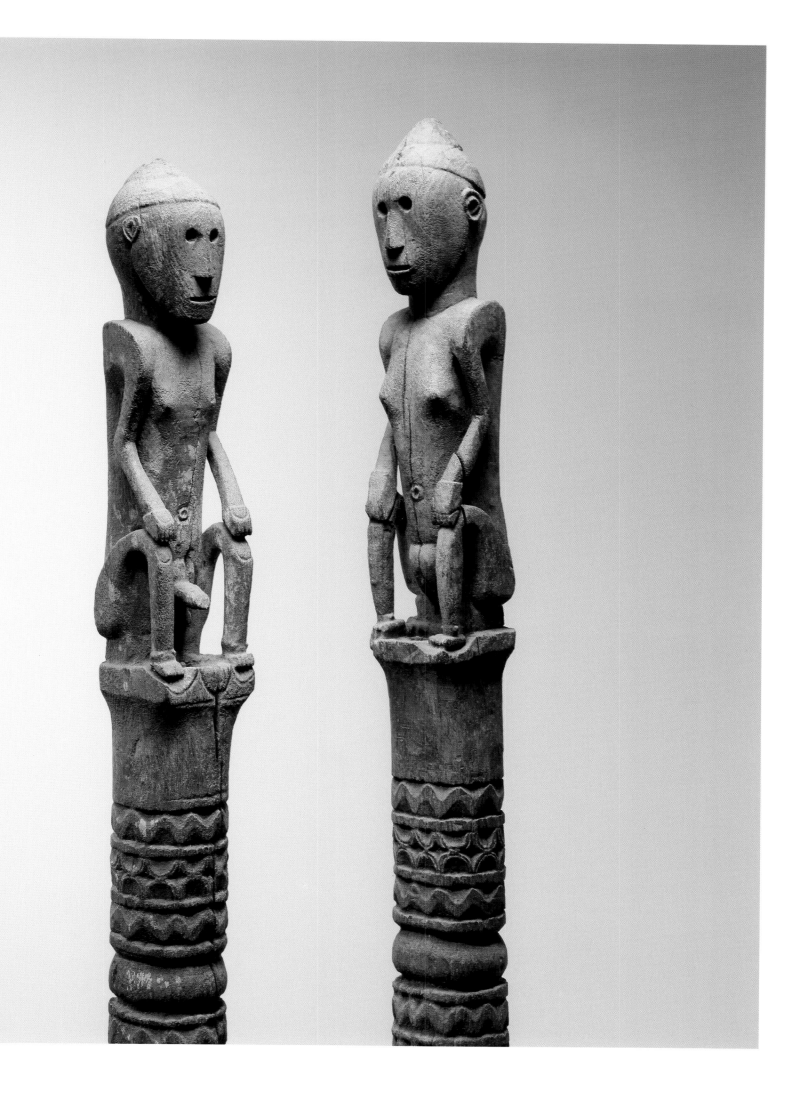

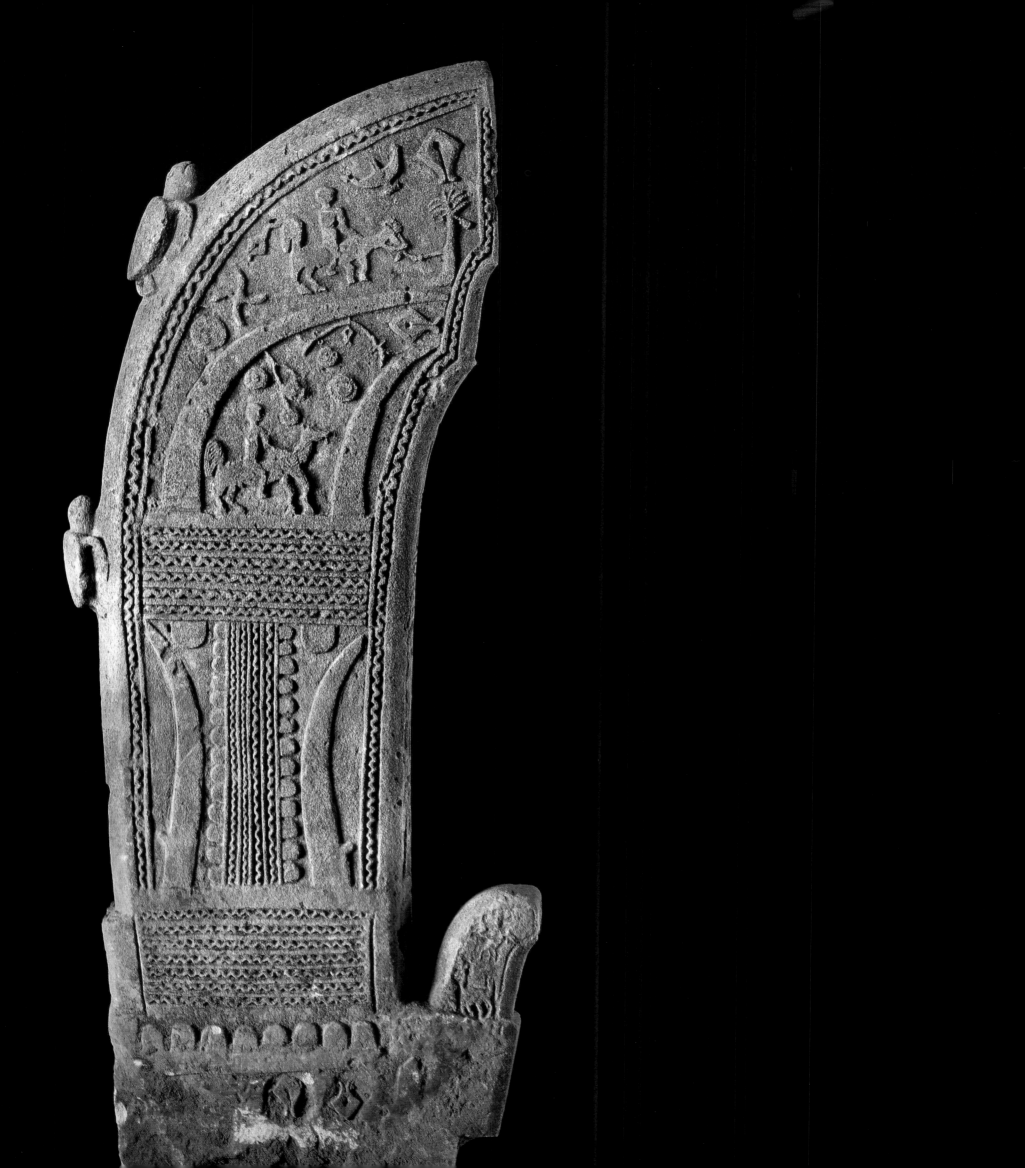

FUNERAL MONUMENT, *PENJI*

Indonesia, Sunda Islands, southeast
Sumba Island, Waijelo area
Formerly P. Robin collection, Paris
Stone, h. 241 cm.
BMG 3686-B

FUNERAL MONUMENT, *PENJI*

Indonesia, Sunda Islands, southeast
Sumba Island, Tidas village
Stone, h. 175 cm.
BMG 3686-I

The deaths of great men in Sumba, as in other parts of Indonesia, are the occasion for extended rituals and celebrations at their laying to rest, which may be spread over many years. The climax is the creation of a stone tomb in the center of the village.

The tombs vary in form and size, according to the wealth and status of the occupant, throughout the island. The most modest may be no more than a simple box of slabs; the grandest a sarcophagus set on stone pillars with freestanding stone carvings at its head and foot. The biggest stones have to be bought with an exchange of gold and textiles, as at a marriage, and then hauled by dozens of men to its village site. The haulers are rewarded at each stop with feasts; and it is not unknown for a family of great wealth to see to it that each stage of the journey is short, so that they can show off their riches in food.

The monument set up at the head of the tomb, the *penji*, is its "banner;" if another is placed at the foot, it is the "tail." In the cases of the two shown here the type is compared to a horse's head or the comb of a rooster, both emblematic of male potency.

One of these *penji* [left] is carved on both sides with a plethora of affirmations of wealth and status: the omega-shaped gold *mamuli* pendants; the gold *lamba* frontlet resembling buffalo horns; and gongs. Riders are also shown, further symbols of maleness; and perhaps the fish and tortoises recall fertility, as they do in other cultures. The other *penji* [above] is a beak-like form of the greatest simplicity, carved with only a spinal ridge and a disc—an eye? or a gong?

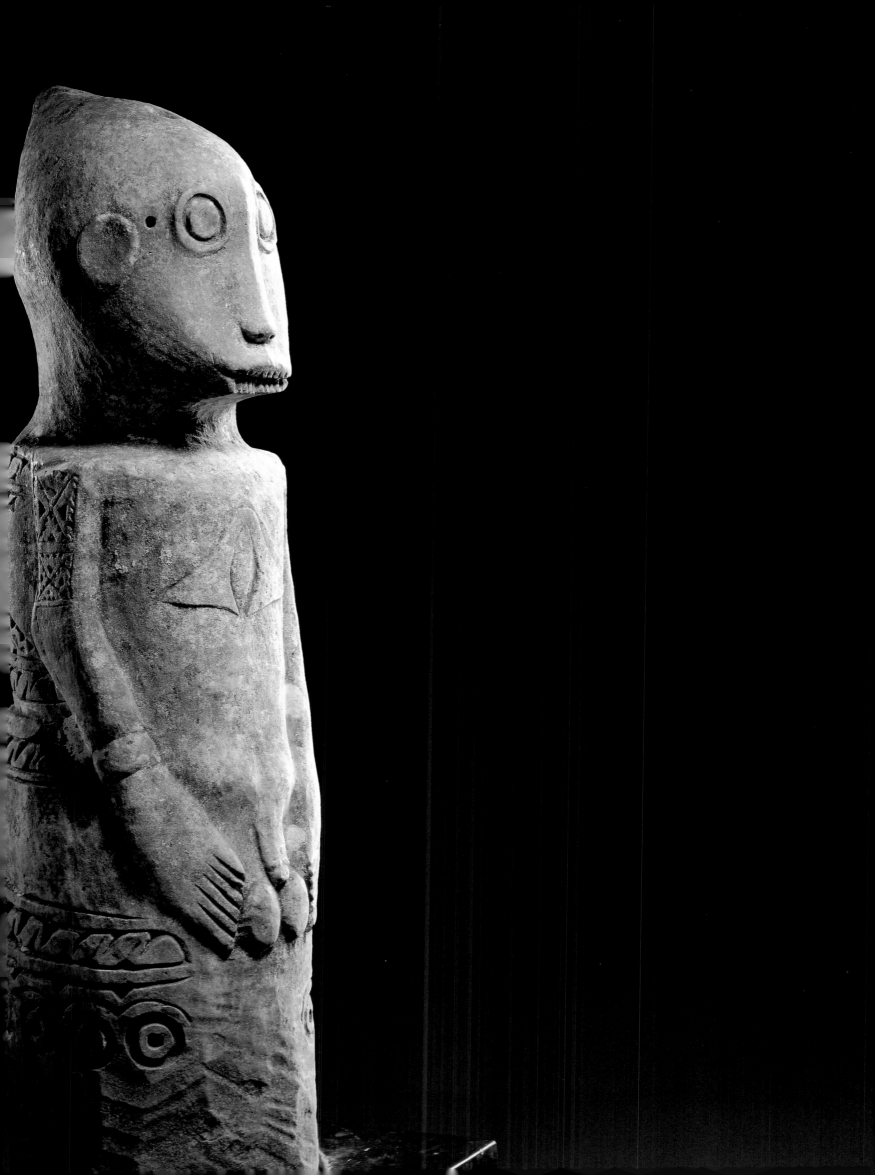

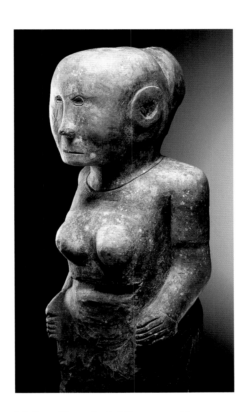

STATUE

Indonesia, Sunda Islands, west Sumba Island, Waikabubak area
Stone, h. 140 cm.
BMG 3656

FIGURE

Indonesia, Sunda Islands, west Sumba Island
Stone, h. 69.8 cm.
BMG 3685

This tall and rigidly erect (in more ways than one) male figure [left] originally stood out of doors, its cylindrical base planted in the ground. On its chest is carved the gold ornament called *marangga*. The head is extraordinary, with its conical cranium, staring round eyes and toothy, chinless mouth. Its distinctive style suggests strongly that it may be the mate of a fragmentary counterpart from the same area (now in the Museum für Völkerkunde, Basel). The figure represents the founding ancestor of a clan, and played a part in agricultural fertility rituals.

The female figure [above], such a contrast with the male figure, so much more naturalistic in its mingling of solid humanity and a certain heavy grace, was an altar (*katoda*) for offerings and prayers to ancestral and other spirits.

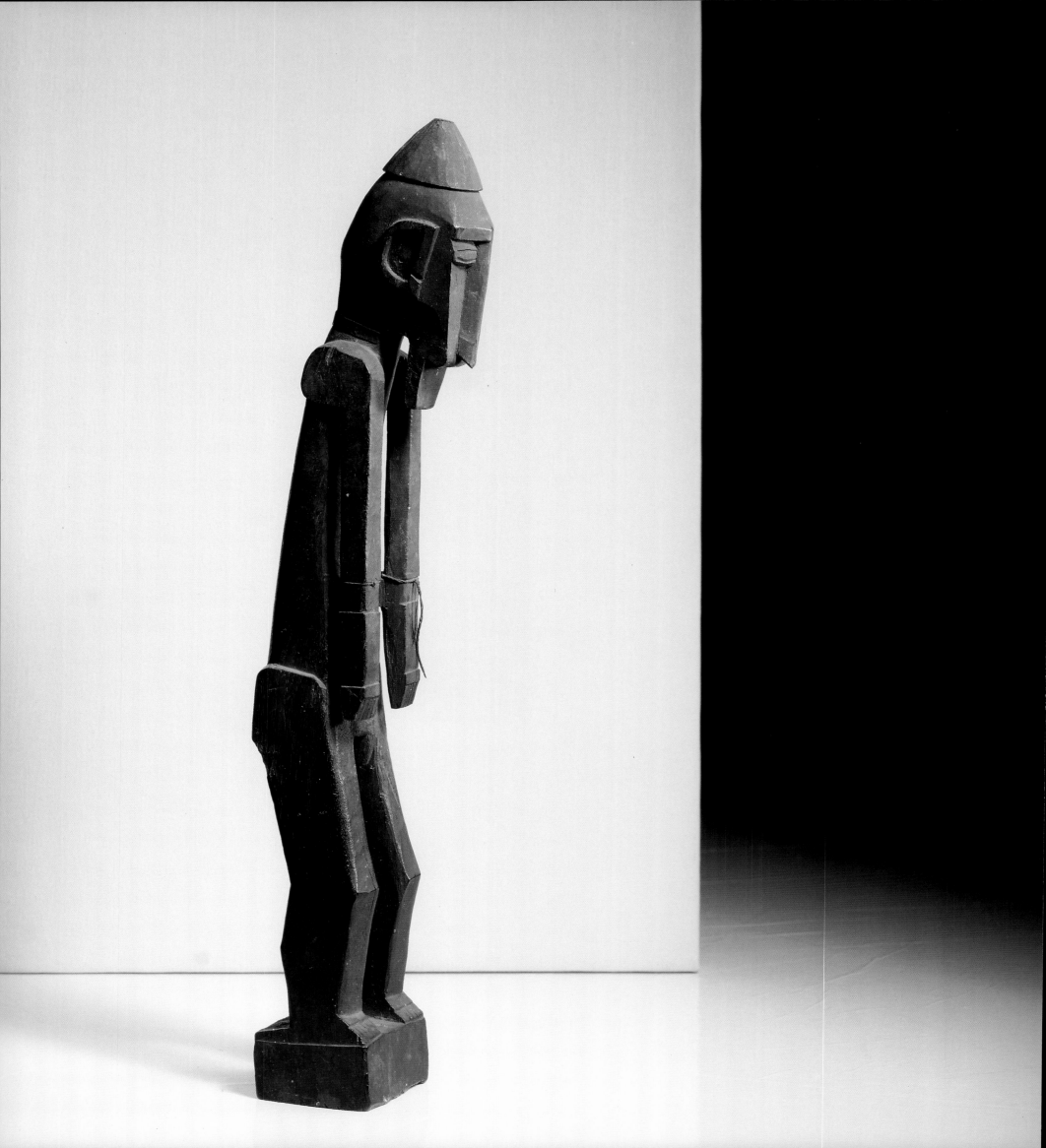

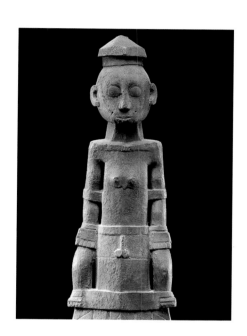

FIGURE, *ITARA*

Indonesia, Sunda Islands, Atauro Island
Wood, h. 52 cm.
BMG 3791

FIGURE (DETAIL OF SHIELD)

Indonesia, Sunda Islands, Atauro Island?
Wood, total h. 90.8 cm., figure h. 34.5 cm
BMG 3795

Atauro is a tiny island lying between the much larger Wetar and Timor; but its people have produced a type of figure sculpture which is quite unique [left]. The majority of the figures stand in a slightly bowed position, knees bent, their shoulders produced forward and their arms hanging. They are usually quite small, and are found as pairs, tied together, of female and male lineage ancestors. They were hung on ritual posts in clusters. The only large sculptures of Atauro were in the shape of long poles carved with human heads representing two deities. These were set up on piles of stone facing each other.

The attribution of a small shield [above] to Atauro is rather conjectural. It is a relatively deep oval tipped at the lower end with a buffalo horn spike, and supporting at the top a figure carved fully in the round. Down the interior runs a gracefully curving handle. The presence of the figure suggests that it is meant to embody a spirit protective of the bearer and threatening to the enemy.

In most parts of Indonesia houses were conceptualized in ways that expressed the polarities (not to say oppositions) found in nature and society, and theoretical ideas about the cosmos. Tetum houses, for instance, were thought of as human bodies, and their various divisions symbolized human male and female elements and organs, with particularly emphatic stress on the sacred female area. The divisions also referred to a sky god and earth goddess: thus also to the cosmic divisions of upper world and underworld. Wall panels and doors often bore square low relief areas patterned with geometricized spirals, pairs of female breasts and crescents representing the metal "buffalo horn" decorations of warriors' frontlets and swords. Full human figures, as in the depiction [above] of a woman with full body, prominent breasts and tiny head, were relatively rare.

In a quite different style, also found on small carvings such as the elaborate handles of buffalo horn spoons, the rice granary door [opposite] is topped with two silhouettes of birds, perhaps roosters, facing in opposite directions. In contrast to their strong outlines, their surfaces are completely filled with minutely incised patterns of diamonds and parallel ridges enclosing rows of tiny knobs.

DOOR

Indonesia, central Timor: Tetum
Wood, h. 131.5 cm.
BMG 3796

END OF PLANK DOOR FOR A RICE GRANARY

Indonesia, west or central Timor: Atoni or
Tetum
Wood, total l. 215 cm., birds h. 61 cm.
BMG 3713

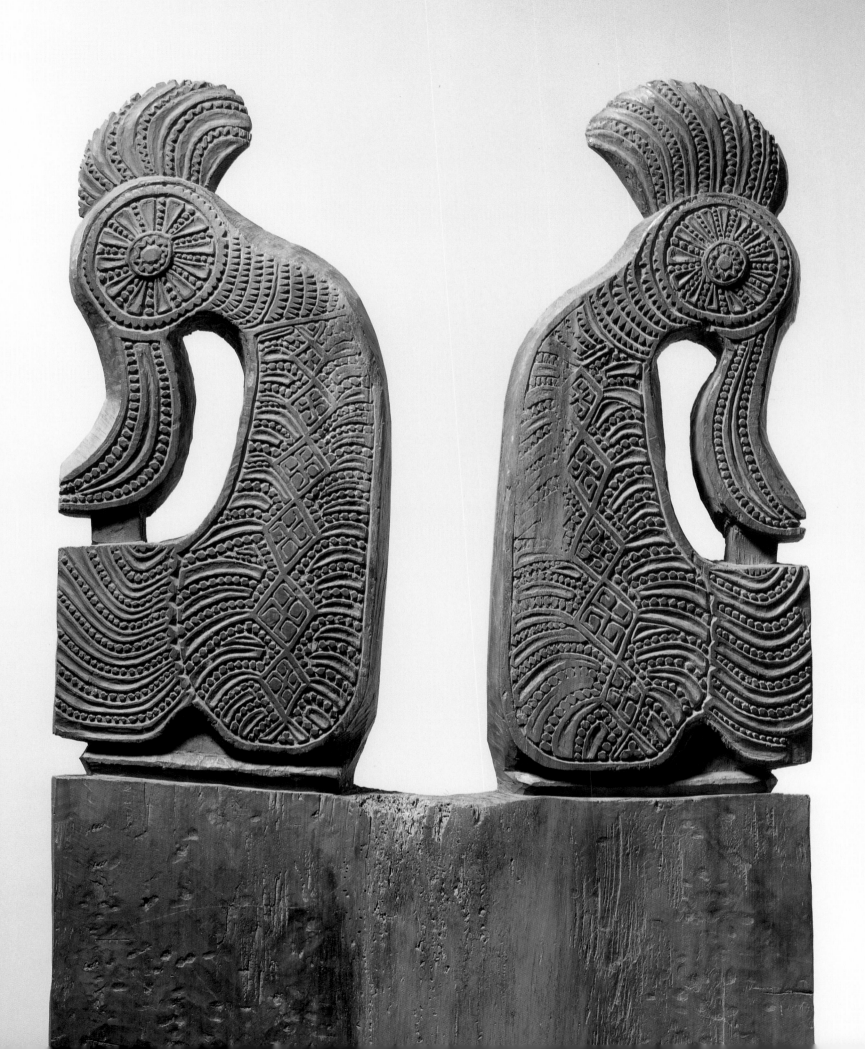

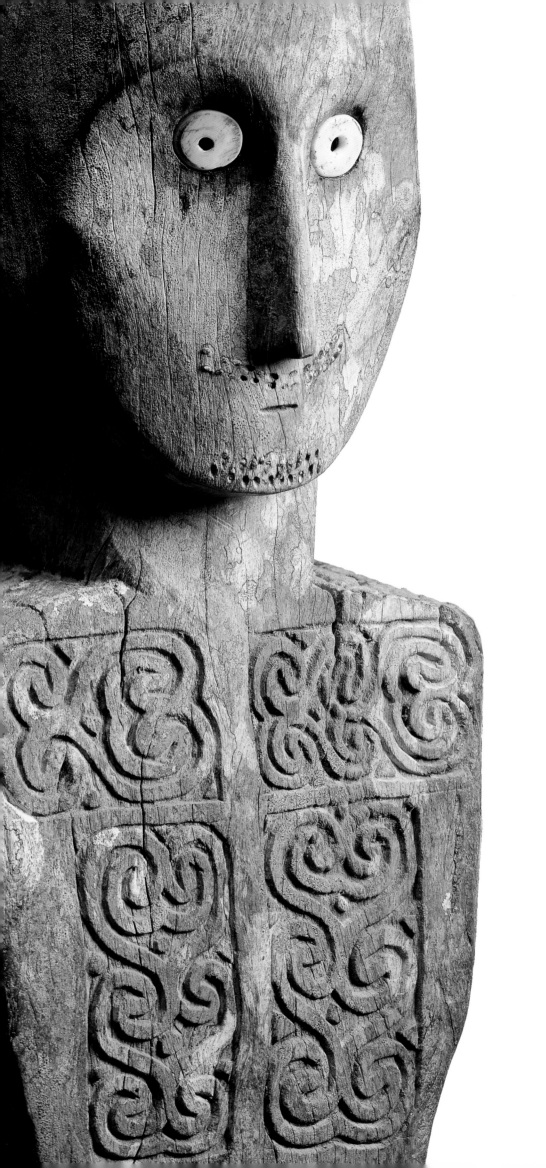

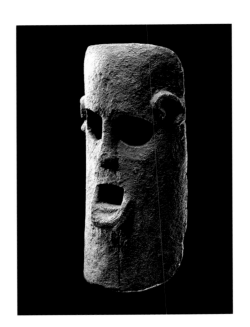

OFFERING STAND FIGURE, *AI TOS*

Indonesia, central Timor: Tetum
Wood, shell, h. 91 cm.
BMG 3726

MASK

Indonesia, west Timor, Atoni area, Kefa
Wood, h. 21.5 cm.
BMG 3710

The Tetum, as other groups, made stands for offerings to the deified ancestors. Usually they are posts in wood or stone set upright on low platforms built of stone blocks. A stone slab is placed on top, carrying a bowl for offerings. Among the Atoni in west Timor the posts were plain. The the Tetum carved theirs with heads [left] below which, on what passed for the torso, were bands or panels of abstract spiral decoration. These figures were dressed with false beards, the frontlets of headhunters, robes and even precious metal ornaments.

Atoni masks [above] are not well recorded or documented, but were probably worn as dance masks by priests.

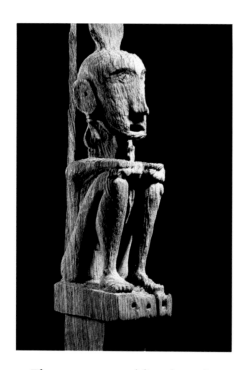

Like the Nage, the Leti islanders carved ancestor figures set on posts, and like the Tetum they mounted them on stone platforms in the middle of villages. Their style and construction, however, are radically different. They often consist of three pieces: the figure is tenoned into a tall pedestal, which again fits into a carved base. (In BMG 3554, pedestal and figure are a single piece.) A small offering cup may be attached just below the figure. The ensemble perhaps shows the ancestor at the top of the cosmic Tree of Life.

The figures themselves, always quite small, are of great elegance. The persons squat with their arms folded over their knees. The heads are disproportionately large. Their features are expressed as slanting oval eyes, and salient pointed noses which occupy most of the face, and inconspicuous mouths. They are furnished with large crowns and earrings.

These were carved five days after a death, wrapped in red cloth, and carried to the deceased's house on a gold plate to be given offerings for the soul. Most remained in the houses; the larger ones with pedestals that were exhibited on the village platforms were the central features around which fertility ceremonies and festivals were held.

OFFERING STAND (DETAIL), *IENE*

Indonesia, Leti Archipelago, Lakor Island
Wood, total h. 147 cm., figure h. 25 cm.
BMG 3554

OFFERING STAND (DETAIL), *IENE*, PERSONAL NAME LEKMASA

Indonesia, Leti Island, Nuwewan village
Wood, total h. 130 cm., figure h. 38 cm.
Formerly Philippe Guimiot collection,
Brussels
BMG 3555

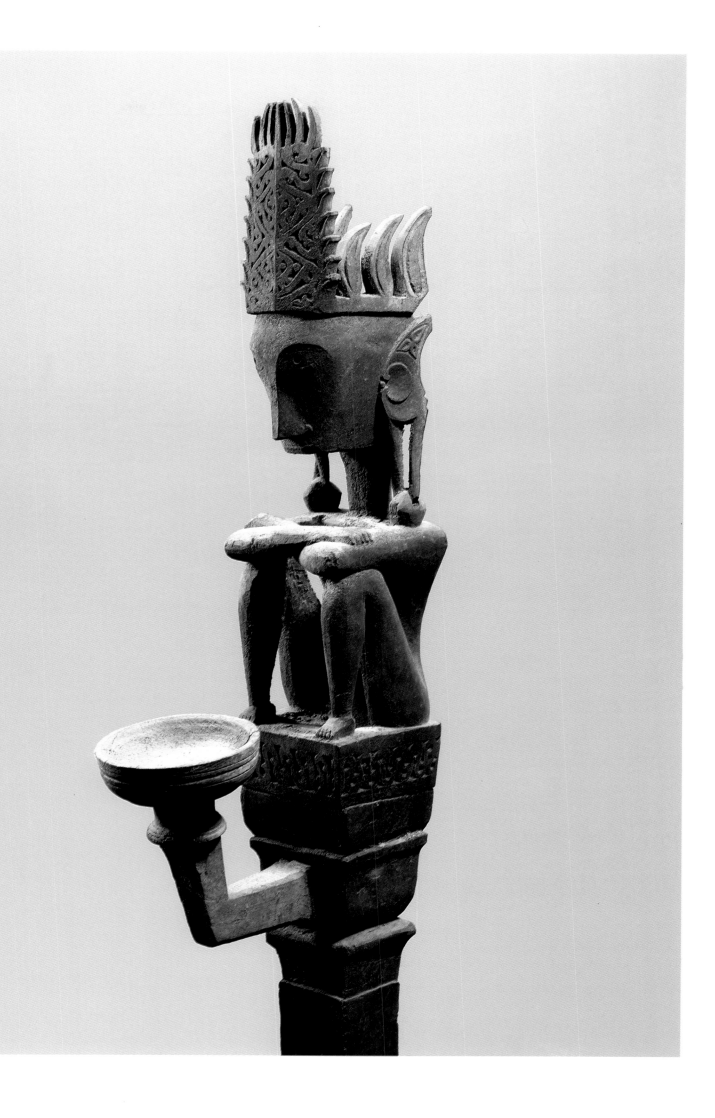

All across the Indonesian archipelago, along the north coast of New Guinea, through Melanesia and right across the islands of Polynesia as far as Easter Island, canoes were built with high vertical prows or sterns, and often both. Not only does this style cover a vast geographical space, it is also an ancient one; boats or canoes of this form are figured on the bronze drums of the southeast Asian Dongson tradition about 300 BC.

Canoes themselves are highly important in this maritime area, not merely as useful and versatile vehicles for trade and war; they bear heavy cargoes of symbolism and belief. They are the vessels of ancestors, sometimes the ancestors in person, sometimes water spirits; just as they carry the living over the seas, they carry the dead from one world to another. In Tanimbar and some other islands the canoe is equivalent to the village and its structure. The ritual center of the village is a platform built of, or surrounded by, stone slabs, with a stone carving at either end duplicating the shape of a wooden canoe's prow and stern pieces. At its middle is an altar dedicated to Ubila'a, the supreme deity.

Like other carvings of their kind, the Tanimbar prows and sterns conveyed metaphorical messages. The outer edges were bordered with ropes of large cowrie shells, signs of wealth. But more important were the carved images. The greater part of the triangular field is taken up with the superb paired or triple spirals typical of Tanimbar art, which call up, at least to Western viewers, the rolling waves. At the base are fish, perhaps the predatory sharks, and a fighting cock. These stand as affirmations of aggression and the will to dazzle, combat and dominate enemies and trade partners.

CANOE PROW CARVING, *KORA ULU*

Indonesia, Moluccas, Tanimbar Archipelago
Wood, h. 150 cm. (tip restored)
Formerly Jef van der Straete collection, Belgium
BMG 3578

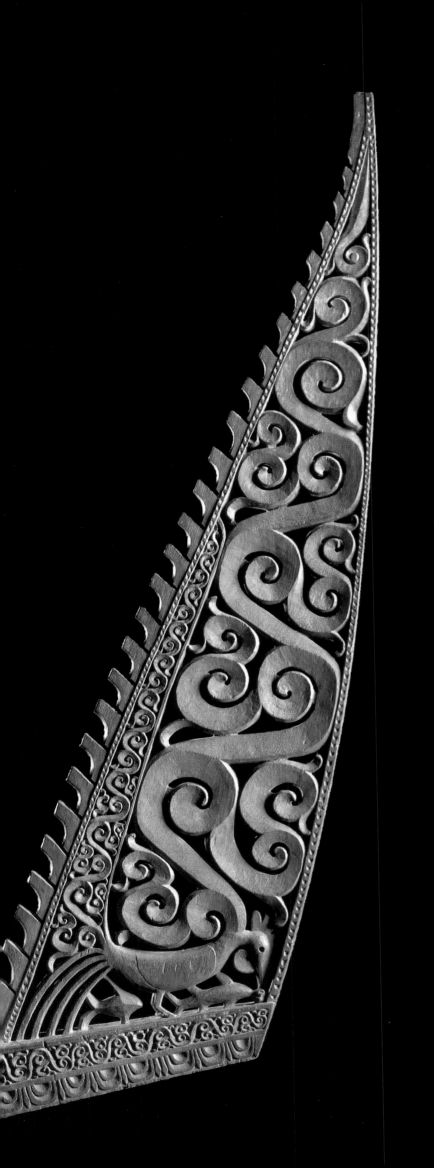

Directly facing the door of every important Tanimbar house there stood a carved board which rose from the floor up to one of the beams. In front of the board was the special seat of the house's owner; behind it was the sleeping place of his daughters. The immediate area had considerable sanctity: the beam was the resting place of ancestral skulls, and shrines for offerings to the gods were nearby.

The *tavu* boards were, with the canoe carvings, the masterpieces of Tanimbar art. The outline is always approximately a human figure, with body, outstretched arms, and a square panel at the position of the neck. On the beam which the "neck" of the *tavu* joined was placed a Chinese porcelain plate that bore the skull of a major ancestor. This probably was intended to be the *tavu*'s own head.

The treatment of the surface of the *tavu* varies. A couple of *tavu* show a male or female figure in relief. On the majority, the whole surface of the body is covered with serried vertical rows of scrolls, arranged symmetrically in alternating directions. The scrolls also extend along the arms, held in the dance position of women imitating the flight of frigate birds, and end in elegant scroll "hands," each endowed with five curved fingers. The square "necks" are expressed in varying manners, and often include images of fish, cocks and dogs—perhaps creatures related to ancestral myths. Most significant of all, from the Tanimbarese point of view, is the depiction of men's gold earrings and breast pendants. These were the great heirlooms, acquired from the supernatural world by a founding ancestor, without which a house had no standing. The *tavu*, then, was a link between two worlds which conveyed the powers and support of the past ancestors to their descendants.

ANCESTOR FIGURE, *TAVU*

Indonesia, Tanimbar Archipelago
Wood, h. 130 cm.
Collected by H. J. Raet van Oldenbarnevelt about 1900; on loan to the Tropenmuseum, Amsterdam, from 1914. Acquired in 1983.
BMG 3568

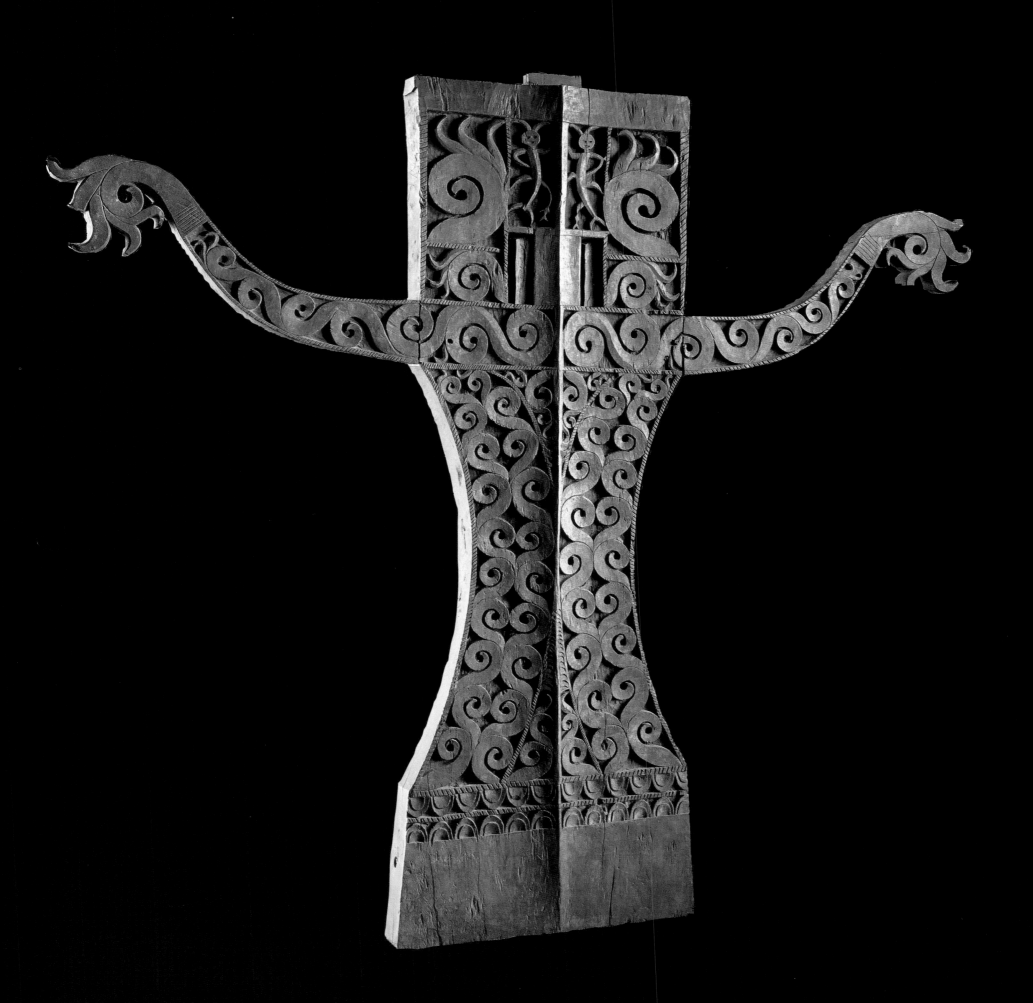

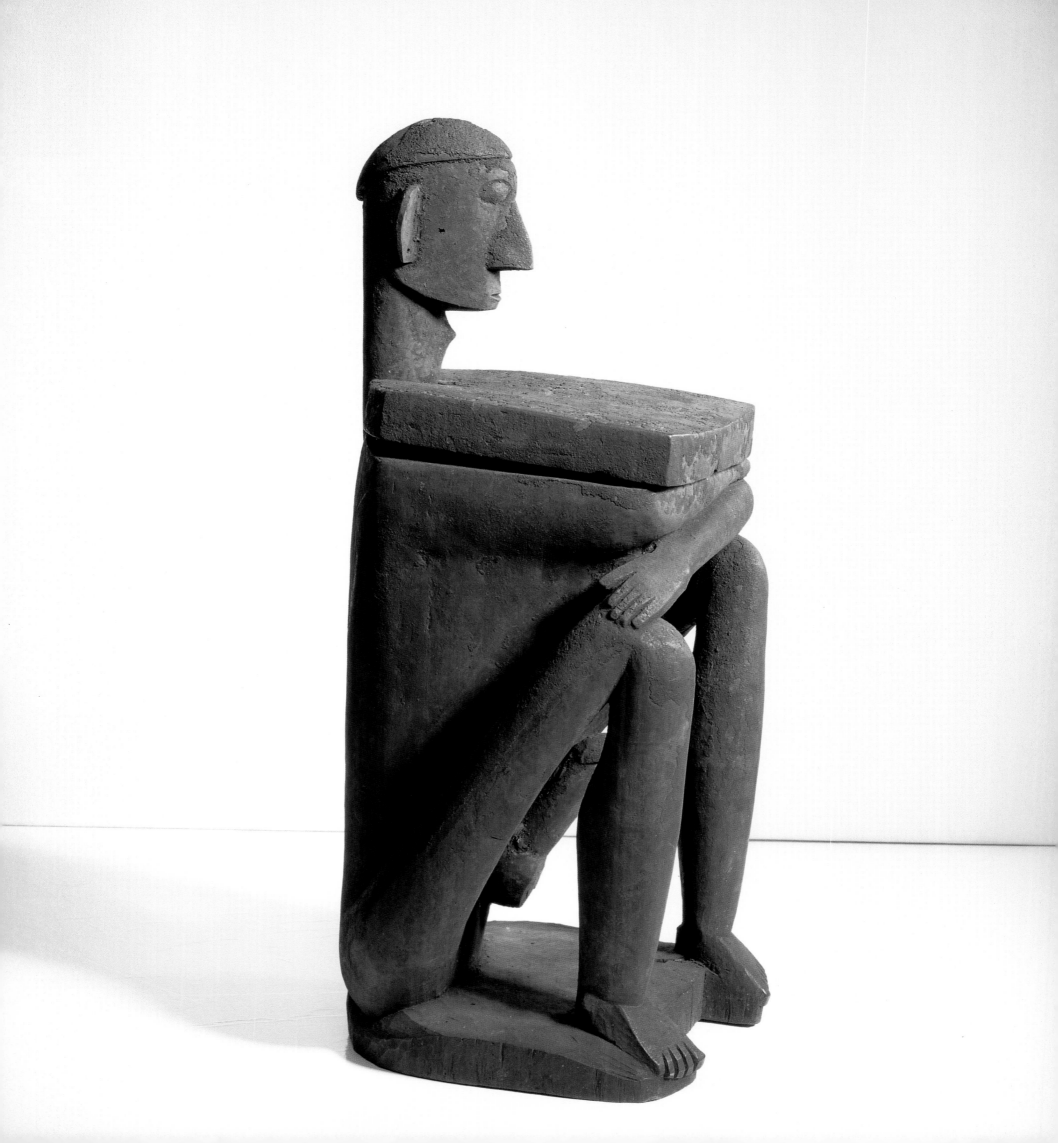

PRIEST'S BOX, *PUNAMHAN*

Philippines, northern Luzon: Ifugao
Wood, h. 65.7 cm.
BMG 3541

SQUATTING FIGURE, *BULUL*

Philippines, northern Luzon: Banaue
(central Ifugao subgroup)
Wood, h. 70.5 cm.
BMG 3501-A

The Ifugao had several classes of gods, each attending to one department of life or another, such as warfare, illness, and so on; none of the gods, it seems, had personal names. The most important class, the *bulul*, were the guardians and promoters of rice cultivation, the staple form of agriculture. The slopes of their mountainous homeland are sculptured into enormous terraces for wet rice cultivation; some sites are known to be over 1,000 years old.

The figures, also called *bulul*, stand or squat on two tiered bases, probably representing a rice storage vessel [above]. They are carved in male and female pairs, only for those who can afford the costly series of sacrifices, rituals and feasts that must be held while the carving process is going on, and during their consecration by priests. When they are completed, they are installed in the rice storage houses, given offerings of meat and rice, and bathed with pigs' blood. They are regularly called upon for good harvests.

Priests' boxes [left] for their magic materials were also kept, like the *bulul*, in granaries. Most of them are rectangular, and have a pig's head carved at each end. This example, showing a squatting human figure with the box on his knees, is unusual. One other kind is recorded as having been made at the time of an epidemic.

Architectural carving was not such a prominent feature of the Luzon highland cultures as it was in other parts of southeast Asia. Nevertheless, the Ifugao and members of some other tribes, displayed their wealth with a certain amount of house decoration. Wooden panels and the ends of beams were carved with animal or human heads, evidence of success in headhunting and the undertaking of lavish sacrifices. Some figures may have been supernatural guardians.

A few doors or shutters exist. This one displays a frontal human figure against a background of beautiful vertical grooving.

DOOR PANEL

Philippines, northern Luzon: Kankanay
Wood, h. 157 cm.
Formerly Alain Schoffel collection, Paris
BMG 3549-42

STANDING FIGURE, *BULUL*

Philippines, northern Luzon: Apano
(southeast Ifugao subgroup)
Wood, h. 75.5 cm.
BMG 3532

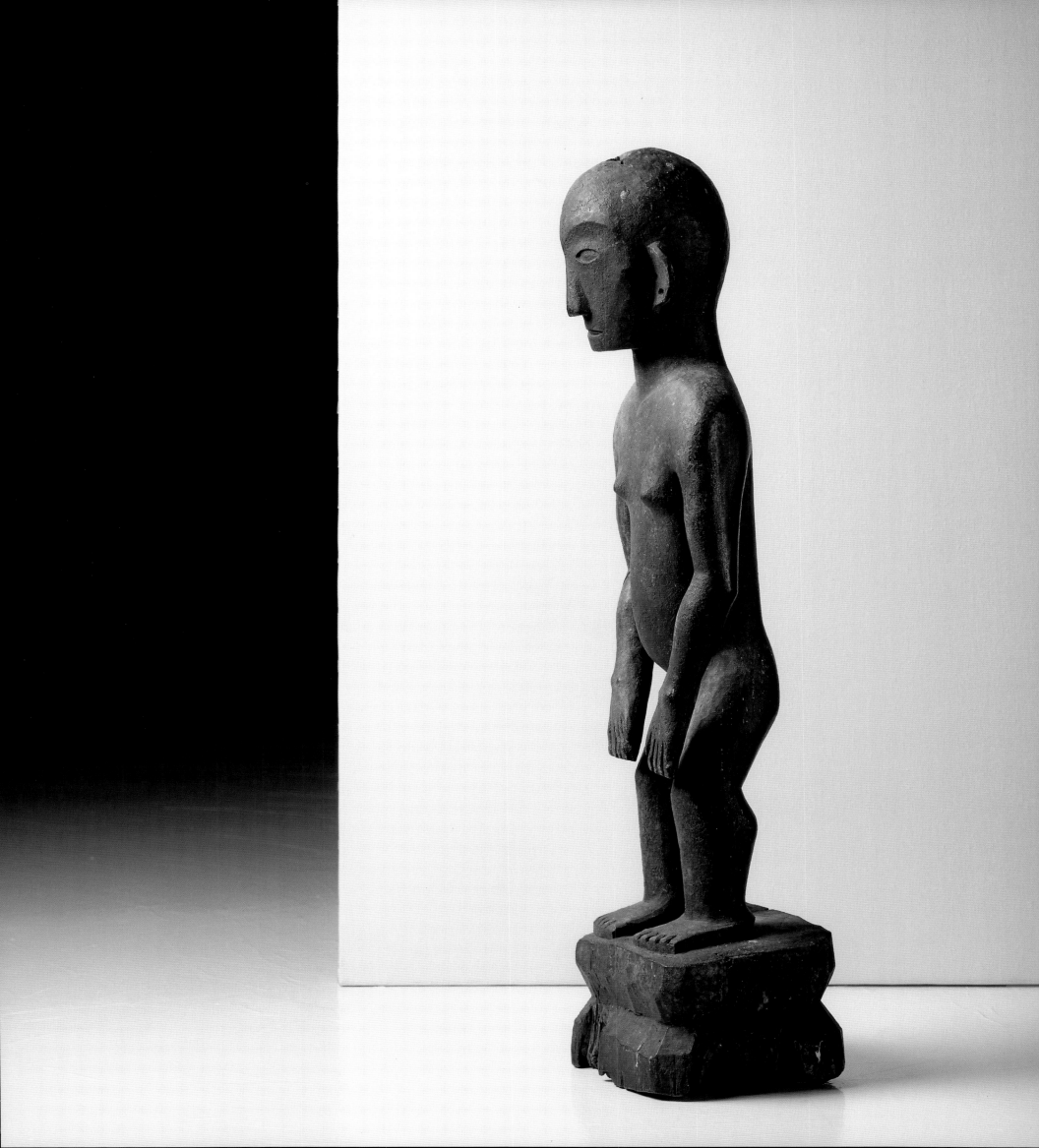

The Kankanay and Ifugao, and per-
haps other groups in the Luzon
cordillera, carved large numbers of
ladles and spoons; practically every-
body possessed one or both, and peo-
ple carried them on their persons
[above]. Spoons have shallow, pointed
oval bowls; ladles have deep, round
bowls. The handles are generally
carved into small, elegant, and rather
summary standing figures, but a
number show genre subjects.

The standing figure [right], carved
in a style all angles and planes, and
with detachable arms that can be
moved into various positions, belongs
to a rare type of Ifugao sculpture made
by the Hungduan subgroup. Although
others exist, it is only equalled by an
identical sculpture once in the collec-
tion of Paul Eluard, and now in the
British Museum.

LADLE

Philippines, north Luzon: Ifugao
Wood, l. 26.1 cm.
BMG 3500-C

FIGURE, *BULUL*

Philippines, north Luzon: Hungduan
(southeast Ifugao subgroup)
Wood, h. 65 cm.
Formerly Josef Mueller collection, before
1939
BMG 3510

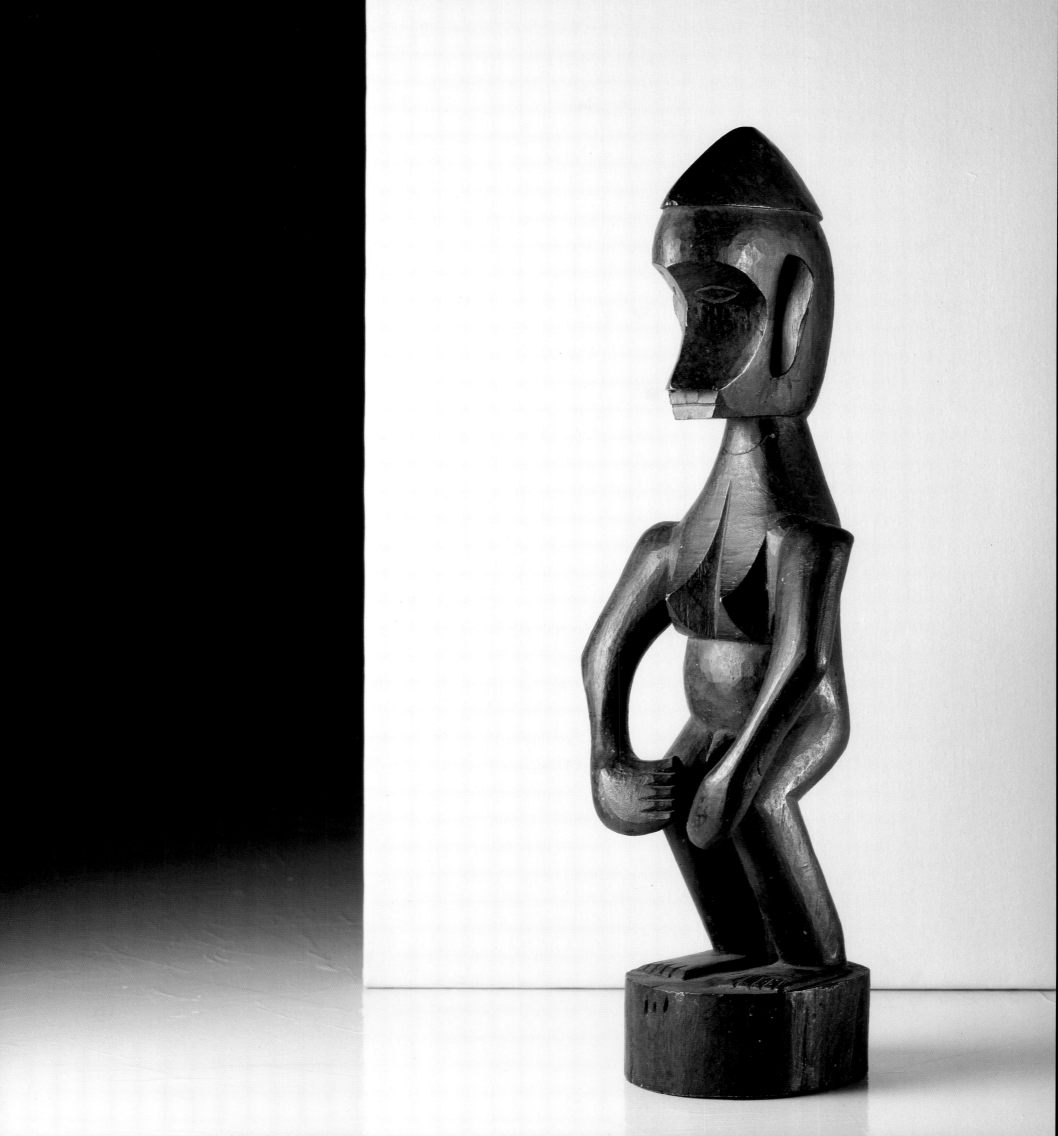

Grave markers, architectural ornamentation and ship carvings are the finest works of the Bajau people of the Philippines, who use a style called *okir* or *ukkil* largely based on a lavish employment of plant motifs. At the same time a variety of other forms are used on their grave markers. They consist of a carved frame laid on the ground to support a horizontal carving which serves as a base for a vertical one. The verticals on female markers are panels in *ukkil* style, those on men's are columnar and distinctly phallic. The horizontal elements include horses—one is shown here speeding with the wind in its mane—*naga*s and ships' prows. It is in fact possible that the grave markers as a whole are seen as "ships of the dead" on their voyage to the next world.

MARKER FOR A MAN'S GRAVE

Philippines, Sulu Archipelago: Bajau
Wood, l. 105 cm.
BMG 3549-38

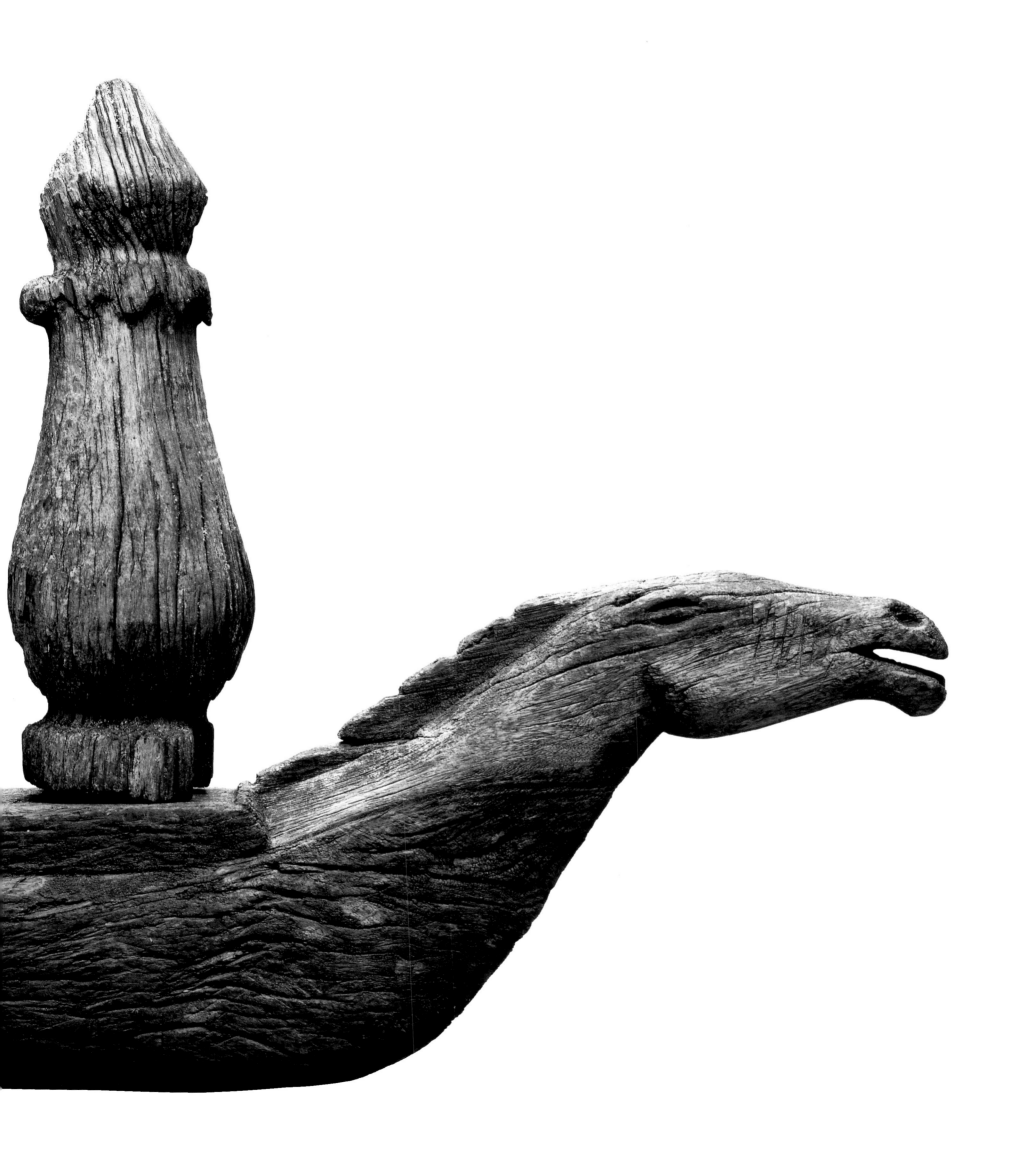

OCEANIA

The Sentani live on a large lake surrounded by steep hills; the limited amount of level ground obliged them to erect their houses over the lake waters at the foot of the slopes. The pile-built structures were connected by jetties, and besides dwellings for the common people comprised pyramidal ceremonial houses and large houses for hereditary chiefs.

The tops of the jetty posts, and the posts projecting up through the floors of the chiefly houses, were carved with human figures, single or in pairs, in several styles all remarkable for their austerity—not a typical aspect of New Guinea art. One of the styles is exemplified by this figure of a mother and child [right]. The position of the head, hanging almost below the shoulders, the general pose of the figure and other details, are also found in Humboldt Bay.

The same features are also to be found elsewhere eastwards along the north coast of New Guinea, and even in the islands of the Massim area to the far southeast—indicative perhaps of the spread of a seaborne culture at some early historic phase.

The Sentani were also prolific carvers of many types of objects, not least their hand-drums [above], which were usually covered with variations on their favorite spiral pattern, and sometimes had figurative human handles. Drums were closely associated with an ancestor who pushed heaven and earth apart. The upper part of the drum symbolizes the sky, the band at the drum's waist the point where heaven and earth are separated—or unite. Below is the earth, symbolized here by a strong animal figure, probably a lizard.

MOTHER AND CHILD

Irian Jaya, Lake Sentani: Sentani
Wood; h. 76 cm.
Collected by Jacques Viot, 1929; formerly
Helena Rubinstein collection
BMG 4051

HAND-DRUM

Irian Jaya, Lake Sentani: Sentani
Wood, skin, cane; h. 63 cm.
Formerly Josef Mueller collection, before
1939
BMG 4050

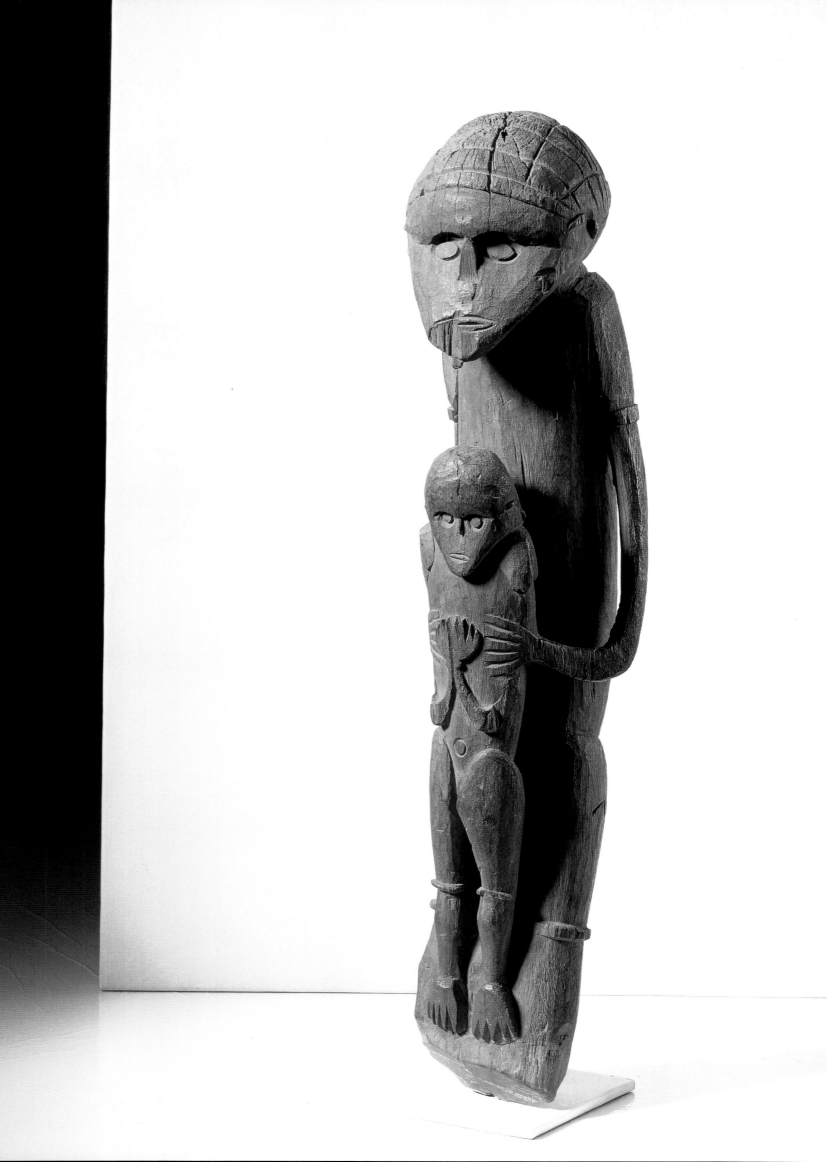

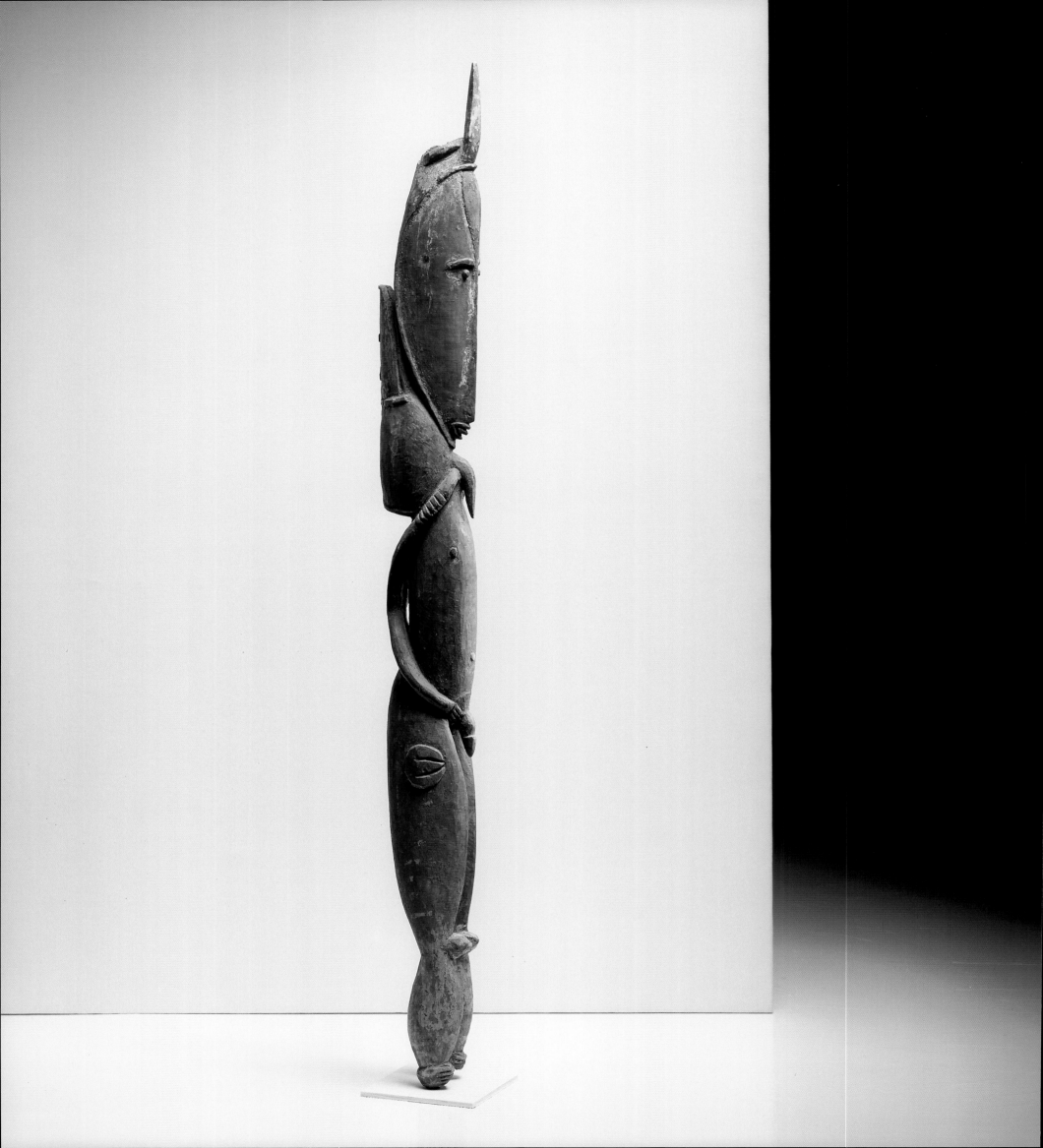

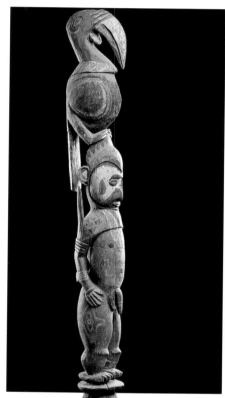

FIGURE

Papua New Guinea, East Sepik Province:
Wosera Abelam

Wood, paint; h. 135 cm.

BMG 4080-7

FIGURE

Papua New Guinea, East Sepik Province:
Wosera Abelam

Wood, paint; h. 123 cm.

Collected by Dr. Hugo Schauinsland before
1906; formerly Übersee Museum, Bremen

BMG 4080-1

A huge triangular sector of northeast New Guinea is drained by the long Sepik River, and its many tributaries, running through a valley encompassed by mountains to north, south, and west. It is inhabited by a phenomenal number of small societies: there are about 200 groups of people speaking different, but sometimes related, languages. They are renowned for their extraordinary productivity in the visual arts.

The Abelam, the largest Sepik group, live in the mountains and plains north of the river. Their art and architecture is designed to produce a mass effect, and succeeds: it is the most spectacular in New Guinea, if not all of Oceania. The pyramidal ceremonial houses of the northern Abelam had gables, towering up to a height of 25 meters, painted with registers of spirit faces, figures, and animals. The ceremonial houses of the southern Abelam were smaller, without the high gables. All sculpture was brilliantly painted, with yellow, white, black and red, in the north. For the long course of male initiations, which could be spread over a lifetime, figure carvings were made in great numbers and crowded the ceremonial houses. The southern, or Wosera style shows standing figures with ovoid heads, often surmounted by birds, with robust rounded forms [above], or—less frequently—slender and laterally compressed [left].

The figure collected by Dr. Schauinsland is one of the oldest Abelam sculptures known. Like a few other figures, it was probably conveyed by some means to German missionaries or traders.

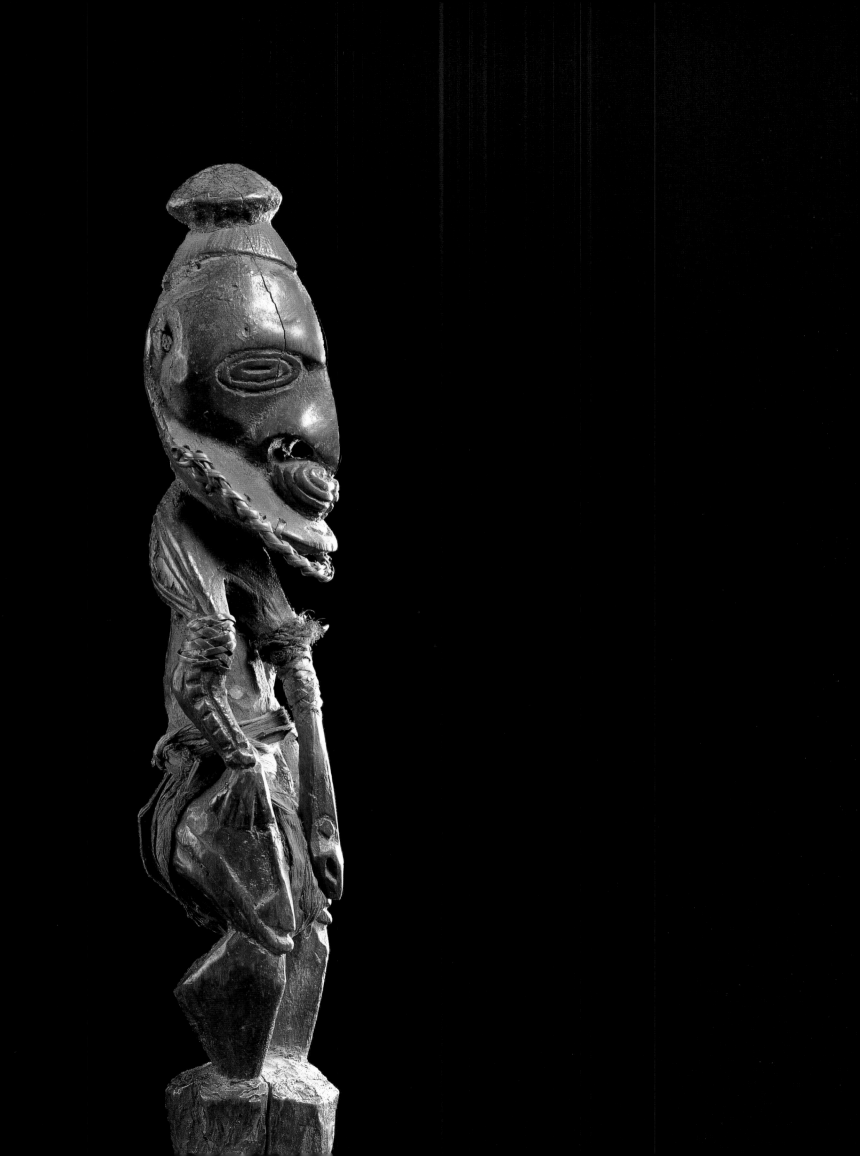

FIGURE, *KANDIMBOANG*

Papua New Guinea, East Sepik Province, lower Sepik River: Murik
Wood, bark-cloth, cane, fiber, h. 30 cm.
Formerly Josef Mueller collection, before 1942
BMG 4073

MASK

Papua New Guinea, East Sepik Province, lower Sepik River: Kopar
Wood, paint, cane, seeds, h. 25.5 cm.
Formerly Josef Mueller collection, before 1942
BMG 4072

In the Sepik River region, groups living in contact with each other may have radically different art styles.

The Murik people, who live on lagoons at the mouth of the Sepik River, carved many male and female figures, large and small in scale [left], representing deified ancestors. Male figures were used in secret men's cults, and female figures in cults practised only by women—the only case of its kind in New Guinea, where religion is normally an exclusively male province of life. The figures are believed to be the "canoes" or receptacles of the spirits. They show a certain degree of naturalism, though it is subordinated to local sculptural conventions in the depiction of the figure. In this example a curious feature is the extension below the chin ending in a zoomorphic head.

In the villages of the Kopar, a short distance up the river, a completely different convention for the human face is found [above]. The masks of this area with enormously exaggerated noses are famous; but in Kopar masks the entire face is reduced to a long spike with a loop enclosing an oval eye on either side. A downward facing bird, perhaps an eagle, is set on the forehead; and that is all.

This possibly unique example has two such faces, united by a single nose. The theme of opposed and conjoined faces is a common one in Sepik art. It usually refers to a pair of ancestors—brothers, or sister and brother—the younger being the smaller.

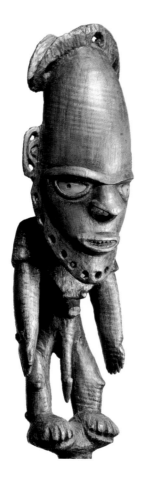

As befitted their importance, the sacred flutes of the Sepik River area were richly decorated, often with woven and painted cane sheaths, ruffs of cassowary feathers, and quantities of shell ornaments. Most striking of all were various types of attached woven objects, small masks and figure carvings. The woven objects and masks were fixed to about the middle of the shafts, the figures plugged into the upper ends.

The Biwat living on a southern tributary of the Sepik River, were unusual in using both figures and masks, adopting the fashions of neighbors. Biwat flute figures [above], with their oversized heads—original-ly sporting wigs and sprays of cassowary feathers—and their aggressive stances, are among the most powerful of all New Guinea figure carvings. These represented the "children" of Ashen, the female crocodile spirit, who devoured boys at initiation—quite literally, as they were pushed inside a large cane model of her, to be "reborn" later. Small masks, with carved wooden or bone bases overlaid with nassa and conus shells set in a blackened compound of clay and vegetable oil [right], were imported from the Yaul people living to the west. They were tied to the middles of the flutes played at initiations in honor of spirits of the forest and swamp.

FINIAL FIGURE FOR A SACRED FLUTE

Papua New Guinea, East Sepik Province, Yuat River area: Biwat
Wood, pearl shell; figure h. 43 cm. (without its spike support)
Collected by A. A. Blouxham before 1928
BMG 4061

MASK FOR A SACRED FLUTE

Papua New Guinea, East Sepik Province, Yuat River area: Yaul
Wood, clay, paint, shells; h. 31 cm.
BMG 4088

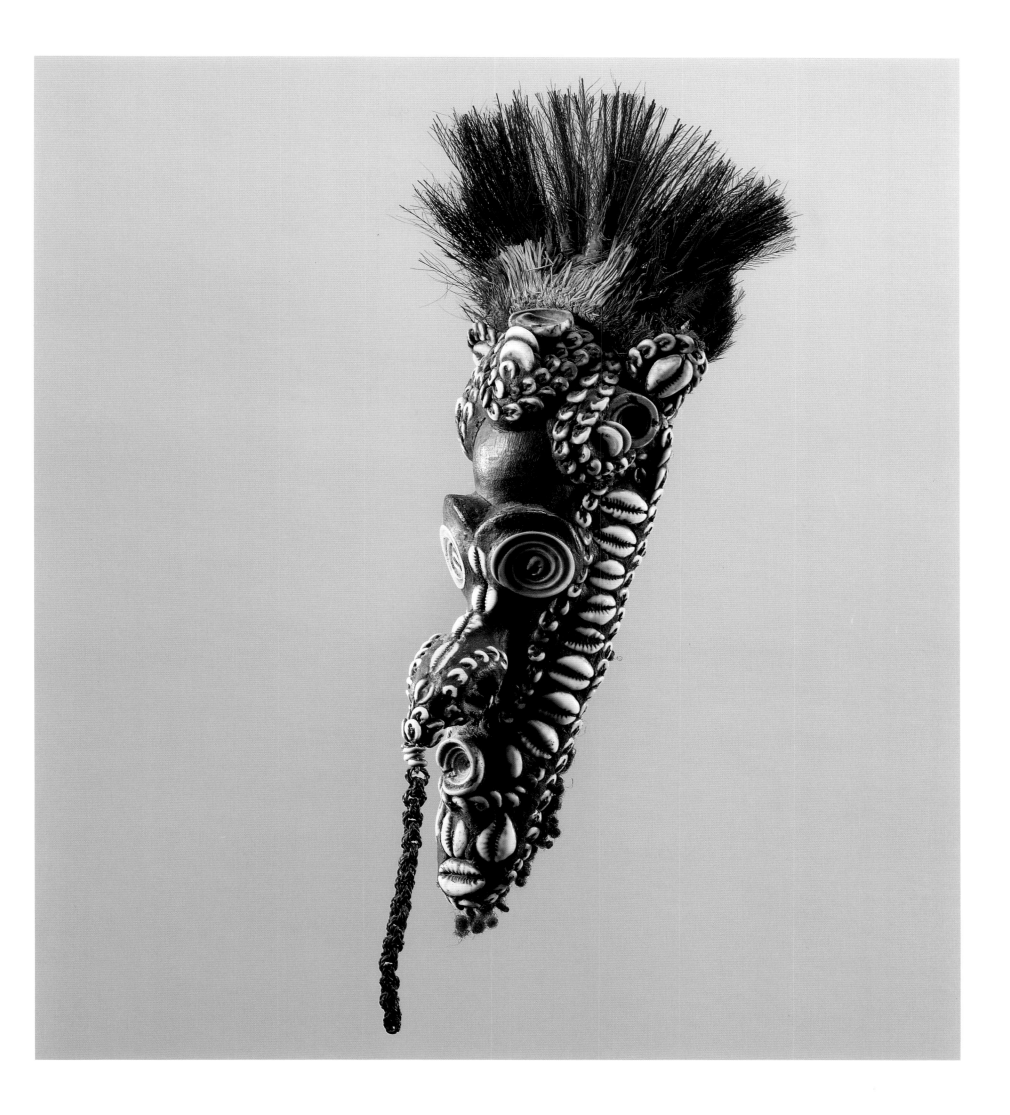

The exact origin of this figure is not altogether clear. It belongs to a lower Sepik River tradition of crouching figures found as far as the mouth of the Yuat River, where it is combined with a formation of the human head similar to the masks from the same region. The head is ovoid, the eyebrows are connected to a bulbous nose. The eyes are set slanting under them, and are inlaid with pearl shell. The limbs are acutely flexed, and stand clear of the torso, with the hands held away from but close below the chin. The narrow torso comes forward to an obtuse angle at the navel. The figure sits on a small conical pedestal, sometimes repeated in a register of three or more cones. Some figures in the same style are shown standing. Those with known provenances come from the Angoram, Biwat and Yaul groups.

The significance of the figures and their use is largely unknown. On one hand the fact that the cone pedestals are hollowed suggests they were gable finials for ceremonial houses, for which there is some evidence. On the other hand more figures of the kind exist than there can have been suitable houses, in many cases the figures are not weathered, and the fragile accoutrements attached to some examples—cords in noses and ears, paint and feathers—also argue against this being the general rule.

It is likely that the same type of carving was used both for carefully preserved cult objects and for architectural pieces—a not uncommon practice in New Guinea. This figure would certainly, like a few others, belong to the category of cult figures, among which it takes a very high place.

FIGURE

Papua New Guinea, East Sepik Province, Yuat River area
Wood, pearl shell, cords, cassowary feathers; h. 146 cm.
Formerly Arthur Speyer and Eckert collections, Basel
BMG 4077

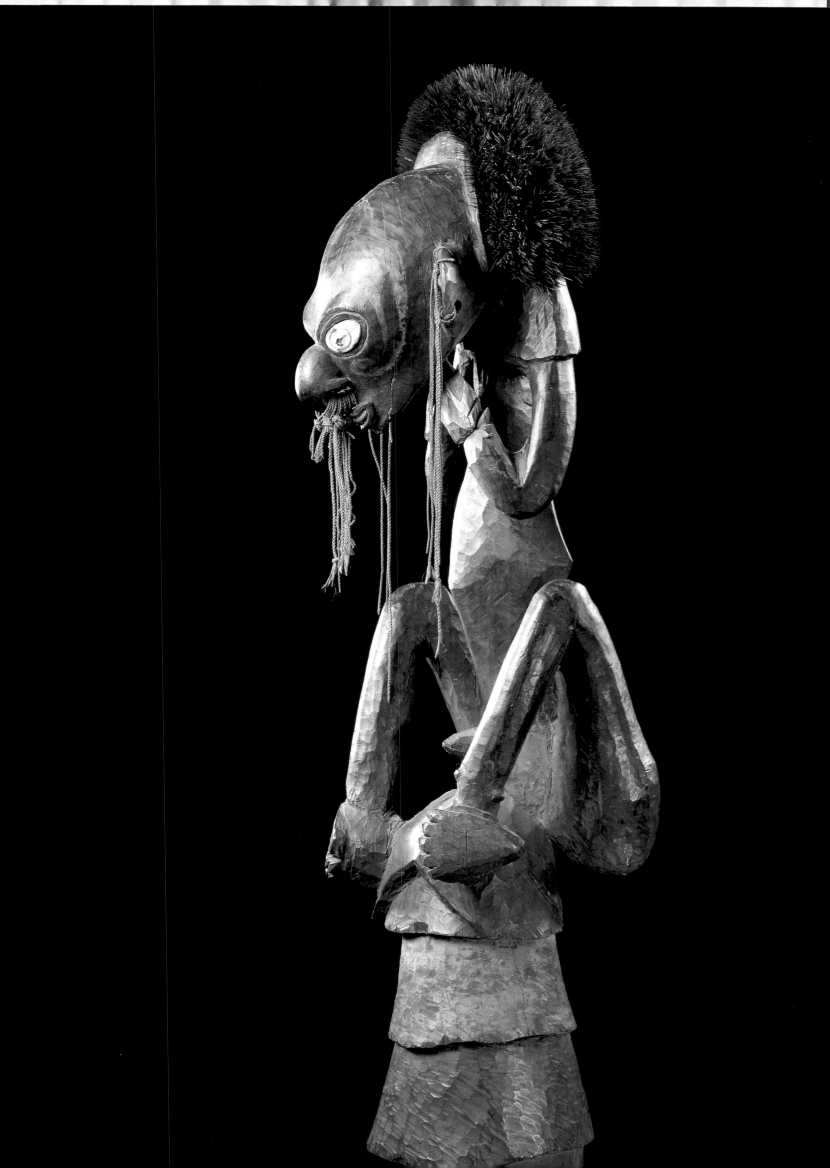

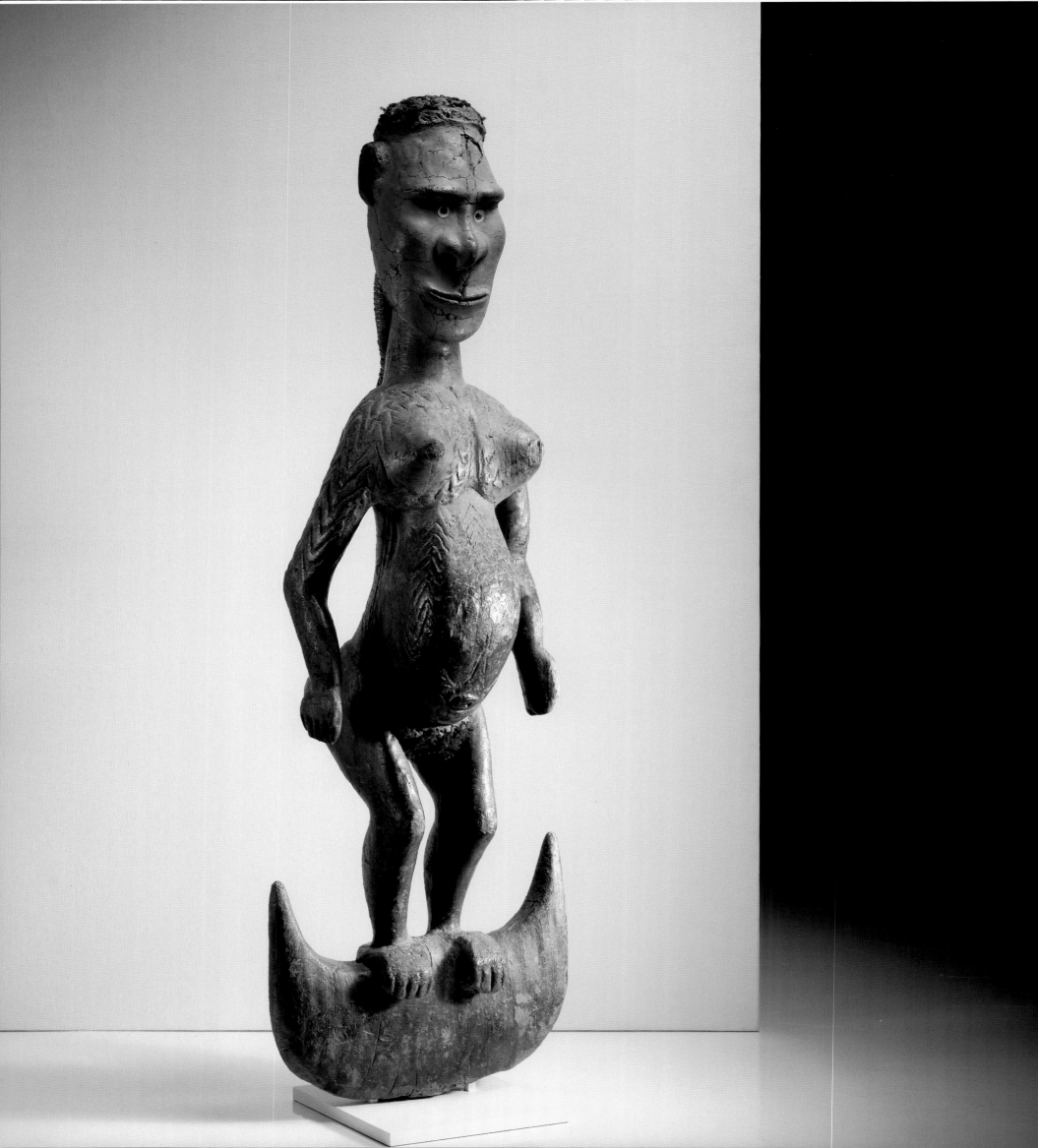

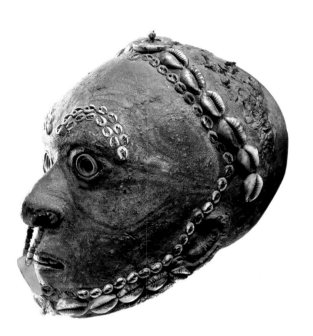

FEMALE FIGURE ON SUSPENSION HOOK, *SAMBUN*

*Papua New Guinea, East Sepik Province,
Sepik River: Iatmul*
Wood, shells, clay, paint, hair; h. 126 cm.
*Formerly Arthur Speyer collection, from an
unidentified German museum*
BMG 4092

DECORATED SKULL

*Papua New Guinea, East Sepik Province,
Sepik River: Iatmul*
Skull, shells, clay, paint; h. 17 cm.
Formerly the Naprstek Museum, Prague
BMG 4089

Like many other Sepik River groups, the Iatmul living along the river's banks in its middle reaches carved wooden hooks with double or multiple prongs. Most were household furniture, suspended from the roofs of houses to secure bags of food and valuable objects hung on them from rats. With their genius for ornamentation, the Iatmul usually carved the shafts as human figures, animals, or more or less abstract designs. Some, however, had much greater significance; the human figure represented an important ancestor standing on the prongs of a hook.

This figure [left] is undoubtedly of the latter type: it is impossible to think of this imposing woman as the mere guardian of personal property. She must have been one of those mythical ancestors who had offerings to her hung on the hooks and was consulted, perhaps through shamans, on crucial matters. She also bears certain insignia of male power, being incised with the patterns of scarification normally inflicted only on males during initiatory ordeals.

Iatmul sculpture embodies a degree of naturalism rare in New Guinea. It appears here in the massive belly, perhaps a sign of pregnancy, and the head, whose stylistic convention marks the work as coming from the western branch of the Iatmul, known as the Nyaura.

As inveterate headhunters, the Iatmul preserved not only the skulls of their ancestors but those of their victims, as possibly the most sacred of objects apart from the holy musical instruments [above]. Stripped of flesh, they were given features modelled in a mixture of clay and vegetable oil, then painted with the designs used in life. They were often displayed on wood or painted bark racks, and sometimes were also hung on suspension hooks.

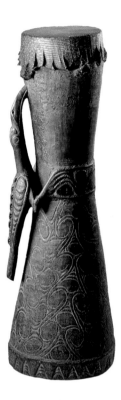

One of the most important, yet still least appreciated, elements of New Guinea cultures was their music. There was a large range of instruments, some merely secular and recreational, others secret and bound to religious life.

Transverse flutes, made from bamboos up to 2.5 meters long, were among the most sacred objects used in Papua New Guinea, and particularly the Sepik River area. When men played them, the spirits of the water, air and forest took the human breath in order to give voice in mysterious and beautiful song. Usually the flutes sang in pairs, in a sort of counterpoint, as the players slowly circled around each other.

The flutes of the Iatmul people, the largest group living along the middle reaches of the Sepik River, were fitted with wood carvings in all likelihood referring to totemic ancestors of the clans which owned them. Judging by its form and size (though rather large for the purpose) the figure [right] is one such. Here we have one of the commonest images of Iatmul art, the fish-eagle, a bird of prey respected by these headhunting people as a hunter and killer. There is also an ambiguity about its surface decoration: the enclosed discs running along the lower beak may refer to the same pattern carved on representations of the mandible of that other great killer, the crocodile.

The hand-drum is a secular instrument, though often played as an accompaniment to religious singing and performances of sacred instruments. It is in hourglass shape with a carved band around the waist. The eagle is again shown in the round, here used as a handle [above].

BIRD FIGURE

Papua New Guinea, East Sepik Province,
Sepik River: Iatmul
Wood, paint; h. 78.5 cm.
BMG 4064

HAND-DRUM

Papua New Guinea, East Sepik Province,
Sepik River: Iatmul
Wood, skin; h. 61 cm.
Formerly Dr. Stephen Chauvet and Charles
Ratton collections
BMG 4090

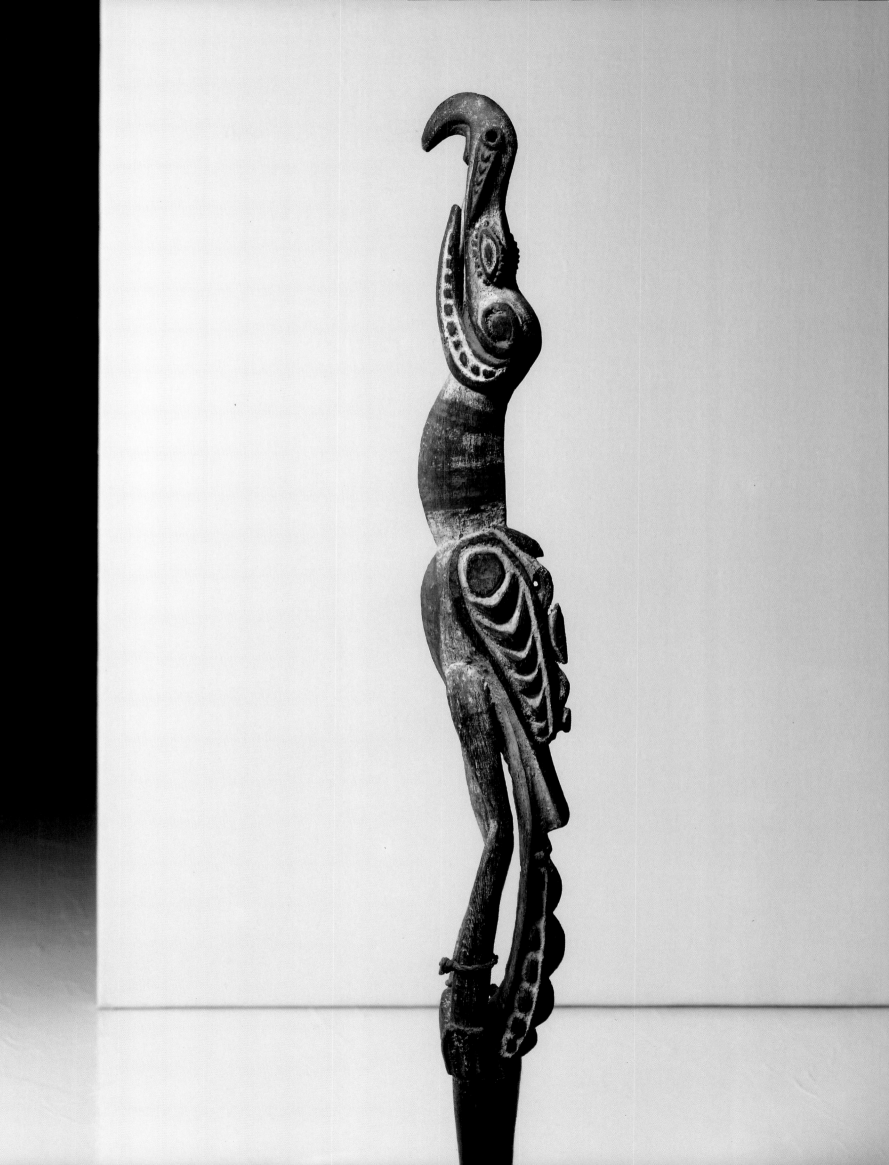

The slit-gong is created by cutting a slit along the length of a log, then through this narrow aperture hollowing out the inside. What results is a monochord musical instrument: striking the edges of the slit at various points produces a scale of tones with immense resonance which can be patterned in intricate rhythms. The slit-gong is widely distributed in southeast Asia, through northern New Guinea and most of Melanesia and Polynesia. Its great antiquity is certain; it was probably introduced to the Pacific basin more than 2,000 years ago.

Several types exist, including gongs that lie on the ground, stand upright planted in the earth, or are suspended upright or horizontally. Some are small, others are up to six meters long. In some areas the largest slit-gongs are extremely sacred, especially in parts of the Sepik region and Vanuatu. At the same time small slit-gongs, privately owned, are used to send messages: there are even "slit-gong languages" for the purpose.

Horizontal gongs are the prevalent type of the New Guinea coast, and they are nearly all enriched with fine carving. The broad sides afford space for panels of incised patterns in more or less symmetrical schemes. "Abstract" as they may appear to the ignorant eye, all the motifs have names and refer to some natural form. (Although the same motifs appear in many places, in each locality they are assigned different meanings.) Coastal Sepik slit-gongs also have a three-dimensionally carved handle, or lug, at each end; often showing, as here, generalized ancestor figures and ani-

mals. The carvings of the Kayan people are much admired, including their slit-gongs, and are a favored item of their trade with other groups.

SLIT-GONG

Papua New Guinea, East Sepik Province coast: Kayan
Wood, l. 168 cm.
Formerly Herz Jesu Hiltruper Mission, Hiltrup bei Münster
BMG 4085

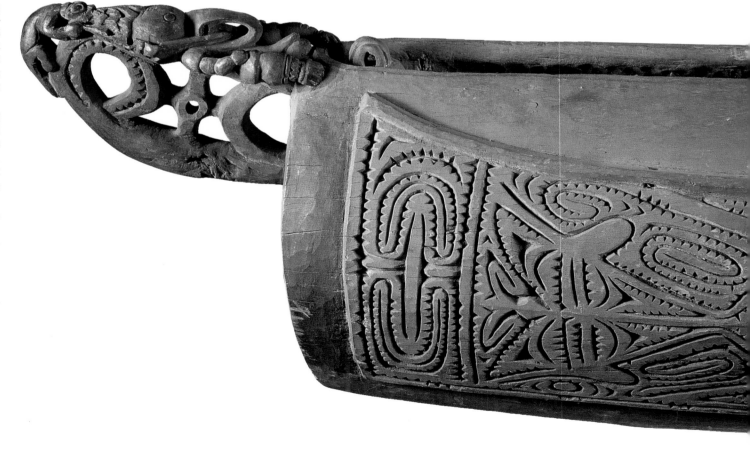

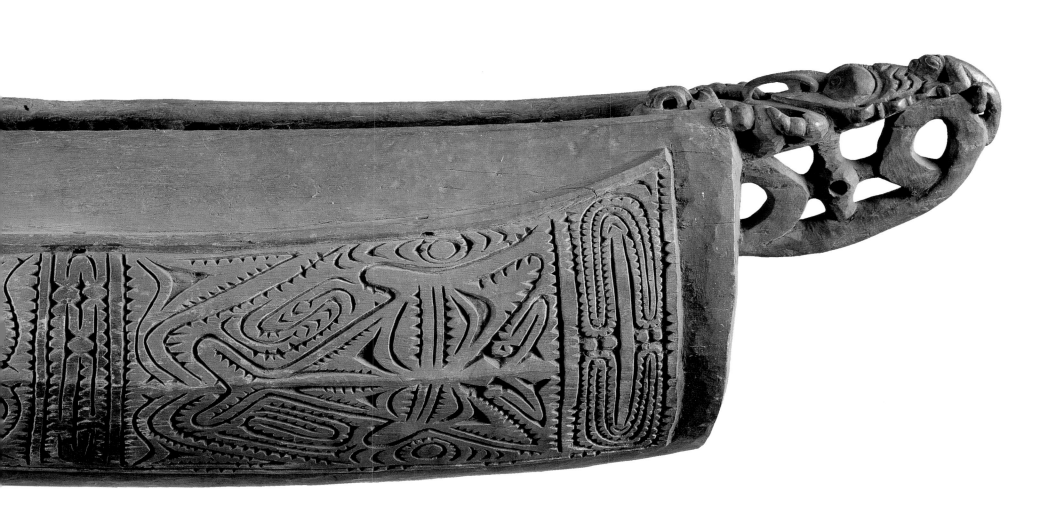

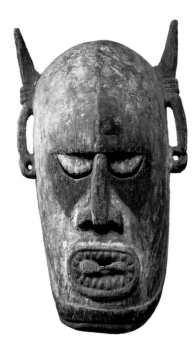

The most important works of the Astrolabe Bay people, southeast of the coastal Sepik-Ramu area, were large figures [right], few of which now remain—the carving tradition appears to have died out before 1900. They are of standing males, posed frontally, shoulders hunched well forward of the torso. The triangular faces have chins extending below the chest and pendant projections from the mouths which represent dance and fighting ornaments carried in this way. The brows are rigidly horizontal, bar-like noses depend from them, the eyes are round and and staring. The hands are placed horizontally on the hips. Unfortunately very little was ever recorded about them, and it can only be presumed that they showed ancestors. Some of the existing carvings were evidently house posts or other architectural elements. Possibly this example was hung by the upper loop from a horizontal beam.

A large area south of Astrolabe Bay encompasses the coast and its adjacent islands, part of the Huon Gulf and west New Britain, all interconnected by a trading system such as also existed on parts of the New Guinea coast. The goods included dances, songs, masks; local styles and types of objects have much in common here, as was not necessarily the case elsewhere. A mask from Sio Island [above] is thus comparable in all details to masks from the Tami Islands, and may have been imported from them.

Masks were originally carved to be worn in ritual; in west New Britain a very similar style of mask, called *nausung*, appeared at the initiatory circumcisions of boys. By 1910 the Tami islanders had abandoned wearing them, but still used masks to decorate their ceremonial houses.

MASK

Papua New Guinea, Madang Province, Sio Island
Wood, paint, h. 44 cm.
Collected by Pater J. Stohsel, before 1925; formerly Rautenstrauch-Joest Museum, Cologne
BMG 4111

FIGURE, *TELUM*

Papua New Guinea, Madang Province, Astrolabe Bay, Bilbil Island
Wood, h. 134 cm.
Collected by Dr. Hugo Schauinsland before 1906; formerly Übersee Museum, Bremen
BMG 4131

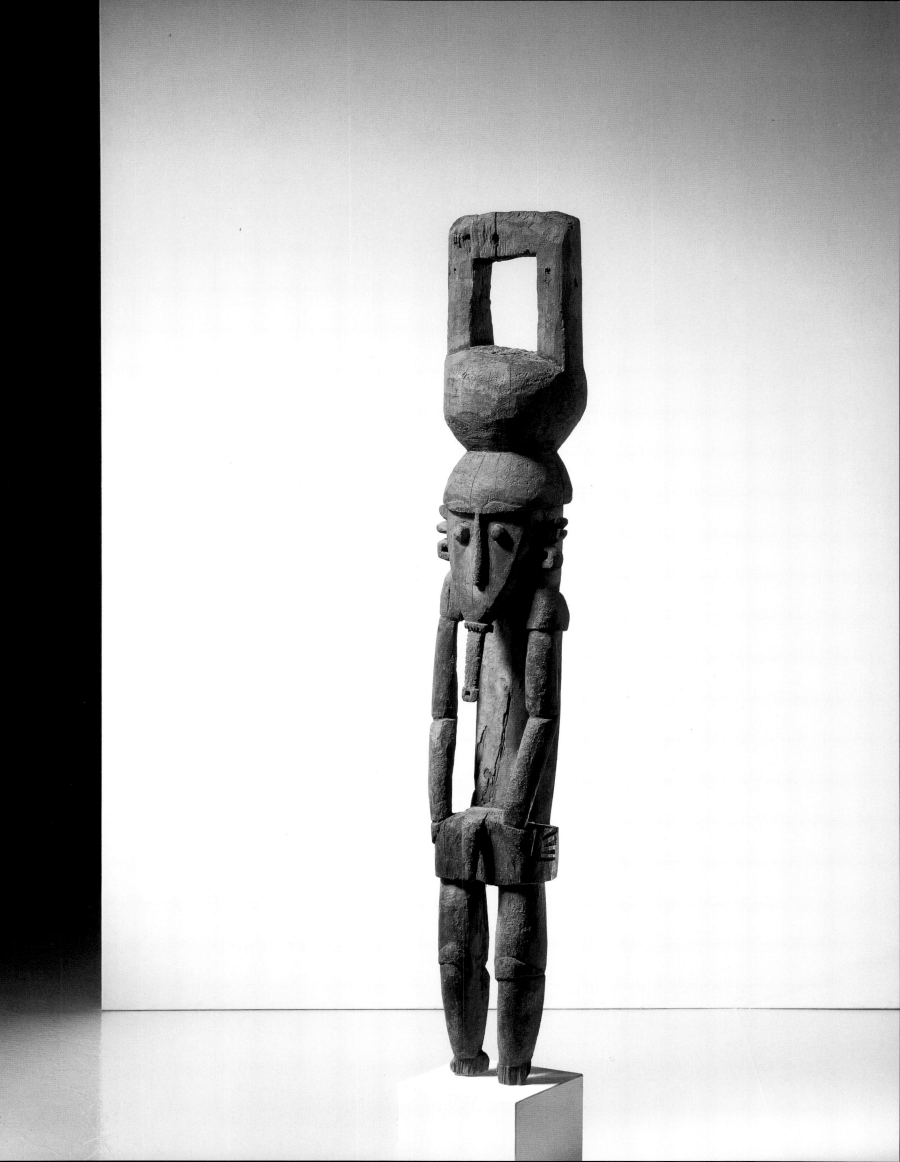

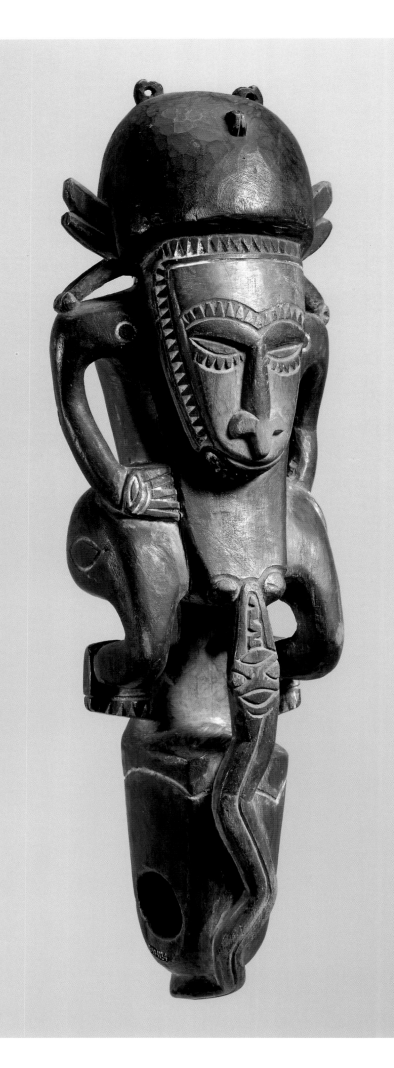

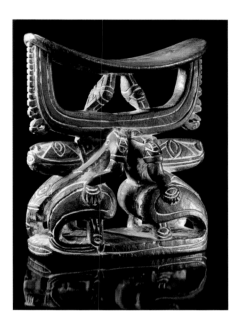

FIGURE

*Papua New Guinea, Morobe Province,
Huon Gulf, Tami Islands
Wood, paint, h. 73 cm.*
BMG 4114

NECK-REST

*Papua New Guinea, Morobe Province,
Huon Gulf, Tami Islands
Wood, paint, h. 17 cm.
Formerly collection of Prof. Czeschka,
Hamburg*
BMG 4113

The style of the Huon Gulf shares some aspects of that of Astrolabe Bay, though its main theme, the human figure, is expressed in strongly geometric shapes: ponderous hemispheres; bodies and limbs with rectangular sections; nearly rhomboidal heads, with heavy upper eyelids, sunk deeply between the shoulders. In this austere style the planes are diversified with some engraved motifs, themselves geometric.

Figures are found in a number of contexts, including massive versions standing or kneeling on support posts for ceremonial houses. Smaller images were probably hung in the same buildings [left]. These kneeling males have snakes extending upwards between their legs. They allude to a myth concerning a sea-spirit that manifests itself as a snake, but can come ashore in human form in order to seduce young men and women, who then die. (And parenthetically, sea-snakes are among the few deadly species in New Guinea.)

A secular household carving turned out for export in large numbers by the Tami was the headrest [above]. According to local tradition, all the groups in the area used the compound headrest (a wood bar with cane legs) until the Tami invented the type made from a single piece of wood. It was then promptly adopted for aesthetic reasons. Most have the concave bar for the neck supported by small standing or kneeling telamons, miniature versions of the larger sculptures. Some have supports in bird or animal shapes.

Besides headrests, the most famous products of this area were hardwood bowls made on the Tami Islands and traded to the mainland and New Britain, where they were highly prestigious objects exchanged at marriages and deaths. The basic form of the great majority is an ellipse pointed at both ends, and all are incised with designs, sometimes in bands around the rims of the bowls, sometimes at one end, and have some small motifs in relief. The designs are fairly standardized; the commonest is a relief human face wearing an elaborate trident headdress carved at one end of the bowl. Lime inlay picks out the designs against the black-stained background. Less common are quadrangular bowls, and least frequent of all those in the forms of birds and fish.

The manufacture of bowls was considered their monopoly by the Tami islanders, and it seems likely that designs were the copyright of individual carvers. But at the beginning of this century, the demand for bowls exceeded the supply. As a result, in the 1930s carvers on other small islands in the strait between New Guinea and New Britain broke the monopoly; they began carving Tami-style bowls, identical to the originals, for themselves and for trade. Their example was followed in the 1970s by carvers in west New Britain—an interesting case of the dissemination of an art style.

BOWL IN FISH FORM

Papua New Guinea, Morobe Province,
Huon Gulf, Tami Islands
Wood, paint, l. 63.5 cm.
Formerly James Hooper collection.
BMG 4110-A

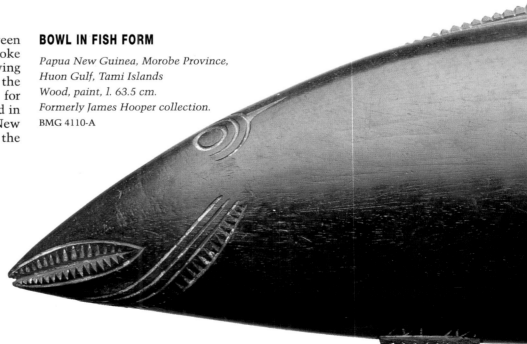

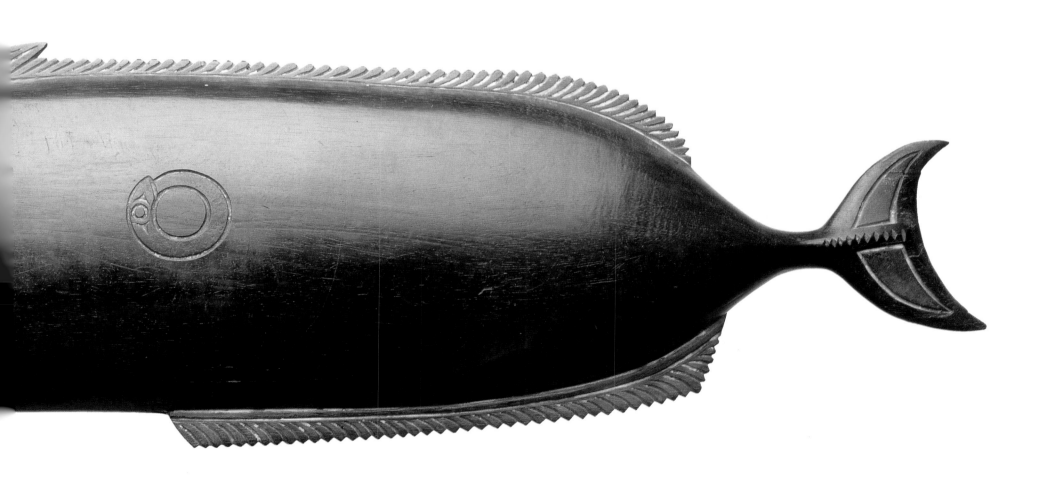

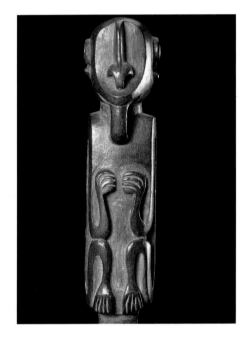

The Elema people live on the coast of a bay at the east end of the Gulf of Papua, which indents the south of New Guinea. Their villages lie along the beaches, and they are in close contact with the sea, here the northeastern part of the Torres Strait between New Guinea and Australia. Not surprisingly, their major cult was devoted to sea-spirits, called Hevehe. The Hevehe cycle of rituals took many years to accomplish, and culminated in a great parade of their enormous elliptical masks. At some moments during the preparations, particularly the building of a new door for the ceremonial house, neighboring villages were invited to festivals of dancing and feasting. The guests brought with them the masks called eharo: "dance masks" or "things of joy," for the entertainment they contribute [right].

Eharo masks were often made in pairs. They are generally tall cones modelled at the lower headpiece as a quasi-human face with gaping mouth and round eyes inside angular patterns. Sometimes wings protrude on either side. Each mask is topped with a large three-dimensional image: and it is here the inventiveness of the Elema artists comes into play. Many of them display totemic creatures and perhaps, it is said, the *eharo* was once more than a "thing of joy", a solemn portrayal of the ancestors.

Betel chewing, using a mixture of areca nut, betel pod and lime, produces a mildly narcotic effect. In New Guinea it is not only an obsessive habit, but also a very old one, that has been practised for 6,000 years. Small spatulas [above], often beautifully carved, are used to extract the lime from its container. In the islands around the southeast of New Guinea—the so-called Massim area—there are carving centers which specialize in the art, particularly on Kitava Island, Kiriwina Island, and a few others. They are traded far and wide; the D'Entrecasteaux islanders receive spatulas from Kiriwina, no doubt the source of this example.

MASK, *EHARO*

Papua New Guinea, Gulf Province, Orokolo Bay: Elema
Bark-cloth, cane, paint; h. 125 cm.
Collected before 1875
BMG 4203-A

HANDLE OF LIME SPATULA, *KANE*

Papua New Guinea, Milne Bay Province, D'Entrecasteaux Islands
Wood, total l. 32 cm., figure h. 13.5 cm.
BMG 4151-A

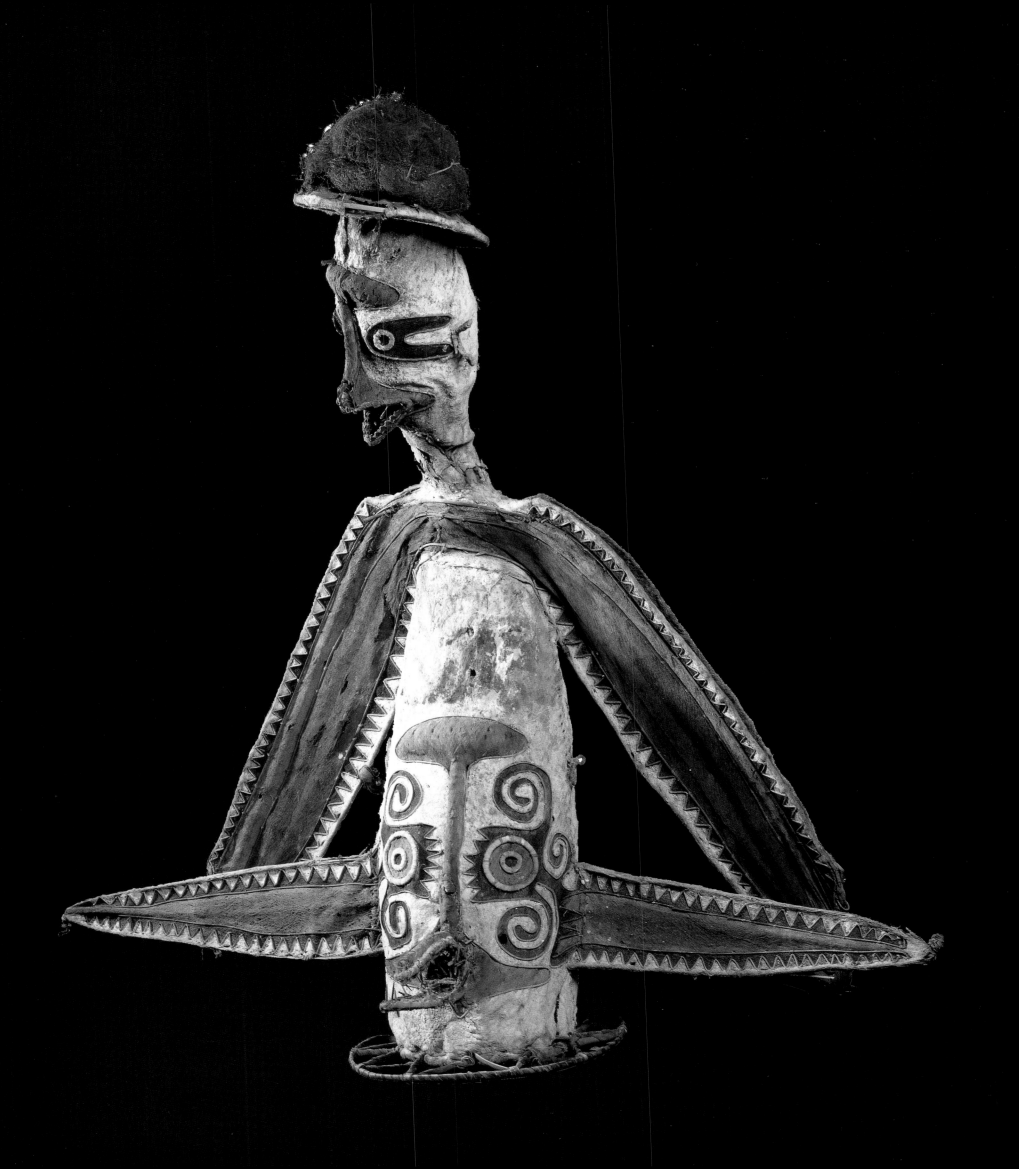

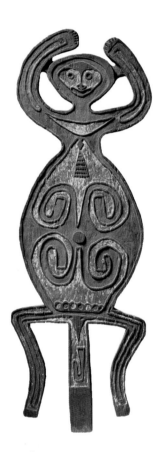

The vast alluvial plain bordering the Gulf of Papua, traversed by sluggish rivers and split by their deltas, was inhabited by a number of groups who were almost as prolific artists as the people of the Sepik River. Those of the central and western areas, unlike the Elema, shared the fully deserved reputation of being fierce head-hunters and cannibals.

Kerebo men lived in longhouses, with small women's houses along the sides. The interiors of the longhouses were divided into cubicles for the clans, and these held the sacred carved objects—the ancestral *gope* boards and the skull shrines, or *agiba* [right]. The *agiba* shows a silhouette half-length figure with an enormous head, upright projections standing between the arms and the torso—the hands sometimes hold these projections. The shrines stood on a shelf in the cubicles, sometimes in male and female pairs. The defleshed skulls of headhunting victims, after being ornamented with colored seeds and artificial noses, were attached to the *agiba* by canes.

The equivalent figures among the people of the rivers to the east including the Era are large silhouettes of standing figures [above], but instead of being hung with human skulls they stood against frames in which the skulls were set in rows. Smaller figures in the same style (*bioma*) were placed on the floor with their legs set on pig and crocodile skulls, which were also regarded as trophies.

SKULL SHRINE, *AGIBA*

Papua New Guinea, Gulf Province, probably Goaribari Island: Kerebo (Kerewa)
Wood, paint; h. 70 cm.
Collected before 1898; formerly Pitt Rivers Museum, Farnham
BMG 4204

FIGURE, *AGIBA*

Papua New Guinea, Gulf Province, probably Era River
Wood, paint; h. 130.5 cm.
Collected early 20th century
BMG 4201-B

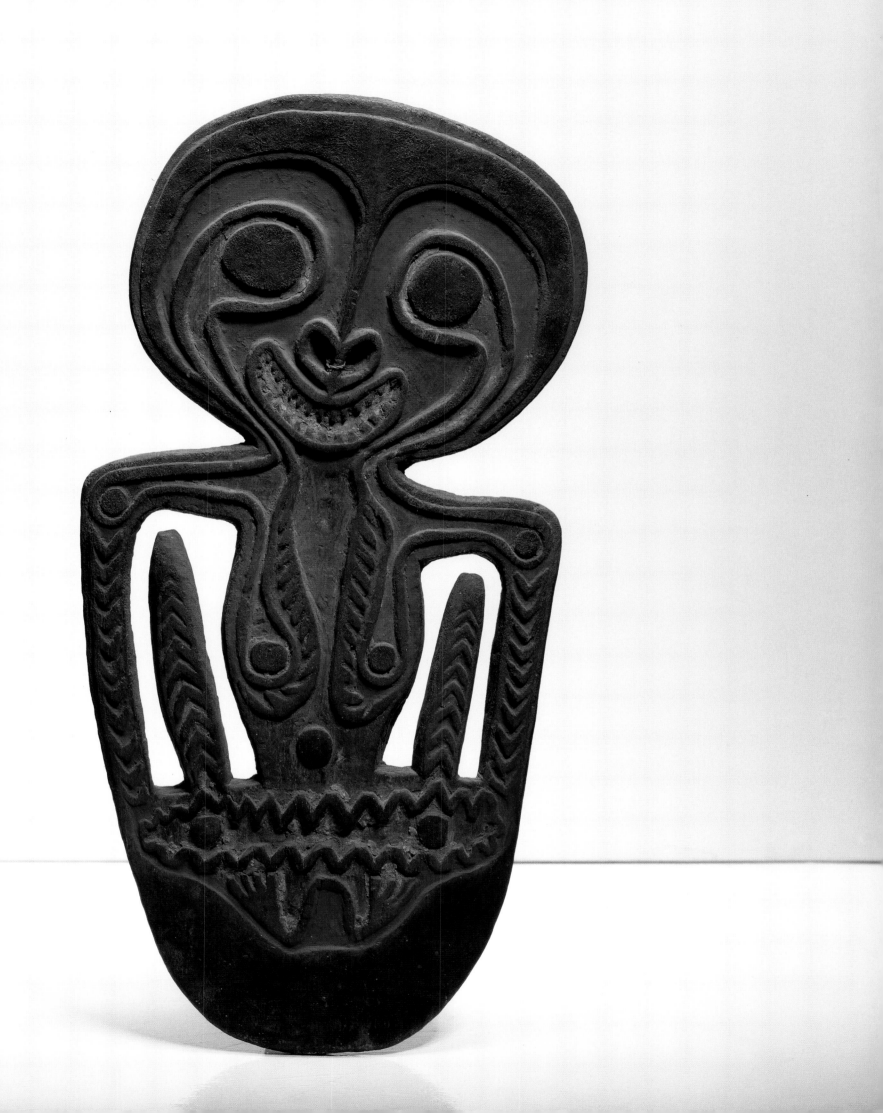

The Torres Strait lies between the south coast of New Guinea and the extreme north of Australia, and is punctuated by a number of small islands. Several types of hand-drum, the most prevalent musical instrument, were made in the area. One is almost cylindrical, flaring slightly at each end, with a handle; one has no handle and divides into two slender jaw-like projections at the open end; the third type, the *warup* of the Straits islands, is a strongly hourglass shape, tightly constricted at the waist, and with broad gaping jaws.

The origin of the *warup* is uncertain. The New Guinea mainlanders say that it originated on Saibai, the nearest island to them, and introduced to them at a time when they had no drums. Later they abandoned the *warup* for the simpler handled type. Some researchers, however, believe that they were traded to the islands from New Guinea, perhaps only roughed-out, to be finished by their purchasers.

In any case, *warup* drums are unique to this area: there is nothing parallel to this unexpected yet brilliantly balanced form, with its two ends so disparate yet echoing each other, in all New Guinea.

DRUM, *WARUP*

Torres Strait, Saibai Island: Kalaw Kawaw
Ya
Wood, paint, lizard skin, cassowary
feathers, nut rattles, l. 91 cm.
BMG 4240

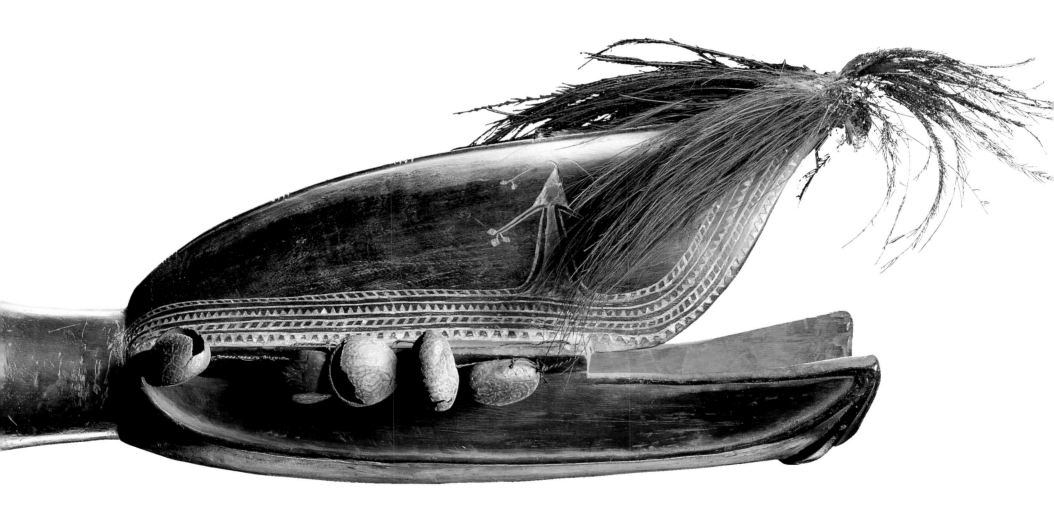

Most of the northern Torres Strait islanders believed that their ancestors had migrated from the south coast of New Guinea under pressure from the headhunters of the Fly River to the northeast. If this is true it might partly account for their being the only Torres Strait people to make much use of wood for sculpture, their masks offering powerful evidence of their talent [right]. They were painted with a bold hourglass design in white which emphasized forehead, nose, and sometimes chin against red or black backgrounds, with dotted patterns in the dark areas. Absence of the garish paint hardly diminishes their impact at all. They convey in their elongated and sharply defined features an almost inhuman simplicity,

even severity, of expression. They stalked the villages at night during the harvest of a certain fruit, terrorizing the people.

On the New Guinea coast opposite Saibai lies an area of swampland, sparsely inhabited by obscure groups of people. Although they made large wood figures, only a couple are known. They are in a geometric style, with long, square-jawed faces. Their features are distinct enough to make it clear that carved arrows, which were made in large quantities for export to surrounding groups of people including the Torres Strait islanders, all come from this source. The shafts of the arrows [above] are carved with crocodiles or men in differing degrees of stylization.

MASK

Torres Strait, Saibai Island: Kalaw Kawaw Ya
Wood, human hair, fibre; h. 70 cm.
Formerly Melbourne Aquarium collection before 1900; subsequently F. C. Smith collection
BMG 4241

ARROW SHAFT (DETAIL OF FIGURE)

Papua New Guinea, Western Province, Binaturi River area
Wood, paint, figure h. 21.5 cm.
BMG 4243

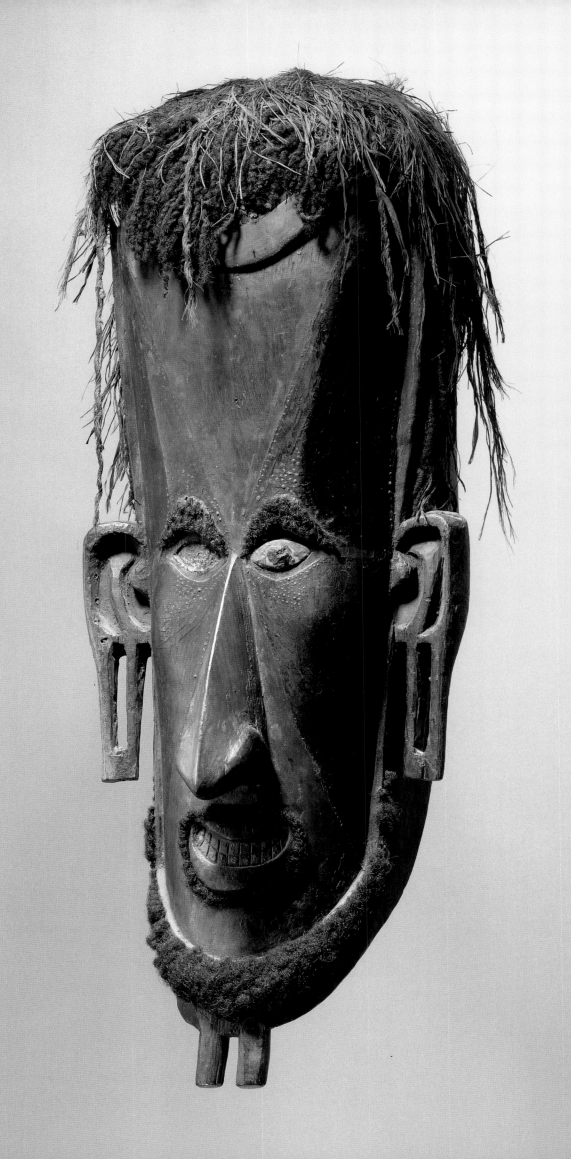

Beyond Saibai, the islanders to the south constructed masks of turtle-shell.

The masks have two main subjects. One is the human face; the style of those from Erub and Mer Islands, in the east, have a distinct resemblance to the wood masks of Saibai. In the other islands, the face tends to be rounder, and engraved with fine patterning; it is invariably bordered and bearded with turtle-shell sheets of openwork geometric patterns.

Other masks are large figures of hammerhead sharks, skates and other fish, and crocodiles—the last being found in the turtle-shell mainland masks, and perhaps derived from them, as crocodiles did not find a sympathetic environment in the islands. Figures of frigate birds surmount some of the face masks. The most remarkable masks combine the horizontal animal forms, usually crocodiles, with human faces.

Masks are known to have been used on many occasions, for instance in fertility ceremonies and at the beginning of the monsoon season. Above all, some masks, the most secret, appeared at the initiation of boys. At these the exploits of a hero were recounted in chanted myths and dances, moral instruction was given, and the lessons were reinforced by the presence of the terrifying masks.

Turtle-shell and paint were not the sole components of the masks. They were made glorious with feathers, fringes, shells and sometimes, if possible, striking foreign components. Two examples of this taste for adaptation are visible in this mask. Below the human face and at its back an engraved bark belt from the Gulf of Papua is incorporated. About 150 years ago, the islanders discovered the wonders of tin. Hence the forehead crest and the crocodile's head are cut from this exotic, precious material.

MASK

Torres Strait, Mabuiag Island: Muralug
Turtle-shell, wood, paint, tin, bark belt,
cassowary feathers, seeds, shells, l. 50 cm.
Collected by Rev. S. MacFarlane, 1872;
formerly Museum fur Völkerkunde,
Dresden
BMG 4244

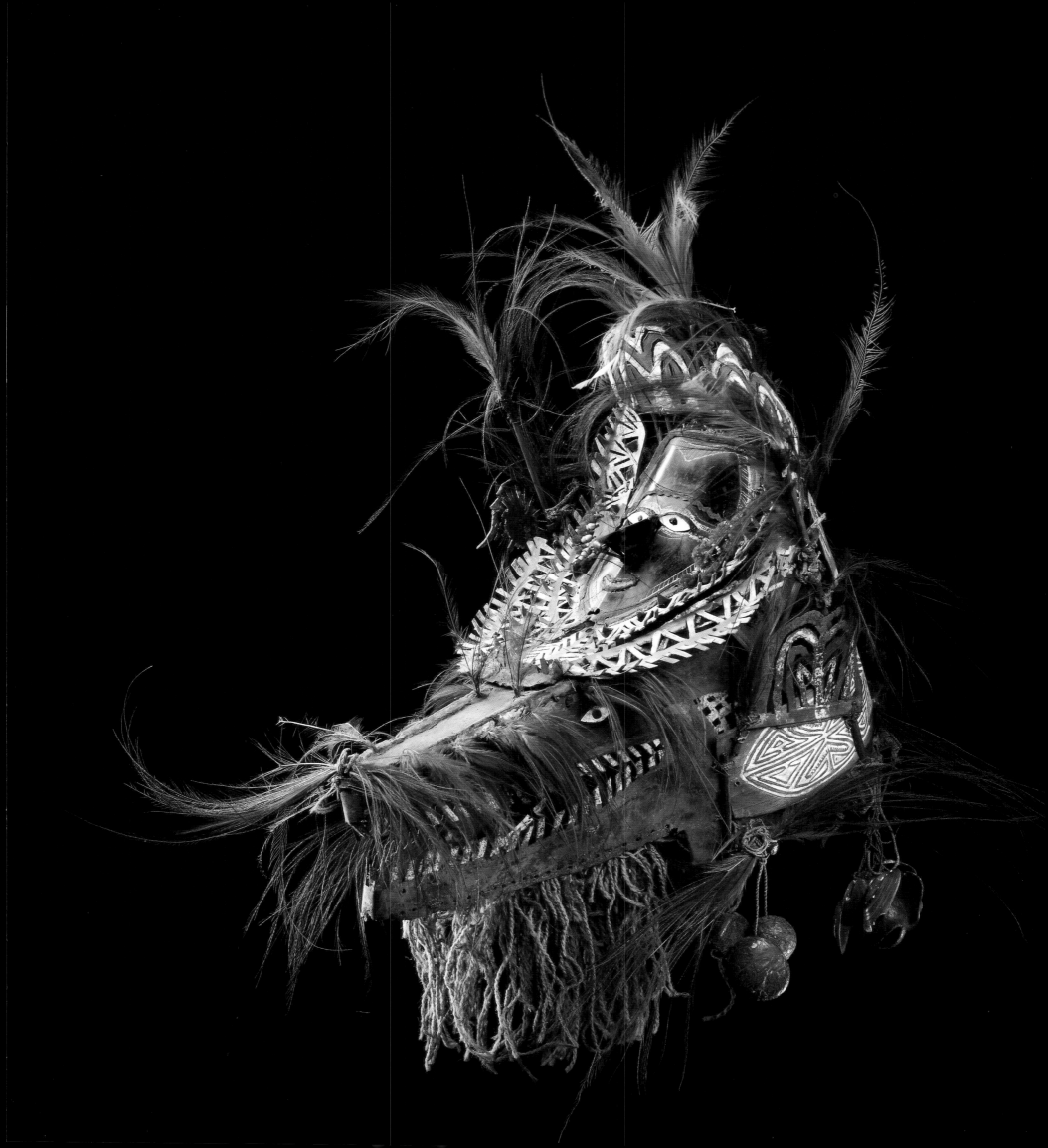

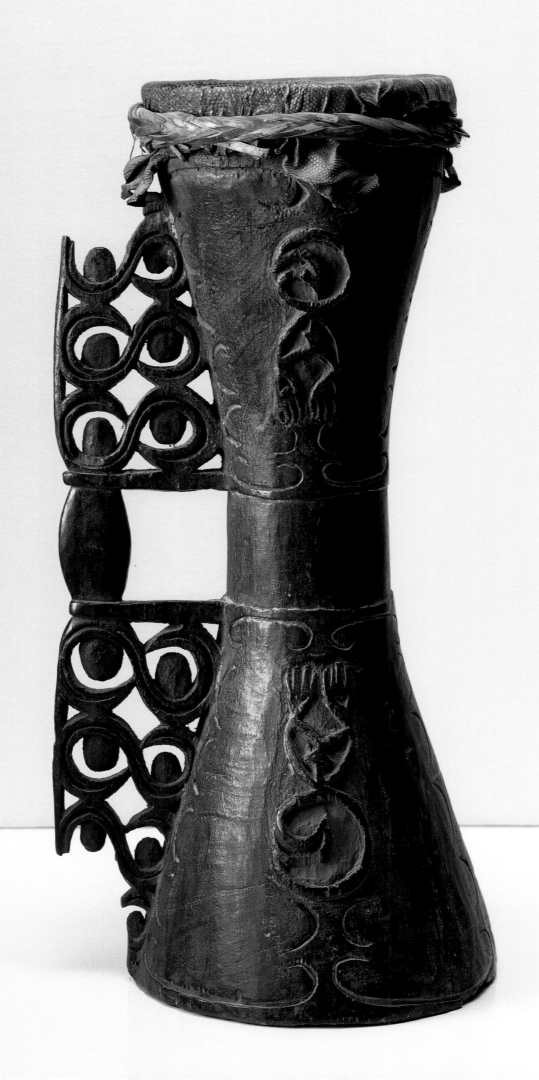

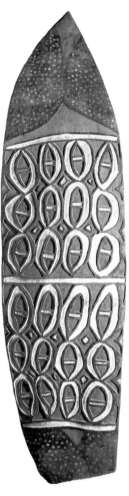

DRUM, *EM*

Irian Jaya, Flamingo Bay-Casuarinen Coast
area: Central Asmat
Wood, paint, lizard skin, cane, h. 50 cm.
Collected by Jac. Hoogerbrugge
BMG 4251-A

SHIELD, *YAMASH*

Irian Jaya, Brazza River: Northeast Asmat,
Bras group
Wood, paint, h. 212 cm.
Collected before 1967
BMG 4250-A

"Orpheus with his lute made trees
Bow themselves when he did sing,"
– the poet says; but the hero
Fumeripitsh did better: he made men
and women of wood, and brought
them to life by beating his drum.

The Central Asmat live in the torrid,
densely forested mudflats of south-
west New Guinea. They were head-
hunters and cannibals and most of
their art is spun out of their obsession
with violent death.

The hand-drum [left] is the only
musical instrument of the Asmat of
any importance. Here the handle is a
series of the double spirals. On the
side of the drum is the spiral ufirmbi,

the beak of a black king cockatoo, and
the forked design representing the
claws of a flying fox. All these are
symbols relating to headhunting.

The Bras group of Asmat live in
isolation far inland, in the foothills of
the central mountain ranges, and
were hardly contacted by Westerners
until twenty years ago. They then
lived in tree-houses high off the
ground, as a defensive measure in
their incessant warfare, for which
they made their only sculptural form,
the shield [above]. This was carved on
the front face with relief images
which, as always in New Guinea,
gave spiritual protection.

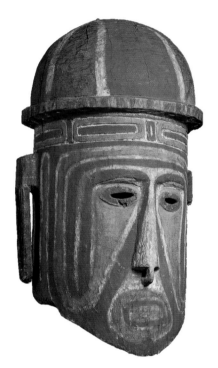

Two types of masks come from the small Witu (or French) Islands which lie off the southwest coast of New Britain. Helmet masks are quite common in Oceania, but perhaps were only made of wood here [above]. The simple cylinder, topped with a rounded sort of cap or coiffure, has a lightly carved face; such detail as it has is expressed in painting. This type of mask was called by early collectors a "death mask," presumably meaning that it was used in funeral ritual.

A second type of mask [right] is also a helmet mask, but made of vegetal materials, including coconut bast, and is known in three subtypes. All of them are conical, and portray a huge face mainly consisting of a long nose equipped a heavy nose-plug, round eyes and a quantity of teeth. On Witu, the mask appeared at circumcision rites.

The general form is common in the western area of New Britain. The

Witu masks have a strong resemblance to the *nataptavo* mask made in the extreme west of New Britain (southwest of the Witu Islands) by the Kilenge people. Here the masks also appeared at initiations when boys were circumcised, as well as in ceremonies connected with yam cultivation. Very similar conical masks, with the same salient features, were also made by several other groups of people living along the southwest coast of New Britain, and seem to be generally associated with spirits activated during periods of mourning.

MASK, *KAKAPARAGA*

West New Britain, Witu Islands: Bali-Vitu
Wood, paint, h. 58.5 cm.
Formerly Herz Jesu Hiltruper Mission,
Hiltrup bei Münster
BMG 4476

MASK

West New Britain, Witu Islands: Bali-Vitu
Wood, cane, fibre strips, paint, leaf strips,
h. 66 cm.
Collected by Lajos Biro 1900; formerly the
Ethnographic Museum, Budapest
BMG 4475

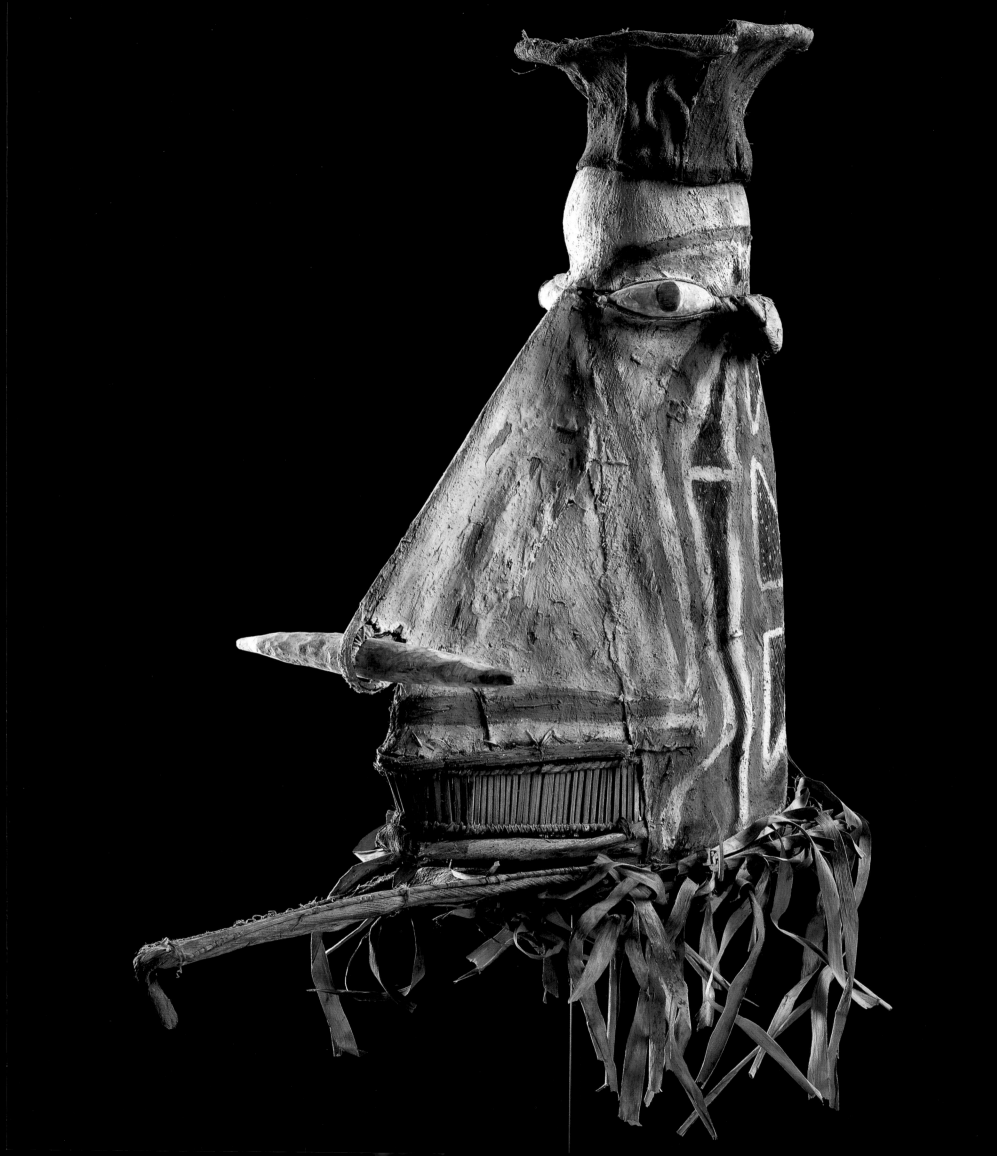

The so-called *burbur* figure [above], associated with a female spirit, is a remarkable stylization of the human head. A few such figures are recorded along the southeast coast of New Britain. In an old photograph, a pair is shown flanking the figure of a female ancestor at Awio or Amio Island, on the border between the Moewehafen and Gasmata languages. In northern New Britain live several groups known as the Baining, who hold dances, at night or in the daytime, for which they use bark-cloth masks painted with designs in black and a red produced by spitting blood from the men's scraped or pierced tongues. The Kairak (Central Baining) have several types of mask including the *kavat* [right], painted with staring circular eyes, with protruding jaws and pendulous lower lip. The upper part of the head rises in a crest.

The Miaus ceremony takes place at night, in a forest clearing. The audience stands around a great bonfire, a group of men chanting as they beat with bamboo tubes on planks. Then from the shadows of the trees emerges the dim figure of the *kavat*, with an enormous white bark-cloth phallus and legs swathed in fiber. It approaches in silence with a trembling gait, and nerve-racking slowness. Reaching the crowd it circles around silently until it reaches the musicians. They break into a rapid rhythm, on which the *kavat* bursts into frenzied stamping dance, shrieking at the musicians in menace. The rhythm stops, abruptly the *kavat* halts, and trembles away around the line of spectators into the darkness, as the steady beat resumes. Meanwhile the next *kavat* is already approaching to repeat the performance.

FEMALE FIGURE, *BURBUR*

New Britain, southeast coast, Maso village: Mamusi
Wood, paint, h. 159 cm.
Collected by Mrs. Parkinson 1912-1913; formerly Museum für Völkerkunde, Leipzig
BMG 4458

MASK, *KAVAT*

New Britain, Gazelle Peninsula, Warangoi River area: Kairak or Uramot Baining
Bark-cloth, cane, paint, h. 100 cm.
Collected by Mrs. Parkinson 1912-1913; formerly Museum für Völkerkunde, Leipzig
BMG 4461

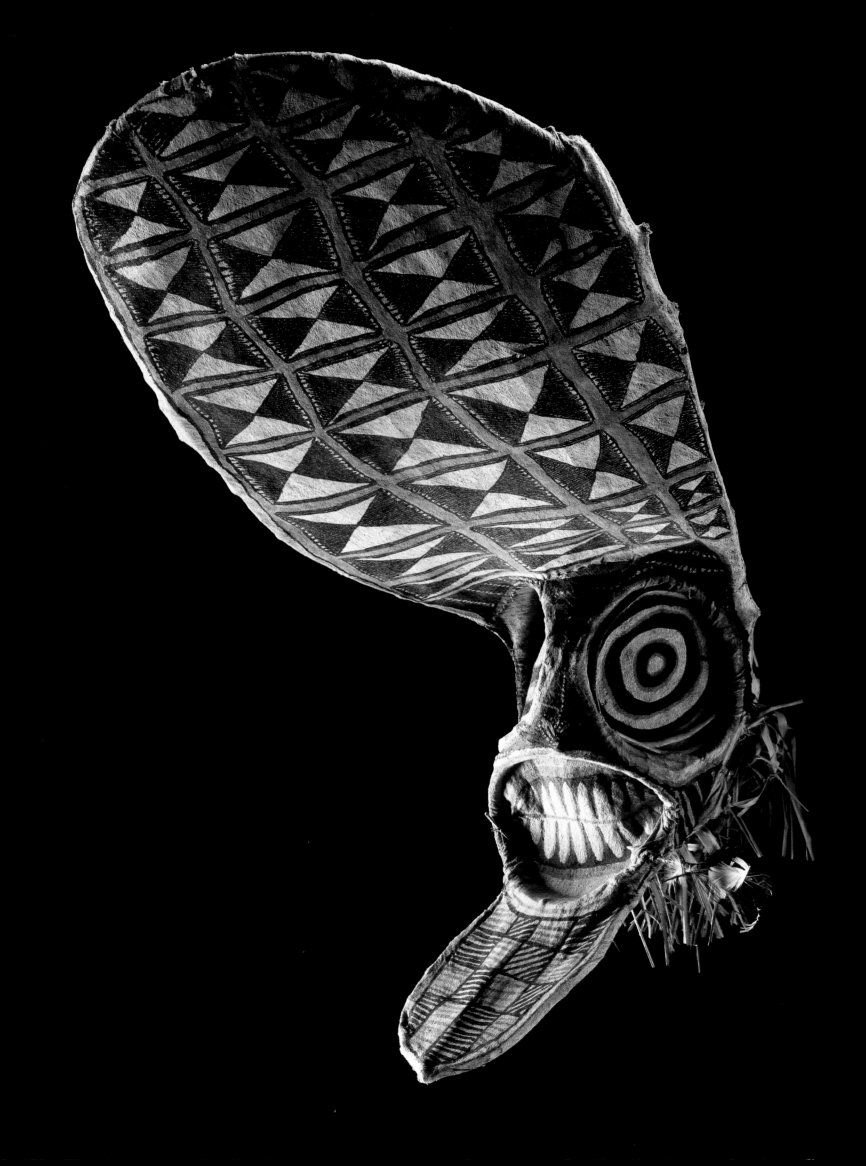

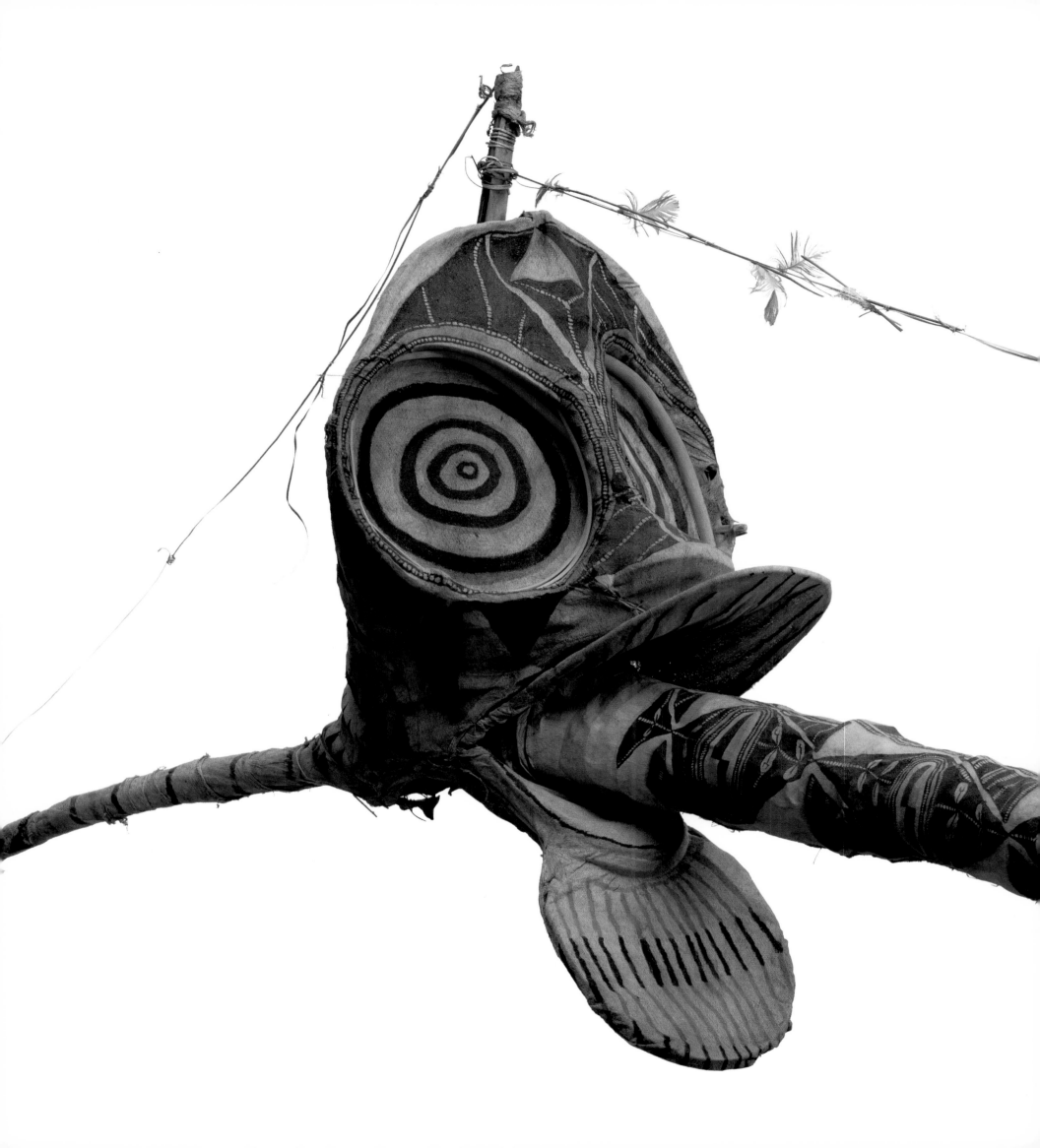

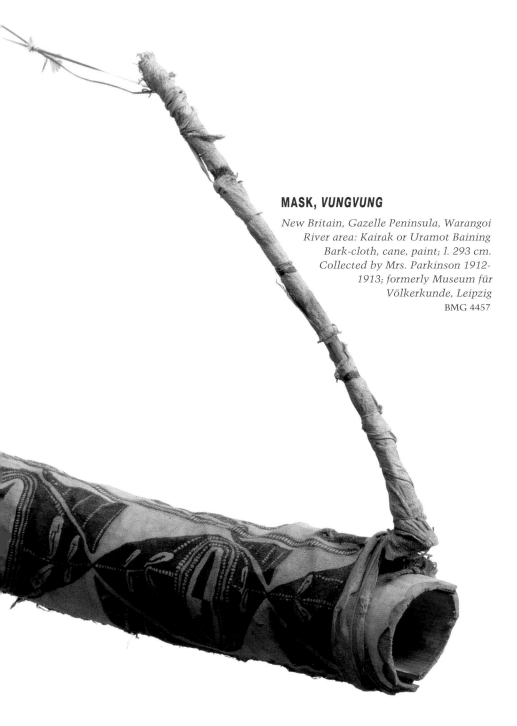

MASK, *VUNGVUNG*

New Britain, Gazelle Peninsula, Warangoi River area: Kairak or Uramot Baining Bark-cloth, cane, paint; l. 293 cm. Collected by Mrs. Parkinson 1912-1913; formerly Museum für Völkerkunde, Leipzig
BMG 4457

Miaus continues when, following the last *kavat*, the *vungvung* enter. To some Baining they are the mothers of the *kavat*, or else their children. They are basically large masks of *kavat* form with long horizontal tails, holding in their mouths bamboo tubes they hoot through. They are partly concealed from sight by panels of bark-cloth hanging on either side of them. When all the masks have assembled, they dance together for hours, leaping through the central fire.

In spite of the efforts of several researchers, the ultimate meaning of the Baining masks remains obscure—perhaps even to the Baining themselves. The dances may once have been the final stage of initiation. The painted designs have an elaborate terminology which refers to almost every element in the natural world, as well as the beings of myth. That the designs and masks seem to be a summary of the Baining universe is strongly suggested by their now also incorporating the novelties, animal and even mechanical, to which they have been exposed by the modern world.

Like the *kavat*, this mask has been mistakenly attributed to the unfortunate Butam, a group of immigrants from the coast who were exterminated by the Kairak and Uramot Baining of the Warangoi River.

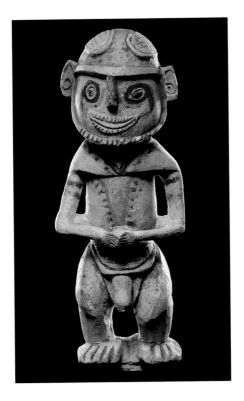

People speaking languages collectively called Patpatar occupy southern New Ireland, islands to the east and between New Ireland and New Britain, and the coast of the Gazelle Peninsula, where the dominant Tolai immigrated from New Ireland. The "secret" male society called Inyet was active in the area, as was a tradition of sculpture in limestone or chalk. The carvings were Inyet possessions among the Tolai but in New Ireland were made only for mortuary ceremonies. Although the Tolai carvings took many forms, in New Ireland they were always male and female figures (kulap) with rounded faces, round eyes, straight noses and wide toothy mouths. The hands are joined in front of the torso or held under the chin. The white stone is merely given accentuating touches of black and red. Most were small [above]; kulap on the scale of the large one [right] are extremely rare.

Apparently the New Ireland carving center was in the mountains, where suitable stone was to be found, and from which the figures were commissioned. On completion they were installed in a small ritual house which only men could enter, as temporary dwellings for the souls of the dead. Eventually, at least in theory, they were smashed.

FIGURE, *KULAP*

New Ireland, southern area, Punam region
Chalk, paint, fiber, beads, h. 75 cm.
Collected about 1890; formerly Pitt Rivers
Museum, Farnham
BMG 4317-B

FIGURE, *KULAP*

New Ireland, southern area, Punam region
Chalk, paint, h. 29.3 cm.
Formerly Josef Mueller collection, before
1942
BMG 4317-C

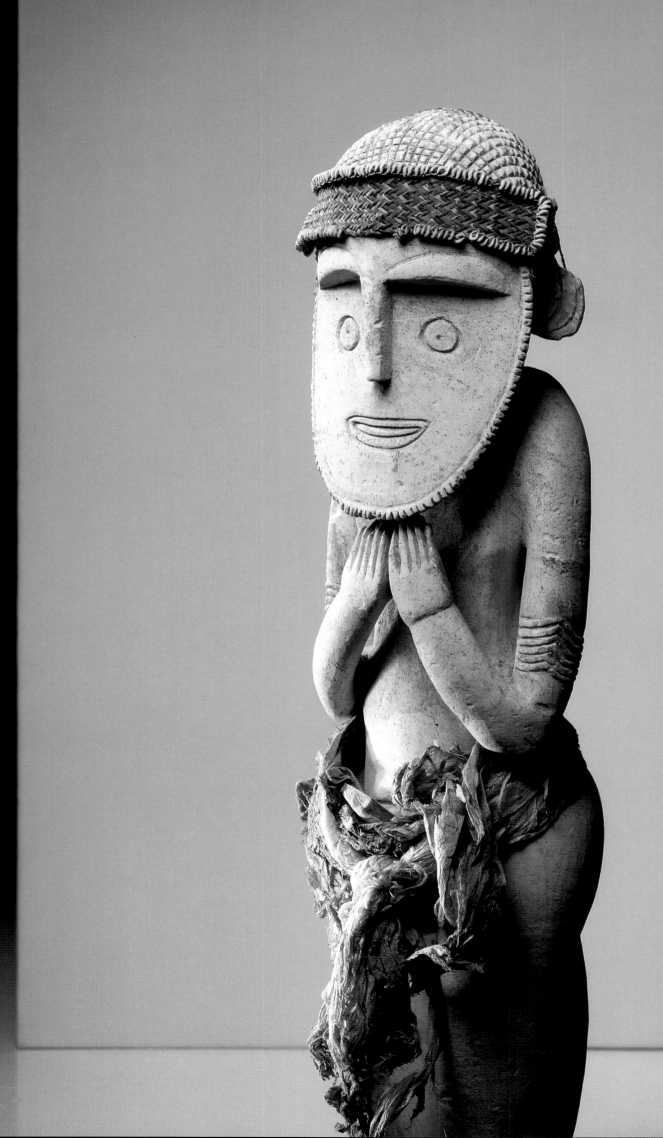

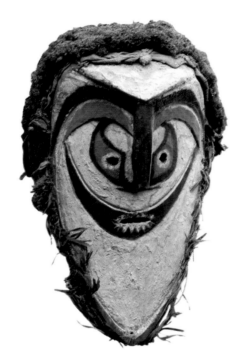

The word *lorr* corresponds to *a lor*, in the language of the Tolai mainlanders, who also have a wooden mask with conical headdress of that name, again corresponding to a type of conical mask of the mountain Baining called *lingan*, which they no doubt adopted from the Tolai. Possibly the Duke of York Islands masks [above] also originally had conical headdresses. As *a lor* means "skull," they were probably used at death ceremonies.

The Muliama mask [right] comes from a troubled area with a history of genocide, immigration and repopulation. It is not known what community it came from; far less its meaning and use.

MASK, *LORR*

Duke of York Islands, between New Britain and New Ireland
Wood, paint, fiber, h. 40 cm.
Collected by Count Festetics de Tolna, late 1895; formerly the Ethnographic Museum, Budapest
BMG 4336

MASK, *LALI*

New Ireland, southeast coast, Muliama area
Coconut bast, cane, paint, fibre; h. 65 cm.
Collected by R. Parkinson, before 1907; formerly Prof. Czeschka collection, Hamburg
BMG 4316-2

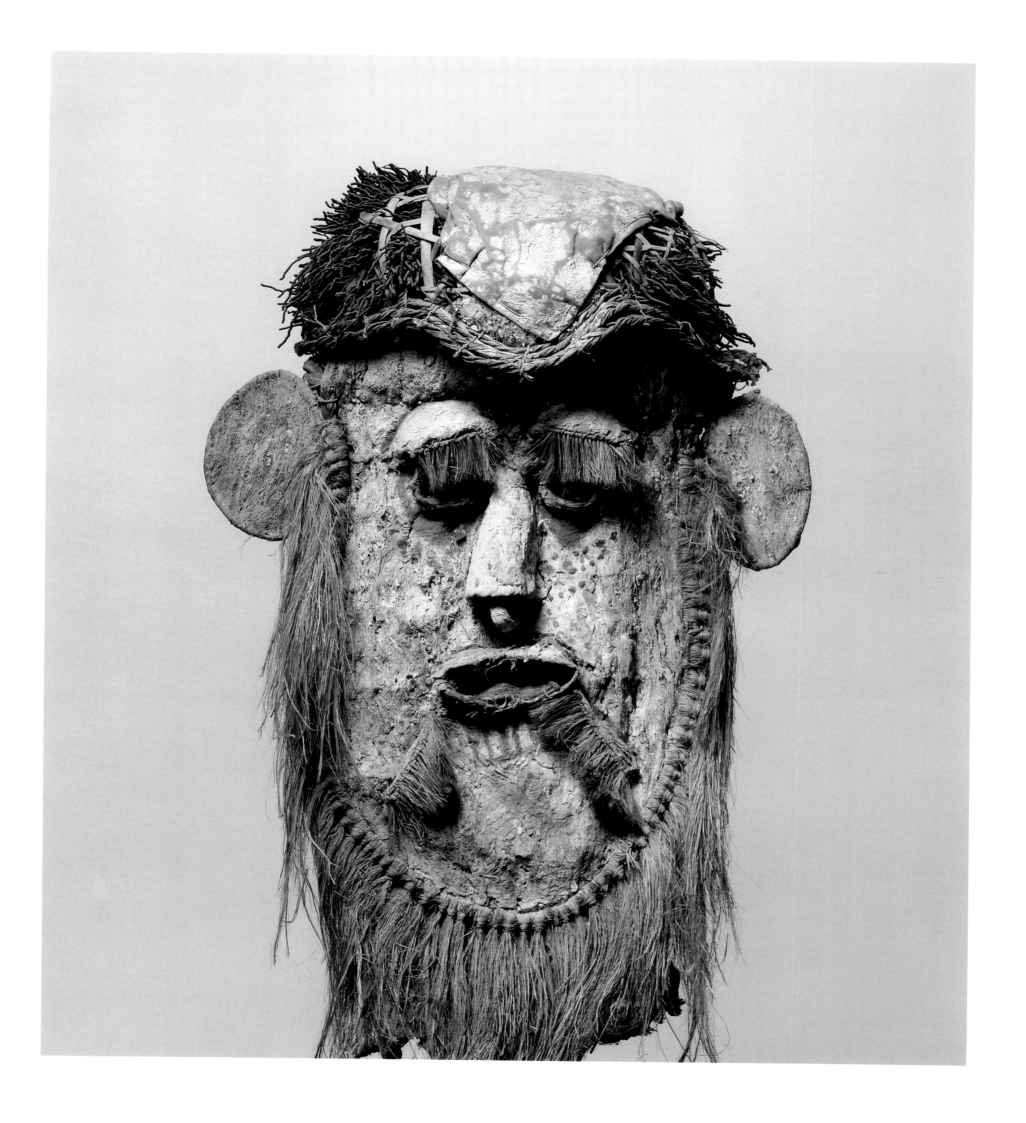

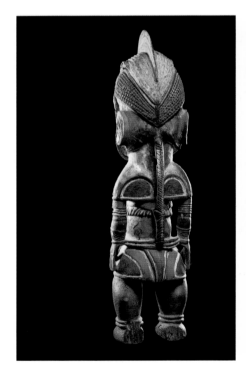
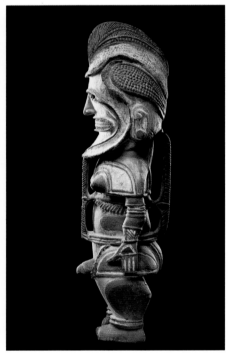

In the middle of New Ireland, among the Mandak, Lamasong and other people, the central objects of mortuary cults were ponderous standing figures with female breasts and male genitals. They sometimes have raised hands, or support smaller figures in front of them, or have subsidiary figures perched on their shoulders. The heads are large and carry thin upright crests; the eyes are inlaid with shell, the noses are hooked and the wide mouths expose the teeth above a triangular chin. Like those of some *malanggan* figures, *uli*s' bodies are often enclosed in sweeping bands, but the intricate polychromy of *malanggan* is absent; white or black is the usual color with touches of red and black, and the figures' forceful presences are owed to their massive, simple volumes. To a certain extent—

though a limited one—they are functionally analogous to the stone figures made in the south, as they also are stylistically.

The figures were carved in commemoration of dead chiefs, and were containers, if only temporarily, for their spirits, so that they could pass on their powers to their successors. The final phase of the mortuary ceremonies and feasts was the display of the *uli* to the men—they were secret from women—accompanied by other *uli* brought in from participating villages. Small *uli* were perched on conical constructions, and the large were housed inside similarly conical huts. The ceremonies associated with the *uli* were elaborate, but their significance—apart from a relationship to fertility and warfare—is obscure.

ANCESTOR FIGURE, *E ULI*

New Ireland, central area, Lelet Plateau
Wood, paint, snail shell opercula, h. 90 cm.
Formerly Arthur Speyer, Serge Brignoni
(Bern) and Charles Ratton collections
BMG 4313

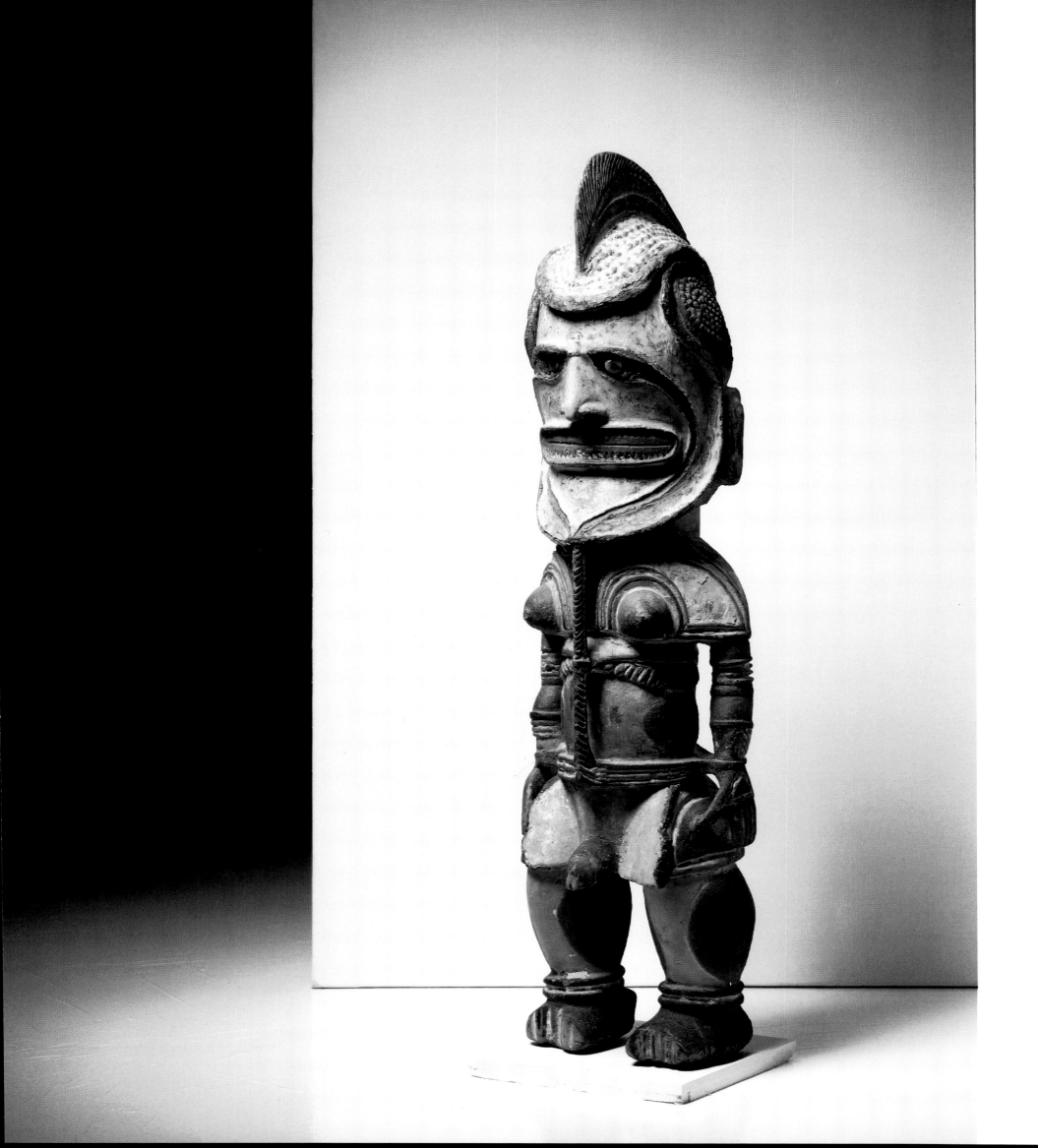

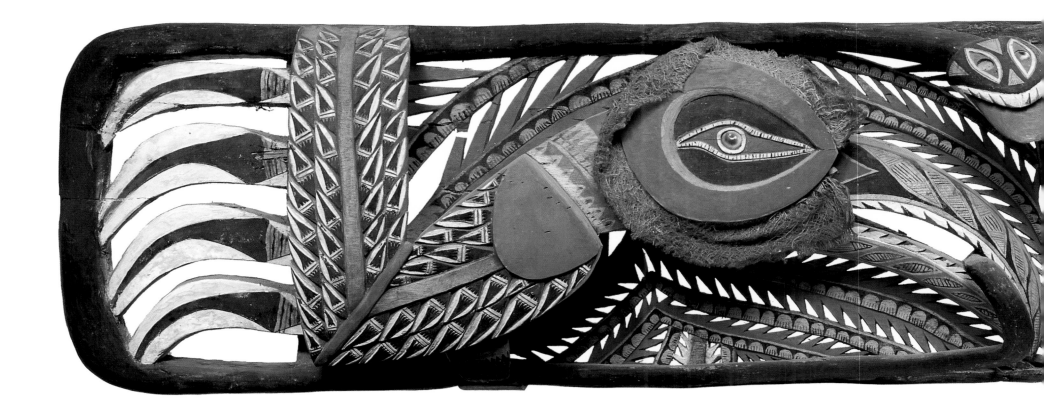

The northwest area of New Ireland, inhabited by Tigak, Notsi and other language speakers, is celebrated for the carvings which share their name with the *Malanggan* series of ceremonies. The *malanggan* style, the most elaborate that ever existed in the Pacific Islands, is said to have originated in the Tabar Islands off the northeast coast. It also evidently has a relatively long history. A contemporary drawing in the Dutch explorer Abel Janszoon Tasman's journal shows that when he visited New Ireland in April 1643, the canoes already had at prow and stern recognizable carvings in the style. It is unlikely that they were then in the intricate openwork technique found in the nineteenth century, which was probably fostered when the islanders acquired steel tools.

Malanggan ceremonies were held primarily as funerary celebrations for members of a man's spouse's clan, but also (by extension) for the validation of land-claims, the establishment of sub-clans, and various other important events. The carvings were commissioned from expert artists, and their preparation was often long-drawn-out. They were displayed at the climax of the ceremonies in enclosures or temporary shelters lined with carved panels or screens of fresh leaves. There are many types: figures, horizontal panels, poles with surmounted figures, all with many variations. Apart from human beings the main subjects were birds, fish and snakes. *Malanggan* designs were owned by specific lineages, and their imagery often referred to the lineage's myths. Copyright in the designs was jealously preserved, but the actual carvings were destroyed after use.

This *malanggan* shows hornbills and snakes, and may have been associated with a form of sorcery.

MALANGGAN CEREMONY CARVING, VAVAL

New Ireland, Tabar Island, Simberi Island
Wood, paint, l. 196 cm.
Collected by R. Parkinson before 1896;
formerly Museum für Völkerkunde,
Dresden
BMG 4335

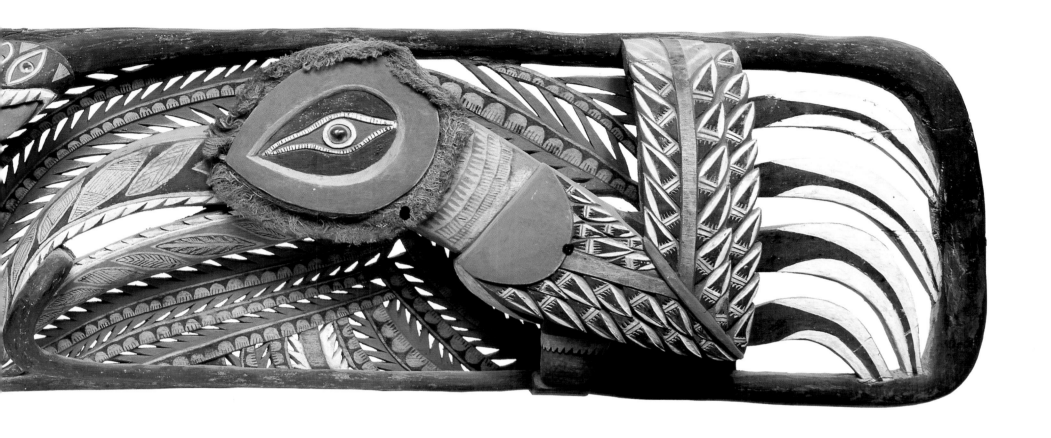

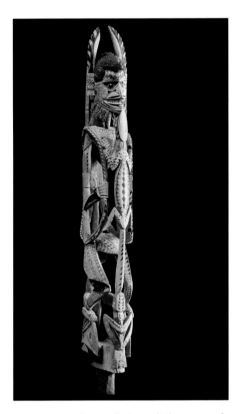

The fully three-dimensional *malanggan* figures generally have added attributes including bird and· animal forms: such as, in the case of the so-called *totok* [above], a reptile. The figures often clutch frameworks of rods which enclose them. Like all *malanggan*s, they are painted for the most brilliant effect with sharply-defined areas of black, white, red and yellow, often further enhanced with small sections of black crosshatching and other patterns.

Another figure [right] holds its arms widespread, in a frequently used pose. An owl is perched on the head, which resembles that of one of the *uli* figures. from central New Ireland. On the chest is painted a *kapkap*, the circular ornament of turtle- and tridacna-shell the New Irelanders excelled in making. The bones of the ribcage

are exposed; a flying fish extends upward from a second owl the figure stands on.

These figurative *malanggan*s, like other sculptures from New Ireland, serve as receptacles for the vital force of one, or even several, dead persons.

MALANGGAN CEREMONY FIGURE, *TOTOK*

New Ireland, northern area, Cape Sass: Kara
Wood, paint; h. 133 cm.
Collected by R. Parkinson before 1894; formerly Museum fur Volkerkunde, Dresden
BMG 4328

MALANGGAN CEREMONY FIGURE

New Ireland, northern area
Wood, paint; h. 162 cm.
Formerly Grand Duke of Baden, Mannheim Museum, and Arthur Speyer collections
BMG 4344

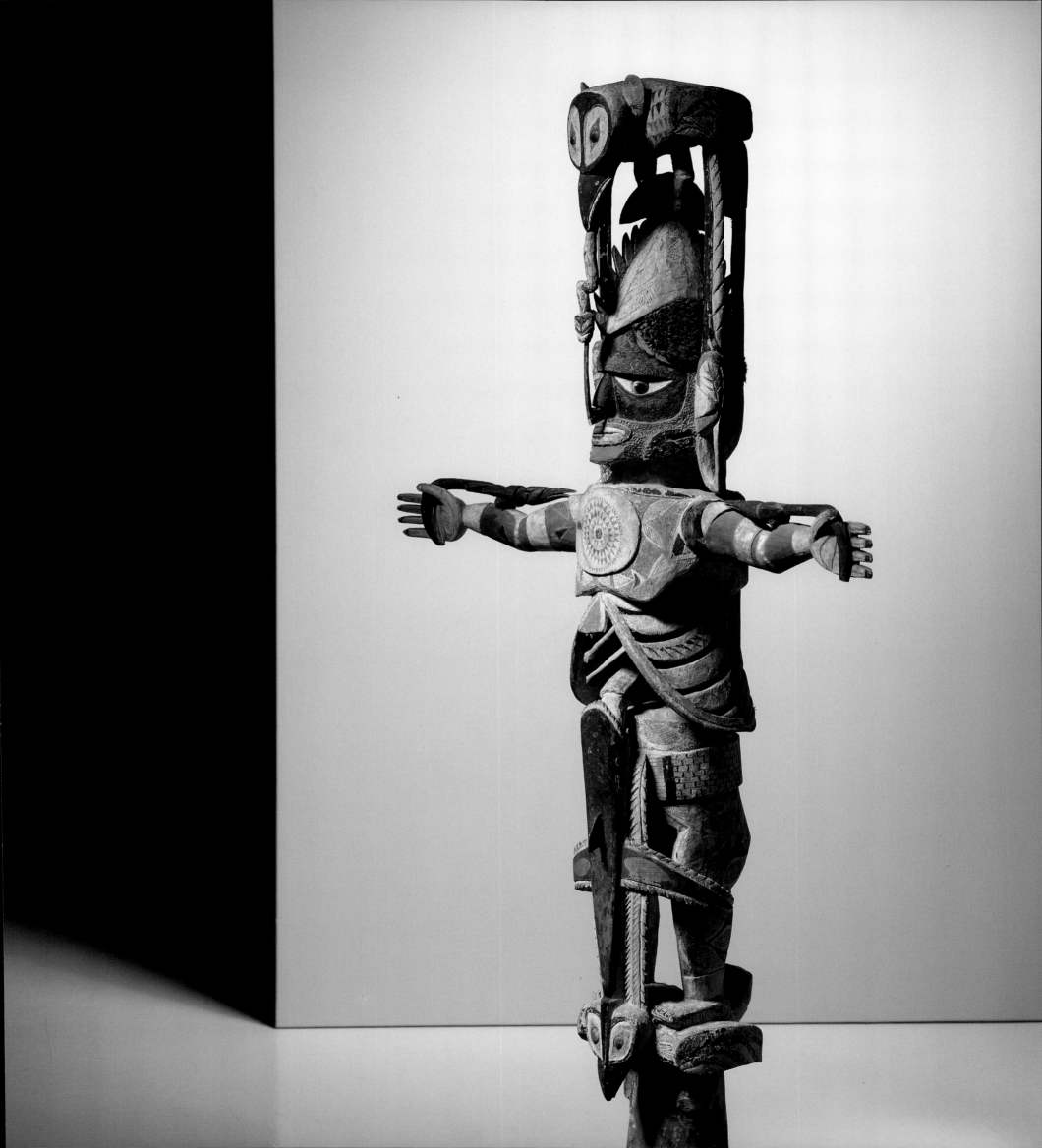

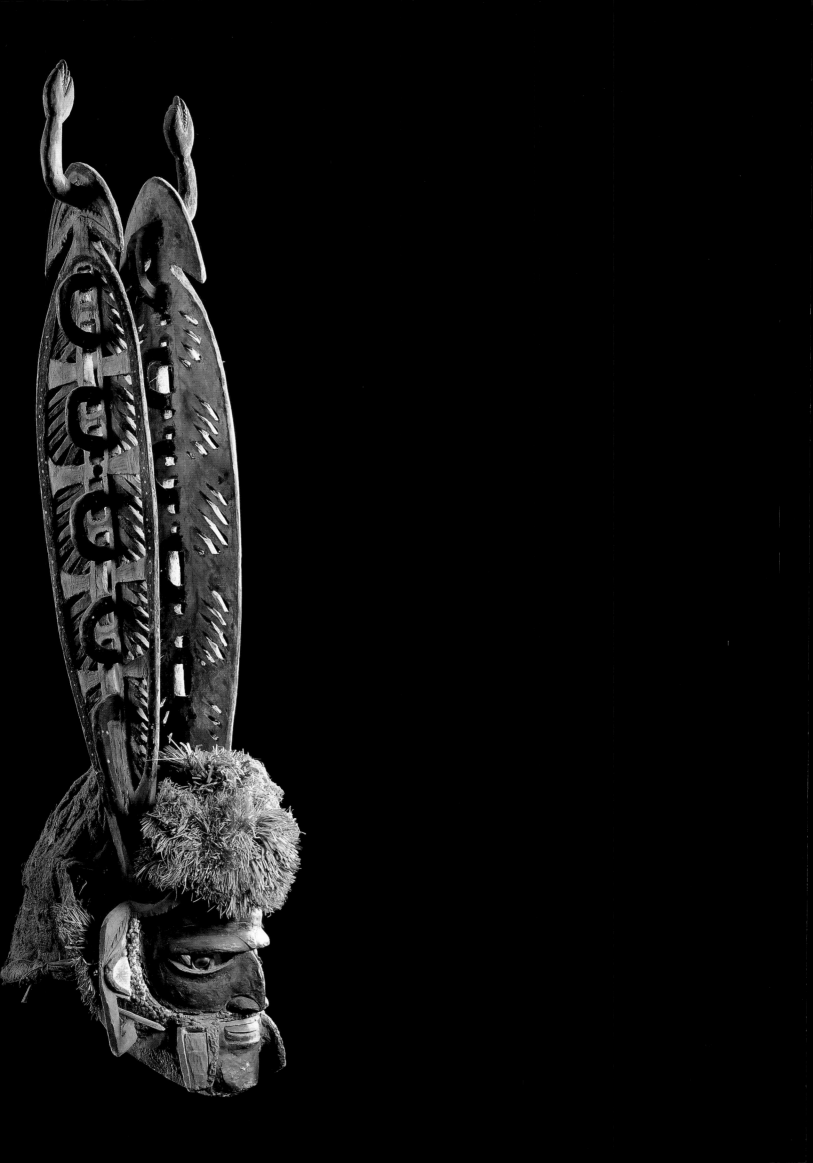

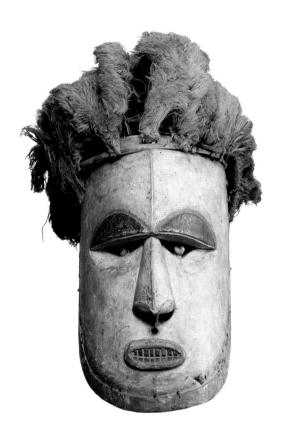

MASK, *MALANGGAN*

New Ireland, northern area
Wood, paint, fibre, h. 102 cm.
Collected by Giovanni Bettanin before
1904; formerly the Ethnographic Museum,
Budapest
BMG 4337

MASK

New Ireland, probably central west coast:
Lamasong-Lavatbura area?
Wood, paint, fibre, h. 39 cm.
BMG 4309

Masks in *malanggan* style also existed in at least twenty to thirty types of greater or lesser elaboration. Some have vertical panels attached at the sides [left], here seemingly showing the skeletons of leaves with snakes twining through them.

The unusual white mask [above], in its stark simplicity, is in a style far removed from the complexity of *malanggan* styles. It seems more closely related to the masks of south New Ireland, or even the Duke of York Islands and north New Britain. By analogy with the few other masks of the type, Michael Gunn believes it to have been collected about 1880.

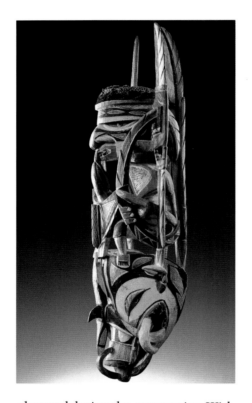

The *malanggan* figure [above] shows a human figure holding slender, curving, perhaps vegetal, objects in its hands, with extensions rising behind and above its head. It crouches on the tusked head of a boar, a fairly common theme of *malanggan* sculpture— a number of masks indeed represent pigs' heads alone. It is likely that here the junction of man and pig refers to the goods offered by participants in *malanggan* ceremonial exchanges, pigs' heads specifically being among them.

Malanggan masks [right] were worn in dances, but some are too large, too elaborate and too weighty to be carried in movement. They were put on by men standing or kneeling in front of the *malanggan* display during an episode of the women's mourning; their function was to remove taboos observed during the ceremonies. With their massed displays of birds and snakes, they are probably embodiments of bush spirits called *wanis*.

MASK, *MATUA*

New Ireland
Wood, paint; h. 93 cm.
Collected by R. Parkinson before 1895;
formerly Museum fur Völkerkunde,
Dresden
BMG 4318

MALANGGAN FIGURE

New Ireland, northern area
Wood, paint; h. 95.5 cm.
Formerly J. F. G. Umlauff (before 1900) and
Arthur Speyer collections
BMG 4341

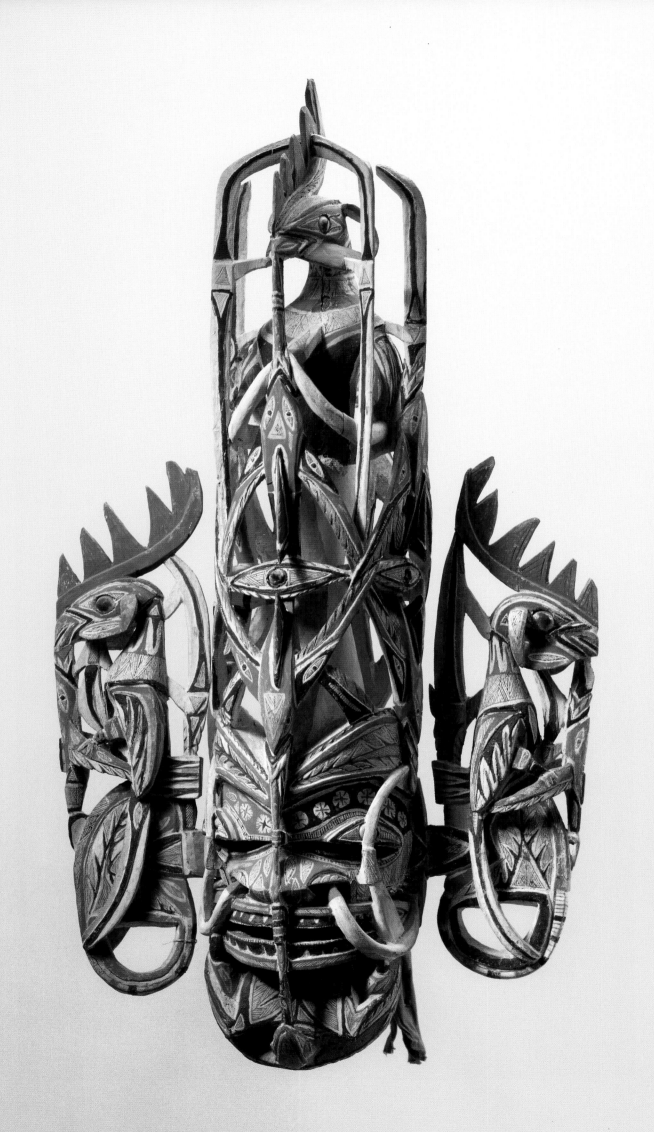

The islands of the Admiralty Group were closely linked by trade. Manus, the largest, is flanked by a number of other small islets. Although there are many different languages in the Group, the people are popularly divided into three communities: the Usiai on Manus Island; small groups of Moanus (Manus) around the coastal periphery of Manus, and the Matankor of the surrounding islands. All the groups relied on the others for some items of food or manufactures. The Matankor produced woodcarvings and decorated objects, each island having its own specialties: Baluan and Rambutyo made bird-shaped bowls, ladles, figures and lime spatulas; Pak made beds (used nowhere else in Melanesia) and slit-gongs.

Lou islanders used obsidian, from sources exploited for thousands of years, for weapon blades, and also carved great hemispherical bowls. These have four columnar legs, bands of relief patterns around the rims, and some carving on their outer walls. Their most spectacular feature, however, is their paired spiral handles. These are of no practical value whatever, as they are carved separately and adhered with a paste of parinarium nuts; they are simply embellishments. The spirals always take two and a half turns, and the outer edge of the first carries a narrow openwork ridge. Precisely the same spirals are fitted to the prows and sterns of

Admiralty Islands canoes, raising the question whether bowls and canoes, both containers, are somehow seen as analogous. We may well remember that as in many Pacific societies the canoe is the vehicle of the dead, in the Admiralty Islands the skull of the respected dead is preserved in a small bowl of the same model as the huge ones and, by extension, of the canoes.

BOWL

Admiralty Islands, Lou Island
Wood, w. 101 cm.
Formerly Herz Jesu Hiltruper Mission,
Hiltrup bei Münster
BMG 4402-A

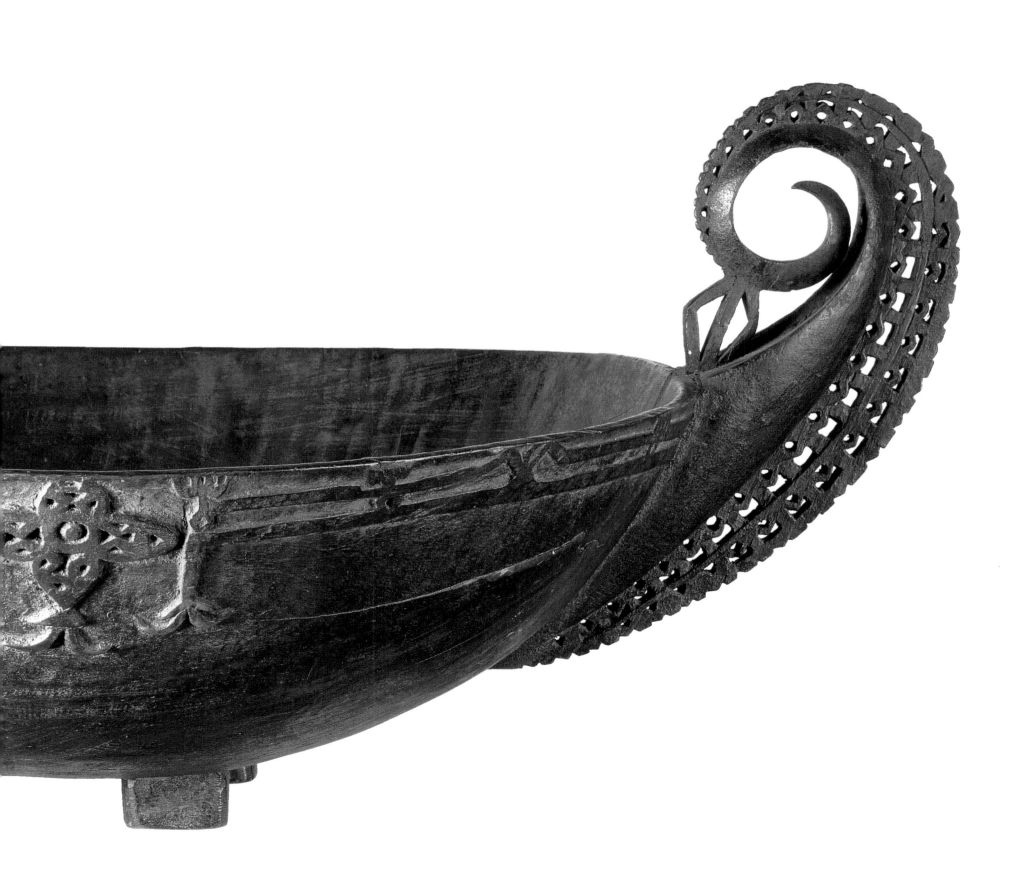

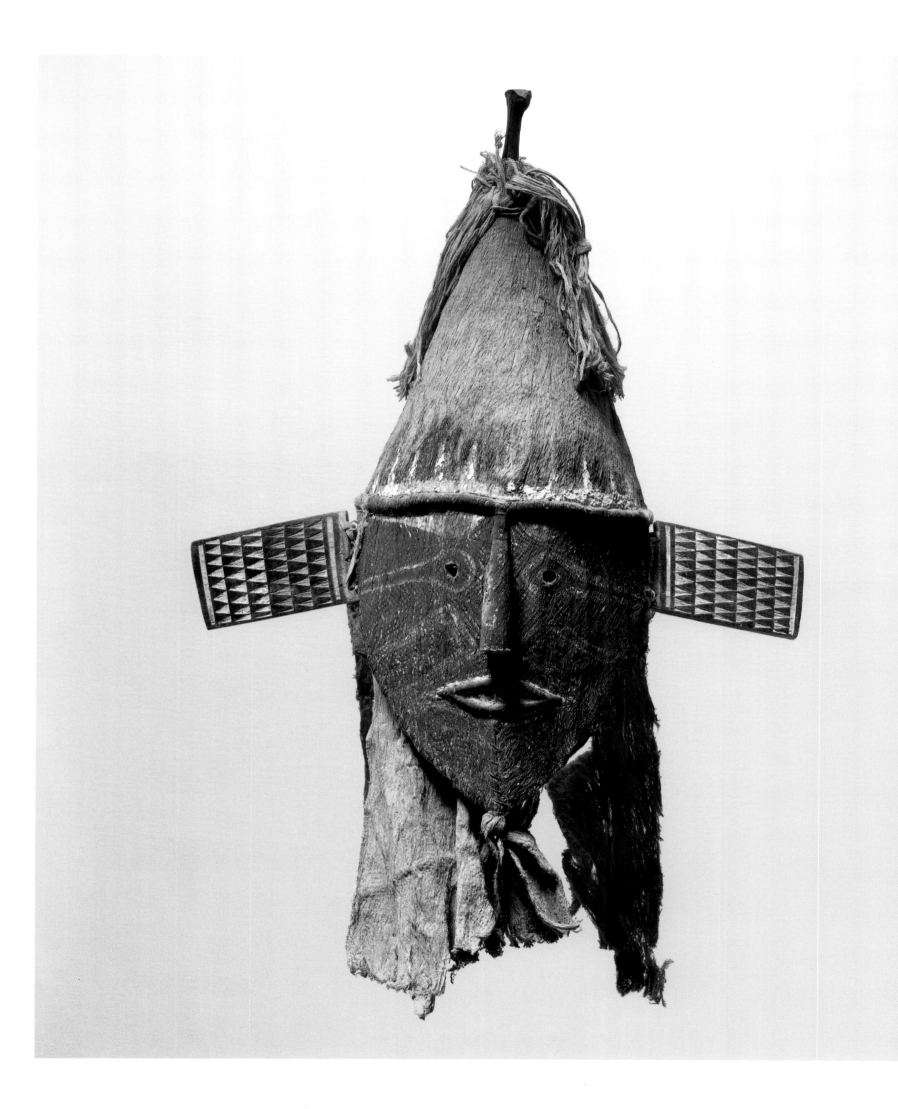

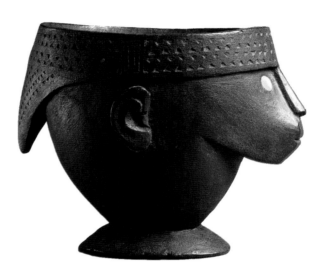

MASK, *KOKORRA*

Nissan Island
Wood, h. 59 cm.
Collected by R. Parkinson, 1895; formerly
Linden-Museum, Stuttgart
BMG 4503

BOWL IN FORM OF HUMAN HEAD

Solomon Islands, north San Cristobal or
Florida Islands
Wood, h. 16.5 cm.
Exhibited at the Exposition Universelle,
Paris, 1889; formerly Josef Mueller
collection, 1938
BMG 4502-I

Nissan, a small island lying between New Ireland and the Solomon Islands, was a trading entrepot for the two areas and used some objects from both. It had distinctive masks, made in two types, both versions of the same model. One, as in this example [left], was of coconut bast over a spindle-shaped cane frame, with modelled features, and conical fiber crania. Attached wood rectangles, with painted angular designs, served as ears. The other masks shared the same essential features but were carved in wood, with caps of human hair. The faces of all the masks tend to be broad, with pointed chins, and are usually painted with fine rows of chevrons simulating facial scarification. It is said that they were worn at festivals held at such occasions as deaths, the completion of house building and the making of canoes, and harvests. *Kokorra*, the recorded term for these masks, is a word used in a generalized way in the northern Solomon Islands for spirits and representations of them.

The small bowl with a human head [above] is of a quite rare type; the existing examples, which show considerable individual differences, come from islands in the southeast Solomons. It is not known if they were made for any specific use.

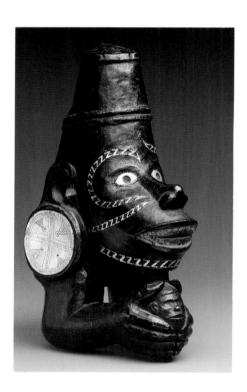

The sculpture of the central Solomon Islands is almost always painted entirely black, and enhanced by inlaid bands of shaped pearl shell pieces. In the case of human figures, the shell bands copied actual patterns of face paint. The islanders were vigorous headhunters, building canoes of great size for their expeditions. The general model throughout the archipelago had tall, upcurved prow and stern posts, decorated with rows of *Ovula ovum* (egg-cowrie) shells. In the New Georgia group and Santa Isabel and Choiseul Islands, a small carving of a human head and arms holding in their hands a miniature human head was fixed at the waterline of the prow [right]. These emphasized the canoes' roles as vehicles for headhunters and, dipping into the water as the canoes

moved, also functioned as guardians against malevolent water spirits which might attack the vessels and those who manned them.

The figure [right] was originally carved at the top of a post, now cut down so that only part of the shaft remains. Unlike the great posts from the canoe houses of these southeastern islands it apparently served no architectural purpose. Rather, it was kept in a private house as a personal family spirit.

CANOE PROW FIGURE, *NGUZU NGUZU*

Solomon Islands, New Georgia Islands
Wood, paint, pearl shell, h. 29.5 cm.
Collected by Count Festetics de Tolna,
October 1895; formerly Dr. Stephen Chauvet
collection; Josef Mueller collection, 1939
BMG 4501-C

POST FIGURE

Solomon Islands, Ulawa(?) Island
Wood, shell, total h. 84.5 cm., figure h. 61 cm.
Formerly Andre Breton collection; Josef
Mueller collection before 1939
BMG 4508

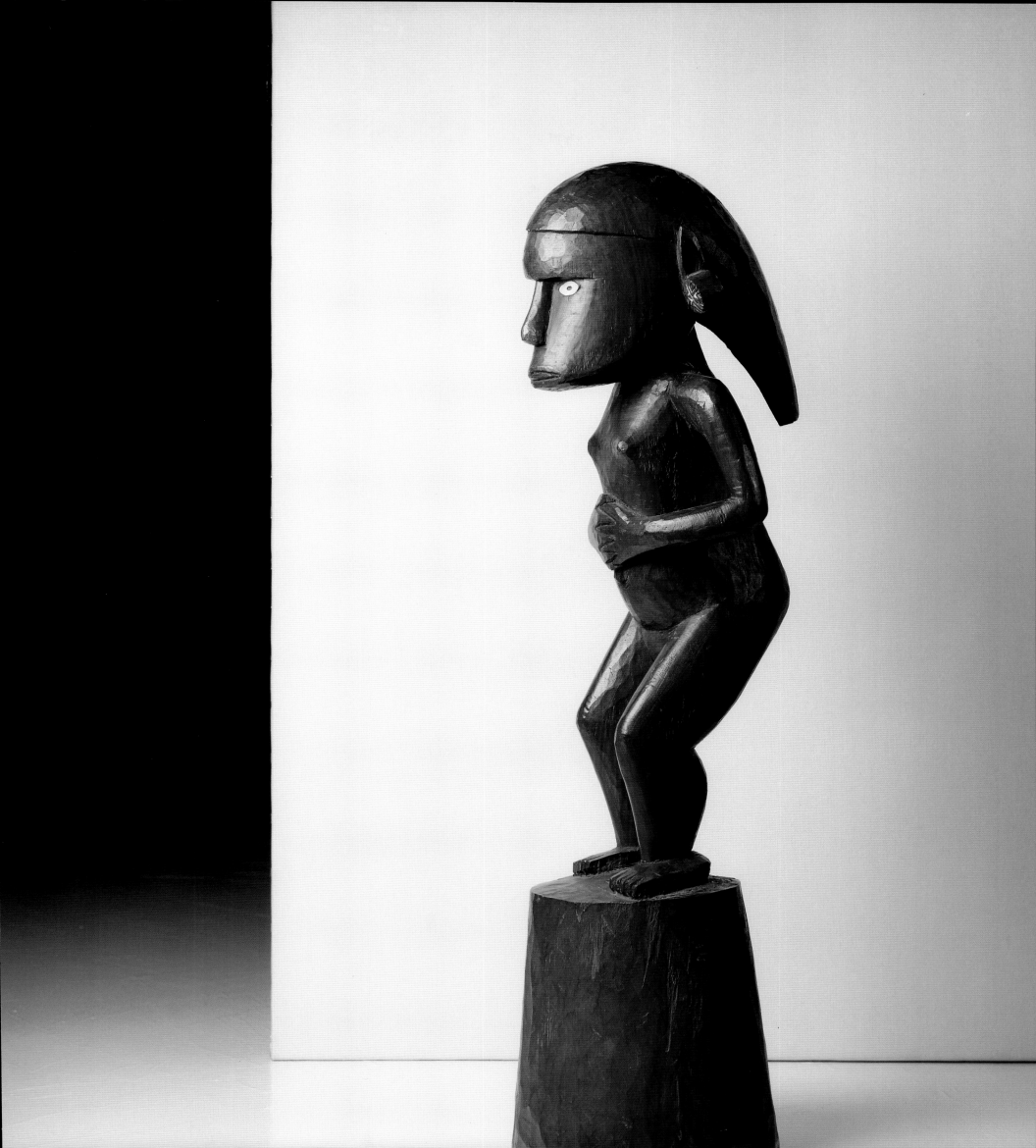

A major cultural focus of the southern Solomons—Florida, Guadalcanal, Malaita, San Cristobal and Santa Ana—was, rather than the headhunting of the central Solomons, fishing for bonito (a large fish between a mackerel and a tuna): an activity with close symbolic ties to sea spirits and ancestors. Bonito (*Katsuwonus pelamis*) being the vehicles and manifestations of the gods, were sacred; therefore fishing, and everything associated with it, was sanctified. Even male initiation was an introduction to its religious aspect.

The buildings equivalent to the ceremonial houses of New Guinea were in fact the canoe-houses. They were the centers of ancestral reverence: model canoes and large carvings of bonito were kept in these houses as shrines for ancestral skulls. They had much the same architectural grandeur; their roofs were supported on huge carved posts carved with full-length figures of bonito, sharks, and

ancestors alone or, as here, copulating in the creative act that engendered their descendants, the present people [right].

A slight mystery surrounds this massive sculpture, which is said to have come from "Magura, a now abandoned village on San Cristobal." (Makira is the indigenous name of the island.) In 1932-1933, the anthropologist Hugo Bernatzik photographed what appears to be this post, perhaps on Santa Ana Island, which lies only a few kilometers away. Did Bernatzik make a mistake about the provenance, or were there two identical posts carved by the same sculptor? In any case, the photograph gives a date before which this post must have been produced.

The lime spatula [above] has been attributed to the same area, but is more probably from further to the northwest: Guadalcanal or Florida Islands.

LIME SPATULA

Solomon Islands
Wood, shell, total h. 26 cm., figure h. 11 cm.
Formerly James Hooper collection.
BMG 4527

HOUSE POST

Solomon Islands, San Cristobal Island, South Harbor, Magura village
Collected about 1965
Wood, h. 211 cm.
BMG 4500-C

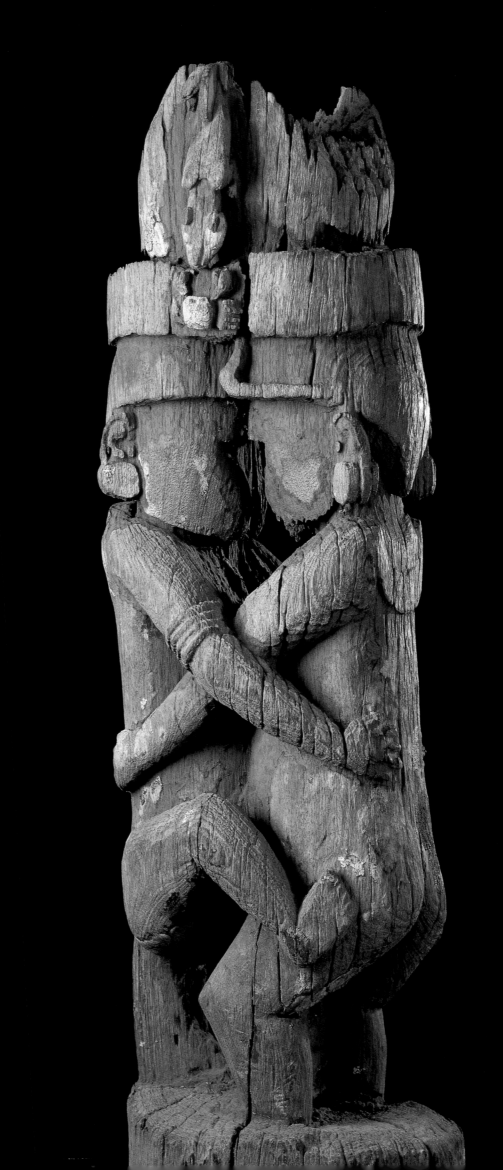

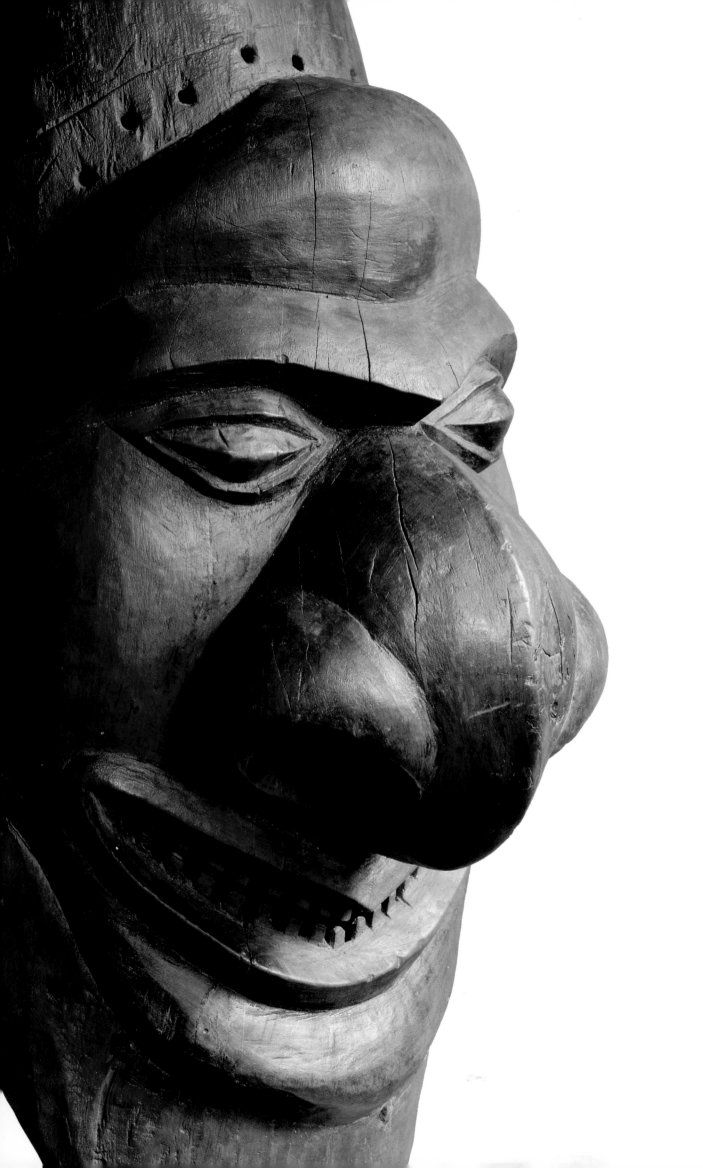

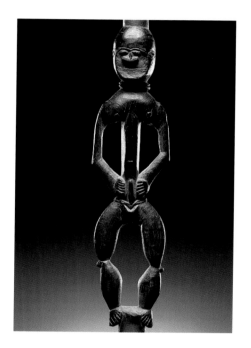

SPEAR SHAFT (DETAIL)

New Caledonia: Kanak
Wood, total h. 143 cm., figure h. 12 cm.
BMG 4706-A

MASK

New Caledonia: Kanak
Wood, h. 52 cm.
BMG 4707

Masks were used throughout the island of New Caledonia except in part of the south. They are called by various terms in thirteen languages, including *pwéémwo* or *pwéémwa*, source of the well-known word "*apouema*," which seems to be the name of a water spirit. According to a myth, the first mask emerged from the water.

They were part of an extraordinary costume [left]. There are several types, but the most remarkable are long faces with strongly arched eyebrows, hooded eyes and grinning toothy mouths. The nose springs forward between the cheeks in a great parrot-like beak. Powerful as they are alone, one must imagine the mask with a beard of human hair, the head crowned with a basketry cylinder topped with a mop also of human hair, and a cloak of black feathers. To complete the ensemble, the wearer carried a sheaf of spears in one hand and a club in the other.

The masks were rich in symbolic and social meanings, and performed in several different contexts. They were closely associated with the spirits of a community and its land, and formed part of the insignia presented to a new chief at his installation. The supernatural power of the mask reinforced his authority. At the chief's death, they represented him in his funeral ceremonies.

The spears of New Caledonia are very long and extremely thin, with a small projecting face carved about the middle of their length. To find a whole figure instead of a face is rare [above]. With its rounded limbs and firm stance, it is a miniature version of larger freestanding figures set on the ground to denote the presence of chiefs and to enforce taboos.

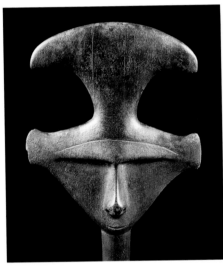
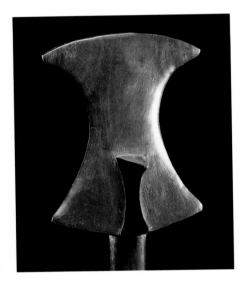

The outrigger canoes of the Vanuatu archipelago (formerly the New Hebrides) were made both as small vehicles for local travel and as large vessels equipped with masts and sails for long voyages. In northeast Malekula, the largest of the islands, and in the small islands offshore, canoes were fitted with separately carved figureheads. Small canoes had one at the prow, large canoes had carvings at both ends. All of them showed stylized frigate birds, those favorite Melanesian images of flight and the sea. Some had a pig standing on the bird's back, facing in the same direction, others human figures reclining on the bird's back and facing inwards [right]. The right to use any of these models was strictly reserved by its owner, and could only be obtained legitimately by purchase.

The bird carvings were also used in the rites held when a man was ascending from one grade of rank to a higher one. A giant matting kite, in a geometric shape resembling the silhouette of a hawk, one of the canoe carvings fixed as its head, was hoisted into the trees for the dances that pre-

ceded the final scene. This was the slaughter of a large number of pigs to consecrate the man's passage from grade to grade.

Clubs [above] were the main weapons of the Vanuatu men, who carried them wherever they went. They were used in formal duels, employing a recognized system of thrusting, striking and parrying. Each island had its own pattern of club, though they were often distributed in trade. Some types, like these, have finials showing janiform human heads in naturalistic to highly abstracted styles.

CLUB (DETAIL)

Vanuatu, Efate Island
Wood, total l. 112 cm.
Formerly Josef Mueller collection, before 1939
BMG 4605-C

CLUB (DETAIL)

Vanuatu, Ambrym or Pentecost Islands
Wood, total l. 82 cm.
BMG 4605-L

CANOE PROW

Vanuatu, Vao Island
Wood, l. 104 cm.
BMG 4611

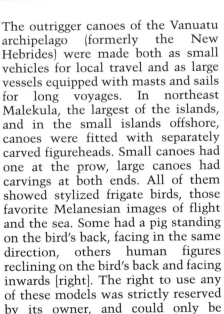

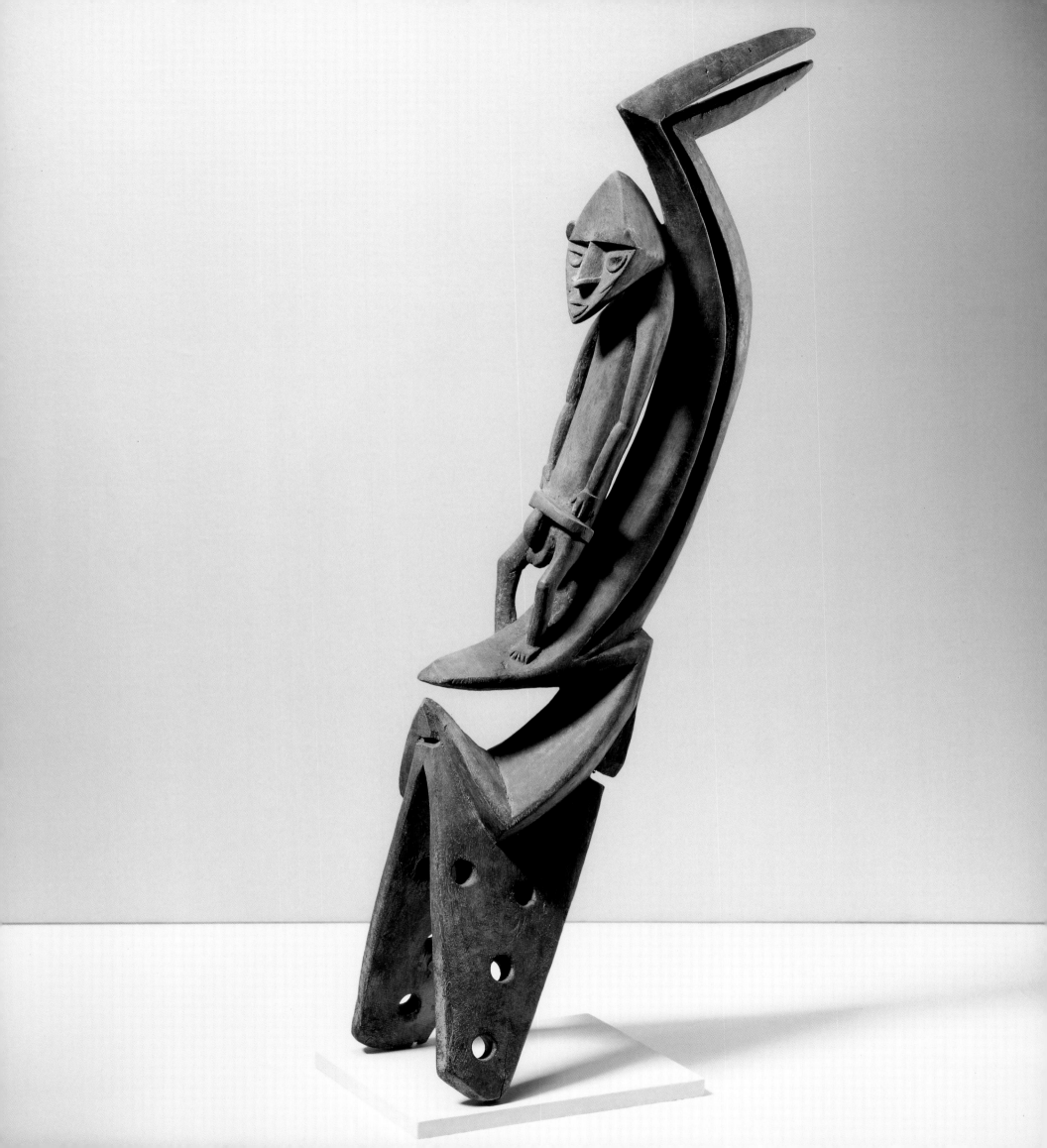

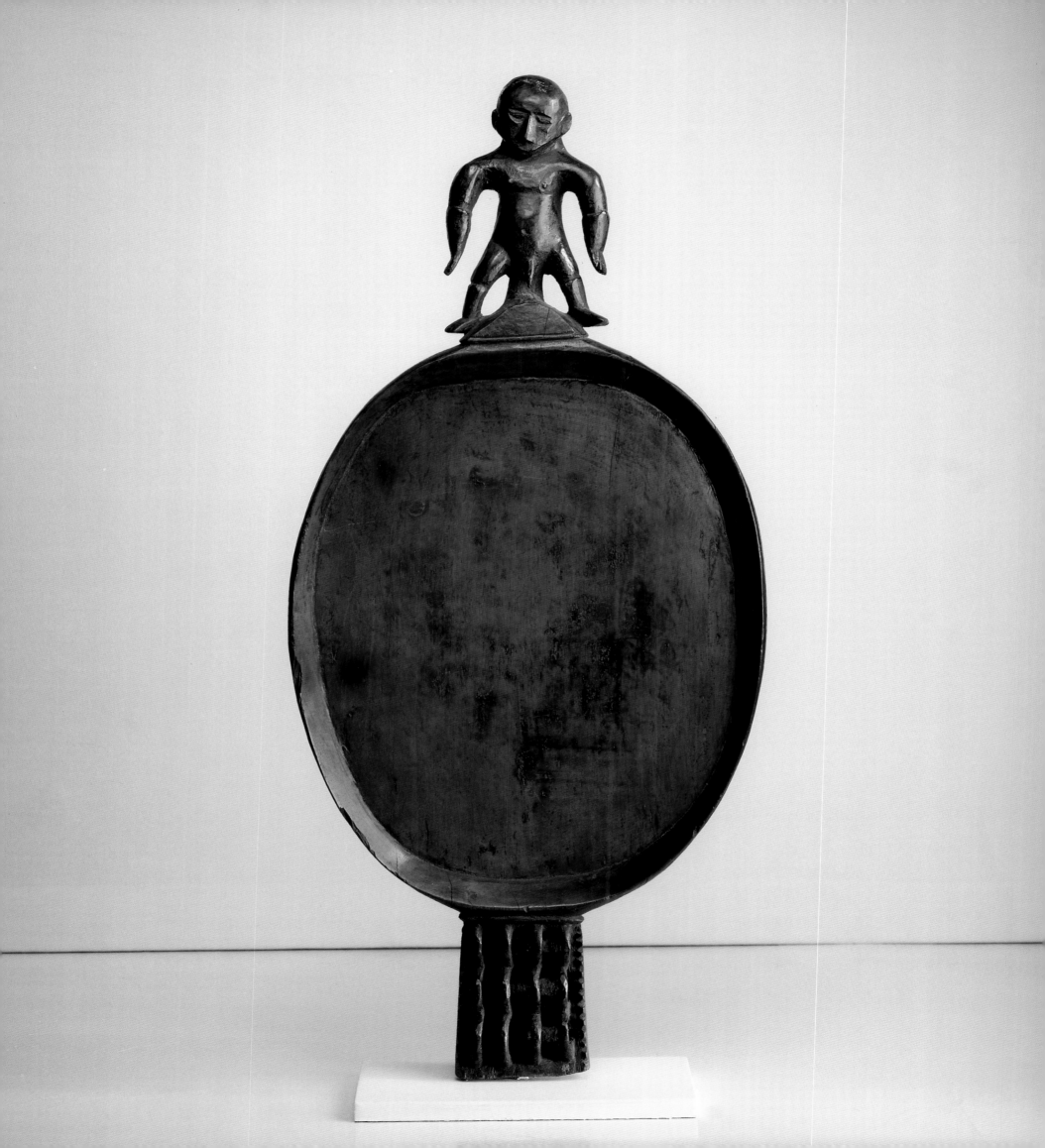

FOOD PLATTER

Vanuatu, Espiritu Santo Island, Terevin village
Wood, l. 87 cm.
Collected by Rev. Yates, early 19th century
BMG 4600-A

FOOD PLATTER

Vanuatu, Ambrym Island
Wood, l. 90 cm.
BMG 4600-D

A major staple dish in Vanuatu was concocted by grating yams, taro, bananas or a combination of them, mixing in coconut, fish, vegetables and fruit as they were available, then baking the mass on heated stones. The resulting "pudding" was served on wood platters, and divided with carved wood knives.

The platters were made in nearly all the islands; some, intended for important and well-attended feasts, were very large. According to place, they were round or oval. Generally they were shallow; on some islands they had decorative handles for carrying them and hanging them up. The Espiritu Santo platter [left] is an example of these, with its tab handle at one end and a sturdy naturalistic figure at the other.

The sculpture of Ambrym Island, off the northeast coast of Malekula, is one of large, simple and well defined shapes. The food platter [above], most probably from Ambrym, exemplifies these characteristics. The strong ovate outline of the platter, the symmetrical group of circles created by four sturdy round legs, and two opposed fernlike curves in relief, unite in a simple, flawless composition.

Very little figure sculpture from the Fiji Islands survives; the largest group of carved wooden objects extant is made up of the shallow dishes used by priests. The majority are geometric forms, circular, leaf-shaped or oval, and often on legs or stands [above]. A small number are representational, giving images of the huge Fijian double canoes, flying ducks or men. The latter are the rarest of all, probably only four still existing [right]. Fijians seem to have regarded some examples of those showing men as the oldest they knew.

Early missionary reports stated that the priests used their bowls to hold the oil with which they ritually anointed themselves, and as a result they have usually been described as oil-dishes. Other equally early evidence informs us that they were recipients for *yaqona* (*yanggona*). This is the slightly intoxicating drink distilled from scrapings of the kava (Piper methysticum) root and water. The priest sucked *yaqona* from the dish through a wood or cane tube while invoking a god or in a state of possession.

PRIEST'S DISH, *DAVENIYAQONA*

Fiji Islands
Wood, l. 63.6 cm.
Formerly Josef Mueller collection, before 1942
BMG 5010

PRIEST'S ANTHROPOMORPHIC DISH, *DAVENIYAQONA*

Fiji Islands
Wood, l. 35.9 cm.
Formerly George Ortiz collection
BMG 5009

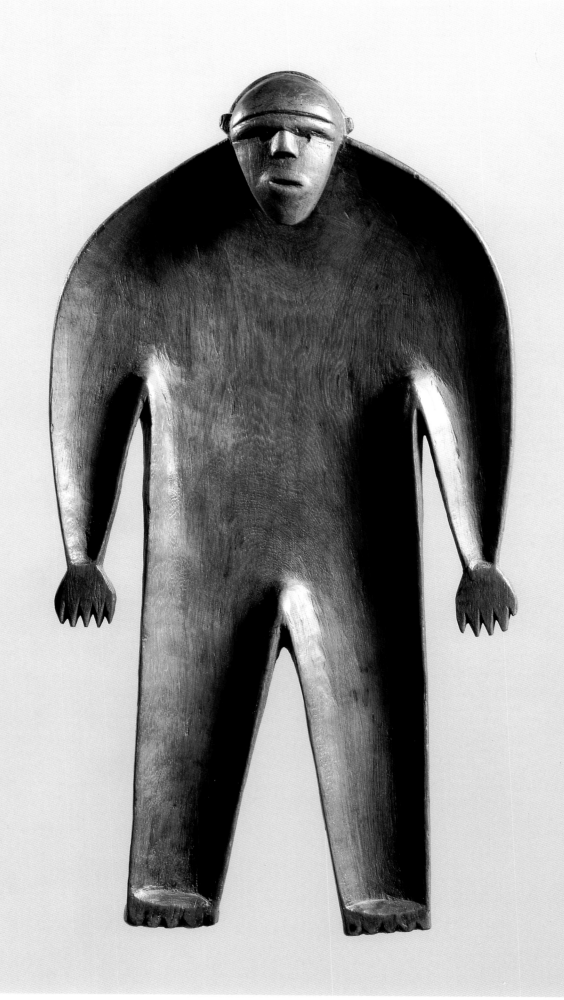

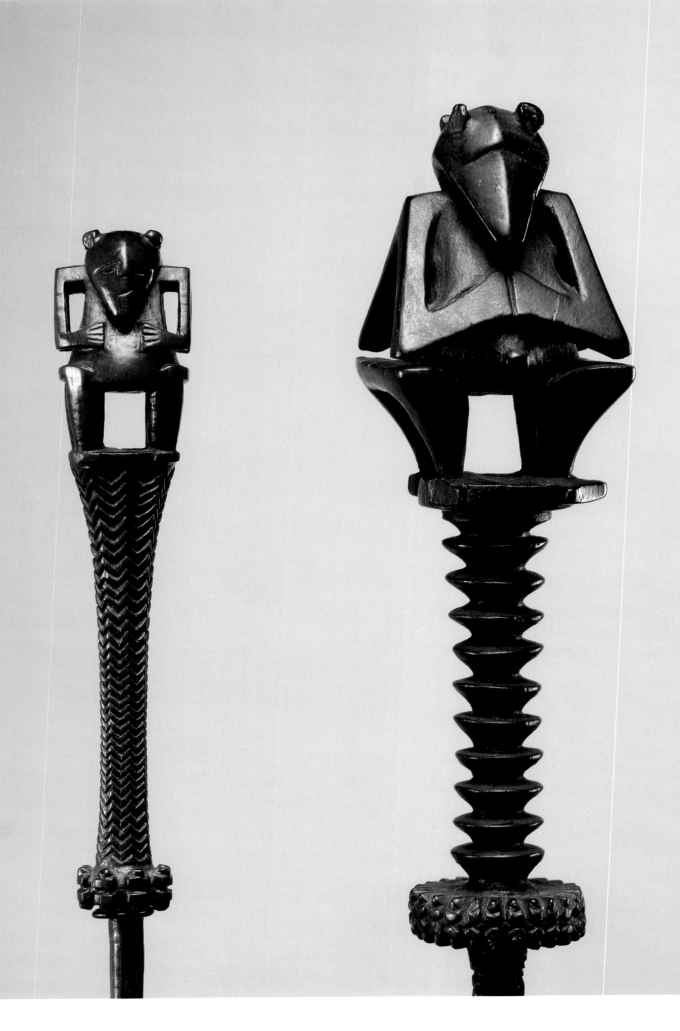

FLY WHISK HANDLE

Austral Islands,
Wood; h. 27 cm.
Formerly H. G. Beasley collection
BMG 5401

FLY WHISK HANDLE

Austral Islands,
Wood; total h. 32.4 cm., figure h. 17.8 cm.
Formerly A. Baessler collection, 1902
BMG 5453

POUNDER

Polynesia, Society Islands, Tahiti
Stone, h. 18 cm.
Formerly Paul de Givenchy and Josef
Mueller collections before 1939
BMG 5451-A

A distasteful feature of the island paradises of Polynesia to early European visitors to the Society Islands was the prevalence of swarms of flies—equally unpleasing, the visitors soon found out, to the inhabitants. The pests were combatted with whisks of one material or another which were continually in action: branches for commoners, whisks of coconut fibre with handles of wood, bone or ivory for persons of high status.

A group of the whisks of that period has often been considered Tahitian, as in old collections they are said to be from "Otaheite:" but this was the eighteenth century's name not only for Tahiti itself, but for all the islands in that part of the Pacific. Though most of them lack detailed provenance, it has been demonstrated conclusively on historic and stylistic grounds that they were actually made in the Austral Islands. Some were in fact collected in the Australs on Captain Cook's first expedition in 1769, one at Rurutu, another from Tubuai.

About forty are known to exist now; they fall into three types, two shown here [left]. All are topped with janiform figures which appear in one type almost geometric, in a double-pyramid shape. The shaft below carved is as a series of flattened cones above a disc carved with minute stylized pigs. The other type has smaller, rounded figures on a fluted shaft engraved with chevrons.

Stone pounders [above] were widely employed in Polynesia and Micronesia for crushing breadfruit, taro and other edible roots into a mash which could be stored or eaten fresh with coconut cream. The pounders of Tahiti had simple, elegantly flared bases and usually handles with slightly curved crossbar tops or two vertical projections. Here the projections take a rare form: they curve sharply upwards in two dramatic horns.

The small figure from the Cook Islands [right], although it did not come to light until the middle of this century, can be dated to at latest the first years of the nine- teenth century. After that time, missionary influence brought the carving tradition of the islands to an abrupt halt. The proportions of the body, its pose, and the formation of the mouth and eyes all point to its being from Rarotonga. Certainly originally a male figure, like so many others from Polynesia it has been emasculated in the cause of propriety. Most probably it stood at the top of the handle of a fan .

Rarotongans used at least eight different kinds of clubs invented, as a myth related, under the tutelage of the god Tane. One was the *'akatara* club [above] with a long shaft and a blade, wide or narrow, serrated along both edges with scallops leaving points between them, and a spike end. Some of these clubs are three meters long.

CLUB (DETAIL), *'AKATARA* (RESTORED)

Cook Islands, Rarotonga
Wood, l. 249 cm.
BMG 5305-B

FIGURE FROM A FAN HANDLE

Cook Islands, Rarotonga
Wood, h. 12.5 cm.
Formerly James Hooper collection, 1951
BMG 5303

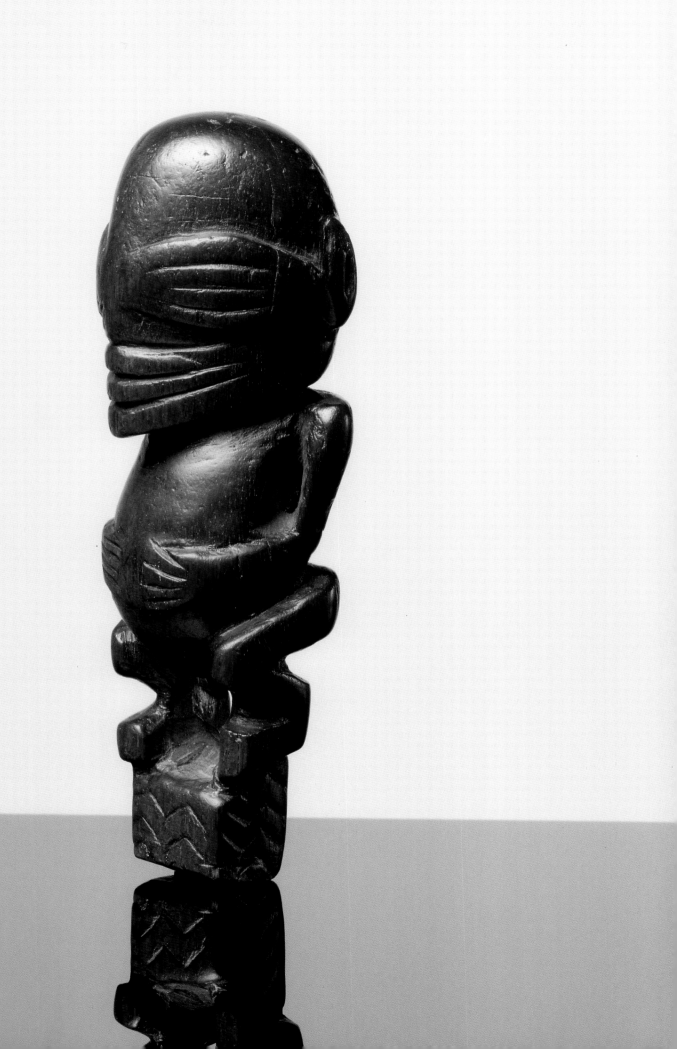

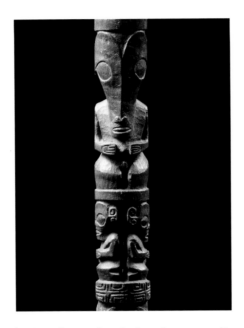

Marquesas Islands art is dominated by the stylization of the human body called *tiki*, which appears in three dimensions or relief on virtually every carved object: figures, clubs, canoe prows, bowls, steps for stilts, ornaments, and many others. The disproportionally large head has huge goggle eyes linked by a frame, small nose, and wide horizontal mouth in three ridges, one being the tongue. The body is squat, and the knees slightly flexed. These features are constant, though there is considerable variety in the *tiki*s' postures.

Small stone *tiki*s—some occur in addorsed pairs—were probably often images of minor gods, and were kept in private shrines [right]. Others seem to have been suspended, perhaps as line or net sinkers intended to attract divine aid in fishing.

Marquesan chiefs carried semicircular fans plaited from banana leaflets, with carved handles of wood, ivory or human bone, and long staffs of office decorated at the upper end with woven binding and clumps of human hair. The shafts of most staffs were uncarved, but *tiki*s appear on some examples, no doubt in silent solicitation of divine or ancestral aid. The more richly carved fan handles show addorsed and surmounted pairs of *tiki*s.

CHIEF'S STAFF, *TOKOTOKO PIO'O*

Marquesas Islands
Wood, human hair, l. 153 cm.
Collected 1830
BMG 5803-B

FIGURE, TIKI

Marquesas Islands
Stone, h. 16 cm.
Formerly Josef Mueller collection, before
1939
BMG 5810-1

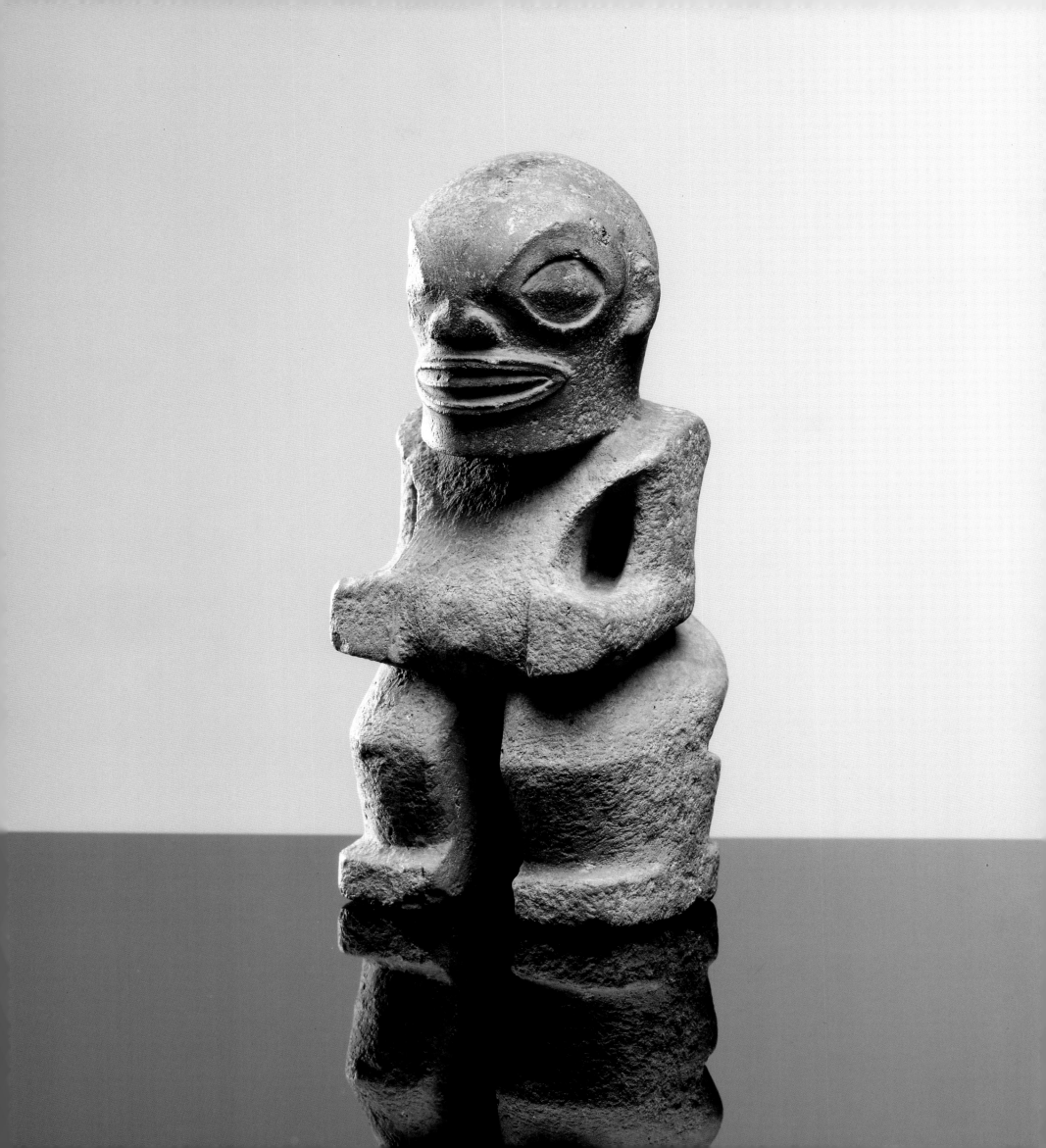

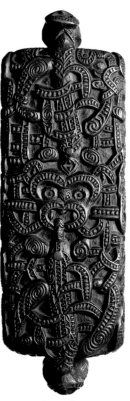

When the ancestors of the present Maori people landed on the two islands of New Zealand about AD 800, they brought with them the culture of their homeland in Central Polynesia. It included a very simple style of sculpture in wood, ivory and stone. This began to develop towards greater elaboration by about 1200, and by 1500 flowered into the complex and florid carving by which Maori art is best known today.

Almost everything the Maori made was decorated, for example, the box [above] for the treasures of a chief. The main subject depicted, running down the middle of the box, is a pair of ancestors, symbolically united though a head separates them.

The Maori's great war canoes were the wonder of the first Western explorers of New Zealand. Hollowed from tree-trunks, they were several meters long and carried up to 70 men. They had horizontal prows carved with gods and ancestors, and stern posts [right], towering panels of openwork fringed all round with feathers, and with long feather streamers dedicated to the gods of the sky and sea.

The style of this *tau rapa* was in existence in the eighteenth century. At the foot of the panel, facing into the canoe, is a three-dimensional figure of the founding ancestor of a tribe. Behind him, up the middle of the panel, rise two long ribs. They are grasped at the top by a *manaia*, an enigmatic creature with a birdlike head. The rest of the field is taken up by a series of openwork double spirals. Judging by its size, this *tau rapa* came from one of the largest vessels the Maori built.

FEATHER BOX, *WAKA HUIA*

New Zealand, North Island, Taranaki area: Maori
Wood, l. 47 cm.
Collected 1823; formerly Museum für Völkerkunde, Leipzig
BMG 5102

CANOE STERN POST, *TAU RAPA*

New Zealand, North Island, probably Bay of Plenty: Maori, Te Arawa tribe
Collected by Mr. Astbury before 1850, formerly Charles Ratton collection
Wood, h. 192 cm.
BMG 5100

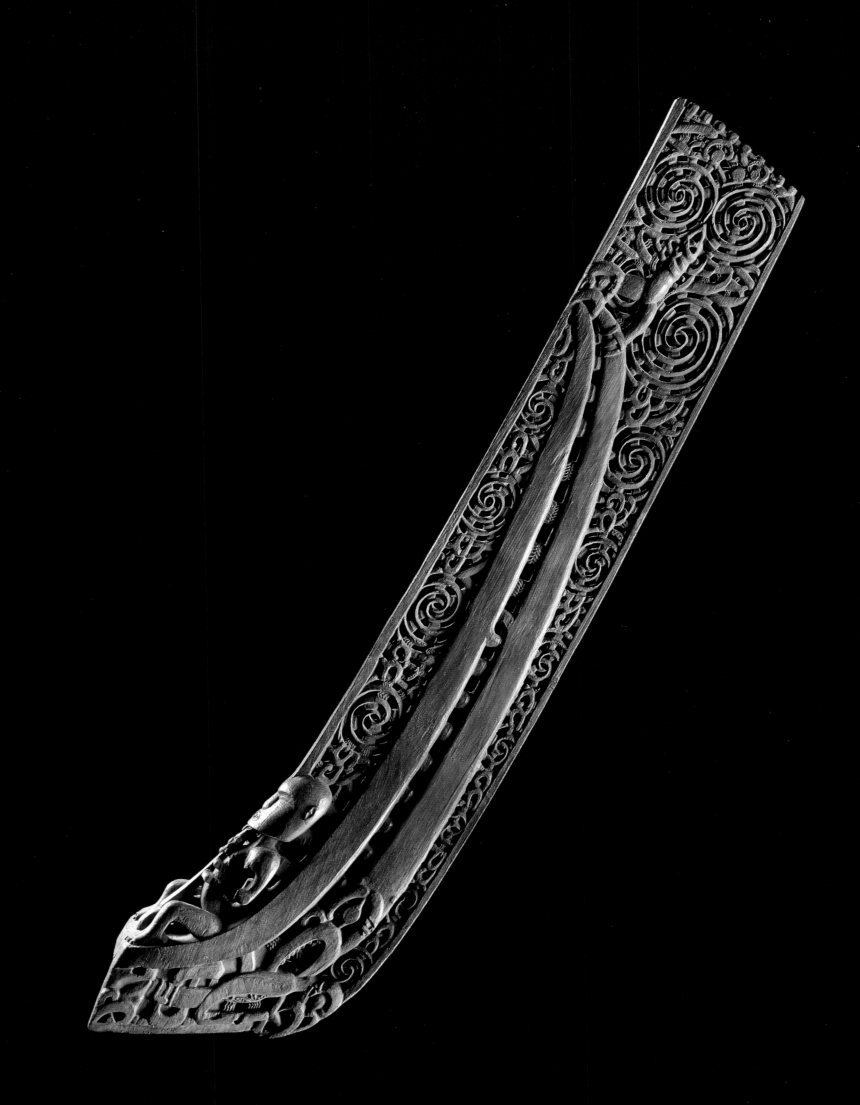

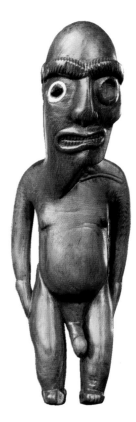

In comparison with the dramatics of Indonesia and Melanesia, the art of a great part of Polynesia may often seem repetitive, bland, "classic." If so, it is because we know less of it: much disappeared in the early nineteenth century at the hands of Christian missionaries, as well as native forerunners who had done destructive work before the missionaries themselves arrived.

The art of Easter Island, isolated after about AD 400 on the farthest rim of Polynesian culture, has many astonishing things to offer, its stone colossi being the most famous. Wooden figures are mainly limited to two or three standard types, but there are a number of highly eccentric pieces. Some of them show physical anomalies, hermaphrodites or biceph-

alic human beings. A small male figure [above] is clearly one of this kind, as the mouth is twisted downwards in a manner which suggests the distorting effect of a stroke. In some cultures such afflictions were considered signs of divinity.

The Easter Islanders performed many dances carrying wood figures and dance staffs [right]. Twirled in one hand while the dancer hopped forward from foot to foot, the dance staffs were thrust close to the face of a seated chief as if to threaten him. Graceful and elegant, the staffs are stylized human figures of the utmost economy. The heads are expressed in carving only by the nose and the ear lobes; the lower swelling area terminates in a penis. The facial features— eyes and mouth—were painted in.

FIGURE, *MOAI TANGATA*

Easter Island
Wood (toromiro), h. 19.2 cm.
Formerly Sir Jacob Epstein collection
BMG 5701

DANCE STAFF, *RAPA*

Easter Island
Wood (toromiro), h. 78.8 cm.
Formerly Butler Museum, Harrow
BMG 5702

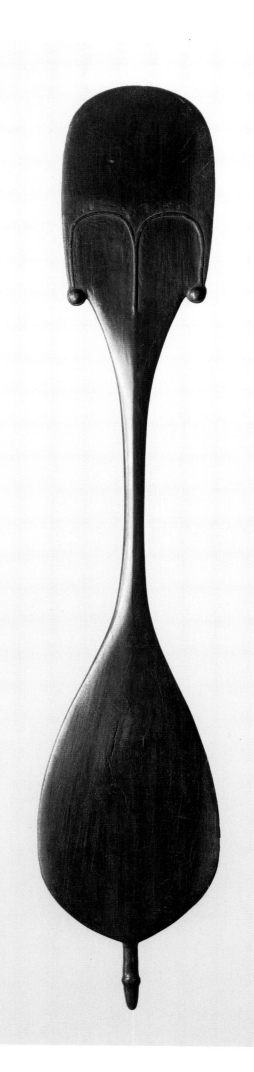

The people of the small island of Wuvulu, northwest of New Guinea, led simple lives as fishermen and gardeners. Everything they made was simple: everything was profoundly graceful: their tools, their weapons, their canoes. Their most astonishing achievements were the wooden dishes [above] they made as a matter of course, for daily use. No one else in the world has ever thought of their solution for a container: to take three similar curved planes, to unite them with each other in perfect balance, and thus to produce a form of the purest harmony. It is difficult, if not impossible, to find a parallel to such a complete combination of intellectual and esthetic refinement in the whole range of art.

Nukuoro, a tiny atoll of many islets, altogether less than two kilometers across, is in the Caroline Islands of Micronesia. It has a minuscule population of Polynesian descent and language, whose ancestors appear to have arrived from the east about 1300-1500. The islanders were not encountered by Westerners until 1806, and thereafter returned to their obscurity—all 200 of them—until the late nineteenth century.

About thirty of their figures of deities [right] are extant. Bernard de Gruenne considers that signs of usage and the employment of native tools indicate that this one was carved about 1800, before Western contact began. Some are small, perhaps owned by families, some large, perhaps the collective national pantheon that was installed on one of the islets. They are virtually featureless abstractions of the human form: most are even sexless, though a few bear female breasts.

We began with a single human figure, a singular work of sculpture; with the same figure we end, having traversed a great part of the world and several hundred years of time; and with an awareness that the ghosts of unknown centuries are standing behind them: human ghosts and the ghosts of their creations that have perished long ago. A singular journey; one that has visited beauties that are always the testimonies of our ancestors, our fellows, and their genius.

DISH

Western Islands, Wuvulu (Maty Island)
Wood, l. 43.7 cm.
Formerly Rudolf Schmidt and Josef Mueller
collections
BMG 4810

FIGURE, *TINO, DINONGA EIDU*

Caroline Archipelago, Nukuoro Atoll
Wood, h. 40.2 cm.
Formerly Paul Guillaume and George Ortiz
collections
BMG 4980-5

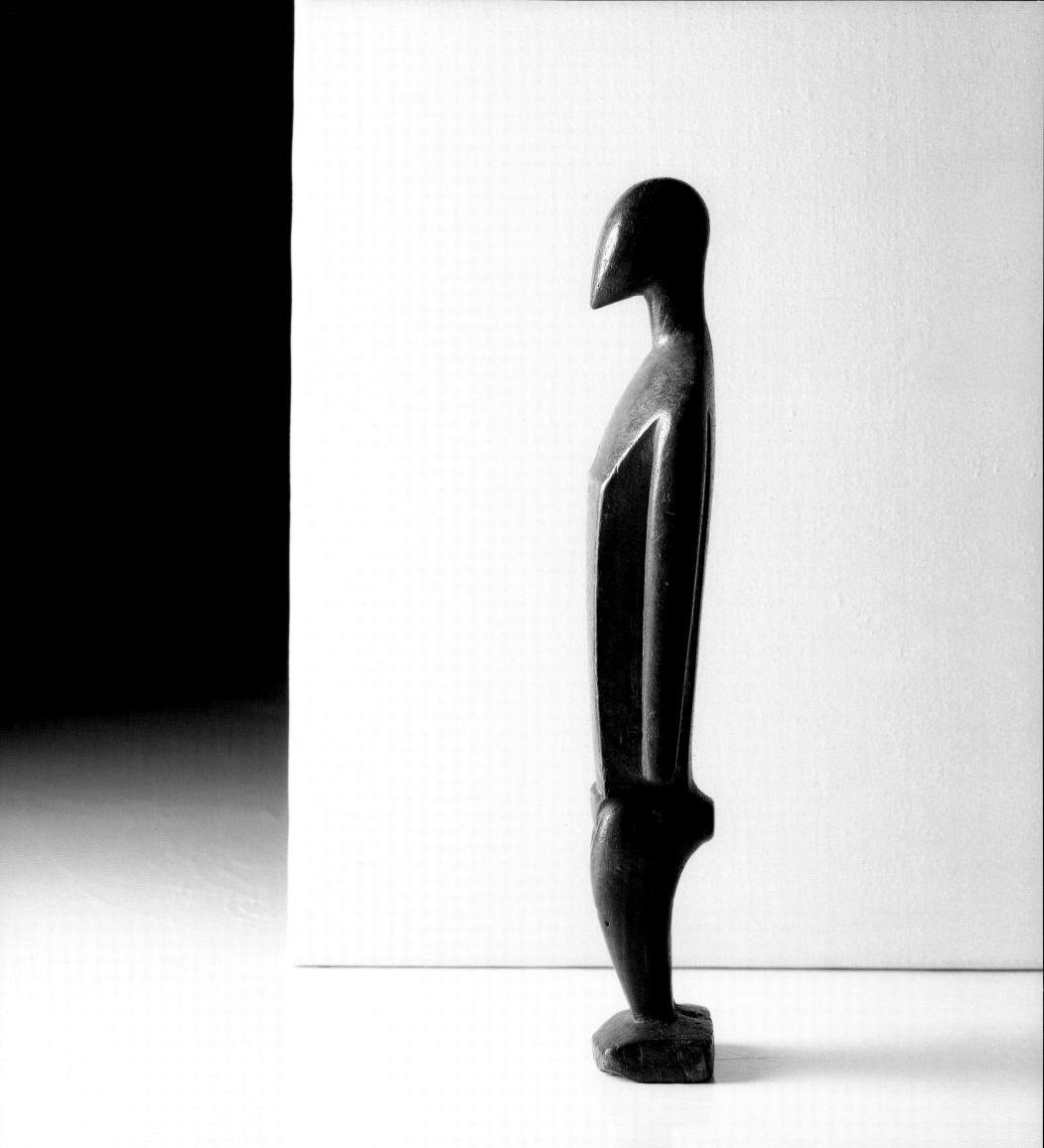

MAPS

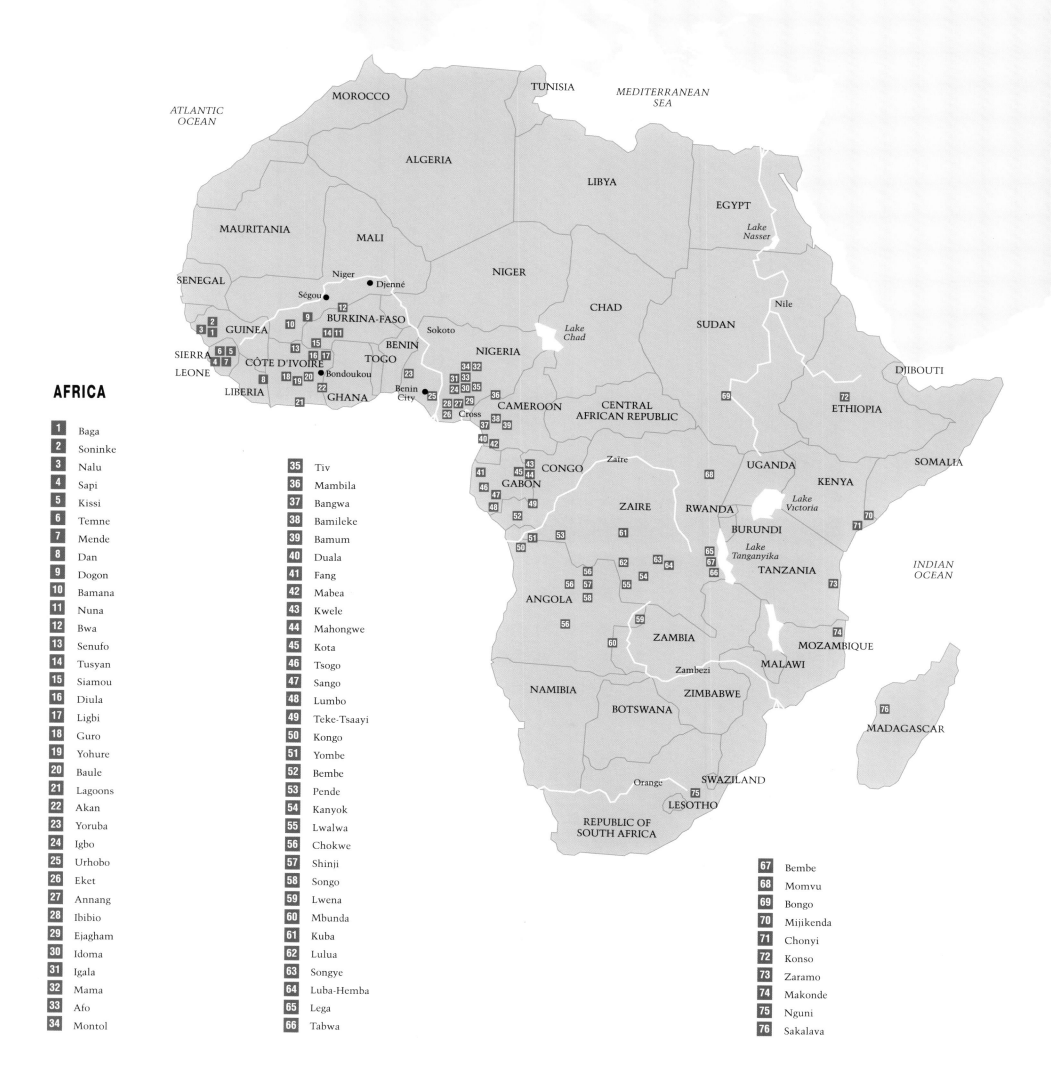

AFRICA

1 Baga
2 Soninke
3 Nalu
4 Sapi
5 Kissi
6 Temne
7 Mende
8 Dan
9 Dogon
10 Bamana
11 Nuna
12 Bwa
13 Senufo
14 Tusyan
15 Siamou
16 Diula
17 Ligbi
18 Guro
19 Yohure
20 Baule
21 Lagoons
22 Akan
23 Yoruba
24 Igbo
25 Urhobo
26 Eket
27 Annang
28 Ibibio
29 Ejagham
30 Idoma
31 Igala
32 Mama
33 Afo
34 Montol

35 Tiv
36 Mambila
37 Bangwa
38 Bamileke
39 Bamum
40 Duala
41 Fang
42 Mabea
43 Kwele
44 Mahongwe
45 Kota
46 Tsogo
47 Sango
48 Lumbo
49 Teke-Tsaayi
50 Kongo
51 Yombe
52 Bembe
53 Pende
54 Kanyok
55 Lwalwa
56 Chokwe
57 Shinji
58 Songo
59 Lwena
60 Mbunda
61 Kuba
62 Lulua
63 Songye
64 Luba-Hemba
65 Lega
66 Tabwa

67 Bembe
68 Momvu
69 Bongo
70 Mijikenda
71 Chonyi
72 Konso
73 Zaramo
74 Makonde
75 Nguni
76 Sakalava

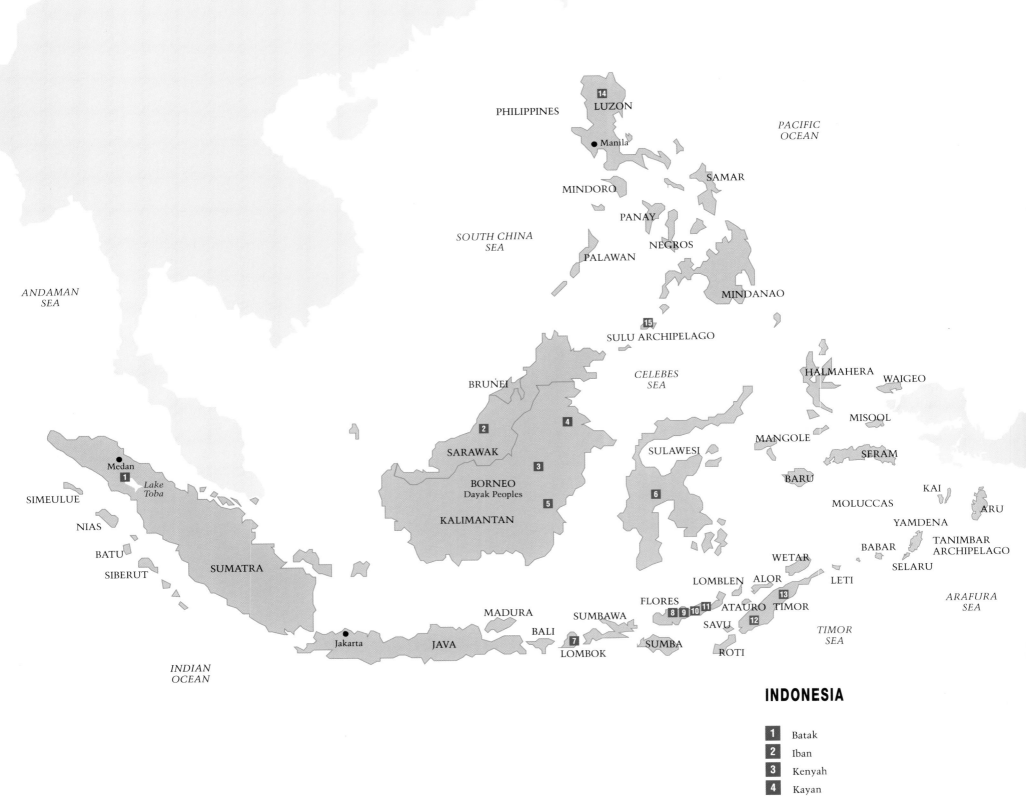

PHILIPPINES

LUZON `14`

PACIFIC
OCEAN

● Manila

MINDORO

SAMAR

PANAY

SOUTH CHINA
SEA

NEGROS

PALAWAN

MINDANAO

ANDAMAN
SEA

`15`
SULU ARCHIPELAGO

CELEBES
SEA

HALMAHERA

WAIGEO

BRUNEI

`2`

`4`

SARAWAK

BORNEO
Dayak Peoples

`3`

SULAWESI

MISOOL

MANGOLE

SERAM

BARU

Medan ●
`1`
*Lake
Toba*

`6`

KAI

MOLUCCAS

ARU

SIMEULUE

`5`

KALIMANTAN

YAMDENA

NIAS

BABAR

TANIMBAR
ARCHIPELAGO

BATU

SELARU

SIBERUT

SUMATRA

WETAR

LETI

LOMBLEN
ALOR

ARAFURA
SEA

FLORES

`13`

MADURA

SUMBAWA

`8` `9` `10` `11`
ATAURO
TIMOR

BALI

`12`
SAVU

TIMOR
SEA

Jakarta ●

JAVA

`7`
LOMBOK

SUMBA

ROTI

INDIAN
OCEAN

INDONESIA

`1` Batak
`2` Iban
`3` Kenyah
`4` Kayan
`5` Bahau
`6` Sa'adan Toraja
`7` Sasak
`8` Ngada
`9` Nage
`10` Ende
`11` Lio
`12` Atoni
`13` Tetum
`14` Ifugao (Igorot)
`15` Bajau

OCEANIA

1	Abelam (Maprik)
2	Murik
3	Kopar
4	Iatmul
5	Biwat (Mundugumor)
6	Kayan (East Sepik province)
7	Elema
8	Kerebo (Kerewa)
9	Kala Kawaw
10	Asmat
11	Bali-Vitu
12	Mamusi
13	Kairak and Uramot Baining
14	Kara
15	Kanak
16	Maori

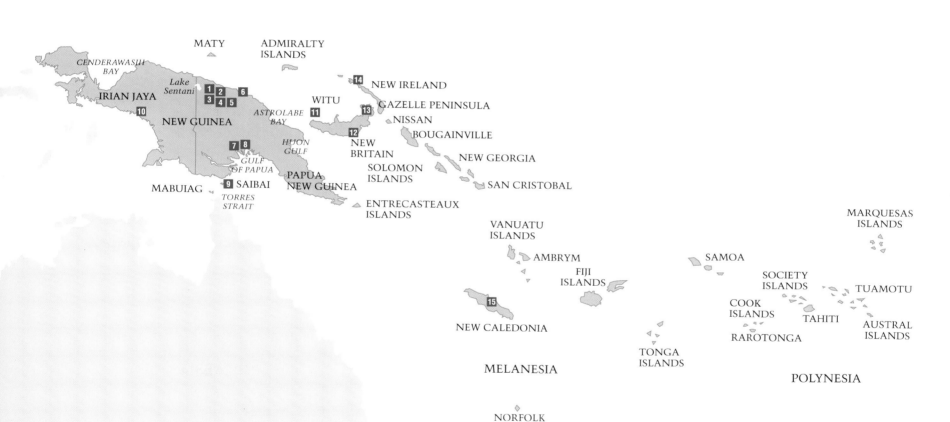

HAWAII

MARIANA
ISLANDS

MICRONESIA

CAROLINE
ARCHIPELAGO

MARSHALL
ISLANDS

NUKUORO

MATY

ADMIRALTY
ISLANDS

*CENDERAWASIH
BAY*

*Lake
Sentani*

14 NEW IRELAND

WITU

GAZELLE PENINSULA

11

13

NISSAN

IRIAN JAYA

10

*ASTROLABE
BAY*

NEW GUINEA

BOUGAINVILLE

12

**NEW
BRITAIN**

*HUON
GULF*

7 **8**

*GULF
OF PAPUA*

SOLOMON
ISLANDS

NEW GEORGIA

SAN CRISTOBAL

**PAPUA
NEW GUINEA**

9 SAIBAI

MABUIAG

*TORRES
STRAIT*

ENTRECASTEAUX
ISLANDS

MARQUESAS
ISLANDS

VANUATU
ISLANDS

AMBRYM

SAMOA

SOCIETY
ISLANDS

TUAMOTU

FIJI
ISLANDS

COOK
ISLANDS

TAHITI

AUSTRAL
ISLANDS

15

RAROTONGA

NEW CALEDONIA

TONGA
ISLANDS

MELANESIA

POLYNESIA

NORFOLK

*TASMAN
SEA*

*PACIFIC
OCEAN*

EASTER
ISLAND

NORTH ISLAND

16

NEW ZEALAND

SOUTH ISLAND